Painting Architecture

Painting Architecture

Jiehua in Yuan China, 1271–1368

Leqi Yu

Hong Kong University Press
The University of Hong Kong
Pokfulam Road
Hong Kong
https://hkupress.hku.hk

ISBN 978-988-8754-23-6 (*Hardback*)

British Library Cataloguing-in-Publication Data
A catalogue record for this book is available from the British Library.

10 9 8 7 6 5 4 3 2 1

Printed and bound by Hang Tai Printing Co., Ltd. in Hong Kong, China

To Shenghan Jiang and Yu Jiang

Contents

Illustrations

Figures

Plates (after p. 100)

Acknowledgments

In the course of my research and writing, many teachers, colleagues, and friends have contributed to this project in a variety of ways. I am especially grateful to Nancy S. Steinhardt, my dissertation advisor and now mentor, for her expertise and patience. In her Chinese architecture course, she encouraged me to study the Yuan painter Xia Yong long before I realized that Xia's *jiehua* had the potential for a book-length project. Her kindness in providing timely feedback and useful suggestions made the completion of this project possible. I also owe thanks to Victor H. Mair, who generously offered his thoughts on the relationship between architectural painting and literature and deepened my understanding of the cultural values of buildings painted. I am deeply indebted to Adam Smith and Qianshen Bai, who also read through my early drafts. Their sensitivity to classical Chinese texts greatly improved my translations of colophons and poems on paintings. Additional thanks are due to Christopher P. Atwood, Paul R. Goldin, Hsiao-wen Cheng, Petya Andreeva, Xiuyuan Mi, Wei Chen, and others at the University of Pennsylvania who were there at the inception of this project and enriched my knowledge.

The generosity of the Henry Luce Foundation/ACLS Program in China Studies enabled me to do primary research in China in the summer of 2017. In Beijing, Song Li of Peking University offered insight into Shanxi mural paintings, and Hui Yu of the Palace Museum expanded my study of Song-Yuan architectural paintings. Yu Hu of the Yunnan Provincial Museum, Peng Huang of the Shanghai Museum, and Shen Wang of the Zhejiang University Museum of Art and Archaeology facilitated painting viewings that were crucial to this project. Heping Liu of Wellesley College graciously offered his thoughts on the concept of *jiehua*. My experience as a visiting scholar in Academia Sinica in the summer of 2018 was more productive than I had expected. Shou-chien Shih offered advice and mentorship, and Yu-jen Liu allowed access to the Song-Ming painting collection of the National Palace Museum in Taipei. As a Smithsonian Institution Postdoctoral Fellow, I was granted time and funds to transform my dissertation into a book. I benefited greatly from the support

and expertise of Stephen D. Allee, Jan Stuart, and other staff at the Freer Gallery of Art and Arthur M. Sackler Gallery.

For other financial and institutional support that I received, I am grateful to the University of Pennsylvania (Department of East Asian Languages and Civilizations, Center for East Asian Studies, and Penn Museum), Caltech Library, the National Library of China, Peking University Library, and the Renmin University of China. The China Postdoctoral Science Foundation (No. 2021M693480) and the Society for Song, Yuan, and Conquest Dynasties Studies generously provided publication subventions. In addition, I wish to especially thank the following people for their assistance to arrange painting viewings or locate research materials: Nancy Berliner and Feier Ying of the Museum of Fine Arts, Boston; Joseph Scheier-Dolberg of the Metropolitan Museum of Art; Cary Y. Liu and Zoe Song-Yi Kwok of the Princeton University Art Museum; Jerome Silbergeld of Princeton University; Nicholas Cahill and Sarah Cahill; and Miki Morita. Hongbao Niu of the Renmin University of China, Shuo Geng of the Central Academy of Fine Arts, Ziliang Liu of Harvard University, and others are due thanks for helping me acquire image permissions.

I must acknowledge all the scholars who offered insightful comments when I presented my research on *jiehua*. In the 2019 Heidelberg-Getty Dissertation Workshop, faculty mentors, including Shane McCausland of the University of London, Yukio Lippit of Harvard University, Sarah E. Fraser of Heidelberg University, Craig Clunas of the University of Oxford, and others, offered excellent feedback and expanded my outlook. In particular, Lothar Ledderose of Heidelberg University provided the initial suggestions about the coordinated production of the professional atelier, which led to the conclusion part of this book. A portion of this project, related to Xia Yong and the legacy of the Southern Song Imperial Painting Academy, was presented at the Association for Asian Studies Annual Conference in 2018. A section of Chapter 2 was presented at the College Art Association Annual Conference in 2020. This book benefited immensely from the scholarly communications there.

I would like to express my thanks to Kenneth Yung and other editorial team members at Hong Kong University Press, as well as anonymous readers who kindly shared their opinions on multiple drafts of this book and immeasurably improved it. Finally, special thanks need to be given to my parents, Changgen Yu and Yamei Lu, for their encouragement and support.

Introduction

One day in the tenth century, Yu Hao 喻皓, the most skilled craftsman of the Northern Song dynasty (960–1127), finalized the design for his architectural masterpiece: a thirteen-story pagoda for the Kaibao Monastery 開寶寺. However, the painter Guo Zhongshu 郭忠恕 (d. 977) warned him about an error in his design. Guo measured the miniature model, calculated the height from its lowermost story, and found that there was not enough space remaining to reasonably assemble the structural components of the framework. Yu spent several nights carefully measuring his design, and it turned out that Guo was right. It was said Yu knelt long in front of Guo, because Yu was extremely grateful that Guo had helped him prevent a disastrous mistake.[1] Guo Zhongshu, a painter, had not only mastered the practices of knowledgeable architects—he had even surpassed them. He was, in fact, one of the most prestigious specialists in *jiehua* 界畫.

Although the history of Chinese art privileges landscape and figure paintings as its objects of study, *jiehua*, or paintings that include architecture as a subject, holds a highly significant yet understudied position in this history. The *Summer Palace of Emperor Ming Huang* (fig. 0.1), traditionally attributed to Guo Zhongshu, is a representative example of *jiehua*. The subject of this painting is architectural, the artist uses tools such as rulers to create consistently even lines for architectural details, and the painting accurately represents the building's structure. All these factors reflected in this work, particularly its technical consideration and mechanical perfection, distinguish *jiehua* from other painting genres and link it to the builder's art. However, the limited scholarship on the subject has never perfectly clarified the relationship between *jiehua* and architectural painting, and has put forward various translations of *jiehua*, such as "boundary painting" and "ruled-line painting"—but unfortunately, none has been accepted with unanimous approval.[2]

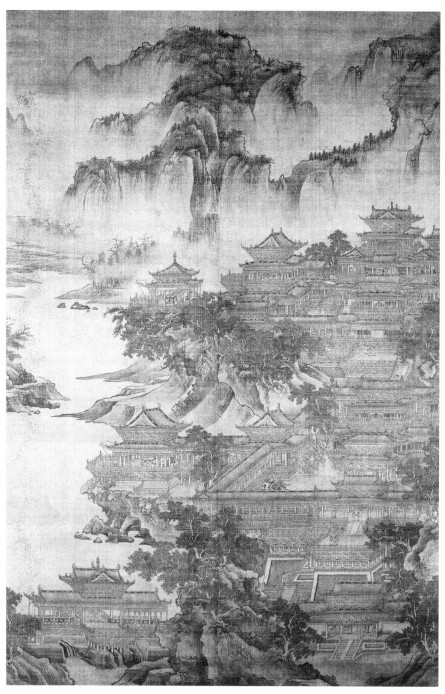

Figure 0.1: Guo Zhongshu (attri.). *Summer Palace of Emperor Ming Huang.* Yuan dynasty (1271–1368). Hanging scroll, ink on silk, 160.2 cm × 105.6 cm. Osaka City Museum of Fine Arts.

The Concept of *Jiehua*

The variety of English translations, in my view, reflects the ambiguous nature of the *jiehua* concept. Indeed, in traditional Chinese literary texts, this complex term, *jiehua*, has been inextricably intertwined with architectural painting and widely used to refer to this subject. However, its invention was much later than the existence of architectural painting. *Jie hua* first appeared as a loosely defined verb in the Northern Song dynasty.[3] In the Southern Song period (1127–1279), the noun *jiehua* began to designate a specific painting genre, which usually depicts architectural subjects and emphasizes the ruled-line technique. *Jiehua*, as a classificatory term, continued to be in widespread use during the Yuan dynasty (1271–1368). Meanwhile, along with the increasing popularity of literati painting and ideals, literati scholars added another layer of meaning to this concept, rendering it a painting style with specific laws. Therefore, the term *jiehua* has accumulated more usages throughout time and has finally combined all these changing meanings into an integrated entity. Given this situation, all current translations of *jiehua* fail to capture its potential multiplicity of interpretations. Instead, each translation separately represents a certain way of thinking about this concept in the history of Chinese painting. At the beginning of this book, we will examine four major interpretations of *jiehua* and explore how key sources exemplify them.

"Boundary painting": *Jiehua* as a verb

The character *jie* 界 is the key to any interpretation of *jiehua*. The basic meaning of *jie* 界 is "boundary." The early second-century dictionary *Shuowen jiezi* 說文解字 (Explaining Graphs and Analyzing Characters) equates this character to *jie* 畍 and explains it as the boundary (*jing* 境).[4] The Qing scholar Duan Yucai 段玉裁 (1735–1815) further comments on the entry of *jie* 界: "*Jie* 界 is *jing* 竟, written as *jing* 境 in the currently circulating editions and here corrected [as *jing* 竟]. *Jing* 竟 means the end of music, extending to mean all boundaries or limits. *Jie* 界 refers to *jie* 介. *Jie* 介 is *hua* 畫; *hua* 畫 is *jie* 介, like holding a brush and dividing a field into four plots." (界，竟也。竟俗本作境，今正。樂曲盡為竟，引申為凡邊竟之偁。界之言介也。介者，畫也；畫者，介也，象田四界，聿所以畫之。)[5] Duan's interpretation of *jie* 界 not only stresses its association with boundaries but also introduces a more active association with division as essential to the meaning of this character.

Clearly, the translation of *jiehua* into English as "boundary painting" largely depends on the basic meaning of *jie* 界. However, when *jie* is simply translated as the noun "boundary," its verbal function is unavoidably missing. Proponents of such a translation have recognized this weakness and supplemented it with further explanations. For example, the art historian Anita Chung suggests that

the phrase "boundary painting" means "painting done by marking out the exact proportions by means of lines."[6] The British sinologist Herbert A. Giles (1845–1935) regards *jiehua* as "pictures drawn in prescribed spaces."[7] Giles also provides an example, which comes from the Ming scholar Chen Jiru's 陳繼儒 (1558–1639) *Nigu lu* 妮古錄 (Record of Fondness for Antiquity): "This picture contains only three or four scattered trunks of trees, with boundary-lines drawn on all four sides. The first stanza of poetry outside the boundary begins with certain words, *Tiewang shanhu*, from which the picture has been named." (其畫止散樹三四株，四面界畫之，其界畫外第一首詩有鐵網珊瑚起句者，故名。)[8] In this entry, the term *jie hua* appears in a description of a landscape painting (not architectural painting) by the Yuan master Wang Meng 王蒙 (1308–1385). Giles' main purpose is to contest the scholar J. C. Ferguson's (1866–1945) statement that *jiehua* referred to drawing buildings.[9] However, on further exploration, we would find that the term *jie hua* in this example could not be treated as a general designation for a painting genre. This term appears twice: the first one simply refers to a specific act of drawing boundaries (*jie hua zhi* 界畫之), and the second one only points to the boundary of a certain picture (*qi jie hua wai* 其界畫外). In either case, the two characters *jie* and *hua* are loosely combined as a whole, which cannot convey the twofold meaning of *jie*—namely "the boundary" and "drawing boundaries"—at the same time. In fact, Giles' example could prove only that the basic meanings of *jie*, suggested by *Shuowen* and Duan Yucai, contribute to the formation of the classificatory term *jiehua* but do not necessarily dominate its interpretation.

The slippage between *jie*'s basic meanings and the painting genre *jiehua* emphasizes their interaction as much as their divergence. Nearly all modern scholars specializing in architectural painting agree that the first appearance of the term *jiehua* (or *jie hua*) in Chinese art texts is in the Northern Song scholar Guo Ruoxu's 郭若虛 *Tuhua jianwenzhi* 圖畫見聞志 (Experiences in Painting, 1074):[10]

畫屋木者，折算無虧，筆畫勻壯，深遠透空，一去百斜。如隋唐五代已前，及國初郭忠恕王士元之流，畫樓閣多見四角，其斗栱逐鋪作為之向背分明，不失繩墨。今之畫者，多用直尺，一就界畫，分成斗栱，筆迹繁雜，無壯麗閒雅之意。[11]

When one paints wooden constructions (*wumu*), calculations should be fault-less, and the linear brushwork should be robust. [The architecture] should deeply penetrate space. When one [line] goes, a hundred [lines] slant. This was true of the work of painters of the Sui [581–618], Tang [618–907], and Five Dynasties [907–960] down to Guo Zhongshu and Wang Shiyuan [tenth century] at the beginning of this dynasty. Their paintings of towers and pavil-ions usually show all four corners with brackets arranged in order. They made clear distinctions between front and back without violating the rules. Painters nowadays mainly use a ruler to mark out the boundaries (*jiehua*) right away. In the differentiation of bracketing, their brushwork is too intricate and con-fusing, and fails to impart any grandeur and easy elegance.[12]

In this paragraph, Guo Ruoxu focuses on the category of *wumu* 屋木 (wooden constructions). The term *jiehua* (or *jie hua*) appears in the phrase *yi jiu jie hua* 一就界畫, in which Guo discusses contemporary painters' technique for depicting *wumu*. Modern scholars have different views on this phrase. Robert J. Maeda, Susan Bush and Hsio-yen Shih translate *jiu* 就 as the verb "accomplish" and *jiehua* as a noun referring to the painting genre "ruled-line painting."[13] This interpretation erroneously historicizes the term *jiehua*'s appearance as a genre. In the original paragraph, Guo Ruoxu consistently employs the term *wumu* to designate the painting genre of architectural subjects and man-made objects. It is unlikely that he would have suddenly inserted a sentence about another genre, *jiehua*, without transitions and explanations. Moreover, there are no other extant Northern Song or earlier texts that could support the use of the term *jiehua* as a painting genre. It would be odd if such a use had appeared only once in *Tuhua jianwenzhi* at that time.

Translations by Anita Chung and by Jerome Silbergeld, in my view, better historicize the term.[14] They both treat the term *jie hua* as a verb that means "to mark out the boundaries" or "to mark off their outlines." However, it is misleading for them to combine *jie* and *hua* into a compound word, as they do in their parenthetical notes. After all, the usage of *jie hua* here is very similar to a random act described in *si mian jie hua zhi* 四面界畫之 in Giles' example, which could not be generalized as a specific technique or genre. Moreover, the juxtaposition of *jiu* 就 and *jie hua* 界畫 in *Tuhua jianwenzhi* might contribute to the uncertain connection between *jie* and *hua*. For *jiu*, some scholars translate it as "accomplish" (such as Robert J. Maeda), and Anita Chung curtly translates it as "right away." Apart from these possibilities, the word *jiu* could also serve as a preposition, "along/from," to show position.[15] If so, *jiu jie hua* should be interpreted together as "drawing along the boundaries." In any case, the juxtaposition of *jie* and *hua* did not serve as a fixed classificatory term here.

In fact, if we treat *jie hua* in *Tuhua jianwenzhi* as a loosely defined verb instead of a painting genre, we can find similar examples in other contemporary texts. As the modern scholar Chen Yunru 陳韻如 has noted, in the builder's manual *Yingzao fashi* 營造法式 (State Building Standards, 1103), Li Jie 李誡 (d. 1110) writes: "If you paint *songwen* (a complicated pattern of wood texture), you need to thoroughly brush ochre into its body; you first mark off their boundaries with an ink brush, and then brush between them with purple sandalwood color." (若畫松文，即身內通刷土黃，先以墨筆界畫，次以紫檀間刷。)[16] Here, the phrase *yi mobi jie hua* 以墨筆界畫 corresponds to *yi zitan jian shua* 以紫檀間刷. While the first three characters of the two phrases work as adverbial ornaments, the latter *jie hua* 界畫 and *jian shua* 間刷 are both verbs that indicate specific actions. Like *jian shua*, *jie hua* had not yet achieved a special position in the history of Chinese painting. As a common verb, it does not refer to a general technique or a painting genre here.

In summary, *jie hua* has long been used as a verb that means "to mark off boundaries," its usage beginning in the Northern Song period and continuing at least to the Ming period (1368–1644). While this initial usage strongly supports the translation of *jiehua* as "boundary painting," it also implies the tremendous gap between a verb and a classificatory term—particularly when these two usages coexisted in the same Ming-Qing period (1368–1911). Was the verb directly transformed into a designation of a painting genre? If so, when and how did this happen? If not, what became the decisive meaning of the classificatory term *jiehua*? In order to answer these questions, we need to first make clear the context of *jiehua* as a painting genre.

"Architectural painting": *Jiehua* as a subject category

In fact, it is in the Southern Song period—not in the Northern Song—that the term *jiehua* emerged as a noun referring to a specific painting genre. In Deng Chun's 鄧椿 *Hua ji* 畫繼 (A Continuation of the History of Painting, preface dated 1167), the term *jiehua* appears in two painters' biographies: "Guo Daizhao, from Zhao county, always boasted about his *jiehua*" (郭待詔，趙州人。每以界畫自矜。) and "Ren An, from the capital, entered the Painting Academy and specialized in *jiehua*" (任安，京師人。入畫院，工界畫。).[17] Both entries suggest that *jiehua*, a noun here, refers to an independent painting genre; since Deng does not spend time explaining this term, its definition must have been widely understood by contemporary audiences. It is worth noting that both Guo Daizhao and Ren An are listed in the painting category *wumu zhouche* 屋木舟車 (wooden constructions, boats, and carts), implying that the meaning of *jiehua* is closely linked with such subject matter. In fact, some modern scholars, such as J. C. Ferguson, directly claimed that *jiehua* referred to drawing buildings.[18] Could *jiehua* be equated with the painting of architecture?

The painting of architecture has a long history in Chinese art. It can be traced to the Eastern Zhou period (770–221 BCE). Jingjun 敬君, from the Qi state of that time, might be the earliest recorded painter who depicted this subject matter.[19] A lacquerware fragment excavated at Linzi, Shandong, includes an architectural image and gives us a hint about the Eastern Zhou representation of architecture. It includes four elevations of a three-bay building with columns and bracketing arms. This image is drawn in abstract forms and repetitive patterns to create a decorative effect. Chinese artists' ability to make more accurate renderings of architecture took many centuries to develop. The architectural mural from the Tang tomb of Crown Prince Yide 懿德 (682–701), for instance, achieves depth and a three-dimensional effect to some extent. These timber-frame gate towers have inverted V-shaped braces, hip-gable roofs, and high foundations, all reflecting features of contemporary

buildings. In fact, during the Tang dynasty (618–907), architectural painting had already been established as an independent subject category but had not yet been given a unified name. In *Lidai minghua ji* 歷代名畫記 (Record of Famous Paintings of Successive Dynasties, preface dated 847), Zhang Yanyuan 張彥遠 writes: "It is not necessary [for the painter] to cover all six elements; he will be selected if skilled in just one technique. This is to say [a painter] should specialize in either figures, architecture (*wuyu*), landscape, horses, ghosts and gods, or flowers and birds; everyone has his specialty." (何必六法俱全，但取一技可采。謂或人物、或屋宇、或山水、或鞍馬、或鬼神、或花鳥，各有所長。)[20] Here, Zhang treats architectural painting as one of the six painting elements (*liu fa* 六法) and uses the term *wuyu* 屋宇 (houses and covered buildings) to designate it. However, in other passages, Zhang also uses alternative names such as *taige* 臺閣 (terraces and pavilions), *gongguan* 宮觀 (palaces and towers), and *wumu*.[21] In *Tangchao minghua lu* 唐朝名畫錄 (Record of Famous Painters of the Tang Dynasty), Zhu Jingxuan 朱景玄 (fl. 840) points out: "For painting, priority should be given to human subjects, and thereafter rank in descending order: birds and beasts, landscapes, and architectural subjects (*loudian wumu*) . . . Lu Tanwei of the previous dynasty ranks first in architectural painting (*wumu*)." (夫畫者以人物居先，禽獸次之，山水次之，樓殿屋木次之⋯⋯前朝陸探微屋木居第一。)[22] Zhu also juxtaposes architectural painting with other painting motifs, such as landscapes, and interchangeably uses terms like *loudian wumu* 樓殿屋木 (storied buildings, palace halls, and wooden constructions) and *wumu*.

It is the Northern Song period that witnessed the elevation of architectural subjects to one of the most important painting genres. For example, Liu Daochun's 劉道醇 painting classification—both in his *Shengchao minghua ping* 聖朝名畫評 (Evaluations of Song Dynasty Painters of Renown, ca. 1059) and *Wudai minghua buyi* 五代名畫補遺 (A Supplement on the Famous Painters of the Five Dynasties, preface dated 1059)—includes *wumu men* 屋木門 (wooden-structure genre).[23] Guo Ruoxu arranged contemporary masters into four groups, and the *wumu* category occupies a place in the fourth group.[24] During the reign of Huizong 徽宗 (1082–1135, r. 1100–1126), *wumu* had become an indispensable discipline in the curricula of the Painting Academy.[25] *Xuanhe huapu* 宣和畫譜 (Xuanhe Catalogue of Paintings, ca. 1120), commissioned by Huizong, also contains architectural paintings as one of the ten painting genres.[26] Although other names for architectural painting—such as *gongshi* 宮室 (palatial chambers) in *Xuanhe huapu*—continued to show up in Song art texts, the term *wumu* was more and more frequently used, and eventually came to predominate.

As mentioned earlier, the noun *jiehua* initially appeared in the Southern Song catalog *Hua ji* and was closely associated with the architectural subject *wumu*. From the subsequent Yuan dynasty on, *jiehua* had replaced older terms such as *wumu* in the classification of painting genres. For example, Tang Hou

湯垕 (active ca. 1320–1330) writes in his *Gujin huajian* 古今畫鑒 (Examination of Past and Present Painting, preface dated 1328):

世俗論畫，必曰畫有十三科，山水打頭，界畫打底……古人畫諸科各有其人，界畫則唐絕無作者，歷五代始得郭忠恕一人，其他如王士元、趙忠義三數人而已。如衞賢、高克明抑又次焉。[27]

In discussing painting, ordinary people will certainly say that it has thirteen categories, with landscape at the top and *jiehua* at the bottom . . . Each of the various categories of the ancients' paintings had its masters. There was no one in *jiehua* during the Tang. In the succeeding Five Dynasties there was only one man, Guo Zhongshu, and a few others such as Wang Shiyuan and Zhao Zhongyi. As for Wei Xian and Gao Keming [eleventh century], they are still lower.[28]

In Tang Hou's painting system, *jiehua* is emphatically placed together with painting genres such as landscape painting. *Jiehua* specialists mentioned here, such as Guo Zhongshu and Wei Xian 衞賢, are in fact those famous architectural painters listed in previous Song catalogs like *Xuanhe huapu*.[29] It seems to confirm the equivalence between *jiehua* and architectural painting. In another Yuan text, *Nancun chuogeng lu* 南村輟耕錄 (Respite from Plowing in the Southern Village, 1366), Tao Zongyi 陶宗儀 (active 1360–1368) makes a list of these thirteen painting categories, where the architectural painting is directly named as *jiehua louge* 界畫樓臺 (*jiehua*, storied buildings, and *louge*, terraces).[30] All these examples confirm the connection between *jiehua* and architectural subjects, but we are compelled to ask: does it mean that the categorizing term *jiehua* could be generally interpreted as an architectural subject classification?

The answer, I believe, is no. A comparison between the term *wumu* and *jiehua* is enlightening. *Wumu* literally describes the specific subject "wooden constructions" and has an obscure relationship with man-made constructions. Although building is the usual subject matter of *wumu*, several *wumu* specialists recorded by Liu Daochun were not famous for this subject. Cai Run 蔡潤, for example, was skilled in painting boats (*zhouchuan* 舟船), and Wang Daozhen 王道真 specialized in painting traveling bullock carts (*panche* 盤車).[31] It suggests that boats and carts are also subordinate to *wumu*. Nevertheless, the Southern Song catalog *Hua ji* names a painting category as *wumu zhouche* 屋木舟車 (wooden constructions, boats, and carts), where the juxtaposition of *wumu* (wooden constructions) and *zhouche* (boats and carts) implies the distinction between these motifs.[32]

Distinguished from *wumu*, we could not literally recognize the subject matter from the term *jiehua* itself, but traditional literati have never suspected that *jiehua* could cover all these subjects, ranging from buildings, boats, and carts to other wooden man-made constructions. For instance, both Guo Zhongshu's *Xueji jiangxing tu* 雪霽江行圖 ("Travelling on the River in Clearing

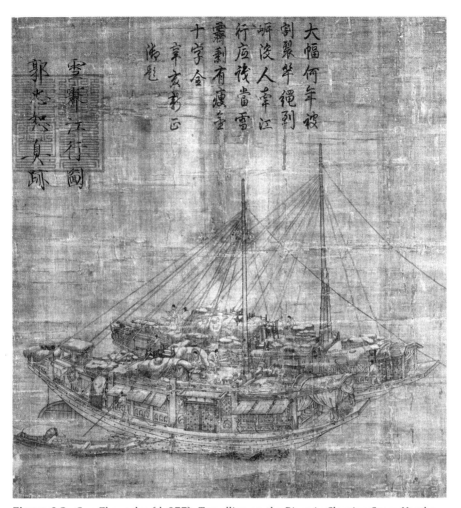

Figure 0.2: Guo Zhongshu (d. 977). *Travelling on the River in Clearing Snow*. Northern Song dynasty (960–1127). Scroll, ink on silk, 74.1 cm × 69.2 cm. National Palace Museum, Taipei.

Snow") (fig. 0.2) and Wang Zhenpeng's 王振鵬 (ca. 1275–1330) *Longzhou juan* 龍舟卷 ("Dragon Boat") clearly depict boats, not architectural subjects, but both paintings were considered typical examples of *jiehua* by Qing scholars.[33]

In fact, although paintings said to exemplify *jiehua* are characterized by specific subjects (such as buildings, boats, and carts), not all paintings of these subjects are unanimously regarded as *jiehua*. There seem to be other decisive factors in shaping this genre. The gap between *jiehua* and its subjects had been manifested earlier when this noun first emerged in the Southern Song

text *Hua ji*. Deng Chun introduces *jiezuo* 界作, a term associated with *jiehua*, as follows:

> 畫院界作最工，專以新意相尚……祖宗舊制，凡待詔出身者，止有六種，如模勒、書丹、裝背、界作種、飛白筆、描畫欄界是也。[34]
>
> In the Painting Academy, *jiezuo* is the most elaborate [category], especially admired for its new ideas . . . According to ancestors' old regulations, all painters of the in-attendance status served only in the following six categories: copying by engraving, drawing in color, mounting, *jiezuo* category, the "flying white" brushwork, and drawing borders.[35]

Here, the term *jiezuo* is put together with five other painting techniques such as drawing in color, which, in turn, proves its role as a specific technique (not a subject). Similarly, the term *jiehua* has been associated with a technical definition, an aspect stressed by its English translation "ruled-line painting."

"Ruled-line painting": *Jiehua* and the ruler

"Ruled-line painting" is another popular translation of *jiehua* among Western scholars. Its leading proponents, including Robert J. Maeda, indicate that the term *jiehua* is the abbreviated form of *jiechi hua* 界尺畫 ("painting done with the ruler").[36] These scholars make their case with evidence from traditional Chinese texts. For instance, when the late-Ming scholar Wu Qizhen 吳其貞 (fl. 1635–1677) praises an architectural painting by Wang Zhenpeng, he claims: "[it] is a *jiechi hua* of a divine order, unmatchable by other painters." (為界尺畫之神品者人莫能及。)[37] Here, Wu's term for architectural painting is directly written as *jiechi hua*.

Even before the creation of the term *jiehua*, there had existed textual evidence that could support the intimate association between architectural painting and its undisguised use of rulers. The earliest known reference seems to be the Tang text *Lidai minghua ji*, where Zhang Yanyuan describes the brushwork of the painter Wu Daozi 吳道子 (active ca. 710–760) in this way:

> 或問余曰：「吳生何以不用界筆直尺而能彎弧挺刃，植柱構梁?」對曰：「……夫用界筆直尺，界筆是死畫也，守其神，專其一，是真畫也……不滯於手，不凝於心，不知然而然，雖彎弧挺刃，植柱構梁，則界筆直尺，豈得入於其間矣。」[38]
>
> Someone asked me: "How was it that Master Wu could curve his bows, straighten his blades, and make vertical his pillars and horizontal his beams, without the use of line-brush and ruler?" I answered: "if one makes use of line-brush and ruler, the result will be dead painting. But if one guards the spirit and concentrates upon unity, there will be real painting . . . [Painting] is not stopped in the hand, nor frozen in the mind, but becomes what it is without conscious realization. Though one may bend bows, straighten blades,

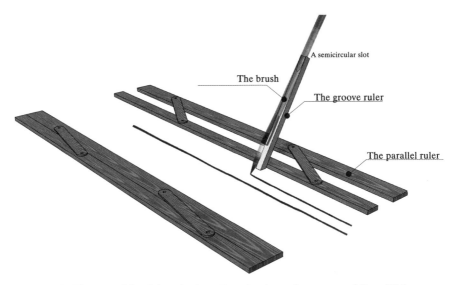

Figure 0.3: The use of the *jiehua* devices. Drawing by and courtesy of Chen Wei.

and make vertical pillars and horizontal beams, why should line-brush and rulers enter into this?"[39]

While Zhang Yanyuan praises Wu Daozi for his emancipation from mechanical aids, Zhang also identifies the line-brush and the ruler, two tools in widespread use among common architectural painters.

The mechanics of Tang-Song *jiehua* tools have been poorly understood. The best interpretation, in my opinion, is given by the modern scholar Shen Kangshen 沈康身, who depends on a Ming device to reconstruct the historical usage of *jiechi* in a general way.[40] According to Shen, a set of *jiehua* tools (fig. 0.3) consists of a parallel ruler (*jiechi* 界尺), a groove ruler (*caochi* 槽尺), and a brush (*bi* 筆). The parallel ruler includes two straight edges coupled with two moveable rods. When the painter holds down the lower edge and changes the angle between the rods and the edges, the upper edge will move and create parallel lines. The groove ruler is a long squared-off stick with a semicircular slot. When a brush is tightly held in this slot, the brush tip should touch the painting surface. The painter attaches the bottom of the groove ruler to the upper edge of the parallel ruler. Then, he uses his right hand to maintain the angles between the groove ruler and the parallel ruler, as well as between the groove ruler and the brush. Thus, the groove ruler glides smoothly along the parallel ruler, guiding the brush to produce a consistently even, straight line.

There is a Ming anecdote about the Northern Song scholar Su Shi 蘇軾 (1037–1101) that might support Shen's understanding of the *jiehua* tool set:

蘇東坡見一家有界尺筆槽而破者，向其主人曰：「韓直木如常，孤竹君無恙，但半面
之交，忽然折事矣。」[41]

In someone's home, Su Dongpo saw a parallel ruler, a brush, and a groove
ruler, and [accidentally] broke them. Su said to their owner: "Han Zhimu
is as usual, the Lord of Guzhu is unharmed, but the one with the half-face
friendship is suddenly broken."

Su Shi compares the three basic tools of *jiehua* to three persons: First, Han
Zhimu 韓直木 (which literally means "Han Straight Wood") alludes to the
appearance of the parallel ruler. Second, Guzhu Jun 孤竹君 (which literally
means "the Lord of Wood and Bamboo") indicates the material of the brush.
Third, *Banmian zhi jiao* 半面之交, always referring to an unfamiliar friend, liter-
ally means "attached to a half face," and thus matches the way the groove ruler
is used; after all, the groove ruler is only attached to the brush or the parallel
ruler at one end (or one side), just like a reserved friend to them. Meanwhile,
Banmian zhi jiao could also describe a superficial friendship between the paral-
lel ruler and the brush—when the groove ruler is broken, their connection
is immediately cut off. Su Shi's metaphors perfectly represent the features of
these *jiehua* tools.

The *jiehua* genre's association with the use of tools makes the traditional
interpretation of this term as *jiechi hua* exceptionally persuasive. If so, shouldn't
the translation "ruled-line painting" take precedence over others? The biggest
criticism proposed by modern scholars like Anita Chung is that the translation
"ruled-line painting" indicates a conflict between *jiehua* and freehand drawing,
and the fact is that several *jiehua* specialists are famous for their freehand tech-
nique rather than ruled-line technique.[42] For instance, when the Northern
Song writer Guo Ruoxu discussed architectural subjects in his *Tuhua jianwen-
zhi*, he disapproved of contemporaries' reliance on rulers and suggested that
earlier masters like Guo Zhongshu and Wang Shiyuan did not resort to rulers,
which was more admirable.[43] But in Yuan and later periods, both Guo and
Wang were treated as representatives of *jiehua* painters. A great example is the
Yuan catalog *Gujin huajian*: "There was no one doing *jiehua* during the Tang.
In the succeeding Five Dynasties there was only one man, Guo Zhongshu, and
a few others such as Wang Shiyuan, and Zhao Zhongyi." (界畫則唐絕無作者，
歷五代始得郭忠恕一人，其他如王士元、趙忠義三數人而已。)[44] In Anita Chung's
opinion, the inclusion of freehand-drawing painters in the category of ruled-
line painting seems odd, so the translation of *jiehua* as "ruled-line painting"
should be discarded.[45] To solve the problem, Marsha Smith Weidner proposes
that *jiehua*, interpreted in a stricter sense as "ruled-line painting," could only
be used for "later (twelfth century and later) painters" while "earlier artists
might still be described as painters of architectural subjects."[46] In other words,
Weidner suggests that we must apply different translations of *jiehua* to masters

from different periods—for instance, the *jiehua* master Guo Zhongshu could only be translated as an architectural painter instead of a ruled-line painter.

In my opinion, "ruled-line painting" is still a relatively appropriate translation—even though it does not exploit the full potential of *jiehua*. The biggest mistake made by its opponents is that they deliberately exaggerate the contradiction between ruled-line painter and freehand style. Although traditional Chinese writers closely linked the *jiehua* genre with rulers, they never thought there was an irreconcilable conflict between ruled-line technique and freehand drawing. For example, in *Nansong yuanhua lu* 南宋院畫錄 (Records on Paintings of the Southern Song Academy), the Qing author Li E 厲鶚 (1692–1752) indicates that Li Song 李嵩 (active late twelfth century) "was particularly skilled in *jiehua*" (尤精於界畫) and his dragon boat and palace scenes "did not use rulers but achieved both actual rules and measurements" (不用界尺，而規矩準繩皆備).[47] Li Song's extant album leaf *Tianzhong shuixi tu* 天中水戲圖 ("Dragon Boat") (plate 1) might support Li E's statement. The painter offers meticulous details within a narrow space. In the boat's super-structure, both the short lines shaping the complex bracket clusters and the curved lines marking out the dense roof tiles demonstrate the painter's mastery of freehand drawing in *jiehua*. Li E's text explains why this kind of drawing could be regarded as *jiehua*: it is because without mechanical aids, the painter still achieves a similar effect of ruled-line technique—namely, to follow "actual rules and measurements." It hints that for *jiehua*, it is more important to evaluate a painting's effect than the tools used. When the Yuan scholar Rao Ziran 饒自然 (1312–1365) discusses *jiehua*, he more clearly expresses this idea: "Even if you do not use rulers, you should still consistently use the law of *jiehua* to accomplish it." (雖不用尺，其制一以界畫之法為之。)[48] Rao distinguishes the law of *jiehua* from the use of rulers, and thus makes the meaning of *jiehua* go beyond its translation "ruled-line painting." In other words, although the genre of *jiehua* stresses mechanical aids and subject category, it is recognized foremost as a painting style with specific laws or principles.

Jiehua as a stylistic entity: Craftsmanship and literati ideals

As mentioned previously, the phrase *gui ju zhun sheng* 規矩準繩 ("actual rules and measurements"), intertwined with the law of *jiehua*, plays a significant role in shaping the *jiehua* style. This phrase could be literally translated as "compass" (*gui* 規), "set square" (*ju* 矩), "spirit level" (*zhun* 準) and "plumb-string" (*sheng* 繩), all carpenters' tools, thus linking *jiehua* with the craftsmen's art. An understanding of Chinese construction techniques and standards is required to produce a *jiehua* painting, a feature that also makes this genre more difficult to execute than other types of painting.

This feature has been repeatedly emphasized in art historians' descriptions of *jiehua* style. For instance, when the Yuan master Zhao Mengfu 趙孟頫 (1254–1322) teaches his son Zhao Yong 趙雍 (b. 1289) to paint *jiehua*, he frankly says: "All of painting is perhaps fabrication to deceive people; but with regard to *jiehua*, no painter could do this without using technique in accordance with the laws." (諸畫或可杜撰瞞人，至界畫未有不用工合法度者。)[49] When *Xuanhe huapu* deals with architectural subjects—the usual themes of *jiehua*—it also reads:

> 畫者取此而備之形容，豈徒為是臺榭户牖之壯觀者哉，雖一點一筆，必求諸繩矩，比他畫為難工，故自晉宋迄于梁隋，未聞其工者。[50]

> When painters took up these subjects and completely described their formal appearance, how could it have been simply a question of making a grand spectacle of terraces and pavilions, or doors and windows? In each dot or stroke, one must seek agreement with actual measurements and rules (*sheng ju*). In comparison with other types of paintings, it is a difficult field in which to gain skill. Consequently, from the Jin through the Sui Dynasties, there are no known masters.[51]

The term *sheng ju* 繩矩, here, recalls *gui ju zhun sheng*, and alludes to architectural procedures and principles.

Art critics describe in detail the basic principles of *jiehua* style.[52] The first principle is faultless calculation, just as *Tuhua jianwenzhi* records: "calculations should be faultless, and brushstrokes of even strength should deeply penetrate space, receding in a hundred diagonal lines." (折算無虧，筆畫勻壯，深遠透空，一去百斜。)[53] The second is structural clarity, also described in *Tuhua jianwenzhi*: "their paintings of towers and pavilions usually showed all four corners with their brackets arranged in order; they made clear distinctions between front and back without error in the marking lines." (畫樓閣多見四角，其斗栱逐鋪作為之向背分明，不失繩墨。)[54] The third principle is correct scale. For example, when the Song scholar Li Zhi 李廌 (1059–1109) praises Guo Zhongshu in his *Deyutang huapin* 德隅堂畫品 (Evaluations of Painters from the Deyu Studio, preface dated 1098), Li writes: "He used an infinitesimal unit to mark off an inch, a tenth of an inch to mark off a foot, a foot to mark off ten feet; increasing thus with every multiple, so that when he did a large building, everything was to scale and there were no small discrepancies." (以毫計寸，以分計尺，以寸計丈，增而倍之以作大宇，皆中規度，曾無小差。)[55] Guo Zhongshu's measurements are to scale. Fourth, the *jiehua* masters are required to acquire mathematical and other architectural knowledge. For instance, *Xuanhe huapu* indicates that architectural paintings by the late-Tang artist Yin Jizhao 尹繼昭 reveal "the methods of multiplication and division of a mathematician" (隱算學家乘除法於其間).[56] *Minghua lu* 明畫錄 (Records of Ming Painting, preface dated 1673) points out that "a painter who depicts palaces and chambers must

first have a volume of *Carpenters' Manuals* in mind and then could paint." (畫宮室者，胸中先有一卷木經，始堪落筆。)[57] Guo Ruoxu also thinks mastery in architectural painting cannot be separated from the painter's building knowledge:

> 設或未識漢殿吳殿，梁柱斗栱，叉手替木，熟柱駝峯，方莖額道，抱間昂頭，羅花羅幔，暗制綽幕，猢孫頭，琥珀枋，龜頭虎座，飛簷撲水，膊風化廢，垂魚惹草，當鈎曲脊之類，憑何以畫屋木也?[58]

> How could one paint *wumu* if he did not understand the great halls of Han and Wu, beams, columns, brackets, trusses, cushion timbers, king-posts, camel's humps, square architectures, *e'dao*, *baojian*, cantilever-heads, perpendicular and longitudinal bracket arms, *anzhi*, *chuomu*, *husun* timber ends, *hupo* timbers, tortoise-heads, tiger seats, flying eaves, water-repelling boards, bargeboards, *huafei*, suspended fish, stirring grass, ridge-supporting tiles, convex and concave roof tiles, and so on?[59]

Guo uses a lot of architectural terminology in this text, proving *jiehua*'s intimate involvement with the procedures of building construction.

Excellent *jiehua* masters are able to produce works that meet building and other construction standards or even surpass experienced craftsmen. In *Yizhou minghua lu* 益州名畫錄 (Records of Famous Painters of Yizhou), the Song scholar Huang Xiufu 黃休復 (eleventh century) recorded an anecdote about the court painter Zhao Zhongyi 趙忠義. Zhao was commanded to draw a picture of *Guan jiangjun qi Yuquan si tu* 關將軍起玉泉寺圖 ("General Guan Erecting the Jade Spring Temple"). The result is as follows:

> 蜀王令內作都料看此畫圖，枋栱有準的否？都料對曰：「此畫復較一座，分明無欠。」其妙如此。[60]

> [When the picture was done] the Shu King ordered his Palace Chief Carpenter to scrutinize the painting and asked if the square columns and the brackets were drawn correctly. The Chief Carpenter replied: "In this painting of the building, all are accurate without a single flaw." Such was the excellence [of his painting].[61]

Zhao's painting could pass the inspection of a skilled architect. It proves that he had fully mastered the actual practices of craftsmen.

However, the interaction between *jiehua* and craftsmanship leads to two negative consequences, which are perfectly summarized by the early Yuan scholar Hu Zhiyu 胡祇遹 (1227–1295): "[the *jiehua* genre] is too difficult to master so few decide to learn it" (難工而學者寡) and "[people] do not think [this genre] is lofty and elegant, so they disdain doing it" (非畫史之高致而不屑為).[62] Indeed, literati always held pejorative attitudes towards the *jiehua* or architectural category. As early as the Eastern Jin dynasty (317–420), Gu Kaizhi 顧愷之 (ca. 345–406) said: "In painting, human figures are the most difficult, followed by mountains and water, then followed by dogs and horses.

Towers and pavilions are just fixed objects, [too hard] to make and [too] easy to appreciate, and devoid of the virtue of conveying ideas." (凡畫，人最難，次山水，次狗馬，臺榭一定器耳，難成而易好，不待遷想妙得也。)[63] Gu regarded architectural subjects as fixed objects that lack expressive ideas. In the Tang period, the catalog *Tangchao minghua lu* also put architectural subjects at the bottom of the painting system.[64] During the Yuan period, after the establishment of the thirteen painting categories by Tang Hou, the *jiehua* genre was widely accepted as the least important one.[65] The Ming scholar Xu Qin 徐沁 (seventeenth century) offers a reason for *jiehua*'s low status after the Yuan:

> 有明以此擅場者益少，近人喜尚元筆，目界畫者鄙為匠氣，此派日就漸滅矣。[66]
>
> There were only a few painters who specialized in this genre during the Ming. Recently, people favored the brushwork of the Yuan (i.e., the calligraphic styles of the great Yuan masters) and viewed *jiehua* practitioners as lowly artisans. Sooner or later, *jiehua* will completely disappear.[67]

From this text, we can see that due to the dominance of literati ideology and literati painting, the *jiehua*, entangled with craftsmanship, was naturally and widely treated as an inferior art and minor category.

Nevertheless, traditional literati still made efforts to bring *jiehua* into the mainstream of painting traditions. For instance, the Qing writer Zheng Ji 鄭績 (nineteenth century) transforms the meaning of *jiechi* from carpenter's tools into abstract laws, in order to eliminate the opposition between *jiehua* and literati painting:

> 文人之畫，筆墨形景之外，須明界尺者，乃畫法界限尺度，非匠習所用間格方直之木間尺也……此文人作畫界尺，即前後遠近大小之法度也。[68]
>
> Literati painting is beyond brushed ink and form; one should be aware that *jiechi* means limits and measures in painting method and does not refer to craftsmen's wooden straight rulers used to divide square and straight forms . . . *jiechi* used by literati painters refers to laws of front and back (location), distant and near (perspective), and large and small (scale).

We could infer from this text that *jiehua*, short for *jiechi hua*, does not reveal this genre's dependence upon rulers, but instead emphasizes its abidance by rules or laws. In this sense, this genre could be translated as "rule (or regulated) painting." As early as the Tang, art historians had already made attempts to emancipate architectural paintings from mechanical aids. For example, *Lidai minghua ji* reads: "Now, if one makes use of marking line and ruler, the result will be dead painting. But if one guards the spirit and concentrates upon unity, there will be real painting." (夫用界筆直尺，界筆是死畫也，守其神，專其一，是真畫也。)[69] By comparing real and dead painting, the author Zhang Yanyuan stresses the significance of abstract spirit and unity, instead of tools, in architectural painting. *Xuanhe huapu* takes a different strategy:

信夫畫之中，規矩準繩者為難工，游規矩準繩之內，而不為所窘，如忠恕之高古者，
豈復有斯人之徒歟。[70]

Among these paintings, it is indeed difficult to follow actual measurements
and rules. If one's paintings freely wander within these rules and are not con-
fined by them—just like Guo Zhongshu's lofty and antique paintings—how
could there exist such painters [as Guo] again?

The text differentiates between two subtypes of architectural painting: while
the inferior one simply follows rules, the superior one is not restricted by them.
In this way, the contradiction between *jiehua* and *jiehua* specialists known for
freehand drawing, brought forward by modern scholars like Anita Chung
and Marsha Smith Weidner, is naturally resolved. We can see that although
jiehua's connection with rulers came into being at the very beginning—which
makes it impossible to separate this genre from craftsmanship—literati always
attempted to change *jiehua* into a style commensurate with orthodox literati
tastes.

To sum up, *jiehua*, an evolving term, reflects different meanings in differ-
ent contexts and periods. It first appeared as a verb that means "to mark off
boundaries" in the Northern Song dynasty, and this usage continued to exist
throughout the history of painting. During the Southern Song period, *jiehua*
began to designate a specific painting genre. From the Yuan dynasty onwards,
this term largely replaced other names of depictions of architectural subjects
and man-made objects. However, this does not mean that the genre *jiehua* is
solely determined by its subject matter. In contrast, the introduction of the
classificatory term *jiehua* reflected special features of architectural painting,
mainly its ruled-line technique. *Jiehua*'s close relation with craftsmanship, a
quality antithetical to literati ideals, led to scholars' disparagement of this
genre; meanwhile, literati scholars wanted to release *jiehua* from mechanical
aids and to redefine it as a painting style that follows or even goes beyond laws.
Therefore, translations such as "boundary painting" and "ruled-line painting"
emphasize certain aspects of *jiehua*, but obscure other potential meanings of
this term. It is the untranslatability of the term *jiehua* that helps unfold multi-
ple layers of this painting genre all at once.

Why the Mongol Yuan?

Jiehua, the unique painting genre, has not attracted the scholarly attention
it deserves. Ever since William Trousdale and Robert J. Maeda made their
preliminary investigation in the 1960s and 1970s, this topic has remained
relatively dormant among Western scholars.[71] Apart from Anita Chung's 2004
monograph, only a handful of dissertations and short articles have touched
upon it, and few of them have provided any technical analysis.[72] While Western

scholars have largely ignored *jiehua*, Chinese scholars have actively disparaged this genre, primarily because of its association with craftsmanship. They usually treat *jiehua* as an inferior art and depend on *jiehua* to theoretically reconstruct ancient buildings.[73] This approach unavoidably downplays the inherent value of *jiehua* itself as a painting genre.

Despite the general lack of *jiehua* studies, considerable research has been devoted to the periods of the Song and Qing (1644–1912). The Song dynasty, considered the peak of this painting genre, left us significant masterpieces like the *Qingming shanghe tu* 清明上河圖 ("Going up the River on the Qingming Festival"), which adopts plentiful depictions of architectural subjects and uses rulers to create consistently even lines.[74] Much closer to our own time, the Qing provided more surviving works by major masters.[75] However, the significance of the short-lived Yuan dynasty, the period of Mongol rule, has been downplayed. Today, most scholarly interest in this era has been devoted to paintings in the orthodox literati style. Perhaps because the calligraphic styles of the great Yuan masters of landscape drew so much attention, *jiehua* that depicts architecture received more pejorative comments than it did during other dynasties.

Yuan artists, most of whom were anonymous, have left us around a hundred *jiehua* that survive today.[76] We can see that Yuan *jiehua* flourished in the face of traditional literati's belittlement and in the context of a Mongol-ruled society. Many factors—such as imperial patronage and the consumer market—helped shape the Yuan *jiehua* traditions. Moreover, Yuan *jiehua* masters made new efforts toward a unique modular system and an unsurpassable plain-drawing tradition. Their paintings showcase how meticulous observation and accumulation of architectural details can be brought to perfection. The typical Yuan *jiehua*, such as those by Wang Zhenpeng and Xia Yong 夏永 (active midfourteenth century), are entirely distinguished from all previous ones because of their flexibly arranged modular motifs and dazzlingly polished ink lines. These two painting strategies, brilliantly employed by Yuan *jiehua* artists, were too difficult for subsequent artists to master, so it is not surprising that the flourishing of these Yuan *jiehua* traditions did not continue long. The contrast between the high artistic achievement of Yuan *jiehua* and their short-term existence makes this topic so fascinating. Yuan *jiehua* encompass a wide diversity of styles, which are inextricably intertwined with the artists' historical contexts and social statuses, and thus offer valuable clues to the changes occurring in the Yuan world. All of these compel a reassessment of the artistic and historical position of Yuan *jiehua*.

This book details the sweep of Yuan *jiehua* traditions over three chapters. The first chapter begins with a dilemma: in two versions of the same composition, the professional painter Xia Yong left both the man-on-crane image and a rhapsody on the Yellow Pavilion, two contradictory clues reflecting different

themes. This chapter examines a broad range of textual and visual sources in order to answer the following questions: To what extent do Xia Yong's two-dimensional *jiehua* images represent contemporary three-dimensional buildings? How did Yuan *jiehua* masters deal with the complex relationships between architectural verisimilitude, preexisting *jiehua* stereotypes, and painters' original creations? This chapter makes a detailed investigation of modular organizations, prefabricated motifs, and standardized components in Xia's works and explains why Yuan *jiehua* so easily seduce viewers into believing that they are accurate depictions of real architecture.

The second chapter moves beyond Xia Yong to conduct a detailed investigation of other Yuan *jiehua* masters, ranging from scholar-amateurs and professionals at the court to those working in regional areas and those who remained anonymous. It pays particular attention to Wang Zhenpeng's lineage (e.g., Li Rongjin 李容瑾, Wei Jiuding 衛九鼎, and Zhu Yu 朱玉) and makes full use of each individual's fragmentary evidence to better understand the Yuan *jiehua* painters as a group. The many examples of their works discussed in this chapter not only show the technical innovation in Yuan *jiehua*—what I refer to as the machinelike precision and plain drawing—but also reflect, to a degree, Yuan *jiehua*'s chronological and regional characterization. In particular, this chapter focuses on the influence of the Northern Song Li-Guo landscape traditions on *jiehua* in the mid-Yuan court, as well as that of the late-Yuan literati painting styles on *jiehua* created by professional artists in Jiangnan.

The third chapter shifts its focus from art to politics. After the Southern Song collapsed and the Mongols finally reunited China, Chinese painters from the South played the most significant role in the formation of Yuan *jiehua* as a distinct tradition that the Mongol court patronized. This chapter examines these painters' political careers at the Yuan court and analyzes how their *jiehua* helped them advance into government. It also explores how Mongol artistic patronage and taste—particularly that of Emperor Renzong of Yuan 仁宗 (Ayurbarwada, 1285–1320; r. 1311–1320) and that of the Grand Princess Sengge Ragi (ca. 1283–1331)—helped shape the mainstream perception of Yuan *jiehua* in the early fourteenth-century court.

This book concludes with an alternative interpretation of Xia Yong's art, thus complementing our discussion about modularity and addressing the lingering issues of the text-image relationship, workshop practice, and art markets that existed for the late-Yuan *jiehua* in the Jiangnan area.

Xia Yong: A Neglected *Jiehua* Master

Xia Yong is the entry point and linchpin for understanding previously understudied aspects of Yuan *jiehua*. Xia has been largely neglected both by traditional literati and by modern scholars. There are almost no surviving

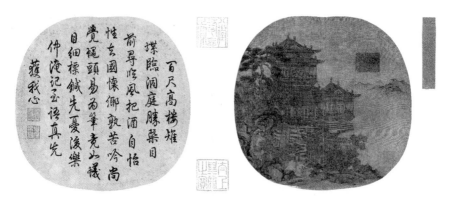

Figure 0.4: Xia Yong (active mid-fourteenth century). *Yueyang Pavilion*. 1347. Fan mounted as album leaf, ink on silk, 25.2 cm × 25.8 cm. The Palace Museum, Beijing.

biographies of this master, and none of his *jiehua* appear in the major painting catalogues, such as the Yuan-period *Tuhui baojian* 圖繪寶鑒 (Precious Mirror of Painting). This is even true in studies of Yuan *jiehua*. Those writings concentrate on the well-known court painter Wang Zhenpeng. Even if they mention Xia Yong, Xia is always characterized as a minor follower of Wang and only discussed in passing.[77] Only one article in Chinese by Wei Dong 魏冬 and two articles in Japanese by Masaaki Itakura 板倉聖哲 have discussed Xia Yong in any detail.[78] In my opinion, Xia's significance has been downplayed. It is extremely important for us to introduce Xia's life and oeuvre before venturing further in the following chapters.

　　Our knowledge of Xia Yong mainly derives from diffuse clues left in his works of art. Xia signed his name in a minute regular script on three of his paintings—one in the Beijing Palace Museum, one in the Yunnan Provincial Museum, and one in the Harvard Art Museums.[79] The Beijing work (fig. 0.4) bears the following detailed information: "Painted and inscribed on the twenty-second day of the fourth lunar month in the seventh year of the Zhizheng reign period, by Xia Yong of Qiantang, known by the courtesy name Mingyuan." (至正七年四月二十二日錢唐夏永明遠畫并書) This inscription tells us that Xia created this work in 1347, during the late-Yuan period, and that his hometown was Qiantang 錢唐, a district of the Southern Song capital Lin'an 臨安 and the modern city of Hangzhou. Xia's courtesy name, Mingyuan, has been repeatedly confirmed by the appearance of his square seal "Xia Mingyuan yin" 夏明遠印 on his works. However, his contemporaries, both the literati scholars and the Mongol court, showed little interest in him. Xia's name is almost absent from official histories and contemporary literati texts. This suggests that Xia was likely a professional painter outside the Yuan court and highest literati circles.

Xia Yong's biographical record appears in Japanese sources. The sixteenth-century Japanese connoisseurs' manual *Kundaikan sayū chōki* 君台觀左右帳記 (Kundaikan Souchoki) includes Xia Yong as a landscape and architectural painter, although not as a highly ranked one.[80] The Japanese scholar Shūe Matsushima 松島宗衞 (1871–1935) believes that Xia Yong lived between 1340 and 1400. Matsushima also thinks Xia's works spread to Japan after the reign of Ming Emperor Yongle 永樂 (1403–1424) because Ming China and Japan re-established communication with each other at that time and Ashikaga Yoshimasa 足利義政 (1436–1490) is known to have sent envoys to bring paintings from China during the Chenghua 成化 reign period (1465–1487).[81] Wei Dong offers a different opinion about Xia's dates, arguing that Xia's date of birth should not be long after the end of the Southern Song, sometime between 1279 and 1309. Wei's main reason is that the Beijing work is dated to 1347, and because he believes it reflects Xia's mature style, it must have been created when he was middle-aged.[82] Masaaki Itakura has recently claimed that Xia Yong was active around the reign of Shundi 順帝 (or Huizong 惠宗, Togön Temür, 1320–1370; r. 1333–1370).[83] Until now, Xia's precise period of activity has been controversial—what we can confirm is that he was active in the mid-fourteenth century.

As for related textual sources in China, the Yuan literatus Ling Yunhan 凌雲翰 (1323–1388), a contemporary of Xia Yong from his hometown of Qiantang, was the first to write a poem on Xia's *jiehua* but provided no information about Xia's life.[84] Equally if not more important is an entry written by Zhan Jingfeng 詹景鳳 (d. 1602) in his *Dongtu Xuanlan bian* 東圖玄覽編 (Dongtu's Notes on Masterpieces of Art and Calligraphy). Zhan mentions that an album, collected by a family named Ye 葉, not only includes paintings like Li Di's 李迪 *dog* painting, but also includes two pieces of "embroidery" by Xia Yong:

> 又有夏時遠繡《滕王閣》《岳陽樓》二片，上于方寸間繡盡王、范二記，雖未見奇趣，然繡法之工，亦是一絕。[85]
>
> There are also two embroideries, *Prince Teng Pavilion* and *Yueyang Pavilion* by Xia Shiyuan (Shiyuan is an error for Mingyuan). The artist embroiders the complete texts of Wang [Bo's "Tengwang ge xu"] and Fan [Zhongyan's "Yueyang lou ji"] on a little space of the works. Although there is no inspired originality, his remarkable craftmanship of embroidery is superlative.

The "Prince Teng Pavilion" and "Yueyang Pavilion" are two of Xia Yong's favorite themes. Today, there still exist three copies of the former and six versions of the latter, and all include related literary texts in miniature scripts, just like the two works described by Zhan. However, while Zhan seems to regard Xia Yong as an embroidery craftsman, Xia's works surviving today are all paintings.

Xia Yong's association with embroidery has puzzled many modern scholars. Wei Dong and Yu Jianhua 俞劍華 both note the reference to Xia Yong in

the text *Huajian xiaoyu* 花間笑語 (Cheerful Talk among Flowers), completed by the Qing scholar Xiong Zhijin 熊之緢 in 1818, and assert that this is the only valuable Chinese source on Xia.[86] The text reads: "Xia Yong, with the courtesy name Mingyuan, used 'hair embroidery' to create the pictures *Prince Teng Pavilion* and *Yellow Crane Tower*, working with lines that are as fine as the eyelash of a mosquito, like the craftsmanship of devils." (夏永字明遠，以髮繡成 《滕王閣圖》、《黃鶴樓圖》，細若蚊睫，侔于鬼工。)[87] Both Wei and Yu understand this text as asserting Xia Yong to be an embroidery craftsman. They put forward their doubts about this judgment. After all, despite the fact that both the hair embroidery and Xia's extant *jiehua* emphasize meticulous details and techniques, the hair embroidery uses a completely different medium from *jiehua* and belongs to the category of the lesser decorative arts in traditional Chinese visual culture.

In fact, the entry from *Huajian xiaoyu* follows a much earlier record by the late-Ming scholar Jiang Shaoshu 姜紹書 (seventeenth century). His writing *Yunshizhai bitan* 韻石齋筆談 (Notes of the Yunshi Studio) includes an entry titled *Jiehua louge shu fu faxiu* 界畫樓閣述附髮繡 (Account of Ruled-Line Paintings of Pavilions, Together with Hair Embroidery):

> 復有夏永字明遠者，以髮繡成《滕王閣》、《黃鶴樓》圖，細若蚊睫，侔于鬼工。
> 唐季女仙盧眉娘于一尺絹上繡《法華經》七卷，明遠之製，庶幾近之。余遍考博雅家
> 言，無所謂夏明遠者，絕技如此，而姓字不傳，可乎？因附著之。
> 精于界畫者，不但以筆墨從事，兼通木經算法，方能為之。空繡之製，至明已失其
> 傳，若仇十洲之精工秀麗，幾于棘猴玉楮，然須規橅舊本，方能譽擅出藍，非匠心獨
> 運也。[88]

There is also a painter named Xia Yong, with the courtesy name Mingyuan. He used "hair embroidery" to create the pictures *Prince Teng Pavilion* and *Yellow Crane Tower*, working with lines that are as fine as the eyelash of a mosquito, like the craftsmanship of devils. The late-Tang female immortal Lu Meiniang embroidered seven volumes of the *Lotus Sutra* on one *chi* of silk—Mingyuan's production almost matches up to hers. I have searched through the writings by learned scholars but found nothing about Xia Mingyuan. He has such consummate skill, but could not leave a name in history—how could it happen? Therefore, I add this entry to record this fact.

Artists skilled at *jiehua* not only work with brush and ink, but also master *Carpenters' Manuals* and *Mathematical Methods*—only by this means could they create such works. Their "open-embroidered (*kongxiu*)" technique has not been handed down to the Ming period. Even Qiu Shizhou (Qiu Ying), whose technical virtuosity could be compared to carving monkeys on the tip of a thorn, still needs to follow the old models in order to achieve a higher reputation—it is not due to his own creativity.

In some sense, Jiang's remarks resolve Wei and Yu's doubts about the relation between Xia Yong and hair embroidery. Jiang compares Xia's *jiehua* with

hair embroidery, another art form that displays the interweaving of fine lines. This seems to emphasize Xia's superlative craftsmanship. Jiang mentions *kongxiu zhi zhi* 空繡之製 "the 'open-embroidery' technique," in a passage not reproduced in *Huajian xiaoyu*, indicating that this technique was lost by the Ming period, so that not even the technical virtuosity of the devoted Ming painter Qiu Ying 仇英 (ca. 1494–ca. 1552) could surpass it. Qiu Ying was not an embroiderer, so clearly *kongxiu zhi zhi* is a metaphorical term for a painting technique or the ability to paint with very densely packed, uniformly fine linear strokes. Similarly, Jiang may use the term *faxiu* 髮繡 (hair embroidery) to describe Xia Yong's superb painting skill.[89] In fact, the nineteenth-century scholar-official Zhao Fumin 趙孚民 had already adopted such understanding. When Zhao writes a colophon on an extant painting by Xia Yong—the one now held by the Museum of Fine Arts, Boston—Zhao quotes Jiang's words and then says: "This painting is one of those that reflect the so-called craftsmanship of *faxiu* (hair embroidery)." (所謂髮繡之工，此畺其一也。) Now we can see that when Jiang suggests that Xia's works could match up to Lu Meiniang's 盧眉娘 embroidery work on the *Lotus Sutra*, he does not necessarily mean that Xia is an embroidery craftsman. He may be stressing the mechanical perfection of Xia's lines.

Jiang's statement also confirms Xia Yong's obscurity in the history of Chinese painting. Jiang has "searched through the writings by learned scholars but found nothing about Xia Mingyuan"—this failed research occurred merely three hundred years after Xia Yong's lifetime. In contrast to his non-existent literary reputation, Xia's paintings, such as *Tengwang ge tu* 滕王閣圖 ("Prince Teng Pavilion") and *Huanghe lou tu* 黃鶴樓圖 ("Yellow Crane Tower"), continued to circulate in the late-Ming period, and even survive today.[90]

Xia Yong left us a wealth of visual materials. There are at least fifteen *jiehua* that can be reliably attributed to him.[91] However, a considerable number of these fifteen were formerly ascribed to different artists from the Five Dynasties (907–960) to the Yuan period. As we shall see, Xia always paints multiple versions of the same composition and subject matter. His surviving works can be divided into five groups on the basis of their recurring subjects.

Group A: Three copies of the *Prince Teng Pavilion*

Xia Yong left three square album leaves depicting the *Tengwang ge* 滕王閣 ("Prince Teng Pavilion"), one each in the Shanghai Museum (fig. 0.5), the Museum of Fine Arts in Boston, and the Freer Gallery of Art. These three paintings are highly consistent with one another, showing only minor variations in composition and motifs. At the bottom right of all three, Xia places a magnificent building with small figures on a high platform, surrounded by rocks and trees, facing a vast expanse of water where a tiny sailing boat

Figure 0.5: Xia Yong (active mid-fourteenth century). *Prince Teng Pavilion.* Yuan dynasty (1271–1368). Album leaf, ink on silk, 25.7 cm × 26.2 cm. Shanghai Museum.

floats. Looking further, we can see distant mountains defining the boundary between water and sky. In the upper left-hand corner of these three paintings, Xia inscribes the Tang poet Wang Bo's 王勃 (ca. 650–ca. 676) text "Tengwang ge xu" 滕王閣序 (Preface to the Prince Teng Pavilion) in miniature standard-script calligraphy, explicitly labelling the subject of these works.

Both the Boston and Freer versions have been traditionally attributed to Wang Zhenpeng. The Freer copy bears a seal that reads "Ci Guyun chushi zhang" 賜孤雲處士章 (Seal of the One Granted the Name Recluse of Guyun), referring to Wang.[92] However, this seal looks very different from the authentic one affixed to Wang Zhenpeng's *Boya guqin tu* 伯牙鼓琴圖 ("Boya Plays the Zither"), especially with regard to their curved lines. The Freer seal is an obvious counterfeit, probably intended to boost the prestige of this painting.[93]

Similarly, a previous collector of the Boston version ignored the presence of Xia Yong's seal, and instead appended a label slip that read "Wang Guyun Tengwang ge" 王孤雲滕王閣 (Wang Guyun's *Prince Teng Pavilion*) on it.[94] This label slip misled Zhao Fumin, who was appointed as a local official at Pinyang 頻陽, Shaanxi, in 1878 after the Dungan Revolt (1862–1877) who happened to acquire this painting there. Zhao wrote colophons on this painting in 1878 and in 1879.[95] His first colophon dwells upon Wang Zhenpeng's biography, quoted from the Yuan catalogue *Tuhui baojian*:

元王振鵬，字朋梅，永嘉人，官至漕運千戶，界畫極工緻，仁宗眷愛之，賜號孤雲處士。

Wang Zhenpeng of the Yuan, with the courtesy name Pengmei, came from Yongjia. His highest official title is "the Chief of a Thousand Households to Supervise Sea Transport of Tax Grains" (*Caoyun qianhu*). His *jiehua* is exquisite. The Emperor Renzong liked him and thus granted him the pseudonym "Recluse of the Lonely Clouds."

This suggests that Zhao directly accepted the attribution of this painting to Wang Zhenpeng. Then, Zhao provides more details about this assertion:

邑人程少峰，嗜古，工鐵筆，高雅士也。時招少峯分領賑事。一日，因公來署，出冊質之。少峯亟賞此啚，謂非孤雲不能也，即此片縑，一幅可值十餘金，皆狃乱兵燹以來，藏於地窖中，偶剩此者，不可多得矣。摩挲半日，屬爲珍藏，鄭重而去。

The local person Cheng Shaofeng loves antiquity, is good at engraving seals, and is a man of refinement. At one time, Shaofeng was asked to take responsibility for relieving the people's hardships. One day, because of public affairs, he went to my office. I took out this album leaf to ask his opinion. He valued this picture highly, saying: "It cannot be the work of anyone except Guyun (Wang Zhenpeng). Despite the smallness of the silk, such a work is worth more than ten *jin*. This work has been hidden in a cellar since the Dungan Revolt and thus accidently survives here. It is rare." Cheng caressed this work for half a day, exhorted me to treasure it, and then solemnly left.

It records that Zhao consulted a well-known local literatus, Cheng Shaofeng 程少峰 (nineteenth century), and Cheng lavished high praise on this painting and confirmed its previous attribution. However, in Zhao's 1879 colophon, he overthrows this judgment, since he accurately recognizes Xia Yong's seal on the copy. Zhao quotes the aforementioned entry about Xia Yong from Jiang Shaoshu's *Yunshizhai bitan* and reflects on his earlier mistake:

按劉吏部公戬《識小錄》云："國初嘗以內府書畫賜大臣，外有標籤，多宸濠、江陵、分宜沒入者，宸濠之真贋參半，江陵多贋，分宜多真。"可見鑒賞家當自具眼光，不必人云亦云，更或欺人以欺己也。

Liu Libu Gongyong's (Liu Tiren 劉體仁, with the courtesy name Gongyong) *Shixiao lu* says: "At the beginning of this dynasty, works of painting and

calligraphy from the imperial collection were once awarded to officials. There were labels pasted outside. Most works were confiscated from the collections of Chenhao, Jiangling, and Fenyi. One half of the works in Chenhao's collection were genuine and the other half of them were fakes, most from Jiangling's collection were fakes, and most from Fenyi's collection were authentic." Evidently, connoisseurs should have their own opinions. They do not have to repeat what others have said, and still less to deceive others in order to fool themselves.

This means that people always have difficulty distinguishing the genuine from the fakes, but they should insist on their own opinions after careful examination. This is exactly the reason Zhao finally changed his judgement on the Boston copy's attribution.

The Boston and Freer versions by Xia Yong are not the only ones mistakenly ascribed to Wang Zhenpeng. More examples will be introduced later, and the second chapter of this book will start with a comparison between the works of Xia and Wang and will further explore their complex relationship.

Group B: Six copies of the *Yueyang Pavilion*

There are six surviving versions of Xia Yong's *Yueyang lou tu* 岳陽樓圖 ("Yueyang Pavilion"), including a newly discovered painting from the collection of Tokusaburō Masamune 正宗得三郎 (1883–1962), two in the Beijing Palace Museum and one each in the Yunnan Provincial Museum (fig. 0.6), the Freer Gallery of Art, and the National Palace Museum in Taipei.[96] The Japanese version is a fan mounted as a hanging scroll, the Taipei version and one of the Beijing copies are fans mounted as album leaves, and the others are square album leaves. On all these works, Xia Yong places a block of text from the Northern Song politician Fan Zhongyan's 范仲淹 (989–1052) "Yueyang lou ji" 岳陽樓記 (Record of the Yueyang Pavilion) in minute calligraphy, alluding to the painting's theme.

These copies have been variously dated and attributed. The Yunnan copy with Xia's seal and signature and the Freer copy with Xia's seal have been correctly attributed to this Yuan artist. Unfortunately, the Beijing square album leaf (fig. 0.7) includes neither Xia Yong's signature nor his seal. Traditional Chinese critics have always treated this copy as a Song work. For example, on its corresponding album leaf, the Qing scholar Li Zuoxian 李佐賢 (1807–1876) writes:

《岳陽樓圖》，界畫精巧，飛閣層檐，一絲不亂，樓中人物，纖悉具備，殆類鬼工。上題《岳陽樓記》楷書，如蠅頭蚊腳，足使離婁失明，不知作者如何著筆。此等書畫，乃宋人絕技，元明以後，已成《廣陵散》矣。古今人不相及，即藝事可見。[97]

Figure 0.6: Xia Yong (active mid-fourteenth century). *Yueyang Pavilion*. Yuan dynasty (1271–1368). Album leaf, ink on silk, 26.0 cm × 25.5 cm. The Yunnan Provincial Museum.

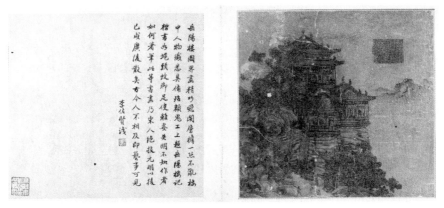

Figure 0.7: Xia Yong (active mid-fourteenth century). *Yueyang Pavilion*. Yuan dynasty (1271–1368). Album leaf, ink on silk, 24.4 cm × 26.2 cm. The Palace Museum, Beijing.

This *Yueyang Pavilion* reflects the virtuosity and craftsmanship of *jiehua*. There are no cluttered lines on the flying pavilions and multiple eaves. The artist depicts all details of the figures inside the pavilion, and his skill is similar to the craftsmanship of devils. "Yueyang lou ji" is written in standard script as small as the head of a fly or the foot of a mosquito. Writing in this way would cause Li Lou to lose his sight. I cannot imagine how the author managed his brush. Such art works could only be made by the Song people's ultimate skill. Since the Yuan-Ming period, these Song techniques have been the same as the lost melody *Guangling san*. No ancient or contemporary people could match this skill—from this, we can see the artistry.

Li Zuoxian stresses the high quality of this painting, placing it on a par with the best Song *jiehua*. Indeed, Xia's paintings, with small-scale formats and a large proportion of one-corner compositions, largely inherit the well-established *jiehua* traditions of the Southern Song Academy.

Viewers of another Beijing version of the *Yueyang Pavilion* (fig. 0.4) also admired the painter's remarkable workmanship. On its corresponding leaf, the Qing emperor Qianlong 乾隆 (1711–1799) has inscribed a poem which includes the following couplet: "One is still thinking that it may be easy to use the head of a fly as a brush; [the lines and scripts here] actually seem to be produced by a fine needle made from the eye of an ant." (尚覺蠅頭易為筆，竟如蟻目細標鍼。) However, unlike the Beijing square album leaf, this fan version was regarded as the work of the Yuan artist Wang Zhenpeng, not a Song person. According to an entry in *Shiqu baoji xubian* 石渠寶笈續編 (Supplement to the Precious Bookbox of the Shiqu Library), there was an old label, "Wang Zhenpeng Yueyang lou tu," 王振鵬岳陽樓圖 (Wang Zhenpeng's *Yueyang Pavilion*) attached to this Beijing version.[98] The Qing scholar Ruan Yuan 阮元 (1764–1849) also confirms this fact in his *Shiqu suibi* 石渠隨筆 (Shiqu Jottings):

> 王振鵬《岳陽樓圖》界畫，樓閣檻楹戶牖細不可視。幅上於方寸地細書《岳陽樓記》一篇，款至正七年四月二十二日云云。字畫之細，幾不可辨，惟可於晴日簷間以意讀之也。[99]

> In Wang Zhenpeng's *jiehua* entitled *Yueyang Pavilion*, its storied structures, balustrades, columns, doors, and windows are too meticulous to be clearly seen. The text of "Yueyang lou ji" is carefully inscribed in a limited area at the top of the painting, with the creation date "the twenty-second day of the fourth lunar month in the seventh year of the Zhizheng reign period" and so on. The strokes of the characters are so fine that they can barely be discerned and can only be presumably read under roof eaves in sunny days.

Although Ruan Yuan mentions the creation date inscribed in this Beijing version—virtually the sole source of information for Xia Yong's precise dates—Ruan ignores Xia Yong's signature that follows the date.

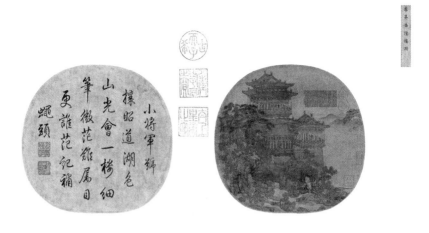

Figure 0.8: Xia Yong (active mid-fourteenth century). *Yueyang Pavilion.* Yuan dynasty (1271–1368). Fan mounted as album leaf, ink on silk, 23 cm × 23.8 cm. National Palace Museum, Taipei.

The Taipei copy (fig. 0.8) was ascribed to Li Sheng 李昇, an artist of the Former Shu (891–925), prior to the Song and Yuan.[100] Such an attribution would appear to be contradicted by the inscription of Fan Zhongyan's "Yueyang lou ji," a well-known literary text created later than Li Sheng's time. However, in order to support the attribution to Li, the Emperor Qianlong proposed that the text "Yueyang lou ji" was not inscribed by the painter himself, but was added later. Qianlong composed a poem, which he inscribed on the corresponding leaf:

小將軍號攘昭道，湖色山光會一樓。
細筆微茫難屬目，更誰范記補蠅頭？

Li Sheng's pseudonym of "Little General" derives from Li Zhaodao's name (active ca. 670–730).
Beautiful lakes and mountains are gathered around a single pavilion.
Minute writing, subtle and obscure, fails to arrest the gaze,
And who supplied Fan Zhongyan's text in characters as small as a fly's head?

In this poem, Qianlong affirms Li Sheng's creation of this painting and denies his writing of the inscription. The editor of *Shiqu baoji xubian* also comments on this painting and agrees with Qianlong:

謹按《岳陽風土記》，岳陽樓，下瞰洞庭，景物寬濶。唐開元四年，中書令張說，除守此州，每與才士登樓賦詩，自爾名著。李昇乃王蜀畫工，時已唐末，其寫樓景，宜也。宋滕宗諒重脩樓，范仲淹作記，乃仁宗時事，蓋後人因昇畫而書記于右耳。恭讀御製，有更誰范記補蠅頭之句，辨析時代，以兩字見之，最為明確矣。[101]

According to the *Records of the Customs of Yueyang*, the Yueyang Pavilion looks down at Dongting Lake, and there is a broad view of the scenery. In the fourth year of the Tang Kaiyuan reign period (716), Zhang Shuo, the Director of the Secretariat, was appointed as the local administrator of this prefecture. He always climbed the pavilion and composed poems, together with talented literati scholars, and subsequently, this pavilion became famous. Li Sheng was an artisan of the Wang Shu (Former Shu), at the very end of the Tang dynasty, so it was entirely natural that he depicted it. During the Song period, Teng Zongliang (991–1047) reconstructed the pavilion, and Fan Zhongyan composed a literary record [to commemorate it], both events occurring during Renzong's reign. It seems likely that some later person superimposed Fan's "Record" onto the right side of Li Sheng's painting. When I respectfully read the [Qianlong] Emperor's inscription, I find it includes the sentence "who supplied Fan Zhongyan's text in characters as small as a fly's head," which concisely captures this question of chronology, and with the utmost clarity.

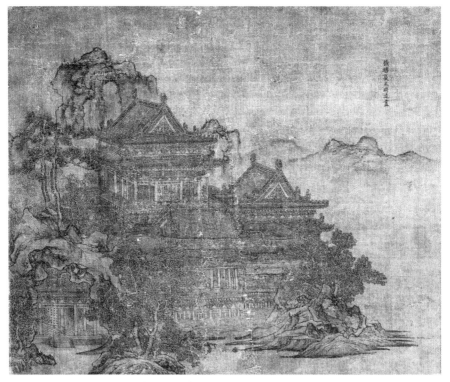

Figure 0.9: Xia Yong (attri.). *Palace by the River.* Album leaf mounted as hanging scroll, ink on silk, 21.6 cm × 26.5 cm. Chazen Museum of Art, University of Wisconsin-Madison, anonymous loan, 5.2002.10.

This entry outlines the sequence of the establishment of the pavilion's reputation, Li Sheng's period of activity, the reconstruction of the pavilion, and Fan's creation of his famous literary record. The author uses this sequence to conclude that the inscription of Fan's literary record was added after the painting's production. We can see now that this line of reasoning is incorrect. Today, after comparing this Taipei copy with Xia's other paintings, scholars like Wei Dong and Xue Yongnian 薛永年 have correctly reattributed it to Xia Yong.[102]

The group of Xia's *Yueyang Pavilion* paintings share a well-established design: a pavilion facing an expanse of water and distant mountains. It is also worth noting that a work (fig. 0.9) titled *Palace by the River*, which was previously in the Jingyuanzhai 景元齋 collection, closely resembles Xia Yong's *Yueyang Pavilion* paintings. Apart from the basic composition of a pavilion on the left and distant mountains on the right, they have particular similarities in the roof constructions of the principal and inferior halls. Nevertheless, the elevated foundation in Xia's *Yueyang Pavilion* has been replaced by halls with pillars in this *Palace by the River*. Besides, the latter's overall execution is much less accomplished. Its weak control of even lines distinguishes it from Xia's *Yueyang Pavilion*.

This *Palace by the River* bears a signature reading "Qiantang Xia Yong Mingyuan hua" 錢塘夏永明遠畫 (Painted by Xia Yong Mingyuan from Qiantang). Apart from this, two more reliable versions of Xia's signature exist on two of the *Yueyang Pavilion* paintings: "Qiantang Xia Yong hua bing shu" 錢唐夏永畫并書 on the album leaf in Yunnan and "Qiantang Xia Yong Mingyuan hua bing shu" 錢唐夏永明遠畫並書 on the fan in Beijing.[103] It is worth noting that Xia's hometown is written as Qiantang 錢唐 in both signatures from *Yueyang Pavilion*, which differs from the characters Qiantang 錢塘 used in the *Palace by the River*. In addition, the rhapsody transcribed on Xia Yong's *Fengle lou tu* 豐樂樓圖 ("Pavilion of Prosperity and Happiness") in Beijing includes the phrase "the extravagance of the ancient area of Qiantang" (*Qiantang gudi zhi haoshe* 錢唐故地之豪奢). Here, Xia Yong also adopts the version Qiantang 錢唐 instead of Qiantang 錢塘. The county name Qiantang 錢唐 first appeared during the Qin dynasty (221–207 BCE). *Shiji Qinshihuang benji* 史記・秦始皇本紀 (Records of the Grand Historian, The Basic Annals of the First Emperor of the Qin) records: "[In the thirty-seventh year or 210 BCE, the First Emperor of the Qin had a trip.] He passed Danyang and arrived at Qiantang." ([三十七年，始皇出遊。] 過丹陽，至錢唐。)[104] It was during the early Tang period that the character "tang" 塘, with the radical "tu" 土, began to replace "tang" 唐 in the place name Qiantang 錢唐.[105] Xia Yong shows a clear preference for the older version Qiantang 錢唐 in two of his genuine *Yueyang Pavilion* and his transcription of a rhapsody. Therefore, if Xia created the *Palace by the River*, it would be very suspicious for him to have adopted the newer version Qiantang 錢塘.

Despite the similar design of Xia's *Yueyang Pavilion* and the *Palace by the River*, I believe the latter's authenticity is quite questionable, considering such issues as the differing signatures and levels of skill demonstrated.

Group C: Two copies of the *Tower Reflected in the Lake*

Two versions of *Yingshui loutai tu* 映水樓臺圖 ("Tower Reflected in the Lake"), in my opinion, may be safely ascribed to Xia Yong. The version (fig. 0.10) in the Beijing Palace Museum, a fan mounted as an album leaf, has been widely accepted as authentic in recent times.[106] It depicts a tower built on a platform, surrounded by a lake, and approached by a bridge on the left side of the scene. There is a rocky landscape in its foreground and distant hills in the background. The Beijing version does not bear the artist's signature or seal and, like several of Xia's paintings, has long been treated as a work by Wang Zhenpeng. Consider, for instance, the poem inscribed by Qianlong on the corresponding leaf to this Beijing version:

下臨無地上凌空，般礴精神想象中。
此日未詳半樂館，早年曾寫大明宮。

The base too distant to see the ground; the top draws near the sky;
[The artist's] boundless spirit may be imagined.
Though he had not yet depicted *Pingle guan*,
He had many years before painted *Daming gong*.

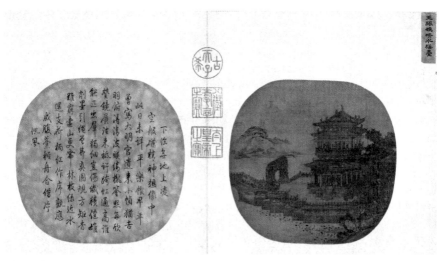

Figure 0.10: Xia Yong (active mid-fourteenth century). *Tower Reflected in the Lake.* Yuan dynasty (1271–1368). Fan mounted as album leaf, ink on silk, 23.9 cm × 25.3 cm. The Palace Museum, Beijing.

Since Wang Zhenpeng was known to have sent a painting named *Daming gong tu* 大明宮圖 ("Daming Palace") to the Yuan court, the poem indicates that Qianlong was identifying Wang as the creator of this *Tower Reflected in the Lake*.[107] An old label for this painting reiterates this identification.[108]

The other *Tower Reflected in the Lake*, an album leaf in the Harvard Art Museums, has hardly been published or studied, and its authorship remains controversial. The museum's official website cautiously dates this work to the Ming-Qing period (seventeenth century), treating it as a later work in the manner of Xia Yong.[109] Suzuki Kei 鈴木敬, however, put forward a different opinion.[110] In the upper left-hand corner of this painting, there is a faint seal and a signature with extremely small, illegible characters. Suzuki was able to use infrared to read the signature and seal, and on this basis ascribed this work to Xia Yong.

I agree with Suzuki's attribution for two reasons. First, the artist's signature seems to read "Qiantang Xia Yong Mingyuan wei □□ hua" 錢唐夏永明遠為□□畫 (Painted for □□ by Xia Yong Mingyuan from Qiantang). The square seal is Xia Yong's frequently used one, "Xia Mingyuan yin." Admittedly, it is unusual that the artist does not insert a solid block of literary text into the painting like Xia does in his *Prince Teng Pavilion* and *Yueyang Pavilion*. Nevertheless, the Beijing *Tower Reflected in the Lake* also lacks this feature. Besides, there is evidence of repairs in the upper left-hand corner of the Beijing version, exactly in the place where the artist signs the Harvard copy. This suggests that the Beijing version might have contained a similar brief inscription (or signature) like the Harvard one. Second, Xia Yong achieves a draughtsman-like precision in his architectural depictions and brings the drawing of lines to perfection, both of which make his works difficult to imitate. The artistic style and *jiehua* techniques of the Harvard version are very similar to those observed in Xia's extant works of art. If the creator of the Harvard *Tower Reflected in the Lake* were not Xia Yong, it would be puzzling to see so accomplished a *jiehua* artist reproducing a work (the Beijing version) by the little-known painter Xia Yong. An accomplished artist would be more likely to sign his own name (if fame were his goal), or to imitate works by prestigious artists like Wang Zhenpeng (if he were interested in profit). Therefore, I consider it very likely that the Harvard copy is a work by Xia Yong.

Group D: Two copies of the *Pavilion of Prosperity and Happiness*

Two square album leaves of Xia's *Pavilion of Prosperity and Happiness* survive today, one in the Beijing Palace Museum and one in the Shanghai Museum (fig. 0.11). Both depict an enclosed pavilion, and people in it can enjoy looking out across an expansive landscape. On these two paintings, in keeping with his consistent practice, Xia Yong leaves his seal, "Xia Mingyuan yin," and transcribes

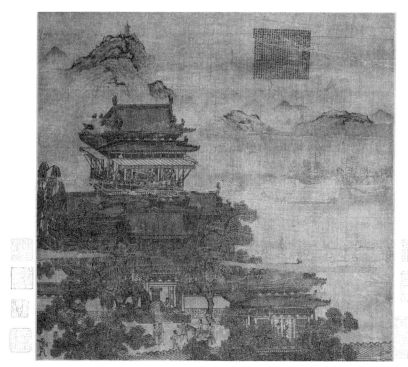

Figure 0.11: Xia Yong (active mid-fourteenth century). *Pavilion of Prosperity and Happiness.* Yuan dynasty (1271–1368). Album leaf, ink on silk, 24.4 cm × 25.6 cm. Shanghai Museum.

a prose poem related to his subject in minute calligraphy. However, this prose poem is not as famous as Wang Bo's "Tengwang ge xu" or Fan Zhongyan's "Yueyang lou ji," and its calligraphy is too minute to be easily read. This has led to subsequent misunderstanding of the painting's theme. The version in the Palace Museum in Beijing bears an old label—"Wang Guyun E'pang gong tu" 王孤雲阿房宮圖 (Wang Guyun's *E'pang Palace*)—and the version from the Shanghai Museum was treated as *Yueyang Pavilion.*[111]

This Pavilion of Prosperity and Happiness was a Southern Song pavilion near the West Lake in Lin'an (today's Hangzhou), and was destroyed during the late-Yuan period.[112] The modern scholar Wei Dong was the first to transcribe the microscopic inscription on the Beijing version.[113] Although Wei Dong could not identify the author of this literary text, he grasped its main theme, a description of West Lake's beautiful scenery and the Southern Song's prosperity. In fact, the local chronicle *Xianchun Lin'an zhi* 咸淳臨安志 (Gazetteer of Lin'an from the Xianchun Reign Period [1265–1274]) records this prose poem and its obscure author, Lin Yede 林曄德.[114] We can assume

that Xia Yong was familiar with Southern Song sites in his hometown and the literature relevant to them. Wei Dong's comparison of Xia's painting with a Southern Song map of West Lake proves that Xia Yong seriously considered the actual location of this pavilion and its relation to nearby sites.[115]

Group E: Two copies of the *Yellow Pavilion* (or the *Yellow Crane Tower*)

The last group of Xia's works include one in the Metropolitan Museum of Art in New York and a counterpart in the Yunnan Provincial Museum. Both versions share the same design. Xia Yong includes the Northern Song poet Su Zhe's 蘇轍 (1039–1112) prose poem "Huanglou fu" 黃樓賦 (Rhapsody on the Yellow Pavilion) in both paintings, reflecting their subject matter. The Huanglou 黃樓 (Yellow Pavilion) was located in Xuzhou, Jiangsu province, and was dedicated to Su Zhe's elder brother Su Shi, commemorating his indefatigable work during a huge Yellow River flood in 1077.

However, in these *Yellow Pavilion* paintings, Xia Yong also adds a puzzling visual element: a man flying off into the distance on a crane's back. Due to this specific image, many viewers have identified the painting's architectural subject as the Huanghe lou 黃鶴樓 (Yellow Crane Tower), a famous building on the bank of the Yangtze River in Wuchang, Hubei Province. For example, even today, nearly all existing publications on Xia Yong's Yunnan version have ignored its inclusion of Su Zhe's "Huanglou fu" and titled it *Yellow Crane Tower*. This is probably because Su Zhe's prose poem is written in a script so minute that few viewers can read it, but it is more likely because the famous Yellow Crane Tower is frequently associated with the deity-on-a-crane image. Here, we are compelled to ask: Why did Xia Yong juxtapose the conflicted visual and textual clues in his paintings? This question will be fully discussed in the first chapter and also be a useful starting point for us to evaluate the uniqueness of Yuan *jiehua*.

Indeed, when this book looks at *jiehua*, the distinctive painting genre with different English translations and multiple interpretations, its main goal is to reconstruct a systematic Yuan *jiehua* history. This book will examine in detail Yuan *jiehua*'s development over time and characterization across regions, and meanwhile situate this painting genre both in the context of a Mongol-dominated society and in the history of Chinese painting. It will be based primarily on visual materials, such as those of the neglected *jiehua* master Xia Yong, to explore *jiehua*'s complex relations to architecture, painter, and politics.

1
Painting and Architecture

Dilemma: The *Yellow Crane Tower* or the *Yellow Pavilion*?

Unlike almost all other *jiehua* artists, Xia Yong always inscribed a famous prose poem on his *jiehua*, thus closely associating his paintings with literature and calligraphy. This feature rarely appears in professional art works but is quite common among literati paintings of the Song and later periods. Although Xia Yong occupies an awkward position between the traditionally opposed categories of literati and professional painters, he acquires a controlling presence in relation to his art. After all, through inscriptions, Xia could directly convey his own thoughts and govern viewers' interpretations of his paintings.

However, the situation becomes extremely complex when there exist slippages between the painter's account and his paintbrush. As mentioned earlier, viewers have tended to entitle Group E of Xia Yong's works—one in New York (fig. 1.1) and the other in Yunnan (plate 2)—the *Yellow Crane Tower*, partly because of Xia's preservation of the man-on-a-crane image. However, such an interpretation contradicts Xia Yong's inclusion of Su Zhe's "Huanglou fu," which labels these paintings the *Yellow Pavilion*. It is almost impossible that Xia Yong would have confused the Yellow Pavilion and the Yellow Crane Tower, two buildings located in cities five hundred kilometers apart and having different cultural implications. One approach to this question would be to examine the architectural features shown in the paintings, and to ask which of the two historical buildings they most resemble, based on our knowledge of them derived from contemporary sources. Most *jiehua*, such as the *Going up the River on the Qingming Festival*, contain both architectural subjects and other categories and treat architectural images in a very generic way. By contrast, Xia's *jiehua* are much purer. All these factors in his paintings—the absolute dominance of architecture, the detailed handling of a distinctive landmark in history (not just any random building), and the painter's inscription of the subject—make Xia Yong's possible portrayal of actual buildings too strong a temptation for us to resist. In other words, Xia's works provide us with an unparalleled opportunity to examine whether Yuan *jiehua* images are true to life.

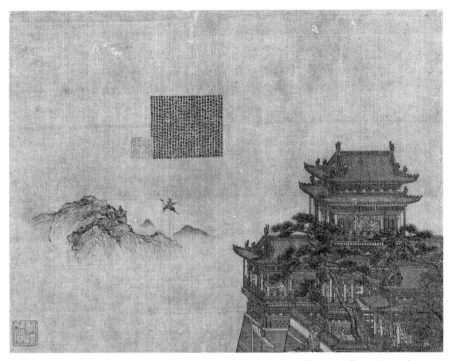

Figure 1.1: Xia Yong (active mid-fourteenth century). *Yellow Pavilion.* Yuan dynasty (1271–1368). Album leaf, ink on silk, 20.6 cm × 26.7 cm. The Metropolitan Museum of Art, Ex coll.: C. C. Wang Family, from the P. Y. and Kinmay W. Tang Family Collection, gift of Oscar L. Tang, 1991 (1991.438.3). Image copyright © The Metropolitan Museum of Art. Image source: Art Resource, NY.

A comparison between Xia's Group E paintings and historical sources of the Yellow Crane Tower is the key to identifying Xia's theme here. We do not choose to focus on written sources describing the Yellow Pavilion, because this building was not as famous as the Yellow Crane Tower, and there is little surviving source material describing its appearance. The most informative piece of its related texts is Su Zhe's preface for his rhapsody "Huanglou fu." The preface describes how the catastrophic flood happened in 1077 in Xuzhou, how Su Shi—the local administrator and Su Zhe's elder brother—applied effective emergency management techniques, and, most importantly, how the Yellow Pavilion was constructed—"[Su Shi] commanded the building of a huge pavilion on the east city gate, plastered with loess, and said: 'Earth surpasses water.' He encouraged local people in Xuzhou to complete this project." (即城之東門為大樓焉,塈以黃土,曰:"土實勝水"。徐人相勸成之。)[1] This suggests that the magnificent Yellow Pavilion stood on a high foundation and faced the

water. Both visual clues are consistent with the architectural image depicted in Group E. However, these clues apply to Xia's *Yueyang Pavilion* paintings equally well. Beyond this, the description of the Yellow Pavilion lacks distinguishing features, and its most unique feature—"plastered with loess"—is not easily discerned in Xia's monochrome ink paintings. Thus, a comparison of Xia's images with historical sources regarding the contemporary Yellow Crane Tower is more compelling.

Texts: How do they describe the Yellow Crane Tower?

It is widely believed that the name of the Yellow Crane Tower derives from Daoist legend. According to the Tang scholar Yan Bojin 閻伯瑾 (ca. 765), the *Tujing* 圖經 (Illustrated Classic) records that a man named Fei Yi 費禕 (ca. 253) achieved immortality at this site and once returned there to rest by riding a yellow crane (《圖經》云："費禕登仙，嘗駕黃鶴返憩於此，遂以名樓。").[2] The same story has been repeatedly quoted by subsequent scholars like the Song-period Yue Shi 樂史 (930–1007), and the Ming-period Wang Qi 王圻 and Wang Siyi 王思義.[3] Apart from Fei Yi, the immortal Wang Zi'an 王子安 was also popularly linked to the tower.[4] The connection between the man-on-a-crane image and the Yellow Crane Tower was further established after Cui Hao 崔顥 (704–754) wrote his famous poem "Huanghe lou" 黃鶴樓 (Yellow Crane Tower). It includes such couplets as the following:

> 昔人已乘黃鶴去，此地空餘黃鶴樓。
> 黃鶴一去不復返，白雲千載空悠悠。
>
> That man of old has already ridden the yellow crane away,
> And here in this land there remains only Yellow Crane Tower.
> The yellow crane, once it has gone, will never come again,
> But white clouds of a thousand years go aimlessly on and on.[5]

By contrasting the absence of this Daoist immortal and the presence of the pavilion, this poem conveys sentiments of nostalgia for the past. The immortal's act of leaving outright is perfectly reflected in the relevant paintings of Xia Yong. On their upper left (fig. 1.2 and 1.3) is a man, with a tall hat and a loose robe, riding a crane. A partial profile of his back is depicted, and the man does not look back to the tower at the bottom right. Both visual details match the assertion of Cui's poem that "the yellow crane, once it has gone, will never come again."

While the New York version was trimmed at the bottom, the Yunnan version, with an intact composition, contains another visual detail (fig. 1.4) relevant to the miraculous moment of Fei Yi's ascent to heaven. In the left foreground are a group of witnesses, looking up, raising their arms, and making obeisance to the immortal. One of them even kneels to show his piety. Both

Figure 1.2: The man-on-a-crane image, from *Yellow Pavilion* (fig. 1.1). The Metropolitan Museum of Art: Gift of Oscar L. Tang, 1991 (1991.438.3) (Detail). Image copyright © The Metropolitan Museum of Art. Image source: Art Resource, NY.

Figure 1.3: The man-on-a-crane image, from *Yellow Pavilion* (plate 2). The Yunnan Provincial Museum.

Figure 1.4: The worshippers, from *Yellow Pavilion* (plate 2). The Yunnan Provincial Museum.

the man-on-a-crane image and the representation of his devotees closely link the tower with the Daoist derivation of the Yellow Crane Tower. The enduring popularity of Fei Yi's legend and Cui Hao's poem have led to the consistent identification of Xia Yong's Group E paintings as the *Yellow Crane Tower.*

In addition to the images of figures, the architectural depiction in Xia's paintings also conforms to our understanding of the environment of the actual Yellow Crane Tower. The history of the tower can be traced back to the Three Kingdoms period (220–280), more than one thousand seven hundred years ago. The Tang text *Yuanhe junxian tuzhi* 元和郡縣圖志 (Maps and Gazetteer of the Commanderies and Counties in the Yuanhe Period) writes: "In the second year of the Wu's Huangwu reign (223), the town of Jiangxia was provided with a fortified wall so that it could support a garrison. The western wall of the city overlooked the Changjiang River. At the southwest corner, a tower was

constructed atop a promontory, and called the Yellow Crane Tower." (吳黃武二年，城江夏以安屯戍地也。城西臨大江，西南角因磯為樓，名黃鶴樓。)[6] Xia's tower (fig. 1.1 and plate 2), placed on a high foundation near the water, nicely fits the description.

However, in our investigation of Xia's Group E paintings, we have until now only dealt with the Daoist imagery and the environment of the Yellow Crane Tower; we have not yet explored the building itself. The Yellow Crane Tower was destroyed and rebuilt several times in its history, so its appearance must have differed through time. It is useful for us to consider specifically the fourteenth-century perception of the building's appearance and compare that with what we see in Xia Yong's paintings.

The existence of the Yellow Crane Tower during the Yuan period is very questionable. In 1170, the Southern Song scholar Lu You 陸遊 (1125–1210) wrote in his travel diary *Rushu ji* 入蜀記 (Record of a Trip to Shu), "The Yellow Crane Tower . . . is destroyed now, and there is nothing left even of its foundations. I queried an old local clerk. He said that between the Stone Mirror Pavilion and the Southern Pavilion, facing Parrot Island, one could still, with imagination, discern the location [of the Yellow Crane Tower]." (黃鶴樓⋯⋯ 今樓已廢，故趾亦不復存。問老吏，云在石鏡亭、南樓之間，正對鸚鵡洲，猶可想見其地。)[7] Lu You's failure to find this tower may serve to indicate that it did not survive in the twelfth century. It is possible that the Yellow Crane Tower was reconstructed in the early thirteenth century.[8] During the following Yuan period, there is a notable absence of references in official histories and documentary sources to indicate the tower's existence.[9] For example, in 1322, when the Yuan writer Song Minwang 宋民望 recorded the rebuilding of the Southern Pavilion, he claimed that this new pavilion "became the most distinguished of multistory structures used for climbing and observing [scenery] in the Southeast." (遂為東南登臨樓閣之冠)[10] At the same time, he made no reference to the nearby Yellow Crane Tower—a much more famous historical building. Song Minwang's failure to mention the Yellow Crane Tower seems to suggest it did not exist then.

Most importantly, the early Ming scholar-official Fang Xiaoru 方孝孺 (1357–1402) confirms the fact that the Yellow Crane Tower no longer stood during the late-Yuan period. Fang writes,

夫黃鶴樓以壯麗稱江、湘間⋯⋯元末諸侯之相持，武昌莽為盜區，屠傷殺戮至於雞犬，求尺木寸垣於頹城敗壘間而不可得，天下之亂極矣！及乎真人既一海內，建親王鎮楚，以其地為國都，旄頭屬車往來乎其上者，四時不絕。盛世之美，殆將稍稍復覯。[11]

The Yellow Crane Tower was famous for its magnificence and splendor in the Jiang and Xiang areas . . . The princes of the late-Yuan fought with each other, and Wuchang was so chaotic that it became a place for bandits. The population was slaughtered, down to the last chicken and dog. It was impossible

to find a small piece of wood and wall [of the Yellow Crane Tower] among the decayed city and destroyed walls. The country had been left in extreme disorder! After the [Hongwu] Emperor unified the country, nominated an Imperial Prince to rule the Chu area, and made Wuchang its capital, cavalcades of riders and chariots that came and went to the Yellow Crane Tower did not stop all the year round. To some extent, the beauty of the tower's heyday could be seen again.

Fang's words assert that there were no remains of the Yellow Crane Tower at the end of the Yuan, and a new tower was rebuilt in the 1370s after the nomination of the Chu king.[12] Because Xia Yong, active in the mid-fourteenth century, was contemporary with Fang Xiaoru, Xia should have shared a similar knowledge of the tower with Fang. That is to say, it would have been impossible for the late-Yuan painter Xia Yong to have seen the tower other than in his imagination before the 1370s.

After examining the textual sources, we can conclude that there are three possibilities when identifying Xia Yong's Group E paintings: If Xia Yong indeed used an actual Yellow Crane Tower as his painting archetype, it was most likely the one built in the 1370s. Otherwise, Xia's *Yellow Crane Tower* paintings are not true to life, or Xia did not intend to paint this theme at all.

Images: How do they represent the Yellow Crane Tower?

The imperial patronage of the Daoist god Zhenwu 真武 (The Supreme Emperor of the Dark Heaven) reached its zenith during the early Ming period. In 1412, the Yongle 永樂 emperor (1360–1424) commissioned a project of restoring and rebuilding Daoist monasteries dedicated to Zhenwu on Mount Wudang 武當.[13] The fifteenth-century woodblock-printed *Daming xuantian shangdi ruiying tulu* 大明玄天上帝瑞應圖錄 (Illustrated Record of the Auspicious Responses by the Supreme Emperor of the Dark Heaven to the Great Ming Dynasty) records the miraculous episodes that occurred during this project. One of its images (fig. 1.5) represents the miracle: in 1412, a giant tree trunk was found standing still in the water in front of the Yellow Crane Tower in Wuchang. The depicted Yellow Crane Tower should be the one rebuilt in the 1370s.[14]

Nevertheless, the tower, placed on the upper right of the printed version, looks entirely different from Xia Yong's images.[15] In the print, the wooden superstructure of the Yellow Crane Tower is erected on (or behind) a long city wall made by layers of bricks, barely matching the high-platform foundation supporting Xia Yong's tower (plate 2). Moreover, in the print, a building with a double-eaved roof is depicted in profile, partly hiding the rear one that has a double-eaved hip-gable roof and perhaps a small projecting portico; these two buildings, possibly connected by corridors, form an L-shaped ensemble. In contrast, the architectural structure (fig. 1.1 and plate 2) in Xia Yong's

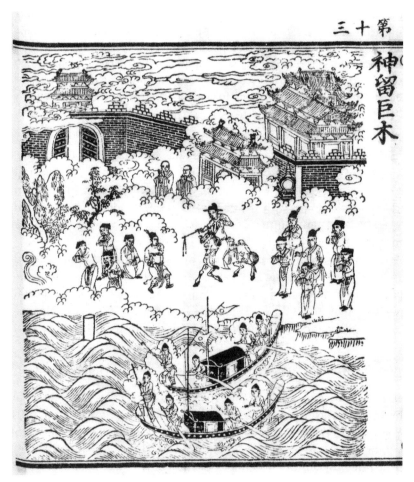

Figure 1.5: The miracle episode *Shenliu jumu*. Image from *Daming xuantian shangdi ruiying tulu*, the Hanfen lou version (Shanghai: Shangwu yinshuguan, 1924), collected by and courtesy of National Library of China.

works consists of three relatively independent units of different heights—a higher main structure, a lower subordinate building with a double-eaved nine-ridge roof, and an enclosed courtyard between them—tightly integrated by their shared platform. A two-storied building, with verandas on each story and a double-eaved hip-gable roof, is placed centrally in the main structure and flanked by a pair of projecting halls on each side. In detail, these two halls, composed of a column network and an outwardly facing hip-gable roof, are symmetrically attached to the overhanging eave (腰檐, *yaoyan*) of the central building. The axial arrangement of Xia Yong's building complex accentu-ates the main structure by making it higher than the surrounding ones and

achieves a more delicate balance than the L-shaped Yellow Crane Tower of the 1370s in the print.

The comparison between Xia Yong's images and the printed illustration makes us less positive about Xia's accurate representation of the Yellow Crane Tower built in the 1370s. If we insist on identifying Xia's subject as the Yellow Crane Tower, we have to investigate more contemporary representations of this tower. The best example is a late-Yuan mural (plate 3) produced by the followers of the professional artist Zhu Haogu 朱好古 on the east wall of Chunyang Hall 純陽殿 at the Yongle Daoist Monastery 永樂宮 in Shanxi. This mural painting is dated 1358, a time close to Xia Yong's creation of the Beijing *Yueyang Pavilion* in 1347 and before the reconstruction of the Yellow Crane Tower in the 1370s.[16] The survival of this valuable mural proves that late-Yuan artists showed interest in drawing this tower even though it might not be extant at that time. The question is whether the mural and Xia's image shared a common visual source. If so, we would be able to more confidently identify the subject of Xia's paintings as the Yellow Crane Tower.

Our further investigation, of course, should be based on the premise that the mural painting indeed depicts this specific tower. This work (plate 3) is a section of a series of 52 compositions that illustrate episodes in the Daoist immortal Lü Dongbin's 呂洞賓 (798–?) life. An inscription label, drawn on the right of this section, names the scene "Wuchang huomo" 武昌貨墨 (Selling Ink at Wuchang) and provides a short description of Lü's depicted miraculous feat:

> 帝君游武昌，詭為貨墨客。持墨二笏，僅寸餘，而價錢三千。連日不售，眾皆咲侮。有鼓刀王某曰：“墨小而價高，其有意邪？”自以錢三千求一笏。與客飲，醉。至夜，俄有叩門者，乃客以錢还，辭去。比曉視墨，乃紫金一笏，上有呂字。遍尋客，已不復見。

> The Sovereign Lord (Lü Dongbin) visited Wuchang and disguised himself as an ink seller. He held two blocks of ink, which were not much more than a *cun* long but were priced at three thousand pieces of cash each. For days, he could not sell them, and people all laughed at Lü. A certain butcher named Wang said: "The blocks of ink are so tiny, but have such a high price. Is there perhaps some special significance to them?" Thus, he paid three thousand pieces of cash to buy a block. Wang drank together with Lü and got drunk. Later that night, someone knocked at his door. It was Lü, who returned the money and left. In the morning, Wang looked at the ink and found it had become a block of gold, with the engraved character "Lü." Wang looked for Lü everywhere, but did not see him again.

This text, with slight modification, is also recorded in the popular Yuan hagiography *Chunyang dijun shenhua miaotong ji* 純陽帝君神化妙通紀 (Annals of the Wondrous Communications and Divine Transformations of the Sovereign Lord Chunyang).[17] The described legend happens in Wuchang, but the Yellow

Crane Tower is not mentioned. Nevertheless, researchers have never doubted that the main building depicted in this mural is the Yellow Crane Tower.[18] After all, in addition to the tower's role as the landmark of Wuchang, its tight association with Lü Dongbin had been solidly established in the Yuan period. According to the Yuan book *Lishi zhenxian tidao tongjian* 歷世真仙體道通鑑 (A Comprehensive Mirror on Successive Generations of Perfected Transcendents Who Embody the Dao), Lü ascended into heaven from the Yellow Crane Tower at noon on the twentieth day of the fifth lunar month (登黃鶴樓以五月二十日午刻昇天而去).[19] With the flourishing of the Quanzhen sect 全真教, Lü Dongbin became the most revered Daoist immortal in the Yuan period. In 1245, an imperial edict was issued to elevate Lü's status to *tianzun* 天尊 (the celestial worthy) and promote his previous residence in the town of Yongle from *guan* 觀 (abbey) to *gong* 宮 (Daoist palace/monastery).[20] Under imperial patronage, the construction of the Yongle Daoist Monastery lasted from the 1240s to the 1360s, reflecting the Yuan court's continued interest in this Daoist immortal. Lü's popularity significantly contributed to the high reputation of the Yellow Crane Tower, the site where Lü ascended into heaven.

There is a degree of resemblance between Xia Yong's building (fig. 1.1 and plate 2) and the Yellow Crane Tower depicted in the Yongle Monastery mural (plate 3), as their towers are both two-storied buildings, nearly square in plan, with a double-eaved roof and an overhanging eave around their waist. However, while Xia Yong's tower—linked with the courtyard and subordinate halls—is an inseparable part of an architectural ensemble, the Yellow Crane Tower in the mural is a relatively independent structure. The painter applies ample malachite green and yellow-orange to the tower image, making it stand out among nearby white-colored architectural structures. In the mural, the only structure adjacent to the tower is a rectangular exposed platform on its right side, used for observing scenery and connected by a narrow passageway to the tower's second story. Although the brown-colored balustrade around the platform and the tower combines the two parts into a *gong* 工-shaped plan, the grey-and-white color of the platform and its top surface distinguishes it from the richly colored tower. Besides, the appendage of a single platform leads to an asymmetrical arrangement and thus differs from the symmetrical structure in Xia's paintings. Apart from the distinct structural relationships of the tower in its building complex, these two tower images vary in some of their components. For example, the tower in the mural has a cross-shaped roof, formed by two hip-gable roofs with exquisite sculptural ornaments, but Xia Yong's tower has a simpler nine-ridge hip-gable roof.

Xia Yong's architectural images do not appear to share a common source with the Yellow Crane Tower depicted in the Yongle Monastery mural. Their difference might be ascribed to the issue of regionalism. Perhaps Xia Yong, a painter from Qiantang, recycled a Yellow Crane Tower composition popular

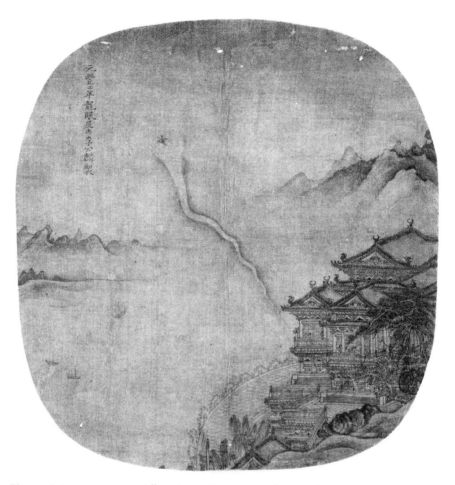

Figure 1.6: Anonymous. *Yellow Crane Tower*. Yuan dynasty (1271–1368). Album leaf, ink on silk, 25.4 cm × 24.5 cm. Guangdong Museum.

in the South and thus distinguished his images from that of the Yongle Daoist Monastery located in the North. In addition, Xia Yong's album paintings in silk and a mural painting made by artisans in a religious site have distinct purposes and audiences. In comparison with the Yongle Monastery mural, another contemporary *Yellow Crane Tower* painting (fig. 1.6) in album format in the Guangdong Museum more closely resembles Xia Yong's images.[21] Several features of Xia's composition are found in the Guangdong painting: the building complex is arranged at the bottom right, distant mountains rise out of the water, and a man rides a crane away. Nevertheless, the architectural portion in the Guangdong work shows another kind of Yuan representation of the Yellow Crane Tower. Two or three subordinate halls with hip-gable roofs

are integrated into the main one-story building behind, which has a double-eaved hip-gable roof. In addition, all the gables of these roofs face the viewers, and a circular foundation platform decorated with a serrated masonry parapet supports the complex of buildings.

Although the Yellow Crane Tower might not have survived into the Yuan period, the diversity of its extant images demonstrates the tower's enduring popularity. The circulation of these images was sustained by the tower's association with Lü Dongbin and the Yuan imperial patronage of Daoism. However, the various Yuan imaginings of the tower, or the absence of a canonical visual representation, leads to a potential problem: the more people admired the theme, the more easily they took pre-conceived ideas to treat other architectural images as the Yellow Crane Tower. In the case of Xia Yong's Group E paintings, we cannot depend on their architectural images to verify their theme as the *Yellow Crane Tower*—especially when they do not resemble any contemporary paintings of this theme and there existed no actual building for them to replicate.

Reception: Its place at the interface between texts and images

Until now, the only favorable evidence we had that could help identify Xia's paintings as the Yellow Crane Tower was their incorporation of the man-on-a-crane image. The questions are: How tightly is this image linked to the theme? Could this visual allusion trump the artist's own words that refer to the Yellow Pavilion? In the Yongle Daoist Monastery mural, there is no man-on-a-crane image. Hence, it is not necessary for such an image to appear in every *Yellow Crane Tower* representation. In this section, I hope to further demonstrate that when a viewer mentions a man-on-a-crane image, they do not necessarily perceive a *Yellow Crane Tower* painting.

In his *Zhexuan ji* 柘軒集 (Zhexuan Collection), the Yuan literatus Ling Yunhan left us a poem on one of Xia's paintings:

科分界畫見良工，詩意分明筆意同。
直下樓陰渾似霧，偶來花氣卻因風。
水晶簾動粼粼皺，雲母屏開曲曲通。
聞道主翁騎鶴去，不應猶落畫圖中。[22]

This work, classified as a ruled-line painting, shows excellent craftsmanship;
The intent behind its brushstrokes is as clear as the writer's poetic intent.
Tracing the shadow of the pavilion downward, it is just like mist;
Sometimes the fragrance of flowers is carried in on the breeze.
Crystal curtains sway in sparking pleats;
Mica screens open into winding passages.
I heard that the master has already ridden away on a crane,
So he must not still be inside the picture.

The last couplet alludes to Cui Hao's "Huanghe lou" poem: "That man of old has already ridden the yellow crane away, and here in this land there remains only Yellow Crane Tower. The yellow crane, once it has gone, will never come again . . . " (昔人已乘黃鶴去，此地空餘黃鶴樓。黃鶴一去不復返……)[23] Cui's poem emphasizes the absence of the immortal Fei Yi and the presence of the Yellow Crane Tower; this point has perhaps been accepted by Ling Yunhan, because Ling questions the inclusion of the absent master inside the picture. Although we cannot view the painting Ling saw, the link between these two poems easily makes us believe it should be a *Yellow Crane Tower* painting.[24] It is worth noting that Ling's mention of a man flying off on a crane's back and the appearance of this man inside the picture also remind us of Xia Yong's Group E paintings, which portray the man-on-a-crane detail. Does it imply that Xia's Group E paintings are the *Yellow Crane Tower*? These paintings indeed match Ling's other poetic description. They strike a balance between the grandiose tower on the right and the mist on the left, between the solidity and the void. They also elaborately depict curtains and screens, as mentioned in Ling's poem. However, Ling's general words are not solely limited to this group of paintings, but are instead applied to almost all of Xia's surviving paintings.

In fact, the title of Ling's poem is absolutely irrelevant to the subject of the Yellow Crane Tower. The title "Mingyuan Xiashi jiehua Gao Pian xiari shanju shiyi" 明遠夏氏界畫高駢夏日山居詩意 indicates that the subject of the *jiehua* work by Xia Yong to which Ling is referring was Gao Pian's 高駢 (822–887) poem "Dwelling in Mountains in a Summer's Day." The first couplet of Ling's poem also praises Xia Yong's work for its fusion of painting and poem. Gao Pian's related poem reads:

綠樹陰濃夏日長，樓臺倒影入池塘。
水精簾動微風起，滿架薔薇一院香。[25]

The green trees are in dense shade—a summer's day is long;
The tower and terrace—their reflections enter the pond.
Crystal curtains sway, as the gentle breeze arises;
With the rose arbor, the courtyard is full of fragrance.

Ling's poem clearly derives from Gao's and revises some couplets of the latter. For example, both poems use the image of "crystal curtains sway" (水晶簾動/水精簾動) and pay much attention to the "fragrance" (花氣/香) pervading the courtyard. Since Xia's painting was a response to Gao's poem, and Ling's poem responded in turn to Xia's work, our knowledge of Gao's poem provides us with more visual details of Xia's work, which Ling Yunhan saw. In Xia Yong's Group E paintings, the green trees in dense shade are easily observed, but the flowers, whose fragrance is mentioned in both poems, are difficult to recognize. By contrast, in Xia's Group C paintings (such as fig. 1.7), an arched gate, composed of climbing or trailing plants and standing

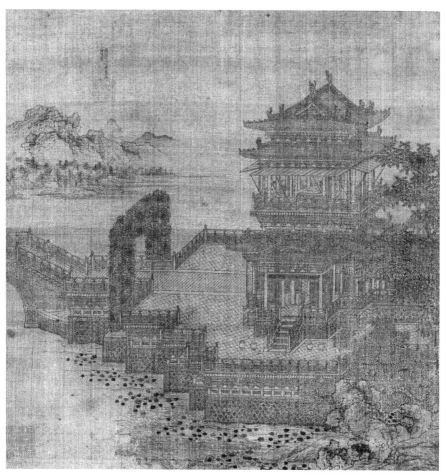

Figure 1.7: Xia Yong (active mid-fourteenth century). *Tower Reflected in the Lake.* Yuan dynasty (1271–1368). Album leaf, ink on silk, 26 cm × 25.4 cm. Harvard Art Museums/ Arthur M. Sackler Museum, Edward B. Bruce Collection of Chinese Paintings; gift of Galen L. Stone. Photograph copyright © President and Fellows of Harvard College, 1923.231.

between the courtyard and bridge, perfectly coincides with the "rose arbor" in Gao's poem. Moreover, Gao's poem particularly stresses the "reflections" of the tower and terrace which "enter the pond." Unlike all of Xia's other paintings, Xia's Group C paintings, the *Tower Reflected in the Lake*, include the distorted reflections of buildings that reflect the water flowing with the "gentle breeze," a feature perfectly matching Gao's poem. Therefore, it is more likely that Ling Yunhan's poem reflects a painting from Xia's Group C, instead of the Group E works. If so, both Xia's painting and Ling's poem simply reflect the pleasures of mountain life in the summer and have nothing to do with the

Yellow Crane Tower theme. The man-on-a-crane image does not appear in the Group C paintings either. However, why would a painting without a man-on-a-crane image remind Ling Yunhan of such a specific detail?

The reason is that the man-on-a-crane image is not exclusively confined to the ascent of Fei Yi or Lü Dongbin at the Yellow Crane Tower, although such an association occupies a dominant position in viewers' reception. In traditional China, the activity of riding a crane (駕鶴, *jia he*) generally alludes to one's pursuit of immortality.[26] The aforementioned poet Gao Pian, for instance, was famous for chasing the hope of eternal life. According to *Zizhi tongjian* 資治通鑑 (Comprehensive Mirror for Aid in Government), Gao carved a wooden crane in his Daoist courtyard and always wore a feathered jacket when straddling this crane (駢於道院庭中刻木鶴，時著羽服跨之).[27] Gao also conducted construction projects to build Daoist pavilions such as "Yingxian lou" 迎仙樓 (Tower for Receiving Immortals).[28] Since the architectural painting Ling Yunhan saw was based on Gao Pian's poem, the painting may well have represented Gao's residence; if so, the "master" (主翁, *zhu weng*, or residence's owner) mentioned in Ling's last couplet refers to Gao Pian. Due to Gao's extreme enthusiasm for immortality and his activity of riding a wooden crane, one may imagine Ling Yunhan writing ironically, "I heard that the master has already ridden away on a crane, so he must not still be inside the picture," (聞道主翁騎鶴去，不應猶落畫圖中) while the master is still depicted in the painting. In Xia's Group C paintings, a scholar-official (fig. 1.8)—perhaps representing Gao Pian, who did not achieve the eternal life he sought—lies on a couch and looks up to the sky in the second story of the tower. My conjecture, then, is that under this interpretation, the textual description of Ling Yunhan's poem perfectly fits the visual representation of Xia's paintings (fig. 1.7).

Ling Yunhan's example demonstrates that when a viewer encountered a man-on-a-crane image, they did not necessarily view it as a depiction of the Yellow Crane Tower subject. Similarly, when Xia Yong placed such an image in his Group E paintings, he did not necessarily intend to paint the *Yellow Crane Tower*.[29] Both the viewer's reception and the painter's intent associated with this image can be shaped by many factors, many of which may remain unknown to us.

I conclude, therefore, that the subject of the Group E paintings is the Yellow Pavilion, not the Yellow Crane Tower. First, Xia Yong was unlikely to have tried to represent the actual Yellow Crane Tower when this tower did not survive during his period. Second, Xia's works do not closely resemble any contemporary paintings of the Yellow Crane Tower and thus do not reflect any fashionable Yuan imaginings of this tower. Third, the man-on-a-crane image taken in isolation is not strong enough evidence to determine the painting's theme. The case for this being the Yellow Crane Tower is thereby undermined.

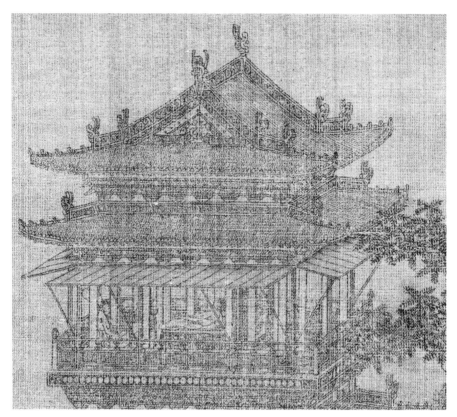

Figure 1.8: Master image from *Tower Reflected in the Lake* (fig. 1.7). Harvard Art Museums/Arthur M. Sackler Museum, Edward B. Bruce Collection of Chinese Paintings; gift of Galen L. Stone. Photograph copyright © President and Fellows of Harvard College, 1923.231 (Detail).

By contrast, Xia's inscription of Su Zhe's "Huanglou fu" directly identifies his painting as a depiction of the Yellow Pavilion.

Modularity in Xia Yong's Art

In the previous section, we resolved the dilemma concerning whether Xia Yong's Group E paintings are the *Yellow Crane Tower* or the *Yellow Pavilion*—or perhaps the dilemma never existed in the painter's mind. Yet, due to insufficient evidence of the Yuan Yellow Pavilion's actual appearance, we could not decide whether Xia's representations are true to life. Based on Lothar Ledderose's pioneering study of the use of modules in Chinese art, this section will compare different groups of Xia's paintings and attempt to demonstrate that Xia's *Yellow Pavilion* painting is also an assemblage of reusable

and prefabricated motifs, not an accurate record of a real building. In other words, the typical Yuan *jiehua*, such as those by Xia Yong, are entirely distinguished from all previous ones because of their unique modular system.[30]

Modular organization and prefabricated parts

Nearly all scholars who study Yuan *jiehua*, such as Chen Yunru and Jerome Silbergeld, have realized the similarities among Xia Yong's different groups of paintings.[31] In the case of Xia's *Yellow Pavilion* paintings, we must emphasize that they strongly resemble Xia's *Yueyang Pavilion* paintings. A comparison between the Yunnan version of the *Yellow Pavilion* (plate 2) and the Freer version of the *Yueyang Pavilion* (fig. 1.9) is enlightening here. Both paintings use the Southern Song diagonal compositional formula in which massive architectural buildings, erected on a high earthen platform and nestled among towering trees and rugged rocks, occupy a lower corner and are separated from the distant mountains by a large expanse of water. The diagonal arrangement is further strengthened by the introduction of the calligraphic inscription in the top corner. Clearly, the architectural image which appears at the bottom right corner of the *Yellow Pavilion* is transposed in the *Yueyang Pavilion* to the left, reflecting two mirror versions of a same composition. The variable nature of Xia's ready-made compositions suggests modular structures.

Moreover, Xia Yong's architectural images are also put together in various ways by interchangeable parts, which are certainly modules. The central tower of the *Yueyang Pavilion*, for instance, is a redeployment of the two-storied main building in the *Yellow Pavilion*. Both images—from their verandas around the three-bay-wide hall to their double-eaved hip-gable roofs—are the same movable part, rotated ninety degrees. In addition, their main structures are similarly surrounded by several one-storied buildings, two of which are visible to viewers in each painting. If considered as independent parts, these inferior buildings are nearly identical to each other. Each one consists of a hip-gable roof and verandas and stands on a high earthen platform. In some sense, the frequent recycling of a similar architectural component implies that Xia Yong relies on a limited repertoire of modular motifs. Meanwhile, however, the painter is able to creatively assemble these modules and thus form almost limitless combinations. In the cases of the *Yellow Pavilion* and the *Yueyang Pavilion*, the relations of their inferior buildings to their main structures are completely different. While all the gables of the roofs in the *Yellow Pavilion* are arranged toward the same horizontal direction, the sloping planes of the auxiliary halls' roofs in the *Yueyang Pavilion* separately turn toward the central tower. In addition, in the *Yellow Pavilion*, the left building is prefabricated as a projecting part combined into the main tower, and the front building is divided from the main structure by a courtyard; in contrast, it seems that the *Yueyang Pavilion*

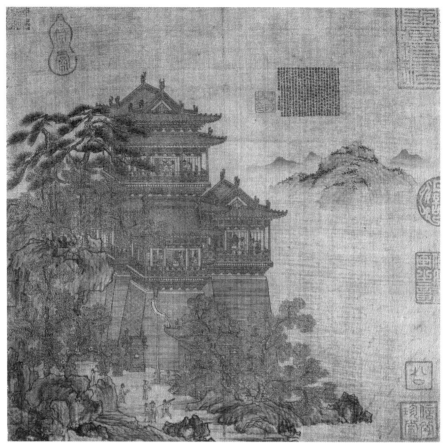

Figure 1.9: Xia Yong (active mid-fourteenth century). *Yueyang Pavilion.* Yuan dynasty (1271–1368). Album leaf, ink on silk, 26.7 cm × 26.2 cm. Freer Gallery of Art, Smithsonian Institution, Washington, D.C.: Gift of Charles Lang Freer, F1915.36i.

has a cruciform floor plan, within which the peripheral halls are located at similar distances from the central one and are connected by corridors. This treatment by Xia Yong of architectural elements as transferable parts that can be placed in varying combinations is what we mean by his *jiehua* painting being a modular technique.

 Note that this means that it is the painter, not the builder, who freely manipulates the modular system of the *jiehua*. Xia Yong consciously assembles preconceived modular images, rather than reproducing every detail of an actual building that consists of modules. Of course, Chinese architecture itself is an advanced modular system, just as Ledderose has pointed out.[32] Builders follow certain principles to combine standardized building modules like bracket sets and pillars, and thus build a structure. If a painter were to

accurately depict a real building, the result would still, in a sense, be a modular one. I emphasize, though, that the modularity that we see in Xia Yong's paintings is his, and not that of the original structure that forms his subject.

Xia Yong provides us with sufficient proof of this in that his renderings of a certain building are not always the same. For example, the Freer album leaf of the *Yueyang Pavilion* (fig. 1.10) is slightly different from the Beijing fan of the *Yueyang Pavilion* (fig. 1.11). In the Beijing fan, a pitched roof lies partially hidden behind the pine trunks on the left side. This suggests that a square hall with a hip-gable roof and a high foundation, similar to the right inferior building, is symmetrically inserted into the Yueyang ensemble. By contrast, on the left side of the Freer version, there is no pitched roof, but there is a long roof ridge which probably belongs to a concealed corridor connected to the main tower. In other words, there is no perfect symmetry of the architectural ensemble in the Freer version. If Xia Yong's *Yueyang Pavilion* paintings were intended to be true to life, one of these two versions must be painted incorrectly. In fact, I believe, there is no fault in either one. It is more likely that Xia Yong adapted the partially hidden roof in order to better fit this modular portion into its nearby environment. The grove in the Freer version is much denser and leaves less space for a pitched roof.

Xia Yong's treatments of the Prince Teng Pavilion theme are also excellent examples. All his *Prince Teng Pavilion* paintings resemble each other. Their wooden superstructures clone those of the *Yueyang Pavilion* paintings, although their compositions are laterally inverted—i.e., the former's right-hand portions are transposed to the latter's left. However, if we examine Xia's

Figure 1.10: A section from *Yueyang Pavilion* (fig. 1.9). Freer Gallery of Art, Smithsonian Institution, Washington, D.C.: Gift of Charles Lang Freer, F1915.36i (Detail).

Figure 1.11: A section from *Yueyang Pavilion* (fig. 0.4). The Palace Museum, Beijing.

Prince Teng Pavilion paintings, there is a noticeable difference between them. In the Shanghai and Boston (plate 4) versions, the hall positioned on the left side of the main tower has a flat roof without a raised ridge in its surface, but the hall in the same place of the Freer version (fig. 1.12) has an entirely different nine-ridged roof. This comparison demonstrates that Xia Yong is not accurately recording the actual Prince Teng Pavilion but is consciously blending available modular components. The rules about what kinds of prefabricated parts he can choose and where he can put them are not so rigid as we may expect. Although Xia's multiple versions of a single subject tend to share a consistent composition, he does not confine himself to a mechanical replication. Instead, Xia Yong shows creativity in the alteration of a few prefabricated parts in his well-established compositions.

Therefore, neither Xia's *Yueyang Pavilion* paintings nor his *Prince Teng Pavilion* paintings are true to life. They are pure modular structures assembled by the artist. Similarly, Xia Yong's *Yellow Pavilion* paintings are likely one of his modular productions. Now, all danger of equating Xia's *jiehua* with accurate depictions of architecture—a problem left over from the earlier section—is dissolved by Xia Yong's modular system. But another question emerges: where did Xia Yong get his repertoire of modular compositions and components?

Transmission of models

For modular compositions, it is suggested here that Xia Yong looked back to older paintings, supplemented them with his original creations, and, in turn, influenced the practices of subsequent *jiehua* painters. For example, an album leaf (fig. 1.13) produced by the Ming painter Qiu Ying is analogous in composition to Xia Yong's *Prince Teng Pavilion* paintings (such as plate 4 and fig. 1.12). At the bottom right, both artists place a magnificent building,

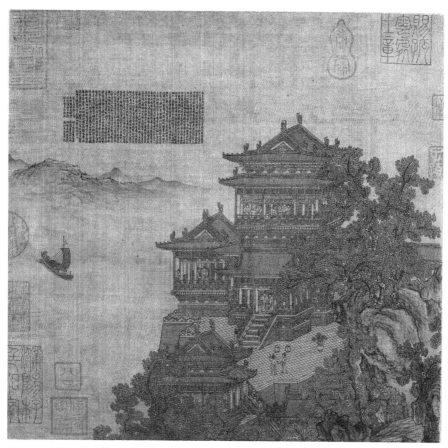

Figure 1.12: Xia Yong (active mid-fourteenth century). *Prince Teng Pavilion.* Yuan dynasty (1271–1368). Album leaf, ink on silk, 26.5 cm × 27.5 cm. Freer Gallery of Art, Smithsonian Institution, Washington, D.C.: Gift of Charles Lang Freer, F1915.36h.

surrounded by rocks and trees, facing distant mountains and a vast expanse of water where a tiny boat floats. In Qiu's and Xia's paintings, the images—a building, mountains, and a boat—become a group. At first glance, Qiu Ying's painting clearly follows one of Xia Yong's *Prince Teng Pavilion* paintings. We cannot deny Xia's role in transmitting this composition to later periods, but we must leave open a question: Did Xia originally create this composition? It is worth noting that Qiu's picture is included in an album titled *Lin Songren hua ce* 臨宋人畫冊 (Album of Replicas of Song Paintings), suggesting that Qiu's model was considered to be a Song painting rather than a Yuan work by Xia Yong. In this case, Xia Yong likely also borrowed a preexisting composition for his *Prince Teng Pavilion.* Whether it is true or not, this known model was widely circulated in the Yuan and Ming periods or even earlier in the Song dynasty.

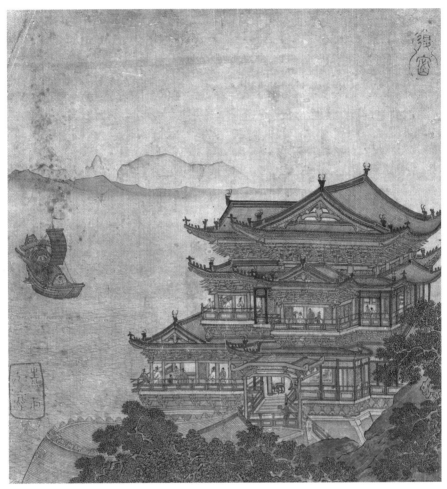

Figure 1.13: Qiu Ying (ca. 1494–ca. 1552). A leaf in *Album of Replicas of Song Paintings.* Ming dynasty (1368–1644). Album leaf, ink and color on silk, 27.2 cm × 25.5 cm. Shanghai Museum.

This means that a fixed composition in the modular system of *jiehua* can be continuously used for a long time.

Traditional Chinese art historians have long recognized the significance of old models. The Yuan-period catalogue *Tuhui baojian*, for example, records, "The preliminary sketches of the classical artists were called *fenben*; former people often treasured these, for their nonchalant and spontaneous character gave them a natural beauty." (古人畫稿，謂之粉本，前輩多寶畜之，蓋其草草 不經意處，有自然之妙。)[33] *Fenben* 粉本 here can be regarded as a kind of old model that people collected, memorized, and learned. Heping Liu identifies

fenben as "a cartoon for transfer," emphasizing its role in the transmission of iconography.[34]

When a great number of art critics' texts and painters' manuals were published during the Ming and Qing periods, the principle of looking at old models instead of nature had already become highly valued in the field of *jiehua*. In his *Huishi weiyan* 繪事微言 (Painting Matters in Subtle Words, ca. 1620), the Ming painter Tang Zhiqi 唐志契 (1579–1651) claims:

畫樓臺寺屋，須宗前人舊跡，今人不能畫樓閣中枅栱窗檻，而徒以青綠粧成，藉口泥金勾鈿等語，殊為謬甚……學畫樓閣，須先學《九成宮》《阿房宮》《滕王閣》《岳陽樓》等圖，方能漸近舊人款式，不然縱使精細壯麗，終是杜撰。[35]

To paint towers, terraces, temples, and dwellings, one must follow in the footsteps of the classics. Painters nowadays fail to draw the brackets and windows of towers and pavilions. They merely use blue and green pigments or inlays of gold and mother-of-pearl to cover up [the poor drawings]. This is ridiculous . . . When learning how to draw towers and pavilions, one should first learn from paintings such as *The Palace of Nine Perfections*, *The E'pang Palace*, *The Prince Teng Pavilion*, *The Yueyang Pavilion*, or others, in order to get close to the manners of the classical artists. Otherwise, even if the portrayals are meticulous and magnificent, they are just fabrications.[36]

In Tang's opinion, some contemporary *jiehua* are "just fabrications," not because they do not accurately replicate actual buildings, but because they do not follow "the manners of the classical artists." He provides some examples of old models, which include the *Prince Teng Pavilion* and the *Yueyang Pavilion*, both favorite themes for Xia Yong. It is reasonable for us to believe that Xia Yong's works had been regarded as admirable old models and had greatly influenced the way Ming artists drew *jiehua*. These old models were not necessarily used as stencils with pinholes—like those in Ledderrose's discussion of paintings depicting the ten kings of hell.[37] Instead of filling stencils' pinholes with ink to transfer images, it was more convenient for artists to directly imitate old models and follow conventional formulas.

The forms and conventional formulas to draw *jiehua*, summarized by Tang Zhiqi in detail, perfectly match Xia's *jiehua* works. Tang writes,

古人畫樓閣未有不寫花木相間樹石掩映者，蓋花木樹石有濃淡大小淺深正分出樓閣遠近。且有畫樓閣上半極其精詳，下半極其混沌，此正所謂遠近高下之說也。聰穎者當自得之，豈筆舌所能盡哉？[38]

When the classical artists portrayed towers and pavilions, they would intertwine the structures with flowers and woods or set them off with trees and rocks because flowers, woods, trees, and rocks show contrasts of the dense and the pale, the large and the small, the dark and the light—all of which serve to differentiate between near and far structures. Moreover, some architectural portrayals are refined and detailed over the upper half, then blurry at

the lower half. These are "the theories of distance and proximity, of the above and the below" (*yuanjin gaoxia*). The wise can certainly understand these. Are they to be fully explained with words or speech?[39]

If we examine Xia Yong's works, such as the *Prince Teng Pavilion* and the *Yueyang Pavilion*, we can find that while Xia places relatively empty courtyards and high platforms in the lower sphere, Xia's "architectural portrayals are refined and detailed over the upper half," conforming to Tang's description of the classical artists' *jiehua*. Xia Yong depends on consistently even, straight lines to create meticulous ornaments for his superstructures, from the complex openwork on the balustrade and geometric patterns on wall panels to extravagant roof decorations and layers of tiles, all giving viewers an impression of weightiness. Xia also arranges opulent furnishings inside the halls, such as vases, bamboo curtains, tables, and opaque screens. These objects provide context for figures' activities inside the building, making the interior space crowded and effectively blocking the viewer's gaze into the interior. In addition, trees and rocks are always incorporated into Xia's *jiehua*. They usually appear at the bottom corner of Xia's paintings, partially covering the architectural structure and thus strengthening the "blurry" effect at its "lower half."

Apart from Tang Zhiqi's text, the Qing-period *Zuisu zhai huajue* 醉蘇齋畫 訣 (Painting Formula of the Zuisu Studio, 1880) written by Dai Yiheng 戴以恒 (d. 1891) also summarizes such a practice—"one should not depict the lower part of the multistory structure; it is best to cover the part by trees and achieve a blurry effect" (畫樓不可畫下層，用樹遮隔最渾淪)—and Dai treats the strategy as a useful suggestion for *jiehua* artists.[40]

The great compatibility between Xia's images and these Ming-Qing texts demonstrates that Xia's works had become role models for subsequent *jiehua* painters. Xia's treatment of space and arrangement of elements, such as architecture, trees, and rocks, did not depend on his observation of actual scenes. Rather, it involved his artistic consideration, which would later help establish the *jiehua* formula. The circulation of old models like Xia's works and painters' manuals greatly contributed to the successful transmission of models in the field of *jiehua*.

This section mainly focuses on stereotyped compositions, whose existence unavoidably broadens the gap between architectural portrayals and real architecture. The case of prefabricated parts in *jiehua*, however, is much more complex. While painters relied heavily upon conventional ways of organizing their paintings, they had more freedom to bring social fashions and personal tastes into their portrayal of interchangeable architectural components. The following section will examine the extent to which Xia's images represent the real appearance of specific architectural components.

Standardized and simplified components

For a traditional Chinese building, its overhanging roof, together with its functional components and non-functional decorations, is the most distinguishable part that reflects changes in characteristics over time. Our discussion will concentrate on Xia Yong's depictions of two roof components, the ridge ornaments and the bracket sets that support the roof. I will compare them with related paintings created before Xia's period as well as extant Song-Yuan architectural objects, and explore which factors determined Xia's representation.

Roof ridge ornaments

The term *chiwei* 鴟尾 (owl's-tail-shaped ornament) characterizes the special decorations that are positioned at each end of a Chinese roof's main ridge. According to *Tang huiyao* 唐會要 (Institutional History of the Tang), such roof ridge ornaments can be traced back to the Han period (206 BCE–220 CE): "There was a fish in the Eastern Sea, whose tail looked like an owl's, and thus it got its name. The fish could cause the rain by spewing waves. The disaster [fire] happened to the Han-period Bailiang Hall. The Yue wizard proposed the use of objects for casting spells. Therefore, Jianzhang Hall was built and the owl-fish's image was placed on its roof ridge." (東海有魚，虬尾似鴟，因以為名。以噴浪則降雨。漢柏梁災，越巫上厭勝之法，乃大起建章宮，遂設鴟魚之像於屋脊。)[41] But there are also records such as *Beishi* 北史 (History of the Northern Dynasties) that claim "there had been no *chiwei* before the Jin period." (自晉以前，未有鴟尾。)[42] Indeed, after the Jin period (281–420), the early roof ridge ornaments were more clearly shaped as fish or owls' tails.

In the Tang period, the front end of the *chiwei*, however, was slowly transformed to an animal's open mouth, appearing to swallow the roof ridge.[43] After the Tang, such an ornament is sometimes called *chiwen* 鴟吻 (the owl's mouth).[44] Most extant roof ornaments from the Liao (907–1125) and Jin (1115–1234) dynasties in North China are shaped in this way. For example, the Front Gate 山門 of the Liao-period Dule Monastery 獨樂寺 in Ji county 薊縣, built in 984, has a pair of *chiwen* (fig. 1.14) with mouths open, fish tails bending up, and bodies covered by fish scales and dorsal fins. The Hall of Bhagavat Sutra Repository 薄伽教藏殿 and Daxiongbao Hall 大雄寶殿 (fig. 1.15) at Huayan Monastery 華嚴寺 in Datong retain great examples of the Liao-Jin glazed *chiwen*, which share similarities with the ones in Dule Monastery but contain forepaws that make them more similar to dragons. This hints at another innovation in the history of roof ridge decorations: namely, the change from a fish form to a dragon form.

The Jin-period ornaments on the main ridge of Amitabha Hall 彌陀殿 at Chongfu Monastery 崇福寺 in Shuo county 朔州, dated 1143, more closely

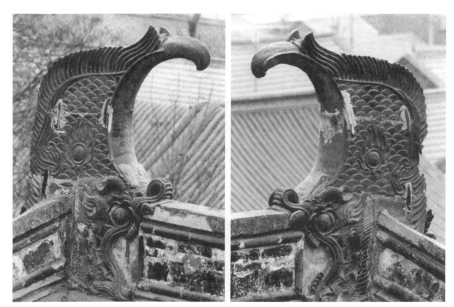

Figure 1.14: *Chiwen*, Front Gate, Dule Monastery (built in 984), Ji County, Tianjin, Liao dynasty (907–1125). Image from Yang Xin, *Jixian Dule si* (Beijing: Wenwu chubanshe, 2007), 382.

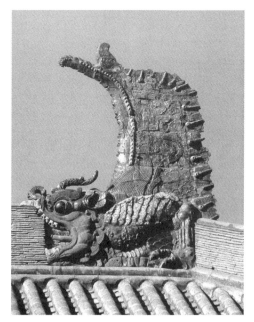

Figure 1.15: *Chiwen*, Daxiongbao Hall, Huayan Monastery, Datong, Shanxi, Jin dynasty (1115–1234). Image from Qi Ping et al., eds., *Datong huayansi* (Beijing: Wenwu chubanshe, 2008), 258.

Figure 1.16: *Longwen*, Sanqing Hall, Yongle Daoist Monastery, Ruicheng County, Shanxi, Yuan dynasty (1271–1368).

resemble dragons and are hence more suitably named *longwen* 龍吻 (the dragon's mouth). The fish bodies with scales are replaced by dragons' long and coiled tails. Two horns grow from their heads. Their forepaws extend, and their hind paws grasp the tips of their tails. The similar dragon-shaped design continued to be adopted by roof ridge ornaments during the Yuan period, such as those in Sanqing Hall 三清殿 (fig. 1.16) of Yongle Daoist Monastery.

Traditional *jiehua* masters could achieve believable likenesses in their representations of ridge ornaments. An excellent example is a fish-shaped ridge ornament image (plate 5) depicted on the wall of the south hall at the Yanshan Monastery 岩山寺 in Fanshi 繁峙 county, Shanxi. Wang Kui 王逵 (b. 1100), a Northern Song artist who served as a Jin court painter, completed extraordinary architectural murals together with his colleagues in 1167 for this hall.[45] This Jin-period *chiwen* image is shaped like a square with stiff right angles and is attached to a slender horizontal tail. It is also characterized by a band of dorsal fins added to its back and a head with an open mouth pointing toward the roof ridge. All these features make the image a convincing replica of Liao-Jin objects like the *chiwen* (fig. 1.14) on the Front Gate of Dule Monastery. Similarly, in the Yuan-period Yongle Daoist Monastery, there is a formal resemblance between the dragon-shaped ridge ornaments placed on

Figure 1.17: Zhu Haogu's followers. A section of *A Scene of Lü Dongbin's Miraculous Feat*. 1358. East wall, Chunyang Hall, Yongle Monastery, Ruicheng, Shanxi. Image from Xiao Jun, ed., *Yongle gong bihua* (Beijing: Wenwu chubanshe, 2008).

its Sanqing Hall (fig. 1.16) and those depicted on the east wall of its Chunyang Hall (fig. 1.17). Although they have different-colored glazes, this Yuan object and this Yuan image—from the twists of their dragon-shaped bodies to the turns of their paws—are made in the same shape. The image even accurately represents the small dragon head appended to the main dragon's belly, just like its contemporary object shows. Therefore, *jiehua* masters are definitely able to benefit from nature and make convincing representations of detailed architectural components.[46]

However, Xia Yong does not take the same approach as the Jin court painter Wang Kui or his contemporary *jiehua* practitioners in Yongle Daoist Monastery. Instead of imitating nature, Xia Yong's portrayals of roof ridge ornaments are more abstract and standardized. In his paintings (such as fig. 1.18), the ornaments on the ends of the main ridges (*zhengji* 正脊) are the same as those on the ends of the vertical ridges (*chuiji* 垂脊) and the angle ridges (*qiangji* 戗脊). All his ridge ornaments are depicted in an S or reversed-S shape, making them similar to a curled tail that extends to the ridge. There are also a pair of prominent eyes embedded in the top of the "tail" and two slender C-shaped horns which rise behind the eyes and extend forward. These two features make the entire ornament more like an animal's open mouth than a tail. In addition, this open mouth does not swallow the ridge, but faces the outside. In this sense, we can say that the ornament is formed by an abstract head of a beast without a body.

No surviving Yuan or earlier ornaments on main roof ridges resemble Xia's images. Compared with contemporary dragon-shaped ornaments on

Figure 1.18: A section from the *Prince Teng Pavilion* (plate 4). Museum of Fine Arts, Boston: Denman Waldo Ross Collection, 29.964 (Detail). Photograph copyright © 2022 Museum of Fine Arts, Boston.

main ridges, *chuishou* 垂獸 (animal-shaped ornaments on gable ridges or hip ridges) decorating the vertical ridges—such as those on the roof of Chongyang Hall 重陽殿 at Yongle Daoist Monastery—more closely fit Xia Yong's representation. These beasts' heads, dating from the Yuan period, also open their mouths, stick out their tongues, and have a pair of horns. The beast-head forms depicted on vertical or angle ridges in Jin-Yuan murals by Wang Kui (plate 5) and by Zhu Haogu's followers (fig. 1.17) also resemble Xia Yong's images of ornaments on the main ridges and other ridges. Xia Yong's practice of standardizing ornamental images on all roof ridges diminishes physical differences between distinct modular components, reflecting a tendency to mechanize the painting process.

Such a practice is not exclusive to Xia Yong. In many Southern Song Academic paintings, such as Li Song's *Yueye kanchao* 月夜看潮 ("Watching the Tide on a Moonlit Night") (fig. 1.19), ornaments appearing on any roof ridges also share the same form. These Southern Song images of beasts' heads place more stress on the pair of C-shaped horns, which nearly form a circle in their frontal representation. By contrast, Xia Yong's beast-head images have two more parallel horns and are thus slightly different from Southern Song forms. However, we can confirm that Xia Yong learned from the Southern tradition to standardize and simplify the repetitive *chiwen* depictions, although Xia was further advanced in terms of mechanization.[47] It is proposed here that architectural murals from the Yanshan Monastery and the Yongle Daoist Monastery, both located in Shanxi, adopt a more realistic approach than Xia's works and

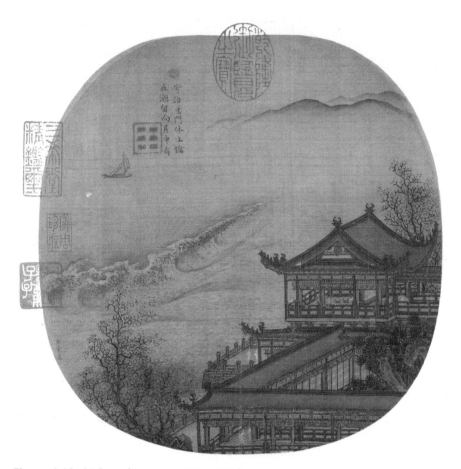

Figure 1.19: Li Song (active ca. 1190–1230). *Watching the Tide on a Moonlit Night.* Southern Song dynasty (1127–1279). Album leaf, ink and color on silk, 22.3 cm × 22 cm. National Palace Museum, Taipei.

perhaps reflect a kind of Northern tradition. In this sense, there existed a contrast between Southern and Northern traditions in the Yuan *jiehua* field.

Bracket sets

Dougong 斗栱 (bracket sets, called *puzuo* 鋪作 during the Song period), a component unique to Chinese architecture, has two seemingly contradictory features—namely, "its extremely complex appearance" and its "structural simplicity."[48] Nancy Shatzman Steinhardt explains the second feature in this way: "the bracket cluster in any Chinese building, from any time period, in fact can be broken down into fewer than five fundamental parts."[49] These

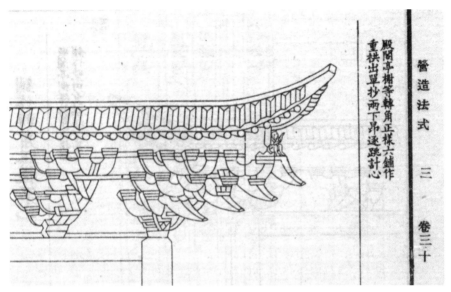

Figure 1.20: The front elevation of a six-tier cluster, from *Yingzao fashi*. Image from Li Jie, *Yingzao fashi*, *juan* 30 (Shanghai: shangwu yinshuguan, 1954), 3:200.

rather limited fundamental parts exist in several subtypes and can be assembled in various ways, thus forming sophisticated shapes. As modern scholars Chen Yunru and Liu Diyu 劉滌宇 have argued, while Northern Song painters struggled to clarify the complicated relationships between different parts of a bracket set, it is Yuan painters who completely released themselves from accurately rendering the detailed structure—they used abstract and repetitive patterns to depict one layer of bracket clusters all at once and thus fully developed a modular system.[50]

The Northern Song treatise *Yingzao fashi* includes elaborate illustrations of architectural constructions and components.[51] Since the manual aims at instructing carpenters and builders, these illustrations endeavor to correctly show how architectural components are fitted together with others. For instance, in a front elevation of a six-tier cluster (fig. 1.20), the illustrator pays equal attention to each component and uses short curves or lines to show their outer edges. Arms (*gong* 栱) and cantilevers (*ang* 昂) are depicted layer by layer, from the front to the behind. Every component is drawn at about a 45° angle, so the front components will not cover all others, and viewers can imagine the hidden parts by looking at their depicted counterparts. This strategy also helps achieve depth and a three-dimensional effect.

Northern Song *jiehua* perhaps hope to meet the strict building standards as well. For instance, the depicted six-tier clusters in the masterpiece *Ruihe tu*

Figure 1.21: A section from Song Huizong (1082–1135), *Auspicious Cranes*, Northern Song dynasty (960–1127). Scroll, ink and color on silk, 51 × 138.2 cm. Liaoning Provincial Museum.

瑞鶴圖 ("Auspicious Cranes") (fig. 1.21), attributed to the Emperor Huizong, closely resemble the illustration in *Yingzao fashi*. The painter carefully draws every component in a bracket set and describes in detail how one component is incorporated with another. A great number of short lines and curves are utilized just like the manual illustration, but unfortunately, those in *Auspicious Cranes* look overly cluttered, with multiple bracket sets overlapping and forming intricate grids, and the inner structure of each bracket set is also confusingly rendered. Compared with *Auspicious Cranes*, the handscroll *Going up the River on the Qingming Festival* (fig. 1.22) more properly handles the complex relationships between multiple bracket sets. When depicting the bracket sets that support the overhanging eave of the city gate, the painter leaves adequate space between the two neighboring sets. But he also treats each bracket set— not a layer of bracket sets—as a unit. When the painter needs to draw two long horizontal tie-beams (*sufang* 素枋) that run through the bracket sets, he does not draw continuous parallel lines, but instead paints the bracket sets first and then adds intermittent lines between them later. Hence, the depicted tie-beams are not very straight. In addition, the painter does not rely on auxiliary parallels to set the position of each cap-block (*ludou* 櫨斗) tenoned to a column, as well as that of each bracket-arm (*huagong* 華栱) perpendicular to the building plane, on the same horizontal level. Since these cap-blocks and bracket-arms are individually drawn, formed by short lines of different directions, their sizes and angles are always inconsistent.

Figure 1.22: The bracket sets from the image of the city gate from Zhang Zeduan, *Going up the River on the Qingming Festival*, Northern Song dynasty (960–1127). Handscroll, ink and light color on silk, 24.8 cm × 528 cm. The Palace Museum, Beijing.

Later *jiehua* masters made an effort to modify these Northern Song realistic representations and more or less sacrificed compositional clarity to standardize their renderings of bracket sets.[52] For instance, in a tower scene (plate 5) from the Yanshan Monastery, the five bracket clusters under the eave look like standard productions assembled by a set of solid blocks, because they are roughly outlined by parallels and short vertical lines and are fully colored, probably hinting at volume. Many neighboring blocks are alternately filled with white and green colors to distinguish between light and shadow on the wooden facets and to stimulate a three-dimensional feeling. Nevertheless, in this process, the artist must simplify his representation of the actual bracket-set structure. But its advantage is that no matter how simply and abstractly each bracket set is depicted, viewers will not confuse it with its neighbors.

Figure 1.23: A section from Anonymous, *Yang Guifei Mounting a Horse*, Southern Song dynasty (1127–1279), first half of the thirteenth century. Album leaf, ink and color on silk, 25 cm × 26.3 cm. Museum of Fine Arts, Boston: Chinese and Japanese Special Fund, 12.896 (Detail). Photograph copyright © 2022 Museum of Fine Arts, Boston.

The Southern Song Academic artists largely carried forward the work of the Northern Song and Jin contemporary artists. For instance, in the Boston copy of the *Yangfei shangma tu* 楊妃上馬圖 ("Yang Guifei Mounting a Horse") (fig. 1.23), the painter's first step in drawing a layer of bracket sets is to draw the tie beams that transversely link them up. The components added later, such as cantilevers, cannot cover the ink traces of these parallel lines. Obviously, the painter treats a layer of bracket sets, and not each individual one, as a whole. In other words, the painter does not care much about drawing each bracket set accurately. Instead, he consciously blurs the boundaries between bracket sets and greatly benefits from the drawing of parallels. Another feature is that the painter exaggeratedly represents cantilevers, the most unique part of a bracket set, to obtain a decorative effect. However, his cantilevers are arranged in a somewhat random and disorderly way and are not uniform in size. The oblique split-bamboo cantilevers (*pizhu ang* 批竹昂) are better arranged in Li Song's album leaf *Chao hui huan pei* 朝回環珮 ("Retiring from Court") (fig. 1.24).[53] This Southern Song court painter places clusters at regular intervals

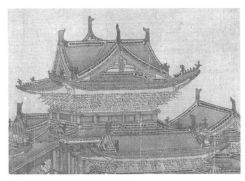

Figure 1.24: A section from Li Song (active. ca. 1190–1230), *Retiring from Court*, Southern Song dynasty (1127–1279). Album leaf, ink and color on silk, 24.5 × 25.2 cm. National Palace Museum, Taipei.

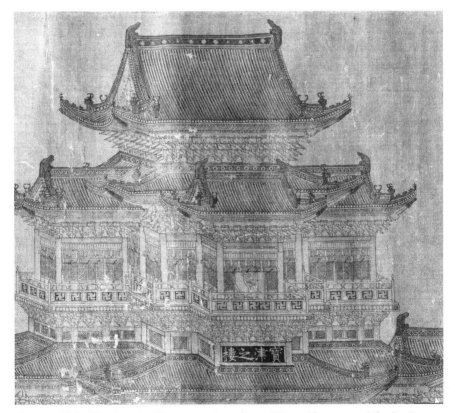

Figure 1.25: The Baojin Tower section from Wang Zhenpeng (after), *Dragon Boat Regatta on Jinming Lake*, Yuan dynasty (1271–1368). Handscroll, ink on silk, 33 cm × 247 cm. The Metropolitan Museum of Art: Bequest of Dorothy Graham Bennett, 1966 (66.174a) (Detail). Image copyright © The Metropolitan Museum of Art. Image source: Art Resource, NY.

on the frontal plane of the building. Meanwhile, Li Song declines to detail all other bracket-set components—except cantilevers—on the lateral plane; he deliberately stresses the parallel arrangement of cantilevers in the same direction.

The Southern Song emphasis on cantilevers and parallel lines is inherited by a series of Yuan paintings on the theme "Dragon Boat Regatta on Jinming Lake" in the style of Wang Zhenpeng. Chen Yunru has thoroughly analyzed the representation of bracket sets in these paintings.[54] In the New York version (fig. 1.25), four horizontal parallels, one intermittent horizontal line, and ten short vertical lines form a grid system across the continuum of bracket clusters under the roof eave of Baojin Tower (*baojin lou* 寶津樓). This linear grid specifies the positions and sizes of certain components in each bracket set. In detail, each vertical line strings a bracket set up. For every cluster, its uppermost bracket arm (*linggong* 令栱), with three end blocks (*sandou* 散斗) that carry longitudinal joists, is elongated and depicted between the two upper parallels. Two cantilevers jut out of each bracket set, and are both diagonally drawn within small squares, which are divided by horizontal and vertical parallels. The intermittent horizontal line, together with the vertical lines, forms ten crosses that become the framework for the V-shaped cap blocks (*ludou* 櫨斗). Almost invariably, the painter repeats his representation of the bracket sets and increases their numbers.

Xia Yong's works also take advantage of the grid system and further simplify the renderings of the orderly cantilevers in the Wang Zhenpeng-style *Dragon Boat Regatta* paintings. For example, in the roof of the main tower of the Boston *Prince Teng Pavilion* (fig. 1.18), apart from two cantilevers that protrude from the corner bracket set (*zhuanjiao puzuo* 轉角鋪作), all other cantilevers are confusingly drawn as two rows of diagonal stripes between three parallels. Based on these two bands of repetitive and continuous modular patterns, a viewer cannot distinguish one bracket set from another. Only by considering their V-shaped bases or cap blocks could they count the number of individual clusters. We can see that Xia Yong had already consummated the modular system for bracket sets, in which all components became ornamental motifs and were minutely standardized.

Therefore, there is a transition from the Northern Song bracket-set images, marked by structural clarity, to the Yuan's simplification and standardization. To some extent, this fact coincided with actual architectural changes, where the size of bracket sets gradually diminished and the number of intermediate clusters slowly increased, and thus their structural components became more closely packed together. These changes led to difficulties in *jiehua* masters' depictions of the cluster's structure and were perhaps able to expedite the development of a modular system. However, the progression of painting styles throughout time, as well as their close interactions, conclusively proves

that *jiehua* masters learned from predecessors, modified their strategies, and established a modular system par excellence. In other words, *jiehua* has its own system quite independent of architectural practice. The gap between the system of painting and that of architecture cannot be completely bridged.

Xia Yong's modular *jiehua* go beyond the imitation of real architecture, both in their organization and components. He renewed compositional modules, blended prefabricated parts from a restricted set of stencils, and accomplished a modular system of standardization and simplification. The result is that it is almost impossible to depend on Xia Yong's *jiehua* to reimagine the real architecture. Meanwhile, his paintings do provide us with clues to the historical development of the *jiehua* system during the Yuan period.

Utility and Artistry

Until now, we have concentrated on Xia Yong's *Yellow Pavilion* paintings to explore the interstices between his two-dimensional representation and three-dimensional architecture. It has been argued that Xia's *jiehua* is less an accurate reflection of real buildings than an art based on a modular system. However, the following question still haunts us and remains unsolved: what tempted viewers into the fallacious equation of Xia's paintings with accurate depictions of real architecture? As briefly mentioned, compared with paintings like the *Going up the River on the Qingming Festival*, Xia's purer *jiehua* possess the following three features: the dominance of architectural subjects, meticulous drawings of specific buildings, and the painter's inscriptions, all of which easily lead to this problem. Another two reasons, further proposed in this section, are (1) people's confusion of architectural design, cartography, and *jiehua*, and their belief in the former two categories' pursuit of accuracy, as well as (2) Xia's concern for artistic verisimilitude (particularly his manipulation of perspective).

Architectural design, cartography, and *jiehua*

The boundaries between Chinese architectural design, cartography, and *jiehua* are hard to define, largely because their subject matter all refers to architecture. Architectural design mainly includes architectural drawings, construction plans, and sketches of floor plans and elevations that can be used by craftsmen to execute a building task. Cartography also deals with the representation of spatial information, such as the location and scale of specific places or buildings. Regional maps in particular, like those found in the introductory sections of gazetteers that represent local tourist attractions, always include detailed renderings of key buildings. To a large extent, such maps are comparable with *jiehua* that depict famous buildings like the Yueyang Pavilion.

Architectural design, cartography, and *jiehua* not only share subjects, but also use similar graphic representational techniques and methods. The most significant one is the usage of a scaled grid system. In the field of architectural design, the collection of architectural drawings made by the Lei family of the Qing dynasty, known as Yangshi Lei 樣式雷 ("Lei Style"), provides us with a great number of site plans that depend on intersecting lines to locate places. For instance, drawings for the Qing mausoleums Dingdongling 定東陵 (fig. 1.26) are plotted on a grid with the aid of rulers.

The similar idea of using graticules existed almost from the inception of the literary history of Chinese cartography. The Six Principles of Cartography (*zhitu liuti* 製圖六體), proposed by Pei Xiu 裴秀 (223–271), have become the most fundamental standards for mapmaking and have laid the scientific foundation for this field.[55] In greater detail, the first principle is *fenlü* 分率 ("graduated divisions"), which determines scale and was interpreted by later literati scholars as the method of *ji li hua fang* 計里畫方 ("measure in terms of *li* and draw a network of squares"), which suggests square grids.[56] In practice, the Yuan-period cartographer Zhu Siben 朱思本 (1273–1337) is recorded as having applied *ji li hua fang* in his mapmaking process.[57] Extant historical maps also give us hints. The earliest known example is the Song-period *Yuji tu* 禹跡圖 ("Map of the Tracks of Yu") carved on steles in 1136 and in 1142.[58] In this map, mountains, rivers, prefectures, and counties are drawn on a grid background, where parallel lines intersect one another at perpendicular angles and the distance between different places is proportionally controlled. In printed maps of the Ming-Qing period, such a grid surface is more widely used.

In fact, this cartographic method of scaled grids is inextricably intertwined with the painting technique of *jiehua*. This point is strongly supported by the early Qing scholar Liu Xianting 劉獻廷 (1648–1695) as follows:

> 紫廷欲作四瀆入海圖。取中原之地。暨諸水道。北起登萊。南至蘇松。西極潼關為一圖。苦無從著手。余為之用朱墨本界畫法。以筆從橫為方格。每方百里。以府州縣按里至填之。府州定而水道出矣。[59]

> Zitin hoped to make a map entitled the *Four Rivers Flowing into the Sea*. He selected the Central Plain area and various waterways [as the subject]. He covered Denglai to the north, Susong to the south, and Tongguan to the west, in order to make a complete map, but it was hard for him to start drawing. For it, I adopted the *jiehua* technique used in books printed in red and black. I designated squares by drawing orthogonal lines. Each square included a hundred *li*. I filled prefectures, distracts, and counties in these squares, according to their distances. After locations of these prefectures and distracts were identified, [shapes of] waterways also appeared.

When Liu describes his mapmaking practice, he directly equates his cartographic method to the *jiehua* technique. Liu's practice of "designating squares"

Figure 1.26: Yangshi Lei, *Drawing for the Qing Mausoleums Dingdongling*. Nineteenth century. Collected by and courtesy of National Library of China.

implies that this method (or technique) refers to a grid system. The sentence "each square included a hundred *li*" reveals the concept of *fenlü* or a graduated scale. This basic concept in the history of Chinese cartography is also elucidated by other *jiehua*-related texts. When the Northern Song scholar Li Zhi 李廌 (1059–1109) praises Guo Zhongshu, one of the earliest *jiehua* masters, Li writes: "He used an infinitesimal unit to mark off an inch, a tenth of an inch to mark off a foot, a foot to mark off ten feet; increasing thus with every multiple, so that when he did a large building, everything was to scale and there were no small discrepancies." (以毫計寸，以分計尺，以寸計丈，增而倍之以作大字，皆中規度，曾無小差。)[60] This means that Guo's *jiehua* works achieve great accuracy in their use of graduated scale. These works could also function effectively as working drawings for architectural projects. Although there is hardly any extant example of *jiehua* drawn on a grid surface, today's scholars have discovered traces of traditional *jiehua* masters' reliance on the grid method. Wang Hui Chuan 王卉娟, for instance, divides the Yuan-period mural painting *Selling Ink at Wuchang* (plate 3) at the Yongle Daoist Monastery into a four-by-four grid of unit squares (fig. 1.27).[61] Wang thinks the spatial relationship of buildings in this painting matches the graphic composition revealed by her added grid system, although the mural painters did not directly paint the grids on the wall. After all, the boundaries or corners of some key architectural components are arranged along the graticules or exactly on their intersections, and the building components are to scale. It is believable that traditional *jiehua* painters might have had a scaled grid system in mind when they painted, regardless of whether they drew the lines.

Therefore, these three categories—architectural design (and its related site planning), cartography, and *jiehua*—have similar themes and representative techniques. Nevertheless, their purposes and audiences are different. Architectural designs instruct carpenters and builders on how to carry out a construction project, so these designs need to give the greatest amount of accurate information. Thus, they can easily be converted into actual buildings. This can explain why the front elevation of a bracket set in *Yingzao fashi* (fig. 1.20) illustrates in detail every tiny component and its relationships with neighboring ones. Similarly, Chinese maps also have utility value. Those maps sponsored by governments serve military or administrative purposes, while those made in religious sites and publications mainly target religious believers. In either case, these maps should offer sufficient information, such as the locations of landed properties, geophysical boundaries, and other architectural details in scale, and thus require accuracy during mapmaking. However, instead of unrealized buildings drawn in architectural designs, maps usually represent architecture that already exists. In this sense, *jiehua* is more closely related to maps than architectural designs. After all, except those imagined residences for immortals, most *jiehua* depict famous buildings existing in the

Figure 1.27: Drawing of *Selling Ink at Wuchang* (plate 3). Image by and courtesy of Wang Hui Chuan.

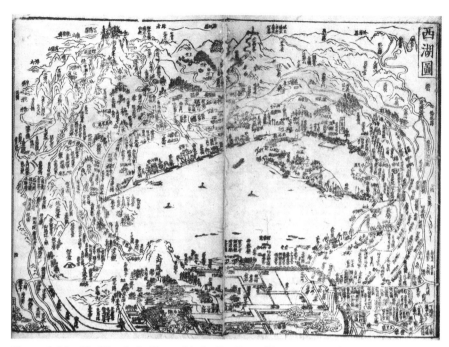

Figure 1.28: *The West Lake Map*, with the Pavilion of Prosperity and Happiness depicted on the southern bank of the Lake. Image from *Xianchun Lin'an zhi*, a Song block-print version collected by and courtesy of National Library of China.

history or the present, and hence are more difficult to be distinguished from maps. Unavoidably, it is very easy for us to believe that *jiehua*, like maps, also aim at accurate renderings of real architecture.

Despite maps' utility value, the accurate representation of architectural details is never an important consideration in Chinese cartography. To cover as much area in a map as possible, the mapmakers carefully filter what is to be included and what is to be excluded. Most topographical maps and gazetteer maps—such as the West Lake map (fig. 1.28) included in the Southern Song block-print gazetteer *Xianchun Lin'an zhi* 咸淳臨安志 (Gazetteer of Lin'an from the Xianchun Reign Period [1265–1274])—pay much attention to indicating the spatial relationships or relative locations of buildings. By contrast, meticulous representations of the outward appearances of these buildings are always disregarded. In the West Lake map, those landmark buildings are simplified and patterned as abstract symbols or geometric figures, and most minor buildings are not even drawn, but only marked by their name labels. We cannot identify these sites by viewing their visual images (if these images exist), but instead must depend on textual evidence. For example, while Xia Yong adds many extravagant architectural details in his *jiehua* works *Pavilion of Prosperity*

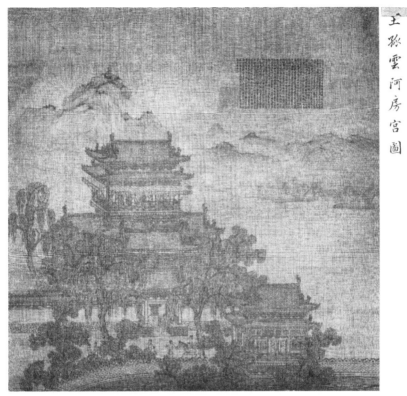

Figure 1.29: Xia Yong (active mid-fourteenth century). *Pavilion of Prosperity and Happiness.* Yuan dynasty (1271–1368). Album leaf, ink on silk, 25.8 cm × 25.8 cm. The Palace Museum, Beijing.

and Happiness (fig. 1.29), this same pavilion located on the shore in the West Lake map is such a rough sketch that it is unrecognizable without its inscription label Fengle lou 豐樂樓 ("Pavilion of Prosperity and Happiness"). Indeed, the accurate identification of buildings in maps relies more heavily on written information than drawing.

In addition, architectural images in maps are not only curtly depicted, but even able to provide fabricated information and thus mislead viewers about real architecture. An excellent example is the panoramic map of Buddhist pilgrimage sites depicted on the wall of Mogao Cave 61 near Dunhuang, Gansu. This map dates from the Five Dynasties and draws significant monasteries known to have existed in the early tenth century. However, these monasteries are not accurate representations. For instance, Foguang Monastery 佛光寺 (plate 6), located at the foot of Mount Wutai 五台山, is depicted as a generic whitewashed square enclosure that has four corner towers, a tower-shaped

entry gate and a two-storied white hall with a green-glazed roof. In 1937, the architect Liang Sicheng 梁思成 (1901–1972) relied on this visual clue to rediscover the East Hall of this monastery built in 857 in Mount Wutai.[62] The actual building (plate 7) is a high-ranking timber-frame hall, but is not whitewashed—it has red walls and a hipped roof with black tiles—and thus looks entirely different from the Mogao cave image. This suggests that the architectural forms featured on this wall map might be stereotyped representations rather than depictions of observable phenomena. It is also worth noting that the inscription labels such as the one reading *Da foguang zhi si* 大佛光之寺 ("The Great Foguang Monastery") (plate 6) offer audiences the most useful clues to architectural identification. As a bosom friend of maps, many *jiehua* are also heavily loaded with texts, like those rhapsodies written in Xia Yong's paintings, and such written information should be given priority in our interpretation of these works.

To sum up, the proper understanding of Chinese cartography's accuracy lies much less in its visual images than in its textual inscriptions, but people's consideration of maps' utility hinders them from realizing this point. Similarly, *jiehua*, a practice comparable to maps, is often mistakenly regarded as an accurate record of real architecture. Despite this, we have to admit that *jiehua* has been elevated as an art, which distinguishes it from architectural designs and maps. In other words, instead of utility, *jiehua* is more closely linked to artistry. But this does not mean that works of art have nothing to do with visual accuracy. On the contrary, Xia Yong and some other Yuan *jiehua* artists tried to achieve artistic verisimilitude in their works. Compared with architectural designers and mapmakers, these painters were more skilled in depicting three-dimensional objects on two-dimensional picture planes. The following section will concentrate on the development of perspective to show how Yuan *jiehua* masters made their images more natural to viewers' eyes.

Perspective

The Western concept of perspective, firmly rooted in Renaissance geometry, implies a single privileged point of view from which the painter looks at his subject and refers to various methods of representing three-dimensional objects on a flat surface. This concept does not fit well with Chinese painting but is still commonly used to examine Chinese painters' spatial treatment.[63] Jerome Silbergeld, for example, describes two general aspects of perspective in Chinese painting, namely "linear perspective, based on placement and proportions, and atmospheric perspective, which depends on adjustments in color (especially tonality) and clarity."[64] *Jiehua* artists' application of basic linear perspective principles, or their ability to paint what they see from one viewpoint, plays an important role in capturing a realistic image. Xia Yong

was one of the master hands. To achieve the effect of spatial recession, Xia painted distant mountains at a much smaller scale than buildings in the foreground and placed these mountains in the top part of his works to indicate they are farther away. In addition, in all of his extant paintings (such as plate 4), architectural structures are seen from above. The aerial view has twofold advantages: First, the painter can illustrate three sides of a building—its top, its front, and portions of its side face—which not only makes its external appearance more complete, but also provides access for viewers to peek into its internal space. By contrast, if the depicted architecture is seen from below, the wide roof eaves would partly cover the rooftop as well as those intricate ornament designs on its surface. Also, a viewer can only see figures leaning against balcony railings, not those inside upstairs rooms and those standing on level ground. Had Xia Yong's paintings been depicted from below, nearly all narrative elements, like the human activities of chatting in the courtyard or viewing artworks on the second floor, would have been totally lost. Second, an elevated viewpoint is more suitable for painters to represent complex architectural ensembles. In Xia Yong's modular system, the spatial relationships of buildings in an ensemble are perfectly reflected in their varying height levels and open spaces—the centered one is usually the highest; surrounding ones are lower, and sometimes mingled with flat courtyards—so fewer images are hidden from an elevated viewpoint. In a word, Xia Yong takes full advantage of this aerial view to balance the painting's composition.

A single point of view—often an elevated one—is achieved in other *jiehua* of the Yuan dynasty. For instance, when Xia's contemporary Li Rongjin (active mid-fourteenth century) creates *Hanyuan tu* 漢苑圖 ("The Han Palace") (plate 8), he consistently uses the aerial view and depicts large-scale architectural complexes with intricate designs and height variations. However, there is a slight difference between Xia Yong's use of the aerial view and Li Rongjin's. While Li's palaces and mountains are looked at from high above, Xia Yong's point of view is much lower—the eye level is just above the depicted roof ridge (or nearly as high as the ridge to make a frontal view). Because of this, Xia Yong cannot represent a scene as grand as Li Rongjin's hanging scroll, but he is able to create a more intimate atmosphere in his small-scale piece. This "more intimate point of view," in Silbergeld's words, already matured in Southern Song Academic painting.[65] A superb example provided by Li Song—namely, his *Watching the Tide on a Moonlit Night* (fig. 1.19)—has low, consistent ground planes. Also, the spatial relation between the nearby pavilions and distant mountains suggests that they are seen from above, although from a relatively low point. Apart from this lower viewpoint, Xia Yong was also skilled at dealing with atmospheric perspective, which was popular in Southern Song landscapes. For example, while Xia carefully depicts every tiny detail of buildings, trees, and figures in the foreground, his distant mountains are

sketchily drawn by massed washes, and trees on them are simply reduced to moss dots—we cannot see any detailed leaves or branches. We can say that Xia Yong's *jiehua*, involving both linear and atmospheric perspectives, are a direct outgrowth of the Southern Song traditions.

However, we must admit that Chinese *jiehua* masters' ability to establish a consistent point of view in their art took many centuries to develop. Before the Southern Song period, painters more frequently used multiple viewpoints than a single viewpoint. In their paintings, the location of the artist or viewer continuously shifts, suggesting a shift in time and making ground planes inconsistent. Art historians have introduced terms like "moving focus" and "changing viewpoint" to distinguish this phenomenon from Western linear perspective.[66] Furthermore, Chinese painters used different types of viewpoints to represent distance, and these viewpoints are closely linked to the Northern Song artist Guo Xi's 郭熙 (ca. 1000–ca. 1090) concept of *sanyuan* 三遠 (three types of distance)—i.e., *gaoyuan* 高遠 (high distance), *shenyuan* 深遠 (deep distance), and *pingyuan* 平遠 (level distance).[67] This unique system of perspective long dominated Chinese artists' spatial treatment, particularly in their monumental landscape paintings with architectural elements. For instance, many Tang-period mural paintings of architecture at the Mogao caves contain varying points of view. In the transformation tableau of the *Sutra of the Medicine Buddha* (dated to 776) on the east wall of Mogao Cave 148 (plate 9), *yaoshi* 藥師 (Bhaiṣajyaguru, or the Medicine Buddha or Buddha of Healing), attended by two bodhisattvas symbolizing sunlight and moonlight, sits with crossed legs on a lotus pedestal in the central platform that rises from the water. The perspective treatment of the Buddhist halls and pavilions around the pool is inconsistent. The main halls behind the Buddha and bodhisattvas are portrayed with upward-turning roofs, and rows of bracket sets are revealed under these roofs. This means that the expected viewer is looking up at them. From this perspective, the buildings appear more magnificent and impressive. The covered arcade connecting these main halls, however, is depicted with relatively intact rooftop planes, reflecting a frontal view. Moreover, there are two side halls with three bays that face the central platform. The artist carefully paints the upper surface of the halls' roofs and fills in green, suggesting a bird's-eye view. The edges of the platforms in the pool are drawn as oblique lines that vanish into one point in the upper center, which implies the aerial view as well. Such a treatment of perspective helps strengthen the depth of the pool and its platforms, while also accentuating the spatial inconsistency between the foreground and background. After all, there are multiple viewpoints in this single scene. Viewers cannot take in all the images at once through their naked eyes but need to peer down and crane up at the same time.

The varying viewpoints in the Mogao cave murals are more like "an artistic vision"—to borrow Silbergeld's words—than an exact replication of the

natural world.[68] After hundreds of years, Northern Song painters still followed this old convention from the Tang and Five Dynasties. Even the masterpiece *Qingluan xiaosi tu* 晴巒蕭寺圖 ("A Solitary Temple Amid Clearing Peaks"), traditionally attributed to the prestigious painter Li Cheng 李成 (919–1322), could not perfectly apply a consistent perspective. For the Buddhist temple (fig. 1.30), the painter makes its flying eaves and supporting rafters visible, suggesting the viewer is looking up from below. However, its neighboring mountains are shown from an elevated vantage, reflecting the painter's unsatisfactory combined use of perspectives.

Fortunately, a series of improvements gradually occurred during the Southern Song and Yuan periods. Although Li Rongjin's architectural landscape *Han Palace* (plate 8) partly inherits Li Cheng's style of rocks and trees and the Northern Song large-scale compositions, he ameliorates the inconsistency of Li Cheng's perspective treatment in a monumental landscape. In another way, Xia Yong's small-scale *jiehua* carries forward the intimate viewpoint that originated in the Southern Song Academy. After these Yuan artists finally attained the technical accomplishment of establishing a consistent

Figure 1.30: A section from Li Cheng (919–967), *A Solitary Temple Amid Clearing Peaks*, Northern Song dynasty (960–1127). Hanging scroll, ink and slight color on silk, 111.76 cm × 55.88 cm. The Nelson-Atkins Museum of Art, Kansas City, Missouri, U.S.A. Purchase: William Rockhill Nelson Trust, 47–71.

point of view, the tension between the artistic vision and the real vision in their art almost dissolved.[69] This can partly explain why Xia Yong's rendering of architecture looks so natural. And I must stress that this kind of verisimilitude derives from the painter's pursuit of artistry, not that of utility. After all, if Xia's *jiehua* aims to provide the greatest amount of visual information, it is better for him to depict all things seen from different viewpoints.

This chapter began with the dilemma concerning the theme of Xia Yong's Group E paintings, which involves a tension between visual representations and textual descriptions. More specifically, these paintings both preserve the man-on-a-crane images, related to the Yellow Crane Tower theme, and contain the painter's inscriptions of a rhapsody on the Yellow Pavilion. A comparison between Xia's architectural images and contemporary visual and textual materials of the actual Yellow Crane Tower proves the priority of the painter's account and the power of the viewers' reception. Our further investigation of Xia's Group E and other paintings discovers the arrangement of modular organizations, prefabricated motifs, and standardized components in these works. We can see that Xia's *jiehua* depend on a modular system related to model transmission and original creation, rather than the imitation of real architecture. Thus, it is almost impossible to depend on Xia's two-dimensional representation to reimagine the three-dimensional real architecture. As for the seductive equation of *jiehua* with architecture, several factors—such as the interconnection between *jiehua*, architectural design, and cartography, and the Yuan *jiehua*'s high level of artistic verisimilitude (for example, its technical accomplishment of a consistent viewpoint)—are influential.

2
Painting and Painter

The theme of the "Prince Teng Pavilion" was popular among *jiehua* masters of the Five Dynasties and Song periods. In traditional painting catalogues, there are considerable clues of these paintings' existence. For instance, it is recorded that the Northern Song Xuanhe imperial collection held one *Tengwang ge yanhui tu* 滕王閣宴會圖 ("Banquet at the Prince Teng Pavilion") and five copies of *Prince Teng Pavilion*—by the Former Shu artist Li Sheng—as well as four versions of *Tengwang ge Wang Bo huihao tu* 滕王閣王勃揮毫圖 ("Wang Bo Taking Up His Brush at the Prince Teng Pavilion") by the Song painter Guo Zhongshu.[1] It is not surprising that Xia Yong, the painter known for his *jiehua*, also favored this theme and left us three miniature paintings of this subject matter. They are perfectly representative of Xia Yong's "intaglio-like painting technique," all using barely modulated lines to depict similarly thin structures and extravagant architectural details. These paintings, as mentioned in the introductory chapter, share the same composition. Their most noticeable difference is the arrangement of human figures: in the Shanghai and Boston versions (plate 4), there are three scholars chatting in the courtyard, while there are only two in the Freer version (fig. 1.12).

Despite Xia's easily recognizable style and composition, two of these three *Prince Teng Pavilion* paintings have been traditionally attributed to Wang Zhenpeng. While a previous label slip mistakenly ascribed the Boston version to Wang, a faked Wang seal was deliberately added to the Freer copy. In fact, one-third of Xia's extant paintings were formerly treated by owners or viewers as Wang's works, suggesting an uncanny resemblance between these two painters' *jiehua*.[2] Perhaps due to this resemblance, modern scholars such as Robert J. Maeda and Yu Hui 余輝 often regard Wang Zhenpeng as Xia Yong's teacher—although to my knowledge, there is no documentary proof to support this claim.[3]

In order to clarify the complex relationship between Xia and Wang, it is necessary for us to compare their *jiehua* styles in detail. Here, a handscroll *Prince Teng Pavilion* (plate 10), held by the Princeton University Art Museum, provides us with an unparalleled example of Wang's style. This painting bears

the signature and creation date, "Wang Zhenpeng, the Recluse of the Lonely Clouds, inscribed and painted during the Mid-Autumn Festival of the first year of the Huangqing reign (1312)" (皇慶元年中秋孤雲處士王振鵬書畫). In addition, there are three seals—a gourd-shaped one that reads "Imperially Designated Sobriquet, Recluse of the Lonely Clouds" (賜號孤雲處士) and two squared ones that separately read "Wang Zhenpeng" (王振鵬) and "Pengmei" (朋梅)—all connecting this painting to the artist Wang Zhenpeng. This painting is rarely published and studied. In addition, while the sinologist Berthold Laufer (1874–1934) directly ascribes it to Wang, James Cahill queries its genuineness, and Cary Liu dates it to the late-Yuan or early Ming period.[4] However, all these scholars confirm its association with Wang, and there is no doubt that this painting exhibits Wang's style. In contrast to Xia's small-scale album leaves, this artist adopts Wang's preferred large-scale format of handscroll. This *Prince Teng Pavilion* also represents a much more complex architectural structure, and some of its architectural details are clearly distinguished from Xia's. For example, the corners of its buildings' roofs, decorated with mythical beasts marching along their ridges, are gently raised up; by contrast, Xia's roofs do not slope up but instead use more straight lines than curves to depict their corners. However, the left portion of the handscroll echoes that of Xia's *Prince Teng Pavilion*: a tiny boat floating in the water, layered distant mountains, and a block of Wang Bo's text "Tengwang ge xu" in minute calligraphy. All these elements of the handscroll make its comparison with Xia's paintings productive.

It is also worth examining another *Prince Teng Pavilion* (fig. 2.1), the one painted by the scholar-official Tang Di 唐棣 (1287–1355) and now housed in the Metropolitan Museum of Art. Even though Xia Yong's exact dates have not yet been established, he was active during the reign of the last Yuan Emperor Shundi and worked after the time of Wang Zhenpeng, whose reputation was more closely tied to Renzong's mid-Yuan court. The southern scholar Tang Di,

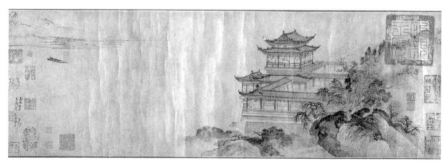

Figure 2.1: Tang Di (1287–1355). *Prince Teng Pavilion*. 1352. Handscroll, ink on paper, 27.5 cm × 84.5 cm. The Metropolitan Museum of Art: Bequest of John M. Crawford Jr., 1988 (1989. 363.36). Image copyright © The Metropolitan Museum of Art. Image source: Art Resource, NY.

however, came to the Yuan capital around 1310, was recommended to paint for Renzong, and almost continuously served as a Yuan official either in the capital or in Jiangnan from the time of Renzong to that of Shundi.[5] This means that Tang Di worked concurrently with Wang Zhenpeng for Renzong and was likely connected with Jiangnan painters like Xia Yong during his later years. It is worth noting that his painting in the Metropolitan Musuem, the *Prince Teng Pavilion*, is signed and dated to "the first decade of the eighth lunar month in the Renchen year of the Zhizheng reign (1352)" (至正壬辰八月上澣), which is close to Xia Yong's time. In our discussion, Tang Di's *Prince Teng Pavilion* promises to bridge the gap between Xia's copies and the Princeton version.

Therefore, this chapter will take these three versions of the *Prince Teng Pavilion*—one by the professional painter Xia Yong (his Boston version is taken as a representative, plate 4), one in the style of the court painter Wang Zhenpeng (plate 10), and one by the scholar-official Tang Di (fig. 2.1)—as clues to clarify Xia Yong's relations with other Yuan *jiehua* masters. Although Wang Zhenpeng did not serve as Xia's direct master, did Wang's style deeply influence Xia's *jiehua*? If so, in what aspect and to what extent? Does it mean that Xia should be considered in connection with the Yuan court like Wang Zhenpeng and Tang Di? If not, why? Before exploring these questions, it is necessary to analyze reliable documents and reconstruct the "real" Wang Zhenpeng—not the figure mythologized by numerous fakes—and then to evaluate the possibility of overlap between Xia's and Wang's life.[6]

Wang Zhenpeng and His Lineage

As the most celebrated *jiehua* master of the Yuan court, Wang Zhenpeng made his presence felt by contemporary official chronicles and literary writings. The late-Yuan art historian Xia Wenyan 夏文彥 provides a brief biography of Wang in his catalogue *Tuhui baojian* (1365):

王振鵬，字朋梅，永嘉人，官至漕運千戶。界畫極工緻，仁宗眷愛之，賜號孤雲處士。[7]

Wang Zhenpeng, with the courtesy name Pengmei, came from Yongjia. His highest official title is the Chief of "A Thousand Households" to Supervise Sea Transport of Tax Grains (*Caoyun qianhu*). His *jiehua* is very exquisite. The Emperor Renzong liked him and thus granted him the pseudonym "Recluse of the Lonely Clouds."

This entry provides some well-known facts about Wang's life, including his name, hometown, official position, specialization, and his close association with the Emperor Renzong. This record forms the basic image of Wang Zhenpeng in the history of Chinese painting and is frequently cited by later writers.

For our understanding of Wang's life, equally if not more important is an epitaph written by Yu Ji 虞集 (1272–1348), Wang's colleague at Renzong's court and a leading literary figure of the Yuan. According to this document, during the summer of the fourth year of Taiding 泰定 (1327), Wang Zhenpeng, with a grade-five official rank at that time, commissioned Yu Ji to write this epitaph for his father Wang You 王由.[8] Yu provides a great deal of data about Wang Zhenpeng's official career, activities, and art:

昔我仁宗皇帝，天下太平，文物大備。自其在東宮時，賢能材藝之士，固已盡在其左右。文章則有翰林學士清河元公復初，發揚蹈厲，藐視秦漢。書翰則有翰林承旨吳興趙公子昂，精審流麗，度越魏晉。前集賢侍讀學士左山商公德符，以世家高材游藝筆墨，偏妙山水，尤被眷遇。蓋上於繪事天縱神識，是以一時名藝，莫不見知。而永嘉王振鵬其一人也。振鵬之學，妙在界畫，運筆和墨，毫分縷析，左右高下，俯仰曲折，方圓平直，曲盡其體，而神氣飛動，不爲法拘。嘗爲《大明宮圖》以獻，世稱爲絕。延祐中得官，稍遷祕書監典簿，得一徧觀古圖書，其識更進，盖仁宗意也。累官數遷，遂佩金符，拜千戶，總海運於江陰、常熟之間焉。[9]

Previously, during the reign of our Emperor Renzong, the country was at peace and the arts flourished. Even as early as the time that the Emperor was heir-apparent, scholars of high character and great talents had already gathered around him. In literature there was the Hanlin Academician, Yuan Fuchu of Qinghe, whose compositions were evocative and forceful, surpassing even those of the Qin and Han periods. In calligraphy there was the chief of the Hanlin Academicians, Zhao Zi'ang of Wuxing, whose writings were of great precision and elegance, surpassing those of the Wei and Jin periods. In painting there was the former Reader-in-Attendance of the Jixian Academy, Shang Defu of Zuoshan, who, being a gifted member of a socially eminent family, enjoyed himself with the brush and ink, and won Imperial approval and favor particularly for his specialization, landscape. Indeed, since the Emperor was endowed by heaven with divine insight in painting, all the famous artists of the time were able to obtain his Imperial recognition, and among these Wang Zhenpeng of Yongjia was one of the most outstanding. The art of Wang Zhenpeng is especially distinguished in the category of *jiehua*. His use of the brush and ink in depicting the most minute architectural details—left and right, high and low, up and down, curve and angle, square and round, plane and straight—is accurate to the last detail, exhausting every representational possibility. But at the same time, the paintings are animated by an inner spirit which uplifts his art beyond the restrictions of rules. He once presented a picture of the Daming Palace to the throne which has been acclaimed in the world as the supreme masterpiece. He was given an official position in the period of Yanyou (1314–1320). He was shortly afterward transferred to the post of the Registrar of the Imperial Library where he was able to examine all the ancient paintings in its inventory. As a result, his knowledge in painting was greatly advanced. This was believed to be an intentional arrangement initiated by the Emperor Renzong himself. After a few more promotions, he became privileged to carry the "golden certificate" and was appointed Chief

of "A Thousand Households," supervising the sea transportation of tax grains between the cities of Jiangyin and Changshu.[10]

This epitaph serves as a useful supplement to Wang's biography in Xia Wenyan's catalogue. First, it outlines Wang's career trajectory in detail. The time when Wang Zhenpeng first received the imperial favor is pushed back to the period when Renzong was still the heir apparent. The epitaph also records that Wang Zhenpeng was first "given an official position in the period of Yanyou 延祐 (1314–1320)" and "shortly afterward transferred to the post of the Registrar of the Imperial Library." As stated in the Yuan-period *Mishu jian zhi* 秘書監志 (Annals of the Imperial Library), Wang Zhenpeng was assigned as the Registrar (*dianbu* 典簿), a secondary-seventh-grade sinecure, on the twenty-fifth day of the third lunar month of the first Yanyou year (1314).[11] This epitaph confirms Xia Wenyan's claim that Wang Zhenpeng finally became the Thousand-Household Chief to Supervise Sea Transport of Tax Grains (*caoyun qianhu* 漕運千戶) and provides more details about Wang's responsibilities in Jiangyin and Changshu. According to *Yuanshi* 元史 (The Yuan History), the Thousand-Household Chief to Supervise Sea Transport of Tax Grains in Jiangyin and Changshu is a grade-five post.[12] It should be noted that Yu's epitaph also points out Wang had already held a grade-five post in 1327. In other words, it took Wang no more than thirteen years to be promoted from a secondary-seventh-grade post in 1314 to a fifth-grade one in 1327. His main period of activity and career extended through the first decades of the fourteenth century, ranging from the reign of Renzong to those of Yingzong 英宗 (Shidebala, 1303–1323; r. 1320–1323) and Taidingdi 泰定帝 (Yesün Temür, 1293–1328; r. 1323–1328).

Second, the epitaph by Yu Ji hints at Wang Zhenpeng's date of birth. It mentions that Wang Zhenpeng's father died at the age of thirty-five in the twenty-fifth year of Zhiyuan 至元 (1288) and that Wang Zhenpeng had an elder brother. This means that Wang Zhenpeng's father was born in the year 1254. So, if he had his second son Wang Zhenpeng at around the age of twenty-five, one can infer that Wang Zhenpeng's date of birth was around 1280.[13] The epitaph also suggests that Wang Zhenpeng arrived in Beijing in 1327 to ask Yu Ji to write this text. It was exactly on the eve of the court intrigues and succession struggles that ran from 1328 to 1329.[14] I agree with Weidner's speculation that "Wang may have died before Wenzong 文宗 (Tugh Temür, 1304–1332; r. 1328–1332) ascended the throne" or "retired during the power struggles" at that time.[15] It is not only because "no mention has yet been found of Wang's activities after 1327"—as Weidner realizes—but also because a poem written by the fourteenth-century scholar Yu Kan 虞堪 clearly points out: "The Recluse of the Lonely Clouds rode on a whale and left; the Emperor Wen hoped to appoint him but could not urge him to stay." (孤雲處士騎鯨去，文皇欲官挽不住。)[16] The Emperor Wen means Wenzong, and Wang's act of riding on a

whale (*qi jing* 騎鯨) refers either to his death or to his pursuit of immortality or reclusion. At any rate, Wang Zhenpeng's period of activity did not extend to Wenzong's reign, which began in 1328.

In addition to the catalogue *Tuhui baojian* and the epitaph by Yu Ji, there is also fragmentary evidence of Wang Zhenpeng's activities remaining in his painting colophons. For instance, Wang inscribes two colophons on his *Weimo bu'er tu* 維摩不二圖 ("Vimalakirti and the Doctrine of Nonduality"), now held by the Metropolitan Museum, as follows:

> 至大元年二月初一日，拜住怯薛第二日，隆福宮花園山子上西荷葉殿內，臣王振鵬特奉仁宗皇帝潛邸聖旨，臨金馬雲卿畫《維摩不二圖》草本。
>
> 至大戊申二月，仁宗皇帝在春宮，出張子有平章所進故金馬雲卿繭紙畫《維摩不二圖》，俾臣振鵬臨於東絹，更敘說"不二"之因。[17]

> On the first day of the second lunar month in the first year of the Zhida reign (1308), also a second day of the *kešig* of Baizhu (1298–1323) in command, in Xiheye Hall on the hill in the garden at the Longfu Palace, I, the official Wang Zhenpeng, received an imperial decree from the Emperor Renzong, [who at that time lived] in the residence of the heir-apparent, to copy the draft of the Jin-period artist Ma Yunqing's *Vimalakirti and the Doctrine of Nonduality.*

> In the second lunar month of the *wushen* year of the Zhida reign (1308), [the future] Emperor Renzong was at the palace of the heir apparent. He showed me a painting on paper, *Vimalakirti and the Doctrine of Nonduality*, by Ma Yunqing of the Jin dynasty that had been presented to him by the Grand Councilor Zhang Ziyou. The humble subject Zhenpeng copied it on silk to describe again the cause of nonduality.[18]

These colophons provide 1308 as the date of the painting's execution, offering an example of Wang's art activities during the period when Renzong was the heir apparent.[19] Apart from Renzong, the Grand Princess Sengge Ragi was also partial towards Wang Zhenpeng's art. There are several surviving *Dragon Boat Regatta* handscrolls, which claim to be Wang Zhenpeng's works.[20] Although all their authenticity is questionable, four of them bear a similar inscription that fully describes the circumstances surrounding their execution.[21] The artist's inscription on the New York version can be taken as an example:

> 崇寧閒三月三日開放金明池，出錦標與萬民同樂，詳見《夢華錄》。至大庚戌欽遇仁廟青宮千春節嘗作此圖進呈……恭惟大長公主嘗覽此圖，閱一紀餘，今奉教再作，但目力減如曩昔，勉而為之，深懼不足呈獻。時至沼癸亥春莫廩給令王振朋百拜敬畫謹書。

> In the Chongning period [of the Northern Song dynasty, 1102–1106], the Golden Bright Pond used to be opened on the third day of the third month, and prizes were offered so that citizens could share its pleasure with the monarch. This is described in detail in the [*Dongjing*] *Menghua lu* (*Dreams of the Splendor of the Eastern Capital* by Mcng Yuanlao). In thc ycar *gengxu* of

the Zhida period (1310), these happened to be the "Festival of a Thousand Springs" (the royal birthday) of His Imperial Highness, the heir-apparent, the future emperor Renzong, when I did a painting depicting this subject for presentation [as a birthday gift] . . . I respectfully recall that on that occasion Her Imperial Highness, the Grand Elder Princess, had seen my painting. Now after a lapse of more than twelve years, I am instructed to make another version of the same composition. My eyesight, however, is not as good as before. Even though I have tried my best to comply, I am still deeply afraid that the painting is unworthy of presentation for her royal scrutiny. In the late spring of the year *guihai* of the Zhizhi (1323), Linjiling (Charge of the granary), Wang Zhenpeng, prostrating himself, respectfully painted and wrote this.[22]

The inscription indicates that Wang Zhenpeng painted at least two versions of the Dragon Boat Regatta subject, one for Renzong in 1310 and the other for Princess Sengge in 1323. The striking resemblance of the extant versions' inscriptions and designs strongly suggests the existence of an original painted by Wang Zhenpeng previously. Yuan Jue 袁桷 (1266–1327), a scholar in Princess Sengge's orbit, left us a record about Wang Zhenpeng's *Jingbiao tu* 錦標圖 ("The Championship"), which was displayed at the princess' elegant gathering in 1323 and might have served as the original model for today's Dragon Boat Regatta copies.[23]

Perhaps due to imperial recognition, Wang Zhenpeng also received considerable attention from the period's scholar-officials and literati, who wrote a great number of colophons and poems on Wang's lost paintings. Poems such as the one by Yuan Jue on Wang's *Linu* 狸奴 ("Cat") and the one by Feng Zizhen 馮子振 (1253–1348) on Wang's *Zimo jiaodi tu* 漬墨角抵圖 ("[Demon] Wrestlers in Puddled Ink") prove that Wang was skilled in a variety of painting categories.[24] However, Wang's specialty in *jiehua* has been demonstrated beyond controversy. For instance, Yu Ji wrote about Wang's *Daming Palace, Da'an ge tu* 大安閣圖 ("Da'an Pavilion"), and *Dong liangting tu* 東涼亭圖 ("East Pavilion"); Zhang Guangbi 張光弼 composed a poem about Wang's *Dadu chiguan tuyang* 大都池館圖樣 ("A Sketch of the Dadu Pond Lodge"); Zhang Gui 張珪, Deng Wenyuan 鄧文原 (1258–1328), Wu Quanjie 吳全節 (1269–1346), Feng Zizhen, and Li Yuandao 李源道 all mentioned Wang's *Jinming Pond*; and Ke Jiusi 柯九思 (1290–1343) also wrote a poem about Wang's picture of *jiehua* and landscape.[25]

Unfortunately, Wang Zhenpeng's authentic works that survive today are extremely rare, and not a single *jiehua*—including the Princeton version of the *Prince Teng Pavilion* to be discussed in this chapter—can be confidently attributed to his hand.[26] To my knowledge, only three or four figure paintings, such as the Beijing *Boya Plays the Zither*, the Boston *Yimu yufo tu* 姨母育佛圖

("Mahaprajapati Nursing the Infant Buddha"), and the New York *Vimalakirti and the Doctrine of Nonduality*, are relatively reliable.

In sum, all aforementioned historical documents and texts on paintings manifest Wang Zhenpeng's deep involvement with the imperial patronage networks of the mid-Yuan court, particularly with that of Renzong's period. Even after Wang gradually disappeared from the stage of art during Wenzong's reign, his pupils and followers continued to carry forward his *jiehua* style. In the history of Chinese painting, three Yuan *jiehua* artists—Li Rongjin, Wei Jiuding, and Zhu Yu (1292–1365, also known as Zhu Bao 朱珤)—are clearly identified as Wang's pupils. Xia Wenyan cursorily mentions Li and Wei in his *Tuhui baojian*:[27]

> 李容瑾，字公琰。畫界畫山水，師王孤雲。
> 衛九鼎，字明鉉，天台人。畫界畫，師王孤雲。[28]
>
> Li Rongjin, with the courtesy name Gongyan, painted *jiehua* and landscape and learned from Wang Guyun (Wang Zhenpeng).
> Wei Jiuding, with the courtesy name Mingxuan, came from Tiantai. He painted *jiehua* and learned from Wang Guyun (Wang Zhenpeng).

Compared with Li and Wei, Zhu Yu is better represented by historical documents. The most detailed one is Zhu's epitaph in the Ming-period *Qiangzhai ji* 強齋集 (Qiangzhai Collection):

> 徵士諱玉，字君璧，姓朱氏。先世自江西來吳，今為崑山人……永嘉王振鵬在仁宗朝以界畫稱旨，拜官榮顯，徵士從之遊，盡其技，王君亟稱許之。至順庚午中，奉中宮教金圖藏經佛像引首以進，方不盈矩，曲極其狀，而意度橫生，不束於繩墨。[29] 人言王君蓋不之過云。至正十有五年，清寧殿成，勑畫史圖其壁。吳興趙雍以徵士輩六人聞，使使召之家，道阻弗果上，徵士亦既老矣，偃蹇一室，以圖史自娛……廿有五年十一月七日卒，春秋七十有四。[30]
>
> The Recluse had the given name Yu, the courtesy name Junbi, and the family name Zhu. His ancestors came from Jiangxi to Wu, and now his family is from Kunshan . . . During Renzong's reign, Wang Zhenpeng of Yongjia created *jiehua* to the satisfaction of the emperor and earned glorious official ranks. The Recluse followed him and learned all his skills, and Wang highly praised the Recluse. In the *gengwu* year of the Zhishun period (1330), the Recluse accepted the commission of the Inner Court (Empress) to paint in gold the Buddha-image frontispieces of a sutra collection and presented the work. His angles did not go beyond that of a set-square, and his curves perfectly attained the form. Also, the figures' bearing was extraordinary, which made his art unconstrained by rules and measurements. People said that even Wang Zhenpeng might not surpass him. In the fifteenth year of the Zhizheng reign (1355), Qingning Hall was finally built, and artisans were commanded to depict its walls. Zhao Yong of Wuxing recommended six persons, including the Recluse Zhu, to the emperor. Officials were sent to their homes to recruit them. Because of the difficult trip, Zhu did not depart for it. Also, the

Recluse was already old, so he stayed in his room and entertained himself
with painting . . . He died on the seventh day of the eleventh lunar month
during the twenty-fifth year [of the Zhizheng reign] (1365), and at the age
of seventy-four.

According to this epitaph, Zhu Yu not only studied art under Wang Zhenpeng's
direct supervision, but also presented his work to the emperor—just like his
teacher—in search of official advancement. Unfortunately for him, Zhu did
not gain entrée into officialdom in 1330 during Wenzong's reign, and when
another opportunity came in 1355 during Shundi's reign, Zhu was too old to
grasp it.

Lin Yiqing 林一清, a native of Wang's hometown Yongjia, replaced Wang
Zhenpeng's position in the late-Yuan court. He was not one of Wang's pupils.
The Yuan official Xu Youren 許有壬 (1287–1364), who served the court from
Renzong's reign to Shundi's period, juxtaposes the *jiehua* achievements of Lin
Yiqing and Wang Zhenpeng:

> 我朝傑出者盖可歷數，十門諸品，各見於世，獨宮室臺閣名者罕聞焉。宣和秘藏所
> 見，不過唐尹繼昭，五代胡翼、衛賢，宋郭忠恕而已，則知此藝世殆未易精也。皇慶
> 間，王震朋者，名一時。今得永嘉林一清。予所知二人爾……昔以岐黃術業供侍文宗
> 青宮，出官監滄州稅，改台州監倉副使。[31]

The outstanding [painters] of our Dynasty can be enumerated. One can
see various specialists that cover ten painting categories in the world, but
rarely hears of painters known for their paintings of palaces and pavilions.
Those [related painters] one sees in the Xuanhe imperial collection are only
Yin Jizhao of the Tang, Hu Yi and Wei Xian of the Five Dynasties, and Guo
Zhongshu of the Song. Thus, one can know that it is not easy for people to
be proficient in this art. During the Huangqing period, Wang Zhenpeng was
famous for a while. Now there is Lin Yiqing from Yongjia. I know only these
two men [who are good at *jiehua*] . . . In the past, because of his medical skills,
[Lin Yiqing] served [the future] Wenzong in the residence of the heir-appar-
ent. He was appointed as a local official to supervise the tax of Cangzhou, and
now is transferred to hold the post of Granary Vice-Commissioner of Taizhou.

Although this text does not identify Lin as Wang's student, the fact that
they both came from Yongjia and that Wang had many opportunities to stay
there—particularly during his official career in Jiangnan and after his possible
retirement—proves a close connection between these two imperially recog-
nized *jiehua* masters.

Having discussed Wang's biography and his followers, we turn to investi-
gate the relationship between Wang Zhenpeng and Xia Yong. Unlike Wang's
officially recorded pupils—such as Li Rongjin, Wei Jiuding, and Zhu Yu—there
is no textual proof of Xia Yong's link to Wang's lineage. This also differs from
the case of *jiehua* artists like Lin Yiqing, because there is no obvious overlapping

of Xia's and Wang's spheres of activities in Jiangnan or at the court. Xia Yong did not come from Yongjia, and while Wang painted Yuan palaces such as the Da'an Pavilion and the Dadu Pond Lodge for his royal sponsors, Xia Yong's surviving works focus only on traditional Chinese palace structures and show no affinity for the Mongol Yuan. Therefore, the assertion that Xia was Wang's pupil cannot be supported at this point. Only by examining their painting styles can we better judge if Wang had a visible impact on Xia.

Baimiao: The Power of Ink and Line

If we compare Xia Yong's *Prince Teng Pavilion* painting (plate 4) with the one in Wang Zhenpeng's style (plate 10), the most striking similarity is their masterfully controlled and dazzlingly polished ink lines. Their meticulous architectural images, superbly rendered in bare monochrome and a fine-line manner, produce overwhelming visual effects on viewers and make them neglect any differences (e.g., painting formats), but bluntly affirm Xia's debt to Wang.

Despite this first impression of their art, we need to develop a fuller understanding of Wang's painting style before confirming that Xia was directly inspired by Wang. In fact, Wang Zhenpeng's art is not exclusively ink monochrome. For example, although the *Vimalakirti and the Doctrine of Nonduality*, one of Wang's few reliably attributed works, is indeed executed in a highly disciplined ink-monochrome outline manner, the artist also provides important evidence in his inscriptions on the painting. He says: "[I] received an imperial decree from the Emperor Renzong . . . to copy the draft of the Jin-period artist Ma Yunqing's *Vimalakirti and the Doctrine of Nonduality*" (特奉仁宗皇帝⋯⋯ 聖旨，臨金馬雲卿畫《維摩不二圖》草本。) and "at that time, I was instructed to make a copy and decorate it with color. After I completed it, I summarized the story and presented it [to the throne]. Hence, I obtained the draft and treasure it. In my spare time I unroll it to entertain myself." (振鵬當時奉命臨摹， 更為修飾潤色之。圖成，并述其槩略，進呈，因得摹本珍藏，暇日展翫以自娛也。)[32] According to Wang's words, the ink-outlined painting we see today is only a preliminary sketch based on Ma's draft (also in monochrome ink, maybe the one now in Beijing) and was created in preparation for a fully colored version for the Emperor. In this regard, the extant *Vimalakirti* painting's lack of color perhaps results from its "unfinishedness" rather than from the artist's preference for an ink-outline style. A Northern Song precedent for this practice is found in the monumental scroll *Chao Yuan xianzhang tu* 朝元仙仗 圖 ("Procession of Taoist Immortals Paying Homage to the King of Heaven"), which depicts clearly outlined religious figures in ink monochrome but only functions as a reduced-size draft for a Daoist Monastery mural project.

Now, let us turn to Wang Zhenpeng's *Dragon Boat Regatta* (such as fig. 2.2), the *jiehua* subject for which he was renowned. There are a considerable

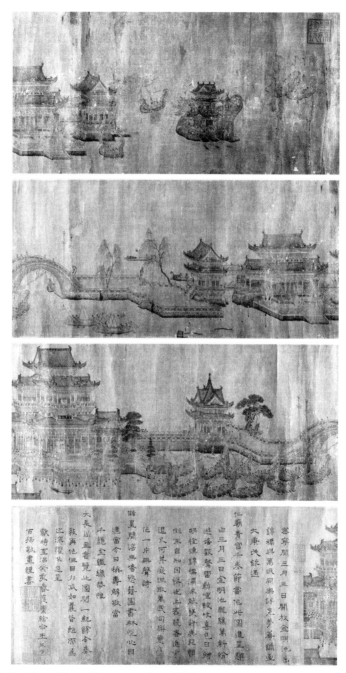

Figure 2.2: After Wang Zhenpeng (ca. 1275–ca. 1330), *Dragon Boat Regatta on Jinming Lake*, Yuan dynasty (1271–1368). Handscroll, ink on silk, 33 cm × 247 cm. The Metropolitan Museum of Art: Bequest of Dorothy Graham Bennett, 1966 (66.174a). Image copyright © The Metropolitan Museum of Art. Image source: Art Resource, NY.

number of related copies, which render architectural structures by a multitude of ink lines over a blank ground and make the fine-line manner a hallmark of Wang's *jiehua*. Scholars have noticed a marked resemblance between these later copies in the format of handscroll, and Chen Yunru has persuasively explained the phenomenon by interpreting them as products of professional workshops.[33] If considered in conjunction with the case of Wang's *Vimalakirti*, one must admit that Wang would likely have prepared a draft for his imperi-ally commissioned *Dragon Boat Regatta*. This draft could be preserved in the Yuan court as a *fenben* or a model for later imitation and transmission. This practice had not been rare in past dynasties—just as the Yuan catalogue *Tuhui baojian* points out, "many *fenben*, collected in the [Song] court of Xuanhe (1119–1125) and Shaoxing (1131–1162), are extraordinarily wonderful." (宣和紹興所藏粉本，多有神妙者。)[34] Thus, the questions are: Is it possible that subsequent workshop copyists only saw and followed Wang's *fenben*, probably an unfinished monochrome drawing? Could Wang's original, finished version be colorful?

In fact, although the majority of Wang's *Dragon Boat Regatta* copies are handscrolls in ink, two related works—a fan version of *A Grand Dragon Boat* (plate 11) in Boston and a pair of Taipei album leaves *Dragon Boat* (plate 1) and *Retiring from Court* (fig. 2.3), both with Li Song's signature—are excep-tions. The Boston fan bears the Yuan Emperor Wenzong's seal "Tianli zhi bao" 天曆之寶 (Treasure of Tianli), demonstrating that it was once included in

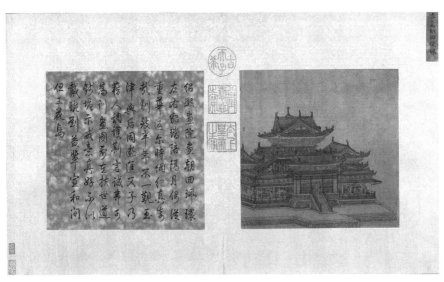

Figure 2.3: Li Song (active ca. 1190–1230). *Retiring from Court.* Southern Song dynasty (1127–1279). Album leaf, ink and color on silk, 24.5 cm × 25.2 cm. National Palace Museum, Taipei.

the mid-Yuan imperial collection. Indeed, the image, originally embellished with gold outlines and filled with rich colors (now much faded), perfectly responded to the Emperor Wenzong's taste for extravagance and luxury. An early fourteenth-century date is also confirmed by the painting's style. In addition, the boat's shape matches the one appearing in the beginning of most *Dragon Boat Regatta* handscrolls. All these reasons might lead to the traditional attribution of this fan to Wang Zhenpeng.[35] The *Dragon Boat* in Taipei is also brightly colored and appears to be very similar to the Boston one. The colored painting *Retiring from Court,* from the same Taipei album, depicts a palace scene that resembles such architectural structures as Baojin Tower in those Wang-style handscrolls of *Dragon Boat Regatta.* The juxtaposition of these two Taipei leaves in the Qing scholar Wu Qizhen's 吳其貞 related description suggests that they could be treated as a pair.[36] Furthermore, as James Cahill has observed, these two Taipei leaves "have vertical cracks which indicate that they were once parts of handscrolls" and Li Song's signatures on them, and "therefore, must be interpolations."[37] In other words, these two Taipei leaves perhaps came from the same handscroll—a colorful one sharing the same composition with other *Dragon Boat Regatta* handscrolls in Wang's style. Hence, the existence of the Boston fan and Taipei leaves provides another possibility for us to understand Wang's original *Dragon Boat Regatta* representation, which may have been originally designed in color. Our examination of Wang's *Vimalakirti* and *Dragon Boat Regatta* implies that Wang's art does not solely rely on the use of ink lines and that he was also good at colored paintings.

However, we should never doubt Wang's role as a precursor of the characteristic Yuan *jiehua* tradition, which is dominated by the *baimiao* 白描 (plain drawing) style and surpasses all previous *jiehua* in its exquisiteness.[38] Today, most works considered representative of Wang's style place particular emphasis on uncolored fine lines, further strengthening his association with this *baimiao jiehua* tradition. For example, while copyists consciously produced *Dragon Boat Regatta* handscrolls in ink monochrome and added Wang's inscriptions to counterfeit his original, the colorful ones in Taipei and Boston do not directly claim to be from Wang Zhenpeng's hands.[39] Obviously, these ink monochrome handscrolls are more commonly accepted as a reflection of Wang's unique style.

Wang Zhenpeng more clearly expresses his obsession with ink and line through his extant figural paintings—such as the *Boya Plays the Zither* (fig. 2.4) and the *Mahaprajapati Nursing the Infant Buddha* (fig. 2.5). These precisely delineated paintings also reveal the important source of Wang's *baimiao* style. When Wang draws figures' flowing robes, he often controls the brush carefully, holds it vertical to the painting surface, and creates long, fluctuating lines like scudding clouds or running water. When Wang represents folds of soft draperies—like those of Mahaprajapati's garment—he adopts elastic, smooth

Figure 2.4: Wang Zhenpeng (ca. 1280–ca. 1329). *Boya Plays the Zither*. Yuan dynasty (1271–1368). Handscroll, ink on silk, 31.4 cm × 92 cm. The Palace Museum, Beijing.

Figure 2.5: Wang Zhenpeng (ca. 1280–ca. 1329). *Mahaprajapati Nursing the Infant Buddha*. Yuan dynasty (1271–1368), early fourteenth century. Handscroll, ink on silk, 31.9 cm × 93.8 cm. Museum of Fine Arts, Boston: Chinese and Japanese Special Fund, 12.902. Photograph copyright © 2022 Museum of Fine Arts, Boston.

curves. But for crisp angles of stiff fabrics—such as Boya's rolled-up cuff— Wang prefers relatively hard lines, which can make his strokes full of strength and vigor. In a word, Wang's variety of drapery-drawing techniques combine shapes of roundness and squareness, as well as textures of softness and hardness, and reflect abstract rhythms and calligraphic qualities. His consummate treatment of ink lines is apparently an echo of the classic "plain-drawing" method of Li Gonglin 李公麟 (1049–1106), an artist whose style inspired painters of the Liao, Jin, and Yuan periods. In this regard, it is not a surprise that the Ming scholar Xing Tong 邢侗 (1551–1612) mistakenly attributed Wang's *Mahaprajapati* painting to Li Gonglin. It is worth noting that Li Gonglin was an originator of the Northern Song literati painting tradition and his style was thought to embody *guyi* 古意 (antique ideas), a feature greatly admired by contemporary literati. Wang Zhenpeng's place in Li's lineage has unavoidably earned him much respect in Yuan and later literati circles.

Wang Zhenpeng's preference for highly disciplined monochrome outline manner exhibits a literati taste, and this feature had been inherited and

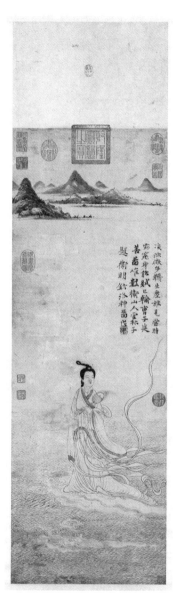

Figure 2.6: Wei Jiuding (fourteenth century). *Nymph of the Luo River*. Yuan dynasty (1271–1368). Hanging scroll, ink on paper, 90.8 cm × 31.8 cm. National Palace Museum, Taipei.

further advanced by his pupil Wei Jiuding. In the *Luoshen tu* 洛神圖 ("Nymph of the Luo River") (fig. 2.6), Wei adopts the finest brush, vertical and pointed, and slowly brings it down to the paper. He creates long, smooth, sinuous lines—just like dropped lute strings or spiders' loose strands—and thus perfectly outlines the nymph's wide sleeves and flying ribbons. Also, some of his lines have modulated widths, which make them look like orchid leaves. Wei shows complete mastery in his handling of ink lines and, alongside his teacher Wang Zhenpeng, transmitted the literati's *baimiao* figure-drawing tradition.

There is a new feature reflected in Wei Jiuding's *Nymph of the Luo River* but not shown in Wang's extant paintings—namely, the use of paper as the medium. From the Five Dynasties to the Yuan period, literati painters' preference for paper instead of silk had continued to grow. After all, papermaking techniques improved, and people realized that paper had better quality and absorbency for calligraphy practices. When painting was increasingly linked with calligraphy in the literati tradition, paper also replaced silk to become the preferred ground for painting. Among the famous painting collections of the Beijing and Taipei palace museums, only 11 percent of the Tang and Five Dynasties are on paper, but the number rapidly increases to be 48 percent for the Yuan period.[40] Like literati painters of landscape and figures, *jiehua* painters also followed this contemporary trend. The *Jiangtian louge* 江天樓閣 ("Terraced Building Overlooking the Water") (fig. 2.7), postdating Wang Zhenpeng's main period but reflecting his disciplined fine-line brushwork, also makes full use of ink on the bare paper ground, and thus achieves a balance between *jiehua*'s craftsmanship and the literati's aesthetics.

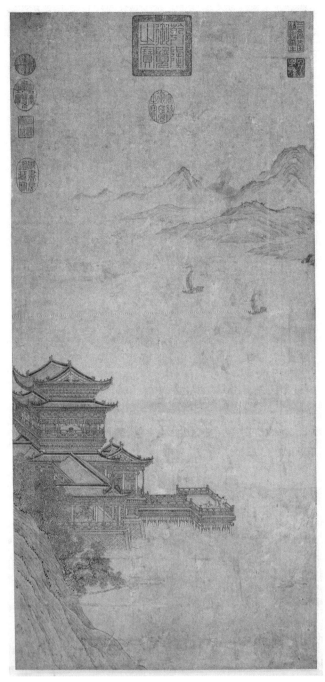

Figure 2.7: Anonymous. *Terraced Building Overlooking the Water*. Yuan dynasty (1271–1368). Hanging scroll, ink on paper, 83.7 cm × 40 cm. National Palace Museum, Taipei.

Compared with this *Terraced Building*, Tang Di's *Prince Teng Pavilion* (fig. 2.1), mentioned at the beginning of this chapter, is a more literati-oriented *jiehua* of the Yuan. It not only benefits from the paper medium, but also shows more calligraphic features in its ink lines. Tang Di's lines are less intricate but much simpler and rougher, and also involve the stark contrast of ink density and tonality. The outlines of the main pavilion's ridges and eaves, as well as those of the roofed corridor depicted in the front, are drawn by much darker ink than those corridors behind the pavilion. Buildings in the rearward, depicted by light ink, look like they are fading into the paper. In this way, Tang Di differentiates between important architectural components and those that are less important, between those located near and those located farther away. All of this imparts solidity and depth to the paper's flat surface. Through rich blackness and varied tones, Tang Di's monochrome *jiehua* fully exploits the potential of ink, in a way similar to calligraphers and literati landscape painters' use of this extraordinarily versatile pigment.

Even though Wang Zhenpeng's work differs from Tang Di's *Prince Teng Pavilion* in its use of fine lines to depict microscopic architectural details, Wang's ink lines do share Tang Di's tonal variations and shading effects. For example, in his *Boya Plays the Zither* (fig. 2.4), Boya's slender fingers and wrinkles on his bare skin are drawn by a much lighter ink than his robe and its folds, distinguishing the texture and color of flesh from those of fabrics. Moreover, every individual line that shapes Boya's curly, long beard contains varying degrees of blackness in itself, and this effect has been enhanced by the shading produced by the underlying light ink wash. *Jiehua* in Wang's style also keeps this kind of tonal contrasts and shading effects. In the Princeton version of the *Prince Teng Pavilion* (plate 10), the ends of tiles arranged on the bottom edges of pavilions' eaves are emphasized by more intensely black lines. The New York *Dragon Boat Regatta* handscroll (fig. 2.2) not only uses lines with varied tones but also utilizes the subtle gradation of ink washes in the bases of platform bricks, roof tiles, and boat hulls. When Yuan Jue, Wang Zhenpeng's contemporary, saw the artist's original *Dragon Boat* picture, he was immediately attracted by this unique feature of Wang's *jiehua*:

余嘗聞《畫史》言："尺寸層疊，皆以準繩為則，殆猶修內司法式，分秒不得踰越。"今聞王君以墨為濃淡高下，是殆以筆為尺也。[41]

I once heard that *The Painting History* says: "[An architectural image's] scale and structure should both follow the actual measurements and rules. It is similar to the Palace Maintenance Office's (*xiunei si*) *Building Standards*— there should not be any tiny discrepancies." Now I hear that Mr. Wang uses ink to differentiate between dense and sparse, between up and down—he must use his brush as a ruler.

Among Yuan *jiehua* masters, Wang Zhenpeng's combination of ink tonality and fine-line manner is distinctively his own, which integrates the literati's calligraphic manner into *jiehua*, the genre that originated from the craftsman's art.

However, although Wang Zhenpeng and his followers had consciously made their *jiehua* commensurate with literati tastes—either to draw inspiration from the literati painter Li Gonglin's style, to introduce the medium of paper, or to emphasize calligraphic elements in brushwork—there was still an inherent gap between the professional/court painters and scholar-amateurs. Zhang Daqian's 張大千 (1899–1983) colophon on Tang Di's *Prince Teng Pavilion* hints at the nature of this difference: "This handscroll by Tang Zihua is pervaded by the scholar-gentleman's spirit and does not conform to the usual model of *jiehua*. It is because of his different mind [from common *jiehua* masters]." (唐子華此卷士氣蔚然，絕去界畫窠臼，良由其胸次不同。) Zhang's reception of Tang Di's *jiehua* is mainly based on Tang's personality, which suggests that Tang Di's status as a scholar-amateur painter largely contributed to the incorporation of his work into the orthodox literati canon of the Yuan. By contrast, works by Wang Zhenpeng and his successors at the court have never been classified in this canon. Indeed, the mixture of expensive materials, decorative designs, and superb specialized skills in their *jiehua* commended themselves more readily to the Mongol court taste.

These court painters always used valuable and rare materials—such as gold and pigments for heavy colors—to make their *jiehua* more luxurious, aiming to display the Mongol empire's material opulence and imperial authority. Perhaps that's why Wang Zhenpeng was instructed by Renzong to decorate the monochrome copy of Ma Yunqing's *Vimalakirti* with color, and that's why there was a colored fan of *A Grand Dragon Boat* (plate 11) in Wenzong's collection. Another noteworthy example is a frontispiece for a *Lotus Sutra* collection (plate 12), created by Wang's pupil Zhu Yu in 1330, which is now housed in the National Palace Museum in Taipei.[42] In this painting, Zhu draws geometrically regular lines to represent architectural elements and adopts even, fine lines to depict Buddhist figures, both of which indicate his indebtedness to Wang Zhenpeng's *baimiao* style. Meanwhile, Zhu replaces ink with gold to better show the magnificence of the Buddhist scene. It is worth noting that, during the same year of the painting's creation, Zhu presented some Buddhist-image frontispieces to the Yuan court, so this Taipei piece, embellished with gold, may give us hints of paintings designed for imperial patrons.[43] Gold played an important role in Mongol culture and, as Joyce Denney has argued, this material was explicitly associated with the Mongol imperial lineage and with Mongol power in general, an association well known to peoples near and far at the time of the Mongol empire.[44]

Plate 1: Li Song (active ca. 1190–1230). *Dragon Boat.* Southern Song dynasty (1127–1279). Album leaf, ink and color on silk, 24.5 cm × 25.1 cm. National Palace Museum, Taipei.

Plate 2: Xia Yong (active mid-fourteenth century). *Yellow Pavilion.* Yuan dynasty (1271–1368). Album leaf, ink on silk, 26.1 cm × 25.0 cm. The Yunnan Provincial Museum.

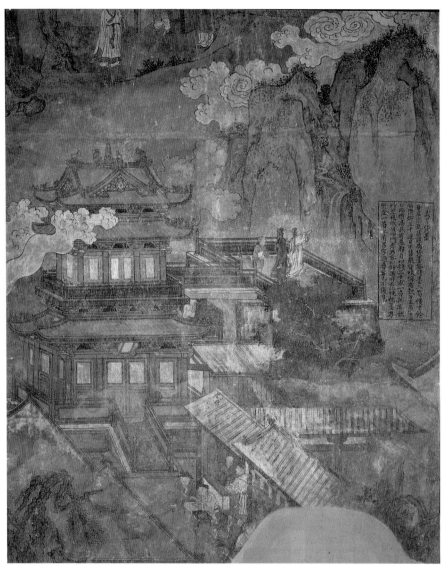

Plate 3: Zhu Haogu's followers. *Selling Ink at Wuchang.* 1358. East wall, Chunyang Hall, Yongle Daoist Monastery, Shanxi. Image from Xiao Jun, ed., *Yongle gong bihua* (Beijing: Wenwu chubanshe, 2008).

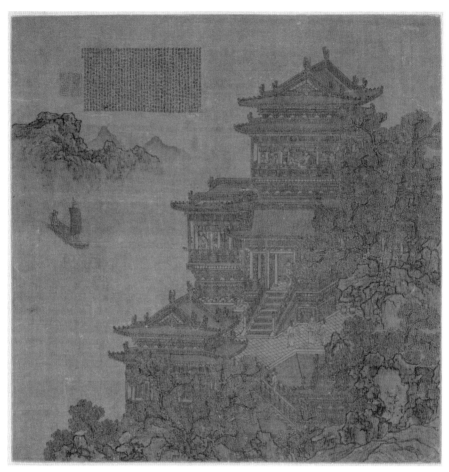

Plate 4: Xia Yong (active mid-fourteenth century). *Prince Teng Pavilion*. Yuan dynasty (1271–1368). Album leaf, ink on silk, 24.7 cm × 24.7 cm. Museum of Fine Arts, Boston: Denman Waldo Ross Collection, 29.964. Photograph © 2022 Museum of Fine Arts, Boston.

Plate 5: Wang Kui (b. 1100) et al. *A Tower Scene*. East Wall, South Hall, Yanshan Monastery, Fanshi County, Shanxi, 1167, Jin dynasty (1115–1234). Image from Chai Zejun and Zhang Chouliang, eds., *Fanshi yanshansi* (Beijing: Wenwu chubanshe, 1990), illustration 92.

Plate 6: Anonymous. The *Great Foguang Monastery*, a section from *Panoramic Map of Buddhist Pilgrimage Sites*. Five Dynasties (907–960). Mural from Mogao Cave 61, Dunhuang, Gansu. Image from Dunhuang yanjiuyuan, ed., *Zhongguo shiku Dunhuang Mogao ku* (Beijing: Wenwu chubanshe, 2013), 5:illustration 62.

Plate 7: East Hall at Foguang Monastery, Mount Wutai, built in 857. Photo by the author.

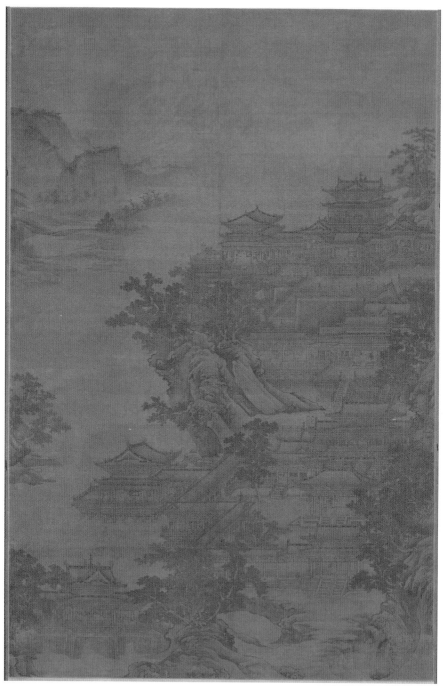

Plate 8: Li Rongjin (active mid-fourteenth century). *The Han Palace.* Yuan dynasty (1271–1368). Hanging scroll, ink on silk, 156.6 cm × 108.7 cm. National Palace Museum, Taipei.

Plate 9: Anonymous. The transformation tableau of the *Sutra of the Medicine Buddha*. High Tang, 776. Mural on the east wall of Mogao Cave 148, Dunhuang, Gansu. Image from Dunhuang yanjiuyuan, ed., *Zhongguo shiku Dunhuang Mogao ku* (Beijing: Wenwu chubanshe, 2013), 4:illustration 36.

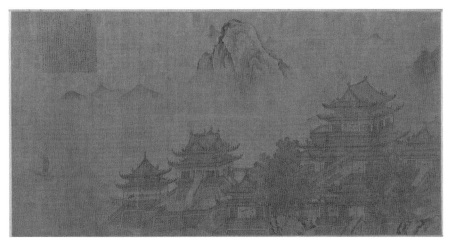

Plate 10: Wang Zhenpeng (attri.). *Prince Teng Pavilion*. Late Yuan dynasty (1271–1368) to early Ming dynasty (1368–1644). Handscroll, ink on silk, 35.9 cm × 71.4 cm. Princeton University Art Museum: Museum purchase in honor of Professor Jerome Silbergeld, Fowler McCormick, Class of 1921, Fund; with a gift from Giuseppe Eskenazi, 2010–65.

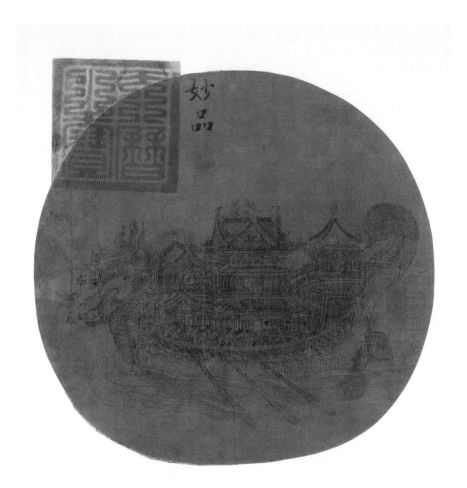

Plate 11: Wang Zhenpeng (attri.). *A Grand Dragon Boat*. Yuan dynasty (1271–1368), early fourteenth century. Album leaf, ink, color, and gold on silk, 25.2 cm × 26.5 cm. Museum of Fine Arts, Boston: Chinese and Japanese Special Fund, 12.899. Photograph copyright © 2022 Museum of Fine Arts, Boston.

Plate 12: Zhu Yu (Zhu Bao). One of Illustrations of the *Lotus Sutra*. 1330. Frontispieces for folding booklet, gold on blue paper, each approx. 29.6 cm × 88.5 cm. National Palace Museum, Taipei.

Although there are almost no surviving paintings by Wang Zhenpeng that use gold or colors, his *baimiao*-style works have their own way of satisfying imperial needs and expectations. As Robert J. Maeda rightfully remarks, Wang Zhenpeng "stressed pattern far more than did his predecessor" and "radically changed the nature of *jiehua* from realism to frank decoration."[45] The artist relies on such a strategy to produce a dazzling effect and thus makes his ink paintings no less appealing to the Mongol court than colored ones. For instance, in his *Mahaprajapati Nursing the Infant Buddha* (fig. 2.5), Mahaprajapati is seated on a couch decorated with intricate geometric patterns and covered by embroidery with round clusters of flowers. The floor tiles and the overlying rug are also meticulously drawn with dainty floral and tendril motifs. For the nearby side table, densely packed auspicious cloud patterns appear on its border. In addition, Wang's adept use of light and shade makes his patterning details more vivid. Between the neighboring folds of Mahaprajapati's robe, there are ink washes producing a velvety dark shading. The flowerpot in the painting's right corner has layers of petal-shaped decorations that are filled with different degrees of ink, ranging from darker black to lighter tint. The flowerpot contains grotesque rocks, and the depressions on their surfaces are also indicated by graded ink washes. Looking up, we can find a glass vessel on the side table, and different parts of the plant—inside or outside the vessel—have distinct ink tonalities, which demonstrates the vessel's transparency. It is safe to say that Wang Zhenpeng's *baimiao* style, with "an all-inclusive decorative design," exerts all the power of ink and line and reflects the painter's superb skills.[46] In addition, Wang's incorporation of fine ornaments and luxurious furnishings—such as textiles depicted in the *Mahaprajapati*—intertwines his paintings with other crafts. Luxury objects, as Roslyn Lee Hammers has argued, attest to the immense wealth and expanse of the Mongol empire and the "armies" of artisans at the emperor's command.[47] Early during the Mongol nomads' conquest of most of Asia, they used harsh tactics such as slaughtering civilians, but always treated artisans more favorably. A great number of skilled artisans from China, eastern Central Asia, and the eastern Iranian world were amassed by the Mongols as war booty to produce luxuries that showed imperial power and noble identity. Wang Zhenpeng's depiction of these well-crafted objects—or the signs of the Mongols' command of skilled labor—might aim to seek the favor of his imperial patrons.

After analyzing Wang Zhenpeng's painting style and his innovations in Yuan *jiehua*, we turn to Xia Yong's works, in which we can see how Wang's emphasis on *baimiao* and decorative designs was passed on to Xia Yong's *jiehua*. Xia's extant paintings are pure ink monochrome on silk—all originally designed to be in this way and never intended as drafts for colored versions. After all, Xia leaves his inscriptions or seals on most paintings, which is generally the last step for an artist to complete his work. In addition, Xia Yong is never stingy about

adding extravagant details in his small-scale paintings. Repetitive geometric patterns fill almost every corner of his architectural images. Also noteworthy is the fact that Xia Yong did not completely duplicate Wang Zhenpeng's style. Xia's parallel lines are barely modulated, have almost the same width and ink density, and lack Wang's tonal variations and shading effects. These features make Xia's architectural images look flatter. For instance, in Xia Yong's *Prince Teng Pavilion* (plate 4), the artist depends solely on a multitude of thin lines to outline his architectural structures, and these structures—either the pavilion perpendicular to the ground or its platform parallel to the horizon—seem to be compressed on the same plane surface.

Although there are no textual records to support the teacher-student relationship between Wang Zhenpeng and Xia Yong, we cannot deny that Xia Yong largely inherited Wang Zhenpeng's *baimiao* style. It is believed here that if Wang Zhenpeng heralded the stylistic change of *jiehua* to a decorative *baimiao* trend in the Yuan period, it is Xia Yong who confirmed this general tendency. This means that Xia Yong had been associated with Wang Zhenpeng's lineage in some sense. But more questions emerge: Was Xia Yong also linked with the Mongol court like Wang Zhenpeng? Did his decorative *baimiao jiehua* also aim at seeking the favor of the Yuan imperial patrons? An examination of landscape elements in related *jiehua* will help us answer these questions.

Landscape in *Jiehua*: Late-Yuan Literati Style versus Northern Song Li-Guo Style

In these three versions of the *Prince Teng Pavilion*—the one by Xia Yong, the one in Wang Zhenpeng's style, and the one by Tang Di—their architectural images are all placed in ink landscape settings. In contrast to their strictly drawn buildings, these artists use flexible brush-wielding manners to produce diverse ink effects on their background mountains and foreground trees and rocks. These expressive ink washes, lines, and dots not only make a harmonious combination of *baimiao jiehua* and ink landscape, but they also help viewers easily trace the sources of the artists' inspiration.

While Xia Yong's architectural representation more nearly imitates Wang Zhenpeng's style—a style that emphasizes meticulous details, techniques, and decorative effects, and thus appealed to the Mongol court in the North—the ink landscape in Xia's work is purely native. As Masaaki Itakura has suggested, such landscape sets Xia Yong apart from other *jiehua* painters working at the Yuan court.[48] Xia's treatment of terrain and rocks is reminiscent of the actual soft scenery in his hometown in the Jiangnan region. For instance, in his *Prince Teng Pavilion* in Shanghai, Xia carefully contours the rocks on the bottom right side (fig. 2.8) with dark black lines and subtly draws their eroded textures using highly individual brush strokes. These long, wavy strokes with grey ink

Figure 2.8: A section from *Prince Teng Pavilion* (fig. 0.5). Shanghai Museum.

Figure 2.9: A section from *Prince Teng Pavilion* (fig. 0.5). Shanghai Museum.

resemble spread-out hemp fibers, and some of them are interwoven with each other, like raveled rope with twisted threads. Another thing to notice is the layers of mountains to the left (fig. 2.9). The edges of more distant mountains are sketchily drawn by massed washes, a device commonly used in Southern Song Academic paintings. Mountains located closer to the viewers, however, are not only modeled by wet hemp-fiber brushstrokes, but also further defined by clusters of round, sooty dots. Despite the absence of color, the depicted landscape triggers viewers' imagination of soft mountains covered by verdant trees, a scene indisputably of the South.

Xia Yong's accumulated hemp-fiber brush strokes and moss dots recall the style of his contemporary Sheng Mao 盛懋 (active 1295–1370), who also came from Jiangnan. In Sheng's hanging scroll *Qiulin gaoshi tu* 秋林高士圖 ("Lofty Scholar in Autumn Woods") (fig. 2.10), mountains rising above clouds are shaped by twisting, linear texture strokes. Notably, the interwoven strokes that spread out over their peaks resemble crisscrossed leaf veins, which helps distinguish between light and shadow on the rocks' facets, thus achieving a volumetric effect. This effect is enhanced by Sheng's lush application of scattered ink dots, which emerge from cracks between rocks or along the contours of mountain slopes.

To a large extent, Xia's and Sheng's landscape renderings are compatible with the scholarly landscape styles of South China. In detail, their hemp-like brush strokes are derived from the southern tradition of Dong Yuan 董源 (active ca. 950) and Juran 巨然 (active ca. 960–980), a tradition admired and fully developed by late-Yuan literati painters in the Jiang-Zhe area. For instance, in the *Xiashan yinju tu* 夏山隱居圖 ("Dwelling in Seclusion in the Summer Mountains") (fig. 2.11), the Yuan master Wang Meng 王蒙 (d. 1385)

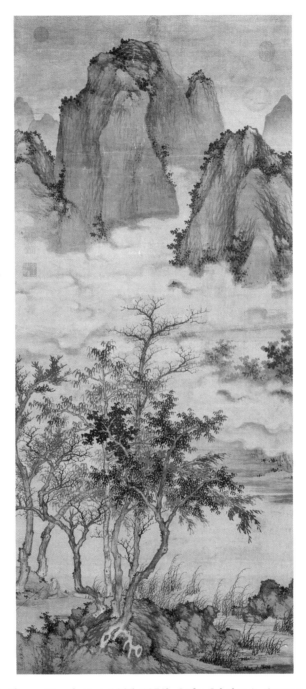

Figure 2.10: Sheng Mao (active 1295–1370). *Lofty Scholar in Autumn Woods.* Yuan dynasty (1271–1368). Hanging scroll, ink and light colors on silk, 135.3 cm × 59 cm. National Palace Museum, Taipei.

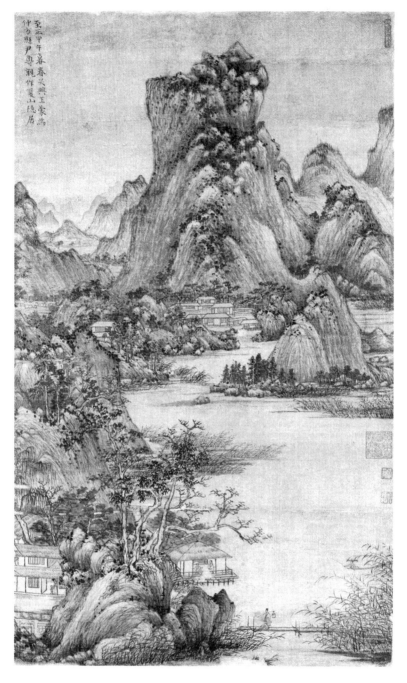

Figure 2.11: Wang Meng (d. 1385). *Dwelling in Seclusion in the Summer Mountains.* 1354.
Hanging scroll, ink and color on silk, 57.4 cm × 34.5 cm. Freer Gallery of Art, Smithsonian
Institution, Washington, D.C.: Purchase—Charles Lang Freer Endowment, F1959.17.

also applies long, hemp-fiber brush strokes on the slopes of rounded mountains and abundant dots along mountain peaks and edges, though his brush strokes and dot groups are denser than Xia's and Sheng's.

Even though Xia's and Sheng's landscape styles reflect the late-Yuan literati's predilection, there is no solid proof to support their role as literati scholars. By contrast, Sheng Mao's biographical information hints at his artisan-painter identity. The *Tuhui baojian* records:

> 盛懋，字子昭，嘉興魏塘鎮人。父洪甫，善畫，懋世其家學而過之。善畫山水人物花鳥，始學陳仲美，略變其法，精緻有餘，特過於巧。[49]
>
> Sheng Mao's courtesy name was Zizhao. He was from the market town of Weitang in the district of Jiaxing. His father, Hongfu, was a good painter. Mao carried on [his] practice and, moreover, surpassed him. He was equally accomplished at painting landscape, figures, and bird-and-flower subjects. He began studying [painting] with Chen Zhongmei (Chen Lin, ca. 1260–1320) and slightly changed his method. [His style is characterized by] great refinement and a particular excess of skillfulness.[50]

According to this entry, Sheng Mao studied painting with his father and Chen Lin 陳琳 (ca. 1260–1320), an artisan-painter from the Jiangnan area. The features of his painting style are described as "great refinement and a particular excess of skillfulness," both associated with craftsmanship and techniques. The Qing gazetteer *Jiaxing fu zhi* 嘉興府志 (Gazetteer of Jiaxing Prefecture, 1721) more clearly notes that Sheng Mao worked as a professional painter.[51] And the prestigious Ming art critic Dong Qichang 董其昌 (1555–1636) even compares Sheng Mao and Wu Zhen 吳鎮 (1280–1354), one of the Four Great Masters of the Yuan, as opposite examples:

> (吳仲圭)本與盛子昭比門而居。四方以金帛求子昭畫者甚眾；而仲圭之門闃然。妻子頗笑之，仲圭曰：「二十年後不復爾。」果如其言。[52]
>
> At the beginning, Wu Zhonggui (Wu Zhen) and Sheng Zizhao lived as neighbors. There were many people that came from different places and sent gold and silk to purchase Zizhao's paintings, but Zhonggui's door was quiet [because no one came and knocked on it]. Zhonggui's wife laughed at her husband, and Zhonggui said: "The situation will be different after twenty years." It indeed occurred as he predicted.

Dong's statement implies that Sheng Mao sold his paintings to earn a living, a usual choice of professional painters. It also emphasizes the tremendous shift in people's reception of the literati-amateur artist Wu Zhen and the artisan-painter Sheng Mao. While Dong's words express his contempt for Sheng, they also confirm the popularity of Sheng's works in contemporary commercial markets. This provides a possible explanation for Sheng Mao's infusion of the late-Yuan literati's landscape styles such as the calligraphic hemp-fiber brush

strokes and ink moss-dot accents. Apart from Sheng's personal affinities, purchasers' demands might have influenced Sheng's absorption of these promising literati trends.[53] Similarly, Xia Yong and other professional painters of the late-Yuan may have adopted Sheng Mao's landscape style mixed with literati's preferences because they wanted to cater to popular taste in the Jiangnan area.[54]

It is also worth mentioning that there was a strong tie of friendship between Sheng Mao and Wei Jiuding, one of Wang Zhenpeng's pupils active in the Jiangnan area. Wei Jiuding left an inscription on Sheng Mao's painting *Jiangfeng qiuting* 江楓秋艇 ("Autumn Boating on a Maple River"), claiming that "Zizhao (Sheng Mao) and I have become friends from very early on" (子昭 與余交最早). It is possible that Xia Yong had direct or indirect contact with Sheng Mao, since Xia's landscape style reflects Sheng's influence and Xia and Sheng's teacher Chen Lin were both natives of Qiantang, where Xia and Chen were likely to meet each other.[55] In this case, we can see how a subtle network of links between Wei Jiuding, Sheng Mao, and Xia Yong might have been established. If so, the fact that Xia Yong had learned with Wei's master Wang Zhenpeng would not be so unacceptable. However, even if it is true, it does not mean that Xia Yong had served the Yuan court as Wang Zhenpeng did. On the contrary, Xia's possible link with Wei Jiuding further proves his close association with southern sources. After all, Wei Jiuding did not have direct connections with the Mongol court. By reading Wei's extant painting *Nymph of the Luo River*, we can use Wei's choice of paper medium, his *baimiao* figural style, and the Jiangnan literati painter Ni Zan's 倪瓚 (1301–1374) inscription (fig. 2.6) to establish Wei's tendency toward southern literati's preferences instead of imperial tastes.

Apart from Xia Yong's close connection with southern sources, his alienation from the Mongol court can be further demonstrated by the deviation of his landscape style from the one prevailing in the northern capital. A comparison between landscape elements in Xia's *Prince Teng Pavilion* (fig. 2.8 and 2.9) and those in the Wang-style *Prince Teng Pavilion* at the Princeton University Art Museum (plate 10) can offer more visual proof. Xia Yong depends on wavy texture strokes and black dot groupings to provide a luxuriant view of soft, low-rolling mountains and land masses in South China. In contrast, the Princeton version represents distant mountains like the barren and austere landscape of North China. These mountains are tall and somber. The artist utilizes wiry lines to manipulate their shapes and exploits rich ink tonalities to make strong dark-light contrasts on the rocks' different facets. Such a rocky landscape style hints at the conservative monumental landscape tradition of the Northern Song, the one preserved and perpetuated during the Jurchen Jin and Mongol Yuan.

Li Rongjin, one of Wang Zhenpeng's pupils, creates the hanging scroll *Han Palace* (plate 8), and this work more clearly shows how widespread and influential the Northern Song landscape tradition—the one particularly associated with Li Cheng and Guo Xi—was among Yuan *jiehua* masters. On the left of the picture, silhouettes of distant hills are shrouded in wintry mists, which rise from flowing streams, and the artist's moist brushwork further creates rich atmospheric effects. There are also flourishing trees that grow along the eroded riverbank and hillside, creating a scene of a desolate world. In the foreground, rocks randomly placed between palatial structures are modeled with wiggly strokes and shaped like rolling cumulus clouds, suggesting their extreme roughness and eroded contortion. Such curled-cloud-shaped rocks are typical Li-Guo motifs. In this work, Li Rongjin naturally combines the Northern Song landscape paradigms with the *jiehua* style inherited from Wang Zhenpeng.

While Wang Zhenpeng's unanimously accepted works—almost all figural paintings—contain few landscape elements, the Princeton *Prince Teng Pavilion* and his pupil Li Rongjin's *Han Palace* help us better imagine Wang's possible landscape style. This style is completely distinct from Xia Yong's softer Southern style of the late-Yuan era and is instead much closer to that of Tang Di, a scholar-official and a painter who served the Mongol Yuan court almost at the same time as Wang Zhenpeng. Tang's style also originates from the monumental landscape traditions of the Northern Song. In his *Prince Teng Pavilion* (fig. 2.1), two bent, craggy leafless trees, growing from the rocky outcrops at the right bottom of the scroll, extend their crab-claw branches to the left. For each branch, several stiff, dry strokes form its downward-turned twigs, conveying a feeling of bleakness, desolation, and loneliness. As for the outcrops, they are defined by sooty contour lines and graded ink washes and have textures like confused clouds or thunder heads on their upper surfaces. Tang Di draws much of his inspiration from the idioms of Guo Xi: both Tang's crab-claw trees and cloudlike boulders can be found in Guo's masterpiece *Zaochun tu* 早春圖 ("Early Spring"). However, Guo Xi conveys more subtle nuances in his variations of ink washes on silk, while Tang Di handles lines in a more relaxed calligraphic manner on paper.

The Yuan painter Zhao Mengfu served as Tang Di's teacher and contributed immensely to Tang Di's absorption of the Li-Guo legacy.[56] As early as in 1303, Zhao produced the painting *Chongjiang diezhang tu* 重江疊嶂圖 ("Serried Peaks along the River") (fig. 2.12), one of the earliest Yuan landscape paintings to rediscover Northern Song paradigms. Both Zhao's crisp, spirited lines and his rich layers of ink washes are derived from the Li-Guo tradition. Particularly noteworthy is the scene appearing at the end of this picture: two towering pines with rugged trunks and stiff needles stand together with highly simplified crab-claw groves on eroded embankments. This scene combines several Li-Guo

Figure 2.12: Zhao Mengfu (1254–1322). *Serried Peaks along the River*. 1303. Handscroll, ink on paper, 28.4 cm x 176.4 cm. National Palace Museum, Taipei.

motifs and transforms them into a stereotyped composition, which became popular among subsequent Li-Guo style works of the Yuan period, including Zhu Derun's 朱德潤 (1294–1365) *Linxia mingqin* 林下鳴琴 ("Strumming the Zither Under Trees"), Cao Zhibai's 曹知白 (1272–1355) *Shuangsong tu* 雙松圖 ("A Pair of Pine Trees," dated 1329), and Tang Di's *Shuangpu guiyu tu* 霜浦歸漁 圖 ("Fishing Returning on a Frosty Bank," dated 1338).

Zhao Mengfu, a Song royal who held a high administrative post in the Yuan court, played a significant role in the early-middle Yuan revival of the Li-Guo landscape tradition among southern scholar-official painters in the northern capital of Dadu 大都 (present-day Beijing). The aforementioned Yuan proponents of this tradition, including Tang Di, Zhu Derun, and Cao Zhibai, all displayed stylistic continuity with Zhao Mengfu's Li-Guo-style paintings. These painters actively sought official advancement from the Yuan government or communed with Northern officials. When Zhu Derun was around twenty years old, he showed his paintings to Feng Zizhen, in order to please this government official from the capital Dadu and get his support.[57] As a protégé of Zhao Mengfu, Zhu Derun finally found favor with Renzong and Yingzong.[58] As for Tang Di, he came to Dadu twice. He was recommended by the official Ma Xu 馬煦 to Renzong and was commanded to paint an imperial screen for the Jiaxi Palace 嘉禧殿, and thus was appointed as a painter-in-attendance at the Academy of Worthies 集賢苑 and then was posted in Jiaxing Prefecture as a local administrator.[59] Before withdrawing from public service, Cao Zhibai also traveled to the capital and communicated with powerful people there.[60] The convergence of these southern scholar-painters' emphasis on the Li-Guo style and their pursuit of service over retirement, with their strategies of using painting skills to attract the attention of powerful aristocrats and officials, indicates that the Mongol Yuan ruling house and officials with northern backgrounds approved of this Northern Song landscape style.

We now return to the three *Prince Teng Pavilion* paintings, the starting points for our discussion in this chapter. Wang Zhenpeng, Tang Di, and Xia Yong all came from the Jiangnan area of South China, but landscape elements in these three *jiehua* reflect different styles. Both Tang Di's painting and the Wang Zhenpeng–style work draw largely on Northern Song paradigms. This is reasonable, since Tang Di's role as a scholar-official and Wang Zhenpeng's

role as a court painter required the styles of their paintings to appeal to imperial tastes. By contrast, Xia Yong appropriates techniques such as hemp-fiber strokes and dotted textures that were beloved by fourteenth-century Jiangnan literati painters and literati-oriented professional painters like Sheng Mao. Xia's different approach from Wang Zhenpeng and Tang Di demonstrates the unlikeness of his ties to the Mongol court.

After comparing Xia Yong's *Prince Teng Pavilion* and other contemporary works, we can conclude that Xia Yong's painting style is indebted to a variety of sources. Although there is no textual proof to support the teacher-student relationship between Wang Zhenpeng and Xia Yong, Xia derived his meticulous *baimiao* style from Wang and further developed Wang's decorative designs to produce more visually attractive effects. Meanwhile, Xia Yong's *jiehua* incorporates features of the fully developed literati landscape style in the late-Yuan Jiangnan area. Since there is almost no evidence of Xia's personal affinities with literati scholars, his literati landscape style was more likely adapted to the popular taste prevailing in Jiangnan markets.

In this chapter, our investigation of Wang Zhenpeng, his successors at court, and southern scholar-official painters also touches upon a significant phenomenon occurring in the mid-Yuan court: after the fall of the Southern Song dynasty in 1279, many Southerners arrived in Dadu to seek official careers, and many of them relied on painting skills to rapidly achieve this goal. What role did paintings—particularly the *jiehua* category—play in the interactions between the Mongol court and Southerners? This issue will be further explored in the following chapter.

3

Painting and Politics

Direct Appointments: Based on Emperors' Interest in Complex Constructions

After the Mongols' reunification of China in 1279, the Mongols, *semu* 色目 (other ethnic groups such as the Uighurs and Khitans), and even northern Chinese citizens were politically and socially more prominent than the southern Chinese populace. Confucian scholars were especially affected by the disenfranchiscment. They had formed an elite group in Southern Song society but were largely excluded from the Yuan bureaucracy, particularly because their traditional route into government—namely, the civil service examination system—was temporarily abolished.[1] Southern scholars' discontentment was perfectly expressed by Song loyalist Xie Fangde's 謝枋得 (1226–1289) sarcastic words:

> 滑稽之雄,以儒為戲者曰: "我大元制典,人有十等:一官、二吏,先之者,貴之也;貴之者,謂有益於國也。七匠、八娼、九儒、十丐,後之者,賤之也;賤之者,謂無益於國也。" 嗟乎,卑哉!介乎娼之下、丐之上者,今之儒也。[2]

> An eloquent person, who mocked Confucian scholars, said: "According to our Great Yuan legal system, there are ten classes of people: Officials rank first, and clerks rank second. Those higher-ranking people are valued; it is said that those valued are beneficial to the country. Seventh, craftsmen; eighth, entertainers (actors and prostitutes); ninth, Confucian scholars; and tenth, beggars. Those lower-ranking people are belittled; it is said that they contribute nothing to the country." Ah, how lowly! Those who are placed beneath entertainers and above beggars are today's Confucian scholars.

Although Xie's words cannot be supported by any other official documents, this passage indeed describes the unprecedented low status of Confucian scholars in Yuan society. Without the examination system, Southerners had difficulty fulfilling their aspirations for official careers. Even if they chose to be lower-echelon clerks first—a job that ranked second, in Xie Fangde's opinion—it was extremely hard for them to gain entrée into the official ranks and further their careers. To borrow Wai-Kam Ho's words:

> In the early years, a minimum of ninety months of service was required before
> a petty functionary could even begin to be considered *jiu-liu* or "joining the
> rank," meaning the lowest ninth grade in official ranking . . . Under normal
> favorable conditions, a Chinese starting young, say twenty-five, from the rank
> of sub-nine would have to pass successfully fourteen to fifteen reviews to reach
> a position of the sub-five grading. By that time he would have been seventy
> years old, the age for mandatory retirement.[3]

For southern Chinese individuals, it was hopeless trying to advance in the
Mongol bureaucracy. After ninety months of service, they would obtain only
the lowest ninth-grade post, and it would cost them at least forty-five years to
get a sub-fifth-grade post in their seventies.

In this situation, Southerners contrived more desirable means to advance
into government. As discussed in the previous chapter, Wang Zhenpeng,
one of the highest-ranking Southerners in the Yuan government, actively
presented his *jiehua* to the throne. Wang's art won him a direct appointment
and also a quick transfer to a secondary-seventh-grade sinecure. It took Wang
no more than thirteen years to achieve a fifth-grade post around the age of
fifty, much quicker than poor Chinese clerks.[4] Compared with government
clerks' tortuous route to office holding, the use of art as a shortcut to direct
appointments was much more effective and thus became extremely enticing.
Modern scholars like Yu Hui have found that many southern literati, such
as Tang Di and Lin Yiqing, used their *jiehua* to move up the ladder.[5] Their
successes, however, were based on the adaption of their paintings to Mongol
emperors' preferences. One of the reasons *jiehua* were particularly favored
is that they displayed the conspicuous wealth and opulence of the Mongol
empire and thus continuously appealed to the imperial taste. In the case of
Wang Zhenpeng, his *jiehua* not only pleased the Emperor Renzong, who first
appointed him, but also remained popular among subsequent Yuan emper-
ors—at least two of the *Dragon Boat* paintings ascribed to Wang, for instance,
were preserved in the Yuan court until the fall of the dynasty.[6]

Due to Mongol emperors' partiality for *jiehua*, even those not specializing
in this genre painted works of this type to seek official appointments. The most
famous example is Li Shixing 李士行 (1283–1328). His epitaph indicates that
Li grew up in the Jiangnan area (the Wu-Yue area in particular) and learned
from southern literati painters such as Zhao Mengfu.[7] In addition, his father
Li Kan 李衎 (1245–1310) was celebrated for the "bamboo, rock, and old tree"
painting genre. As the Yuan catalogue *Tuhui baojian* records, "(Li Shixing's)
paintings of bamboo and rocks show skills handed down from his father and
even surpass his father's works in their subtlety. Li Shixing was particularly
good at landscapes." (畫竹石得家學，而妙過之，尤善山水。)[8] Nevertheless,
instead of those literati paintings for which he was usually known, Li Shixing

chose to present a *jiehua* to attract the attention of the emperor. The reason for this was implied in his epitaph:

于時公卿大臣喜尚吏能，不樂儒士，君年壯無所遇，乃遊名山……仁廟在御，崇尚藝
文，近臣以君名薦，遣使召之。君以所畫《大明宮圖》入見，上嘉其能，命中書與五
品官。[9]

At that time, high officials and ministers esteemed the clerks' abilities but did not like Confucian scholars. Li Shixing did not get any opportunities before he was thirty, so he visited famous mountains instead . . . After Renzong ascended the throne, this emperor favored art and literature. His intimate ministers recommended Li Shixing, and Renzong sent officials to summon Li. Li presented his *Daming Palace* to the throne. The emperor praised his skills and thus commanded the Secretariat to assign Li a fifth-grade post.

In his early years, Li Shixing's official career did not go well, for Confucian scholars struggled to get recommendations and direct appointments. In this situation, it is reasonable that Li preferred to paint a *jiehua* rather than insist on his specialization in literati paintings, and his decision was immediately rewarded. It is worth noting that Li painted the Tang-period Daming palace complex, a subject that was also once depicted by Wang Zhenpeng for Renzong.[10] The coincidence of these two artists' choices suggests that the emperor preferred paintings of historical buildings.

He Cheng 何澄 (1223–c. 1316) is another painter who benefited from presenting paintings of historical buildings to Renzong. He Cheng was already famous during the first Yuan Emperor Shizu's 世祖 (Khubilai, 1215–1294; r. 1260–1294) reign and retired as the Superior Grand Master of the Palace (*taizhong dafu* 太中大夫), a secondary-third-grade post in the Imperial Library (*mishu jian* 秘書監). When he was ninety years old, he tried to return to officialdom. He presented a handscroll of *jiehua* to Renzong, which resulted in his appointment to a secondary-second-grade position—namely, the Grand Master for Palace Attendance (*zhongfeng dafu* 中奉大夫)—as well as the Grand Academician in the Institute for the Glorification of Literature (*Zhaowen guan daxueshi* 昭文館大學士).[11] Which kind of painting rewarded He Cheng with such high official positions? His colleague Cheng Jufu 程鉅夫 (1249–1318) inscribed poems on this handscroll, indicating that He Cheng painted three famous architectural subjects in the history, including "Gusu tai" 姑蘇台 (Gusu Terrace), "E'pang gong" 阿房宮 (E'pang Palace), and "Kunming chi" 昆明池 (Kunming Lake).[12]

Renzong expressed a strong interest in traditional Chinese architecture and promoted painters who depicted this subject. It was provident for the Yuan emperor, as Roslyn Lee Hammers has argued, "to signal his acceptance of Chinese tradition in order to attempt to establish hegemony over the larger Mongol Empire."[13] In other words, Renzong's strategy could help "balance

power between the Mongol aristocracy and Chinese advisers."[14] It seemed to work well—at least when Cheng Jufu wrote poems on He's paintings, Cheng treated these architectural images as vehicles to admonish the enlightened sage-ruler (i.e., Renzong), implying that Chinese officials like Cheng accepted Renzong's legitimate Chinese rulership. Cheng's poems are full of historical allusions. First, the "Gusu Terrace" poem refers to the story of King Fuchai 夫差 (r. 495–473 BCE) of the state of Wu, who was seduced by the famous beauty Xi Shi 西施 from the state of Yue and thus soundly defeated by the Yue king later. Cheng vividly describes Fuchai's and Xi Shi's sumptuous feasts and revelries on the splendid Gusu Terrace, warning Yuan emperors against lusting after women and pleasures. Second, the E'pang Palace, a huge and costly palace complex, was built by the First Emperor of Qin 秦始皇 (r. 221–210 BCE), but completely burnt down in the revolt against the Qin.[15] Numerous literary texts, such as Du Mu's 杜牧 (803–c. 852) famous rhapsody, link the destiny of the E'pang Palace to that of the Qin Empire. Similarly, in Cheng's poem, the E'pang Palace's magnificence after the construction contrasts sharply with its desolation after the destruction. Through the Palace's fate, Cheng seriously condemns the First Emperor's extravagance and admonishes Yuan emperors to learn by this historical figure. Third, to expand the empire's territories in the Southwest, the Emperor Wu of the Han dynasty 漢武帝 (r. 141–87 BCE) constructed the Kunming Lake for naval maneuvers. Cheng compares this story with Shizu's (Khubilai's) naval expansion, a decisive factor in the Yuan's victory over the Southern Song, and thus highly praises this Mongol emperor for his military prowess and foresight. In addition to these three poems, Cheng adds a note in the end and claims:

自古以翰墨見知當世，不為無人，澄獨以姑蘇臺、阿房宮、昆明池，託物寓意，其庶幾執藝以諫者歟！[16]

Since ancient times, it has not been rare that there were people known for their brushes and ink (i.e., calligraphy and painting) in their ages. [However,] only He Cheng paints the Gusu Terrace, E'pang Palace, and Kunming Lake, and makes use of these objects to convey implied messages. He is almost using his art to expostulate [with the monarch]!

In Cheng's opinion, He Cheng's *jiehua* are allusive paintings, which could serve as tools for advising their emperor on correct behavior, and that is also the reason why He's art should be valued. In some sense, He Cheng's role as an upright court official, instead of an outstanding painter, helps him gain the respect of scholar-officials like Cheng Jufu.

For these Chinese scholar-gentlemen in the Yuan court, good *jiehua* could be used to admonish and advise their monarch, and, in turn, the monarch who accepted honest advice could be treated as a sage-ruler and thus justify his rule. Their readings of *jiehua*—not only paintings of historical buildings, but

also those depicting contemporary Yuan architecture—were associated with a moralizing tone. A notable example is a colophon on Wang Zhenpeng's *Da'an Pavilion* painting, written by the leading Chinese literatus and Yuan official Yu Ji:

世祖皇帝在藩，以開平為分地，即為城郭宮室，取故宋熙春閣材于汴，稍損益之，以為此閣，名曰：大安。既登大寶，以開平為上都。宮城之內，不作正衙，此閣巋然，遂為前殿矣。規制尊穩秀傑，後世誠無以加也。王振鵬受知仁宗皇帝，其精藝名世，非一時僥倖之倫。此圖當時甚稱上意，觀其位置經營之意，寧無堂構之諷乎！止以藝言，則不足盡振鵬之倦倦矣。[17]

When the Emperor Shizu was still in his fief, he had Kaiping within this territory, and built cities and palaces. He moved the pieces of the previous Northern Song Xichun Pavilion from Bianliang (the Northern Song capital) and slightly altered that pavilion to complete this [new] one. He named it Da'an. After Shizu ascended to the throne, he made Kaiping his Upper Capital. There is no audience hall in the palace-city, and since this pavilion is tall, it becomes the main hall. Its appearance is magnificent and elegant, and nothing could be added by later generations. Wang Zhenpeng finds favor with the Emperor Renzong. It is not a fluke that Wang's art becomes famous in the world. At that time, this picture (*Da'an Pavilion*) gratified the emperor's wishes to a great extent. If one views Wang's idea about the arrangement of buildings [in his painting], doesn't it include an admonition to [the emperor] to inherit his ancestors' legacy? If one only considers Wang Zhenpeng's art, one could not judge the full extent of Zhenpeng's sincerity.

In this colophon, Yu Ji interprets Wang Zhenpeng's *jiehua* as "tanggou zhifeng" 堂構之諷—namely, an admonition to the emperor to be a true inheritor of his ancestors' legacy. The term "tanggou" is quoted from *Shangshu Dagao* 尚書·大誥 (the "Great Announcement" from the *Book of Documents*): "if a deceased father [wanted to] build a house and had determined its layout and size, but his son did not want to lay the foundation, how could the son be willing to raise up the house?" (若考作室，既厎法，厥子乃弗肯堂，矧肯構。)[18] Here, "tanggou" directly refers to the activity of laying the foundation and building the house, suggesting the ancestors' legacy—which Wang's *jiehua* advised the emperor to inherit—is related to architectural undertakings. Yu Ji's description of the Da'an Pavilion project, sponsored by the Emperor Shizu (Khubilai), further intensifies this impression. The Han scholar Kong Anguo 孔安國 (active second century BCE), however, comments on the entry of *Shangshu* in this way: "it compares the activity of building a house to that of governing the country." (以作室喻治政也。)[19] If so, Yu Ji's interpretation of Wang's "tanggou zhifeng" conveys specific political meanings: Wang's *jiehua* depicts the Da'an Pavilion, which reused the materials from an old Northern Song pavilion, kept the traditions of Chinese architecture, and was newly built by a Mongol emperor. In Yu Ji's view, Wang's choice of this topic hints at the legitimatization of Mongol rule of

China—the Yuan took over the Northern Song, a native Chinese dynasty. If so, Wang's admonition to the reigning Yuan emperor might be to maintain the Mongols' power in China, just like his ancestors.

Yu Ji's interpretation of Wang's *jiehua* is not entirely unfounded. A stele inscription for today's "White Stūpa" (*baita* 白塔) of Beijing, written on Shizu's (Khubilai's) imperial command, offers an excellent example that overtly explains the design principle of the Mongols' architectural undertakings in China. The inscription records:

我大元之有天下也，宗尧祖舜，踵禹基湯……建都定鼎，树闕营宫，以为非巨丽无以顯尊严，非雄壮无以威天下。[20]

Our Great Yuan's possession of the world follows [the Chinese sage-rulers] Yao and Shun and inherits from [the dynastic founders] Yu and Tang . . . [after Shizu] established the capital, he raised up gate-towers and built palaces. He believed that it could not show [the Yuan's] sanctity if the architecture was not magnificent, and it could not overawe the world if the architecture was not grand.

It seems that during the first years of Mongol rule in China, the question of dynastic legitimacy was probed in this way. That is the reason Shizu (Khubilai) used majestic architectural buildings in his new capital to cultivate an image of the Mongols as legal holders of the throne. The Mongols conducted various building projects, which encouraged the production of *jiehua* in the Yuan period. For instance, Wang Zhenpeng depicted contemporary architecture in such works as *A Sketch of the Dadu Pond Lodge*.[21] Zhao Yong, Zhao Mengfu's son, was summoned by the Emperor Shundi in 1341 to paint the newly built palaces, terraces, and pavilions, and he also produced *jiehua* for a Mongol prince's residence.[22] According to extant Yuan *jiehua* and their later copies, an outstanding feature of these Mongol building projects is that they represent Chinese patterns and styles, thus announcing both the grandeur of the Mongol empire and its authority over China.

Apart from architectural projects, the extensive imperial sponsorship of shipbuilding projects—intended to establish maritime power—provided another significant subject for Yuan *jiehua* and also stimulated the popularity of this painting genre. The aforementioned poem on the Kunming Lake, written by Cheng Jufu for He Cheng's *jiehua*, references Shizu's (Khubilai's) development of a war-winning maritime capability, and Cheng's note following this poem explains even further:

臣待罪秘書日，秘書監扎馬剌丁出示中統年間習水戰船樣，長尺有咫，竟平江南一天下，世祖規模宏遠矣。[23]

When I worked in the Imperial Library, Jamal al-Din from the Imperial Library showed me the design of a ship for naval battles. [The ship design]

is only one *chi* and one *zhi* long, but it [helped Shizu] conquer Jiangnan and unify the country. Shizu had the foresight to plan [these] wisely.

In this note, Cheng links He Cheng's *jiehua*, one that depicts boats on a lake, to the design of a naval ship, and reflects on the combination of utility and artistry in *jiehua*. Meanwhile, Cheng connects the painting of boats to the early Yuan political circumstances of naval expansion and reads Shizu's (Khubilai's) expansive naval ambition and insight into this work.

The extant Yuan *jiehua* of boats are almost all *Dragon Boat Regatta* paintings, like the handscroll (fig. 2.2) that was supposed to be Wang Zhengpeng's birthday gift for the future emperor Renzong. However, while Shizu (Khubilai) pursued extensive maritime capabilities and built the requisite number of naval ships, a prohibition against the dragon-boat regatta was promulgated during his period.[24] This ban presents the dragon-boat regatta, a festival custom of the previous Song dynasty, as a useless practice involved with mass gatherings that easily led to crimes as well as a threat to Mongol rule in China.[25] If so, the surviving Yuan *Dragon Boat Regatta* paintings are unlikely to have depicted the scenes of Yuan dragon-boat regattas. Take the handscroll attributed to Wang Zhenpeng (fig. 2.2), for example—the artist's inscription clearly refers to the event happening on Jinming Lake during the reign of the last Northern Song emperor Huizong. It means that this *jiehua* of boats has nothing to do with the artist's praise for Yuan naval expansion. Some Yuan poems treat Wang Zhengpeng's *jiehua* of the Jinming Pond subject as allusive paintings, just like He Cheng's handscroll. For instance, Wu Quanjie 吳全節 (1269–1346), the Daoist priest who served the Mongol court, writes:

龍舟疊鼓出江城，送得君王遠玉京；惆悵金明池上水，至今嗚咽未能平。[26]

[People] rowed the dragon boats, played the drums, and went out of Jiangcheng,
[Which] led to the Emperor's departure from the Capital.
Melancholy water in the Jinming Pond,
Is still puling and unable to calm down now.

In this poem, Wu contrasts the lively scene of the dragon boat regatta—a kind of lavish entertainment for the Northern Song Emperor Huizong before the fall of the dynasty—with this Emperor's humiliating fate of being taken captive by the Jurchen conquerors and brought back to their country. The poem even establishes a causal relationship between these two events, and thus urges the contemporary Yuan emperor to absorb Huizong's lessons.

Wang Zhenpeng himself did not necessarily intend his *Dragon Boat Regatta* pictures as allusive paintings. Judging by clues on their extant copies, we can see that Wang's original works were designed either for a Yuan emperor's birthday or for a Yuan princess' commission. And the artist's poem clearly

says that "what actually counts is the idea of shared pleasures with the entire populace. For that reason alone, I dare to compose this piece of 'soundless poetry' (namely, painting)." (但取萬民同樂意，為作一片無聲詩。)[27] In addition, through a visual analysis of these *Dragon Boat Regatta* paintings, the modern scholar Chen Yunru finds that the artist mixes details from the Northern Song, Southern Song, and Yuan periods, aiming at achieving an idealized vision of the dragon-boat regatta.[28]

I believe these two interpretations of the Yuan-period *Dragon Boat Regatta* paintings—either as carriers of admonitions or as representations of shared pleasures—help bolster the image of the Mongol emperor as a Chinese sage-ruler and make these paintings politically useful gestures for the emperor. In the Confucian tradition of statecraft, only an enlightened sage-ruler or legitimate "Son of Heaven" was willing to accept his officials' admonishment and maintain his concern for the welfare of the people. In other words, Chinese officials' interpretations of these paintings could justify the Mongol emperors' legitimacy in China and thus please these royal sponsors. Putting aside such political aims, I believe the visually pleasing designs of these *Dragon Boat Regatta* paintings also gave delight to the Mongol emperors. As shown in the previous chapter, *jiehua* created for the Mongol court tended to use expensive materials like gold and emphasize the decorative *baimiao* style. For example, Wang Zhenpeng's extant paintings (such as the *Mahaprajapati Nursing the Infant Buddha*, fig. 2.5) and copies after him (such as the *Dragon Boat Regatta on Jinming Lake*, fig. 2.2) are full of sophisticated gadgetry and excessive details. Indeed, the Mongol ruling house was fascinated with all sorts of delicate mechanisms and exquisite handicrafts that could attest to their great wealth and full control of skilled artisans.

After the collapse of the Yuan dynasty, the Chinese literati of the Ming period were not inclined to read admonition or extolment into Yuan *jiehua*, but instead directly emphasized their superb craftsmanship. Specifically, they compared the *jiehua* genre to the category of embroidery. For example, the Ming scholar Jiang Shaoshu stressed the resemblance between Xia Yong's *jiehua* and hair embroidery and introduced the concept of *kongxiu zhi zhi* (the open-embroidery technique) to his description of Xia's mechanical perfection of lines. Similarly, when the Ming scholar-official Wu Kuan 吳寬 (1435–1504) wrote a poem on Wang Zhenpeng's *Ink-Drawn Regatta* painting, he used many specific terms related to embroidery:

> 五色彰施成畫片，刺繡刻絲吾屢見。何來一段蹟尤奇，烏絲細入鵝溪絹……
> 女工挑綾亦常有，誰聚氄毛爲此圖？印文特識元文代，上有奎章天曆在。
> 么麼十五字題名，至大仍書庚戌載。
> (後有字二行，曰："至大庚戌王振鵬爲翰林承旨曹公作。")
> 御府畫圖皆等閒，後皇對此獨開顏。苑中刻木能依樣，贏得都人號魯班。
> (順帝性巧，自製龍舟，人稱魯班天子。)[29]

The five colors shown vividly to complete paintings,
As well as embroidery and *kesi* tapestry—I frequently see such works.
How could this piece have so unusual a trace?
Black color, which forms fine lines, penetrates the E'xi Silk . . .
It is also common for workwomen to do needlework.
Who [could] gather fine feathers to make this picture?
The seals could be recognized specifically as those of Wenzong's reign,
Since there are "Kuizhang" and "Tianli" written on them.
There are fifteen tiny characters inscribed [on the work].
[The date] is written as the Gengxu year of the Zhida reign.
(There are two lines of inscriptions at the end, saying: "In the Gengxu year
 of the Zhida reign, Wang Zhenpeng produced this for Mr. Cao, the
 Chancellor in Hanlin Academy.")
The paintings in the imperial storerooms were all ordinary [by comparison],
And so, a subsequent emperor was especially delighted by this [painting].
He could depend on this example to sculpt [dragon boats] out of wood in
 gardens,
Earning him the name among the citizens, Lu Ban (the master carpenter).
(Shundi was ingenious. He produced a dragon boat by himself, so people
 called him the Emperor Lu Ban.)

The inscription on this work by Wang Zhenpeng—including the artist's signature, creation date, and purpose—matches that of the painting *Baojin jingdu tu* 寶津競渡圖 ("Dragon Boat Race by Baojin Tower") (fig. 3.1), one of several *Dragon Boat Regatta* handscrolls attributed to Wang Zhenpeng and held by the National Palace Museum in Taipei.[30] It suggests that the work Wu Kuan saw is also a painting with Wang's typical *baimiao* style—a style characterized by clearly distinct, very fine lines, and these lines are sometimes packed densely and sometimes left with geometrically regular spacing between them. It is no wonder that Wu Kuan compares this painting to embroidery and exclaims in admiration: "It is also common for workwomen to do needlework. Who [could] gather fine feathers to make this picture?"[31] These Ming receptions

Figure 3.1: Wang Zhenpeng (attri.). *Dragon Boat Race by Baojin Tower*, 1310 (the date may be forged), Yuan dynasty (1271–1368). Handscroll, ink on silk, 36.6 cm × 183.4 cm. National Palace Museum, Taipei.

of *jiehua*—including those of Xia Yong's and Wang Zhenpeng's—ignore the allusive aspects of this painting genre, but rather associate it with womanly embroidery and equate *jiehua* artists to craftsmen, sufficiently demonstrating *jiehua*'s decline in status during the Yuan-Ming transition. After all, embroidery was traditionally regarded as a lower tradition of Chinese crafts, and the comparison of painting to embroidery was a classic method of criticizing the painter's skillful craftsmanship. For example, as early as in the first quarter of the twelfth century, the literati scholar Dong You 董逌 complained that the court painter Zhao Chang's 趙昌 (active eleventh century) flower paintings lacked the sense of life and thus were like embroidered screens made by women.[32] To paraphrase Roslyn Lee Hammers, the bias towards artists who possessed technological or craft-related skills had appeared early in the Northern Song and had been firmly established as tradition by the Ming.[33]

Wu Kuan's poem also mentions Shundi, another Mongol emperor addicted to mechanical things. It indicates that Shundi not only appreciated Wang Zhenpeng's *jiehua*, but also relied on it to make an actual dragon boat successfully. However, Shundi's fondness for such *jiehua* had nothing to do with his ancestor Shizu's (Khubilai's) naval expansion, but rather was purely derived from his unbridled hedonism. The late-Yuan scholar Quan Heng 權衡 (active fourteenth century) elaborates further on Shundi's production of a dragon boat with moveable components in 1359:

帝又造龍舟，巧其機括，能使龍尾鬣皆動，而龍爪自撥水。帝每登龍舟，用綵女盛粧，兩岸挽之，一時興有所屬，輒呼而幸之。[34]

The Emperor also built a dragon boat. He made its components ingenious, which could make the dragon's tail and mane sway and its claws paddle automatically in the water. Whenever the emperor climbed up onto the boat, he used palace ladies, dressed in all their finery, to tow the boat along the banks of the river. Occasionally when he fancied someone on a whim, he would immediately summon her and have sexual intercourse with her.

Here, Shundi's dragon boat was simply a marvelous tool for him to wallow in licentiousness. It may be presumed that his appreciation of *jiehua* depicting such constructions also came from this purpose. It is worth noting that in the same year that Shundi made the dragon boat, a famine that caused nearly a million deaths occurred in the capital and rebellions continued in different areas of the country.[35] Shundi, the last Yuan emperor, obviously had forgotten his ancestor Shizu's (Khubilai's) ambition to maintain Mongol rule of China.

In summary, Yuan emperors' interest in complex constructions and *jiehua*—either for political aims or for imperial pleasures—provided Chinese literati, particularly Southerners, with a shortcut to officialdom. Artists actively presented *jiehua* to seek the personal favor of Mongol emperors. In addition, Chinese officials' judgments on the quality of *jiehua* emphasized its allusive

aspect and thus associated this painting genre with Confucian ideals of statecraft.

Elegant Gatherings: The Interactions between Southern Scholars and Northern Officials

In addition to Yuan emperors, there were other members of the Mongol ruling houses partial to *jiehua*, thus providing Chinese *jiehua* artists some opportunities to further their official careers. The Grand Princess Sengge Ragi of the Lu State exemplifies these patronage networks.[36] She was the daughter of Shunzong 順宗 (Darmabala, 1264–1292) and was closely connected to two of the most cultivated "Chinese-style" emperors in the Yuan history—she was the elder sister of Renzong and also the aunt and mother-in-law of Wenzong.[37] She was famous for having assembled a number of masterpieces of Chinese painting and calligraphy. The princess' seals can still be seen on paintings today, including *jiehua* such as the *Longchi jingdu tu* 龍池競渡圖 ("The Boat Race on the Dragon Pond") in Taipei and the *Guanghan gong tu* 廣寒宮圖 ("The Guanghan Palace") in Shanghai.[38] Like her brother Renzong, Sengge Ragi was extremely fond of Wang Zhenpeng's *jiehua*. In 1323, she held a historic elegant gathering at Tianqing Temple 天慶寺 to display her art collection.[39] While most works were dated to the Song and earlier periods, at least two paintings by Wang Zhenpeng—including his famous *Dragon Boat Regatta* handscroll—appeared in this event and became the few contemporary art works appreciated by Sengge Ragi.[40]

The elegant gathering, associated with art appreciation and literary activities, has long been bound up with the Chinese literati tradition. This princess-sponsored gathering, however, was not purely a leisure activity. Mid-Yuan court politics, to borrow Ankeney Weitz's words, "were plagued with factional tensions between groups of bureaucrats (of all ethnicities—Chinese, Mongols, and various Central Asian groups)."[41] Due to Sengge Ragi's close relationship with "Chinese-style" emperors Renzong and Wenzong, both her appropriation of literati culture and her adoption of Chinese elite behaviors helped this Mongol princess work in alliance with Chinese bureaucrats and increase her power. Sengge Ragi's political strategy, in turn, provided Chinese aspirants an occasion to socialize with dignitaries and thus to advance their careers. After all, the system of direct appointments left a great deal of space for powerful officials and aristocrats to recommend people. In this case, the appreciation of art works (including *jiehua*) in elegant gatherings served as a means to gain career opportunities. In Sengge Ragi's gathering, there were at least twenty-one officials (or retired officials) from different ethnic groups.[42] As the modern scholar Shih Shou-chien 石守謙 has pointed out, although Southerners like Feng Zizhen left many colophons on works collected by Sengge Ragi, they had

much less political power than participants who came from the northern areas of China, and these Han officials such as Wang Yue 王約 were known for their willingness and ability to elevate others.[43] Under the Mongols' dominion, it was reasonable for Northerners to gain an advantage over Southerners, since northern China was conquered much earlier than the southern area.

Aside from Sengge Ragi's gathering, Northern officials also played a dominant role in other elegant gatherings in Dadu. For example, almost all the members of the elegant gathering held at Snow Hall 雪堂 in around 1288 were northern Chinese.[44] Although Zhao Mengfu—a southern literatus and painter who later earned prestige in Dadu—also showed up, he had just arrived in the capital and needed support from others at that time. In fact, Zhao was a protégé of Zhang Kongsun 張孔孫 and Zhang Jiusi 張九思, two Northern officials who participated in the Snow Hall gathering.[45] It seems that elegant gatherings remained an effective means for Southerners' career advancement.

Even in the Jiangnan area of South China, Northern officials actively held elegant gatherings, invited multiethnic guests to appreciate art, and provided opportunities for Southerners to enter the officialdom. The Yuan scholar Liu Guan 柳貫 mentioned five such officials in his writing:

異時論至元間中州人物極盛，由去金亡未遠，而宋之故老遺民，往往多在⋯⋯遊仕于南而最愛錢塘山水者，予及識其五人焉，曰：李仲芳、髙彥敬、梁貢父、鮮于伯幾、郭祐之⋯⋯俱嗜吟，喜鑒之法書、名畫、古器物，而吳越之士因之引重亦數人⋯⋯時趙子昂解齊州歸吳興，頗亦來徔諸君醼集。[46]

In the past, it was said, the reason there were many luminaries in the central plain during the Zhiyuan reign was that it had not been long after the Jin's collapse and the leftover subjects of the Song were mostly alive . . . Among those who left the capital to serve as local officials in the South and favorited the landscape of Qiantang, I know five of them: Li Zhongfang, Gao Yanjing, Liang Gongfu, Xianyu Boji, Guo Youzhi . . . they were all addicted to reciting poems, and fond of appraising calligraphy models, famous paintings, and ancient objects. Because of this, several Wu-Yue people (Southerners) were recommended [by them] . . . At that time, Zhao Zi'ang was just dismissed from office in Qizhou and went back to Wuxing. Zhao always went to their elegant gatherings as well.

Liu Guan's passage describes the cultural exchanges between the North and the South after the Mongols' reunification of China and emphasizes the influential role of Northern officials such as Xianyu Shu 鮮于樞 (1257?–1302, *zi* Boji 伯幾) in the art activities of Qiantang. These officials' great enthusiasm for art contributed to their interests in holding elegant gatherings, which attracted local literati with similar tastes. And, in turn, these guests were likely to benefit from these gatherings and gain recommendations from these Northern officials. Xianyu Shu—a native of Jizhou 薊州 and an official living in Qiantang for more than ten years—for instance, held such a gathering in his residence

in the second lunar moon of 1298. Thirteen art connoisseurs presented themselves, including Northerners like Li Kan and Southerners like Zhao Mengfu and Zhou Mi 周密 (1232–1298). They viewed Wang Xizhi's 王羲之 (321–379) calligraphy "Sixiang tie" 思想帖 (*Sixiang Note*) and Guo Zhongshu's *jiehua* entitled *Travelling on the River in Clearing Snow* together.[47]

However, almost all of these northern-dominated elegant gatherings occurred before the mid-fourteenth century. After that, Northerners' cultural influence was severely diminished, at least in the Jiangnan area. By contrast, Southerners actively held their own elegant gatherings at that time. The most famous ones were Gu Ying's 顧瑛 (1310–1369) gatherings in his Thatched Hall at Jade Mountain 玉山草堂, which began in 1348 and lasted for seventeen years.[48] The host Gu Ying, a wealthy and cultivated Southerner, declined official positions offered by the Yuan government and chose to remain in retirement. He had a wide circle of acquaintances among southern Chinese. For his 1348 gathering, no Northerners appeared, and the Southerners present were mostly recluses (or retired literati); in addition, among sixty-nine guests associated with all of Gu's gatherings, only three came from the North and only sixteen had low official positions.[49] Gu Ying's example clearly shows two transformations in elegant gatherings in late-Yuan Jiangnan. Southerners not only replaced Northerners' active role, but also lost interest in seeking official advancement. In these gatherings, as David A. Sensabaugh has claimed, "we see the energies diverted by the frustrations of Mongol rule from traditional pursuits in philosophy and government now actively engaged in poetry and painting" and "such a way of life centered in the arts as a part of informal social intercourse created a precedent for a pattern of life in Wu, a pattern that was to flower in the fifteenth and sixteenth centuries."[50]

The alteration in the nature of elegant gatherings did not occur in isolation during the mid-fourteenth century. Simultaneously, the Four Great Masters' landscape style grew in popularity in South China and increasingly supplanted the Northern Song landscape style, which had long been favored by the Mongol court. Even *jiehua* artists, like Xia Yong, decided to abandon court painters' long-standing practice of combining the Li-Guo tradition and *jiehua* and instead began to incorporate the fully developed literati landscape style. In fact, Northerners' political advantage over Southerners in the Yuan government, as well as the Mongol ruling classes' predilection for the Li-Guo style, never changed until the disintegration of the empire. The things that abruptly changed during the 1340s and 1350s were the Mongols' power and Northerners' influence in southern China, both of which quickly deteriorated. A series of natural disasters and rebellions happened in the country during the reign of Shundi, the last Yuan emperor. Such political chaos extinguished Southerners' desire to advance into government, so they no longer needed to adapt their art to the tastes of the Mongol court and other northern patrons.

In this situation, other stimuli, such as the needs of the southern literati and the flourishing consumer markets, may play a more important role in the production of the late-Yuan *jiehua* in Jiangnan.

Conclusion

In order to comprehensively investigate Yuan's unique role in China's *jiehua* history, this book has considered how significant issues like modularity, craftsmanship, literati ideals, and imperial patronage influenced the development of this art form. In addition to the professional artist Xia Yong, this book has emphasized how *jiehua* masters interacted with the mid-Yuan court in northern China and beyond. Now it may be helpful to add a few brief remarks at the end and shift our perspective to the trends and developments of the post-1350 art in the south.

The city Suzhou became the most significant art center of the southeast in the late Yuan period. The Yuan provincial district circuit *Jiangzhe xingsheng* 江浙行省, which consisted of today's Zhejiang, Fujian, Shanghai, and the lower Yangtze River regions of Anhui and Jiangsu, had long been the wealthiest part of the country, and thus became a major focus of contention between Mongol rulers and rebels.[1] Although Suzhou, like other cities of this district, suffered greatly during rebellions and uprisings, it attained great prosperity under the domination of the rebel leader Zhang Shicheng 張士誠 (1321–1367) in the 1350s and 1360s. Zhang's nominal submission to the Yuan, effective agricultural and economic strategies, and active recruitment of intellectuals encouraged a significant number of southern literati to make the city their home. Literati artists in Suzhou and its nearby regions—such as Huang Gongwang 黃公望 (1259–1354) and Ni Zan, both members of the Four Masters of the Yuan—pioneered new artistic styles with expressive brushwork and paved the way for the southern style of landscape painting identified in the work of the artist Dong Yuan to dominate the later history of literati painting. The flowering of Suzhou's artists—particularly in their landscape paintings—overshadowed artistic trends developed in the other cities of the late Yuan Jiangnan. Evidence of painting and collecting practices in these areas is scattered and cannot rival the tradition associated with Suzhou.

Xia Yong's *jiehua* provide us with an unparalleled opportunity to examine how art other than landscape was produced and received in these ignored areas. Xia Yong came from Qiantang, a district of the Southern Song capital

Lin'an (today's Hangzhou). After the fall of this city to the Mongols, Hangzhou preserved its infrastructure and long remained a major hub of commerce in south China. In the field of art, the Southern Song Academic styles prevailed in this region, and brilliant artists from its neighboring city Wuxing—like Zhao Mengfu—brought in new art ideas, making Hangzhou a leading art center of the early Yuan, a position superseded by Suzhou later in the mid-fourteenth century. Despite Hangzhou's decline, many characteristics of Xia Yong's *jiehua* demonstrate his inheritance of the Southern Song legacy. Xia's surviving works retain the rendering of broad blank space and diagonal composition, two features typical of Southern Song Academic landscape paintings. In addition, the diagonal arrangement is always strengthened by a solid block of literary text in minute calligraphy placed at the top, a feature that sets Xia's *jiehua* apart from those made by contemporary court painters. Xia Yong's combination of painting, calligraphy, and literature also reflects a significant artistic trend in Song Academic painting and literati art. When we discuss Xia Yong's art in this book, the emphasis has been put on his multiple versions of the same composition and subject matter. His calligraphic inscriptions have only been treated as clues to the subject matter. It has never been explained how Xia Yong considered the relationship of texts to images and why he selected these literary sources. These questions will be answered in the following sections.

The Professional Atelier: An Alternative Interpretation of Xia Yong's *Jiehua*

In traditional Chinese connoisseurship, determining the authorship of a painting is absolutely central to determining its value. Signatures and seals form the basis of such an authentication process, because they are relatively difficult to forge and remain the customary form of identification among Chinese painters. It is safer for us to identify a painter who signed their work like Xia Yong or had access to Xia's own seal as Xia himself. Similarly, it can explain why we spent so much time analyzing the faked signature of Xia Yong in the *Palace by the River* (fig. 0.9) to decide the authenticity of this work.

Despite the significance of signatures and seals, it is the painter's original style that plays the decisive role in connoisseurs' judgements. For Xia Yong's authentic works listed at the beginning of the book, only some include his signatures or seals, but all their architectural images reflect Xia's style and thus should be from his hand. This makes us tend to take it for granted that the calligraphy of literary texts on Xia's paintings is also Xia Yong's. For connoisseurs, these calligraphic inscriptions draw less attention than signatures and are too small to allow for easy reading. However, after comparing literary texts on Xia Yong's *Yueyang Pavilion* paintings, the modern scholar Zhao Yang 趙陽 has proposed that they were inscribed by different calligraphers.[2] For example, when

the calligrapher of the Beijing fan wrote "ancient paragons of humanness," a phrase from Fan Zhongyan's "Yueyang lou ji," he used the characters "gu ren ren" 古人仁, completely different from the "gu ren ren" 古仁人 inscribed on the other five versions of Xia's *Yueyang Pavilion*. Since the calligraphic inscription on the Beijing fan contains Xia's signature and offers us the sole piece of information for Xia's dates, we might conclude that Xia Yong himself wrote this and simply made a clerical error here. However, this is not an isolated case. In three of Xia's *Yueyang Pavilion* paintings—namely, the Yunnan version, the Freer copy, and the Beijing album leaf—the first two characters of the sentence "regrets intensify and turn to melancholy" (感激/極而悲者矣) are written as "gan ji" 感激, but the other three versions—namely, the Taipei copy, the Beijing fan, and the Japan one—use the different characters "gan ji" 感極; as for the sentence "First feel concern for the concerns of the world. Defer pleasure until the world can take pleasure" (先天下之/知憂而憂，後天下之/知樂而樂), its two phrases "zhi you" 之憂 and "zhi le" 之樂, which appear in the Yunnan version, the Japan version, and the Freer version, differ from the "zhi you" 知憂 and "zhi le" 知樂 transcribed in the Beijing fan, the Beijing album leaf, and the Taipei one.[3] It is almost impossible that a calligrapher wrote all these texts and frequently made such clerical errors. Because all these *Yueyang Pavilions* show Xia Yong's superb *jiehua* skill and five even contain Xia's signatures or seals, it means that these paintings are indeed Xia's authentic works, but not all—or even none—of the calligraphy on them are Xia's.

If we take a closer look at the combination of texts and images in Xia's works, we will find that the selected literary text is always paired with a specific image and composition. No matter how similarly Xia assembled the architectural images in his *Yueyang Pavilion* and *Prince Teng Pavilion*, paintings with a building placed at the left must be *Yueyang Pavilion*, and those mirror versions could only be *Prince Teng Pavilion*. These paintings' themes are confirmed by their incorporate texts. The fixed juxtaposition of texts and images in Xia's works was most likely designed from the very beginning. Otherwise, it could not explain why both versions of Xia's *Yellow Pavilion* paintings coincidentally contain the man-on-a-crane image, a contradictory clue reflecting the theme of the Yellow Crane Tower. If the calligraphic inscriptions were tampered with later, it would have been more reasonable for forgers to select literary texts related to the Yellow Crane Tower instead of the Yellow Pavilion. In addition, inscriptions on many of Xia's paintings—including these two versions of *Yellow Pavilion*—are followed by Xia's seals. It means that not only are Xia's architectural images an assemblage of standard and simplified modules, but that the transcribed literary texts are also part of the transmitted modules. The image-text matching had been precisely decided before the artist began to work, which further complicates the modular system of Xia Yong's *jiehua*.

Apart from calligraphic inscriptions on Xia's works, we may surmise that other minor elements, such as landscape settings and figures, were sometimes done by others as well. For example, although we have confirmed Xia's general adoption of the late Yuan literati landscape style in his *jiehua*, we can see subtle differences between "his" representations of distant mountains, like those in his *Prince Teng Pavilion*. While the Shanghai and Freer ones (fig. 2.9 and 1.12) emphasize the dotted textures, the Boston one (plate 4) uses thick ink lines to highlight the mountain's rugged contours. In other words, Xia Yong cooperated with other specialists like calligraphers and landscapists to execute *jiehua*.

It was not rare for *jiehua* artists to collaborate with other specialists. Ren An 任安, a Northern Song *jiehua* artist, is recorded to have often worked with landscapists like Zhu Zongyi 朱宗翼 and He Zhen 賀真 to complete a single work.[4] However, distinguished from Zhu or He, Xia's colleagues did not leave their names in painting catalogs. Only Xia's signatures and seals frequently appear on their coordinated *jiehua*. It is most possible that Xia Yong directed the entire process of *jiehua* creation while others were only partially responsible. Their coordinated production, to borrow Lothar Ledderose's words, is "compartmentalized into single steps" and "these steps can also be viewed as modules—modules of work in a system of production."[5]

Such a system of production—characterized by "standardization, coordination, and predictability"—was more likely developed by professional workshops than individual literati painters, because this system encouraged efficiency to maximize profits.[6] Indeed, Xia Yong's *jiehua* possess the unique qualities of workshop products. In contrast to Wang Zhenpeng's long hand-scrolls and large hanging scrolls, Xia's paintings are either fans or album leaves. These miniature paintings are the perfect size for the painter to churn out quickly in large numbers. In addition, Xia Yong replicated his own paintings, developed a modular system of architectural drawing, and organized successful teamwork. His practice ensured sustained, consistent quality for multiple works in the most effective way, a feature shared by the production of commodities. Therefore, Xia Yong might have earned a living through selling paintings and leading a professional atelier.

Xia Yong's professional status can also be supported by the absence of his name from official histories and contemporary art texts. When we sought biographical information about Wang Zhenpeng and other Yuan *jiehua* artists mentioned in this book, we often turned to *Tuhui baojian*, a comprehensive reference work compiled by Xia Wenyan of Wuxing in 1365. After all, it records approximately 200 artists active from 1276 to the time of the author's writing, providing the broadest coverage of Yuan painters. However, *Tuhui baojian* completely ignores Xia Yong, a capable painter contemporary with the author and living in a nearby city. As noted by Deborah Del Gais Muller, there are underlying literati values hidden in *Tuhui baojian*, such as the overemphasized

interconnections of social class and artistic practices.[7] It further confirms that Xia Yong, neglected by this important painting catalogue, was a professional painter.

How do Xia's professional status and workshop practice influence our evaluation of his paintings' authenticity? When the modern scholar Chen Yunru studied the multiple *Dragon Boat* paintings in the style of Wang Zhenpeng, she gave up the quest for Wang's best copy or original copy. To paraphrase Chen, these paintings' production involved a certain division of labor in workshops, which made a single painting show varying levels of qualities in different areas and thus confused Wang's original style.[8] I agree with Chen that it makes no sense for us to pick out the best copy from the multiple versions of the same composition and subject matter made in workshops. However, distinguished from those *Dragon Boat* paintings, Xia Yong's *jiehua* are made up of simpler painting elements, and all their architectural images maintain a consistent quality, perfectly reflecting Xia's original style. Thus, there is no need to question Xia's authorship of these *jiehua*. In my opinion, Xia's atelier would have been a small enterprise. As its principal master, Xia Yong drew these massive architectural buildings, the most significant part of *jiehua*, and supervised the work of his apprentices and assistants. That is why the coordinated *jiehua* were released under his name.

After acknowledging Xia's *jiehua* to be workshop products, it is virtually impossible to divorce the participation of potential buyers from the production and transmission of these *jiehua* in the art market. What do texts inscribed on Xia's *jiehua* suggest about their audiences? Who were these audiences and what did Xia's *jiehua* offer them?

The Art Market: The Cultural Values of Buildings Painted

Despite the insufficiency of available data, some observations can be made regarding the art markets that existed for the late Yuan *jiehua* in the Jiangnan area. As already noted, Xia Yong's *Tower Reflected in the Lake* paintings differ from his other four groups of *jiehua* because there are no corresponding literary texts inserted. While texts and images are matching or interlocking modules in Xia's *Prince Teng Pavilion*, *Yueyang Pavilion*, *Pavilion of Prosperity and Happiness*, and *Yellow Pavilion*, texts on Xia's *Tower Reflected in the Lake* paintings are not exclusive modules, but interchangeable ones. The calligrapher flexibly added texts as the final step to accomplish those ready-made works, thus better meeting buyers' specific requirements. For example, Xia's Harvard version of the *Tower Reflected in the Lake* includes the brief inscription: "Painted for □□ (two faint characters) by Xia Yong Mingyuan from Qiantang," suggesting the painter was filling a commission. The questions are: Who was the original recipient? A bureaucrat, a merchant, an erudite recluse, or a literatus?

The initial audiences of Xia's *jiehua*, in my view, were likely educated clerks or lower-ranking literati in the Jiangnan area. Note that Ling Yunhan, a contemporary of Xia Yong from his hometown of Hangzhou and a scholar who rejected official appointment under the Yuan but instead served the following Ming, once wrote a poem on a painting by Xia.[9] We may surmise that Xia's *jiehua* once circulated among local literati, particularly those loyal to ethnically Chinese dynasties. However, I am not arguing that Xia's paintings should be interpreted as friendly gestures that this professional painter made to network with his literati friends or to enhance his social acceptance. Instead, I emphasize that Xia Yong either received commissions or openly sold his works in the art market to acquire profits. After all, in the title of Ling's poem, this literatus called Xia Yong by his courtesy name and last name—"Mingyuan Xiashi" 明遠夏氏—showing a reserved and distant manner not used between friends. The literati's disdain toward professional artists, who emphasized craft-related skills and painted to earn a living, already appeared in the Song-Yuan periods and further dominated the orthodox literati tradition in the Ming. In other words, Chinese literati-elite preferred amateur artmaking to buying paintings from professionals. Thus, only lower-status cultured clients would buy Xia's works of lesser art.

Xia Yong's painting strategies satisfied the demands of this clientele. His *jiehua* were all done in a small, portable format, which made them more affordable and informal than scrolls and thus quite suitable for lower-status gentlemen's private enjoyment or long-distance gift-giving. In addition, the placement of classical literary texts within the paintings not only demonstrates the owners' cultured taste and complete mastery of reading, but it also suggests that the owners identified themselves as lofty scholars who used painting as a means of expression. Indeed, Xia Yong's works exhibited distinct preferences with regard to subject matter. Considering the mercantile aspect of Xia's art, the incorporate literary texts should have given voices to the clientele's concerns and aspirations, rather than those of the painter.

Xia almost exclusively depicted grandiose Chinese palace structures—none of his extant paintings represents contemporary Mongol Yuan buildings—and made copious quotations from canonical Tang-Song literary sources, including Wang Bo's "Tengwang ge xu," Fan Zhongyan's "Yueyang lou ji," Su Zhe's "Huanglou fu," and Lin Yede's "Fengle lou fu" 豐樂樓賦 (Rhapsody on the Pavilion of Prosperity and Happiness). As previously discussed, during the last chaotic decades of the Yuan, the Mongol control waned and the respective positions of Yuan officials, southern literati, and other social groups underwent major changes. It should come as no surprise that erudite gentlemen in the south might favor painting themes linked to ethnically Chinese dynasties to shore up long-sagging Chinese pride and aim at resisting political authority. Xia Yong's preference for Song and earlier architectural subjects of the

prominent literary tradition might have been a means of keeping up with this latest fashion or of responding to an increased need for cultured clientele.

We can see that Xia Yong's *jiehua* reflect a transparent, general intention to imbue audiences with Chinese confidence, but his selective depiction of celebrated Chinese buildings was not random. Otherwise, it was more reasonable for Xia to identify his Group E of paintings as the Yellow Crane Tower than the Yellow Pavilion. After all, alongside the Prince Teng Pavilion and the Yueyang Pavilion—two of Xia Yong's favorite themes—the Yellow Crane Tower is also one of the "Three Great Towers of Jiangnan" and long recognized as a literary shrine, like the other two. That is why subsequent viewers easily conflated Xia's *Yellow Pavilion* with paintings of the Yellow Crane Tower. However, as discussed, Xia Yong—or, more precisely speaking, his potential buyers—preferred the Yellow Pavilion, a far less famous building and less conventional painting subject, to the Yellow Crane Tower. In addition, Xia deliberately concealed this real preference by adding the man-on-a-crane images to his *Yellow Pavilion* paintings.

In this case, we are compelled to reexamine literary sources selected by Xia. We need to elucidate the implicit meanings his *jiehua* evoked for a late-Yuan southern literatus and to discover what ideas, in addition to growing Chinese confidence, Xia sought to communicate. The literati writers or scholar-officials involved in Xia's *jiehua*—such as Wang Bo, Fan Zhongyan, Su Zhe, and Su Shi—were classically educated officials and highly respected throughout time for their achievements in literature. Wang Bo was a child prodigy and regarded as one of the "Four Outstanding Writers of the Early Tang." At a feast, he spontaneously improvised the "Tengwang ge xu," the one later inscribed on Xia's *Prince Teng Pavilion* paintings, sufficiently displaying Wang's superior ability in the parallel prose style. Similarly, Fan Zhongyan, Su Zhe, and Su Shi were all preeminent personalities of the Northern Song. They achieved notable success in the highest-level civil examinations and became Presented Scholars (*jinshi* 進士). Most importantly, they all embraced the ideal of classical-style prose (*guwen* 古文) and were engaged in reclaiming the authority of the classical. By inscribing these Northern Song intellectuals' prose poems, Xia Yong seemed to associate himself and his potential buyers with the tradition of classicism. Xia's painting style, which echoes the Northern Song literati artist Li Gonglin's "plain-drawing" method, further confirms this point. To paraphrase Roslyn Lee Hammers, when Su Shi claimed that Li Gonglin had captured the antique ideas of Gu Kaizhi and Lu Tanwei, Su was paying Li one of the greatest compliments possible by aligning his work with the classical.[10] Xia Yong displayed his historical consciousness through his adoption of both Song *guwen* writers' texts and the painting style they admired.

Among the four lengthy pieces of literary texts on Xia's extant paintings, the "Fengle lou fu" inscribed on Xia's *Pavilion of Prosperity and Happiness* is

relatively unusual. It is not as famous as the others, and its obscure author, Lin Yede, was not a talented personality like Wang Bo or Su Shi. This rhapsody describes the magnificence of the Pavilion of Prosperity and Happiness and the beauty of its nearby West Lake. It is possible that Xia Yong simply depicted this Southern Song site to remember the good old days in his hometown. Nevertheless, the following couplet from the rhapsody—"it is so fortunate that we enjoyed an enduring peace, and it is even better to share our pleasure with common people" (幸太平之日久，宜行樂以民同)—also suggests the author's concern for the welfare of the people.[11] In fact, both Fan Zhongyan, the author of the "Yueyang lou ji," and Su Shi, the protagonist of the "Huanglou fu," sympathized with commoners' difficult lives and actively oversaw the affairs of the people. Fan Zhongyan, a Confucian official of humble origin, proposed the Qingli 慶曆 Reform of 1043–1044 to ameliorate farmers' living standards. After the failure of this reform movement, Fan was appointed to local posts at his request and directly responded to the needs of the people. Fan's statement, "first feel concern for the concerns of the world and defer pleasure until the world can take pleasure" (先天下之憂而憂，後天下之樂而樂)—extracted from his text "Yueyang lou ji" and quoted by Xia's *Yueyang Pavilion* paintings—fully reflects this reformer's political aspiration and naturally became a motto for subsequent scholar-officials.[12] As for Su Shi, this Northern Song statesman also held a variety of local government positions in his life and maintained his concern for the welfare of the people. Su Zhe's prose poem "Huanglou fu," inscribed on Xia's *Yellow Pavilion* paintings, commemorates Su Shi's indefatigable administrative work in Xuzhou during a huge Yellow River flood in 1077 and expresses Su Shi's idea that "those who are used to happiness can never know why happiness becomes happiness; only by experiencing adversity first could they really know it." (今夫安於樂者，不知樂之為樂也，必涉於害者而後知之。)[13] This statement encouraged the scholar-officials to consider commoners' plights. Based on the cases of Fan Zhongyan and Su Shi—and perhaps also that of Lin Yede—we can see that the concern for the welfare of the people was viewed as central to Xia Yong's selection of historical figures for his *jiehua*.

Apart from talent and virtue, there is another point of similarity among scholar-officials who inspired Xia Yong. These aforementioned Tang-Song geniuses—including Wang Bo, Fan Zhongyan, and Su Shi—suffered demotion and exile. Wang Bo was expelled for his work of bitter satire and a complex murder case, which also implicated his father. This promising young scholar died by drowning when he went to visit his father in exile, and, perhaps on the same journey, Wang wrote his "Tengwang ge xu." That is why this prose poem is full of Wang's anguished lamentation and regret at not using his talent for the government. Similarly, Fan Zhongyan's "Yueyang lou ji" was composed after the failure of his reform program and commissioned by Fan's friend Teng Zijing 滕子京 (991–1047), who was also banished at that time. As for

Su Shi's case, although the "Huanglou fu" was completed before Su's major remote trips into exile in his life, Su's appointment as a local administrator in Xuzhou also resulted from political opposition. In Tang-Song literature, the issue of unvalued talent emerged frequently, and apparently, it continued to appeal to the late-Yuan southern literati, the highly targeted buyers of Xia's *jiehua*. By depicting buildings associated with these exiled literati, Xia Yong articulated the frustration of thwarted recognition of talent for government service and aligned his audiences with these Tang-Song literati whose ideology they admired. As already noted, the majority of Xia's audiences were lower-status local literati and educated clerks of the late Yuan. Confronted with the frustrations of Mongol rule, they had more difficulties in gaining entrée into the Yuan bureaucracy. Meanwhile, unlike those literati-elite, they were too poor to live in reclusion and too obscure to get recruited by the various insurgent forces operating in the area. These audiences used Xia's *jiehua*, linked to unvalued talent, as a means to express personal grievances. As early as the Northern Song, scholar officials were already quite used to this means—they hid coded expressions of protest and discontent in seemingly innocuous paintings, as thoroughly discussed by Alfreda Murck.[14]

Like his Song predecessors, Xia also learnt to conceal dangerous political messages on purpose. His *Yellow Pavilion* paintings are great examples. We must admit that Xia's paintings of this theme also explore what constituted an ideal scholar-official, a subject central to his other works like the *Yueyang Pavilion* and *Prince Teng Pavilion*. After all, Su Shi, the historic exemplar connected to Xia's *Yellow Pavilion*, had many spiritual qualities appreciated by literati such as (1) his remarkable talent and espousal of the classical ideals; (2) his concern for the welfare of the people; and (3) his integrity and, as a result, his exile. However, Xia's *Yellow Pavilion* paintings not only provide a traditional means for his audiences to identify themselves with the model scholar-official Su Shi, but also touch upon the topic of the Yellow River flood—Su Zhe's "Huanglou fu" highly praises Su Shi's excellent flood control in 1077. Considering the Yellow River's frequent flooding during the Yuan and the government's ineffective emergency management, it seems extremely provocative for Xia Yong to inscribe this rhapsody on his paintings.[15] In the late Yuan, catastrophic floods—particularly the one caused by the sudden break of the Yellow River's banks in the 1340s—led to widespread famine, which exacerbated existing social tensions and fueled violent conflict. In this situation, Xia's depiction of the Yellow Pavilion would be dangerous, because Mongol rulers would easily treat it as a sign of the painter's advocacy for rebellions. Xia was apparently aware of this, so he took effective strategies to protect himself and his like-minded audiences from the Yuan government's scrutiny. Here, I completely agree with the art historian Wen Fong's assertion that both the artist's transcription of Su Zhe's "Huanglou fu" in an illegible minute script and the

inclusion of the man-on-a-crane image, a contradictory clue linked with the more influential theme of the Yellow Crane Tower, aimed at "concealing his real message" about "the momentous social changes caused by the flood of the 1340s, which would lead to the downfall of the Yuan dynasty less than twenty years later."[16] It provides us with a different angle with which to approach the dilemma we encountered in interpreting the theme of Xia's Group E paintings, and supports the conclusion we reached in the first chapter: from the very beginning, Xia had intended to paint the Yellow Pavilion, not the Yellow Crane Tower.

We can see that Xia's *jiehua* enjoyed popularity with lower-ranking clerks and local literati, since the cultural values of his depicted buildings—either the growing Chinese confidence, or the development of an interest in the model scholar-official—paralleled social changes that occurred in the late-Yuan Jiangnan and met these audiences' needs. Even the artist's coded expression was a cultured practice inherited from the Song and perpetuated among literati circles. However, although the production of Xia's *jiehua* was driven primarily by local demand, we should not ignore the facts that Xia Yong's name appeared in sixteenth-century Japanese sources, and that some of his extant paintings and fakes—such as the *Yueyang Pavilion* held by Masamune Tokusaburō and the *Palace by the River* in the Jingyuanzhai collection—survive (or were once circulated) in Japan. In addition to Xia's *jiehua*, other Yuan professional artists' *jiehua*, like the one (fig. 0.1) imitating Li Rongjin's *Han Palace* and collected by the Osaka City Museum of Fine Arts, also found some popularity in this neighboring country. This is another noteworthy issue connected to the art market for late-Yuan *jiehua* in Jiangnan: namely, their exportation to other East Asian countries. It is unclear when these Yuan *jiehua* entered the overseas market. After the Yuan instituted a Maritime Trade Supervisorate in Hangzhou in 1284, this city continuously functioned as an important center of international trade and ocean shipping and was closely connected to Qingyuan (today's Ningbo), the major harbor for trade with Japan.[17] Despite a lack of documentary proof, there can be no doubt that Japanese monks and merchants actively sought paintings in art markets of Hangzhou and Ningbo during the Yuan-Ming transition. As for the early Ming period, Ashikaga Yoshimasa officially sent envoys to acquire Chinese art works. Therefore, though overshadowed by the flourishing of the literati landscape in Suzhou, we can assert that *jiehua* still grew steadily in the late-Yuan Jiangnan, responding to the need of local and overseas markets and providing a fuller picture of the East Asian world in the fourteenth century.

Notes

Introduction

1. Wenying 文瑩, *Yuhu qinghua* 玉壺清話 [Stories excerpted from corpora at Yuhu] (Beijing: Zhonghua shuju, 1997), 2:21; Jiren Feng, *Chinese Architecture and Metaphor: Song Culture in the Yingzao Fashi Building Manual* (Honolulu: University of Hawai'i Press, 2012), 201.

2. In Anglophone academia, the debate about the correct translation of *jiehua* began between Herbert A. Giles and J. C. Ferguson in the 1910s. When William Trousdale, Robert J. Maeda, and Marsha Smith Weidner made their preliminary investigation into architectural painting in the second half of the twentieth century, they all attempted to define the ambiguous term *jiehua*. This topic has still been important in recent studies of architectural painting, such as Anita Chung's 2004 book.

3. In most cases, I use *jie hua* for the loose verbal act of drawing boundaries, aiming to distinguish it from the classificatory term *jiehua*.

4. Jiang Renjie 蔣人傑 ed., *Shuowen jiezi jizhu* 說文解字集注 [Collected commentaries on explaining graphs and analyzing characters] (Shanghai: Shanghai guji chu-banshe, 1996), 2899.

5. Duan Yucai 段玉裁, *Shuowen jiezi zhu* 說文解字注 [Commentary on explaining graphs and analyzing characters], *juan* 13 (Taipei: Yiwen yinshuguan, 1974), 703.

6. Anita Chung, *Drawing Boundaries: Architectural Images in Qing China* (Honolulu: University of Hawai'i Press, 2004), 16.

7. Herbert A. Giles, *An Introduction to the History of Chinese Pictorial Art*, 2nd ed. (Shanghai: Messrs. Kelly & Walsh, Ld., 1918), 201.

8. Chen Jiru 陳繼儒, *Nigu lu* 妮古錄 [Record of fondness for antiquity], *juan* 3 (Taipei: Yiwen yinshuguan, 1965), 3:13; trans. with slight emendation, Herbert A. Giles, *An Introduction to the History of Chinese Pictorial Art*, 2nd ed. (Shanghai: Messrs. Kelly & Walsh, Ld., 1918), 202.

9. Herbert A. Giles, *An Introduction to the History of Chinese Pictorial Art*, 2nd ed. (Shanghai: Messrs. Kelly & Walsh, Ld., 1918), 201.

10. To my knowledge, the only exception is Fu Xinian 傅熹年, "Zhongguo gudai de jianzhuhua" 中國古代的建築畫 [On architectural painting of ancient China], *Wenwu* 文物, no. 3 (1998): 82. Fu pointed out that the term *jiehua* as a painting genre first appeared in the Southern Song period.

11. Guo Ruoxu 郭若虛, *Tuhua jianwen zhi* 圖畫見聞誌 [Experiences in painting], *juan* 1, in *Huashi congshu* 畫史叢書, ed. Yu Anlan 于安瀾 (Shanghai: Shanghai renmin meishu chubanshe, 1982), 1:6.

12. Translation adapted from Anita Chung, *Drawing Boundaries: Architectural Images in Qing China* (Honolulu: University of Hawai'i Press, 2004), 10–11.

13. Robert J. Maeda, "Chieh-Hua: Ruled-Line Painting in China," *Ars Orientalis* 10 (1975): 123–124; Susan Bush and Hsio-yen Shih, *Early Chinese Texts on Painting* (Hong Kong: Hong Kong University Press, 2012), 111–112.

14. Anita Chung, *Drawing Boundaries: Architectural Images in Qing China* (Honolulu: University of Hawai'i Press, 2004), 10–11; Jerome Silbergeld, "All Receding Together, One Hundred Slanting Lines: Replication, Variation, and Some Fundamental Problems in the Study of Chinese Paintings of Architecture," in *Qiannian danqing: xidu Zhong Ri cang Zhongguo Tang, Song, Yuan huihua zhenpin* 千年丹青：細讀中日藏中國唐宋元繪畫珍品, ed. Shanghai Museum (Beijing: Peking University Press, 2010), 16.

15. Xu Zhongshu徐中舒et al., *Hanyu da zidian* 漢語大字典 [The grand dictionary of Chinese characters] (Wuhan: Hubei cishu chubanshe, 2006), 1:556.

16. Li Jie 李誡, *Yingzao fashi* 營造法式 [State building standards], *juan* 14 (Shanghai: Shanghai guji chubanshe, 1987), 673–513. The term *Songwen* 松文is not clearly explained in *Yingzao fashi*, and thus has caused controversy among scholars. Here, my translation of *Songwen* is based on Su Bai's 宿白 explanation of this term. See Su Bai 宿白, *Baisha Song mu* 白沙宋墓 [The Song tomb in Baisha] (Beijing: Wenwu chubanshe, 2002), 78, note 114. This example of *jie hua* as a verb has been recognized by Chen Yunru 陳韻如, "'Jiehua' zai Song Yuan shiqi de zhuanzhe: yi Wang Zhenpeng de jiehua wei li"「界畫」在宋元時期的轉折：以王振鵬的界畫為例 [The change of *Jiehua* during the Song-Yuan period: The example of Wang Zhenpeng's *jiehua*], *Meishushi yanjiu jikan* 美術史研究集刊, no. 26 (2009): 145.

17. Deng Chun 鄧椿, *Huaji* 畫繼 [A continuation of the history of painting], *juan* 7, in *Huashi congshu* 畫史叢書, ed. Yu Anlan 于安瀾 (Shanghai: Shanghai renmin meishu chubanshe, 1982), 1:57.

18. Herbert A. Giles, *An Introduction to the History of Chinese Pictorial Art*, 2nd ed. (Shanghai: Messrs. Kelly & Walsh, Ld., 1918), 201.

19. Liu Xiang 劉向, *Shuoyuan* 說苑 [Garden of persuasions], in *Taiping guangji* 太平廣記, ed. Li Fang 李昉, *juan* 210 (Beijing: Zhonghua shuju, 1961), 1604.

20. Zhang Yanyuan 張彥遠, *Lidai minghua ji* 歷代名畫記 [Record of famous paintings of successive dynasties], *juan* 1, in *Huashi congshu* 畫史叢書, ed. Yu Anlan 于安瀾 (Shanghai: Shanghai renmin meishu chubanshe, 1982), 1:7.

21. Zhang Yanyuan 張彥遠, *Lidai minghua ji* 歷代名畫記 [Record of famous paintings of successive dynasties], *juan* 1, in *Huashi congshu* 畫史叢書, ed. Yu Anlan 于安瀾 (Shanghai: Shanghai renmin meishu chubanshe, 1982), 1:15–16 and 20–21.

22. Zhu Jingxuan 朱景玄, *Taochang minghua lu* 唐朝名畫錄 [Record of Famous Painters of the Tang Dynasty], in *Zhongguo shuhua quanshu* 中國書畫全書, ed. Lu Fusheng 盧輔聖 (Shanghai: Shanghai shuhua chubanshe, 2000), 1:161; trans. modified from Anita Chung, *Drawing Boundaries: Architectural Images in Qing China* (Honolulu: University of Hawai'i Press, 2004), 11.

23. Liu Daochun 劉道醇, *Shengchao minghua ping* 聖朝名畫評 [Evaluations of Song dynasty painters of renown], in *Zhongguo shuhua quanshu* 中國書畫全書, ed. Lu Fusheng 盧輔聖 (Shanghai: Shanghai shuhua chubanshe, 2000), 1:446–447; Liu Daochun 劉道醇, *Wudai minghua buyi* 五代名畫補遺 [A supplement on the famous painters of the Five Dynasties], in *Zhongguo shuhua quanshu* 中國書畫全書, ed. Lu Fusheng 盧輔聖 (Shanghai: Shanghai shuhua chubanshe, 2000), 1:460.

24. Guo Ruoxu 郭若虛, *Tuhua jianwen zhi* 圖畫見聞誌 [Experiences in painting], *juan* 3, in *Huashi congshu* 畫史叢書, ed. Yu Anlan 于安瀾 (Shanghai: Shanghai renmin meishu chubanshe, 1982), 1:38.

25. "The curricula of Xuanhe Calligraphy and Painting Systems include six: (1) Buddhist and Daoist subjects, (2) human figures, (3) landscapes, (4) birds and beasts, (5) bamboo and flowers, and (6) wooden constructions." (宣和書畫學之制……其習有六：一曰佛道，二曰人物，三曰山川，四曰鳥獸，五曰竹花，六曰屋木。) See Zhao Yanwei 趙彥衛 (fl. 1140, d. 1210), *Yunlu manchao* 雲麓漫鈔 [Casual notes from the cloudy foothill], *juan* 2 (Beijing: Zhonghua shuju, 1998), 28.

26. *Xuanhe huapu* 宣和畫譜 [The Xuanhe painting catalogue], in *Huashi congshu* 畫史叢書, ed. Yu Anlan 于安瀾 (Shanghai: Shanghai renmin meishu chubanshe, 1982), 2:5.

27. Tang Hou 湯垕, *Gujin huajian* 古今畫鑒 [Examination of past and present painting], in *Zhongguo shuhua quanshu* 中國書畫全書, ed. Lu Fusheng 盧輔聖 (Shanghai: Shanghai shuhua chubanshe, 2000), 2:903.

28. Trans. with slight emendation, Susan Bush and Hsio-yen Shih, *Early Chinese Texts on Painting* (Hong Kong: Hong Kong University Press, 2012), 248–249.

29. *Xuanhe huapu* 宣和畫譜 [The Xuanhe painting catalogue], *juan* 8, in *Huashi congshu* 畫史叢書, ed. Yu Anlan 于安瀾 (Shanghai: Shanghai renmin meishu chubanshe, 1982), 2:81–82.

30. Tao Zongyi 陶宗儀, *Nancun chuogeng lu* 南村輟耕錄 [Respite from plowing in the Southern Village], *juan* 28 (Beijing: Zhonghua shuju, 1959), 355. To be noted, this text ranks landscape painting the sixth and *jiehua* the tenth, different from Tang Hou's claim "landscape at the top and *jiehua* at the bottom."

31. Liu Daochun 劉道醇, *Shengchao minghua ping* 聖朝名畫評 [Evaluations of Song dynasty painters of renown], in *Zhongguo shuhua quanshu* 中國書畫全書, ed. Lu Fusheng 盧輔聖 (Shanghai: Shanghai shuhua chubanshe, 2000), 1:459.

32. Deng Chun 鄧椿, *Huaji* 畫繼 [A continuation of the history of painting], *juan* 7, in *Huashi congshu* 畫史叢書, ed. Yu Anlan 于安瀾 (Shanghai: Shanghai renmin meishu chubanshe, 1982), 1:57.

33. Hu Jing 胡敬, *Xiqing Zhaji* 西清箚記 [Notes about works in the imperial collection], *juan* 1 (Shanghai: Shanghai guji chubanshe, 1995), 64; Ruan Yuan 阮元, *Shiqu suibi* 石渠隨筆 [Shiqu jottings], *juan* 4 (Shanghai: Shanghai guji chubanshe, 1995), 452.

34. Deng Chun 鄧椿, *Huaji* 畫繼 [A continuation of the history of painting], *juan* 10, in *Huashi congshu* 畫史叢書, ed. Yu Anlan 于安瀾 (Shanghai: Shanghai renmin meishu chubanshe, 1982), 1:77.

35. English translation adapted from Heping Liu, "Painting and Commerce in Northern Song Dynasty China, 960–1126" (PhD diss., Yale University, 1997), 88.

36. Robert J. Maeda, "Chieh-Hua: Ruled-Line Painting in China," *Ars Orientalis* 10 (1975): 124; William Trousdale, "Architectural Landscapes Attributed to Chao Po-chü," *Ars Orientalis* 4 (1961), 287, note 10.

37. Wu Qizhen 吳其貞, *Shuhua ji* 書畫記 [A record of paintings and calligraphies], *juan* 5, in *Zhongguo shuhua quanshu* 中國書畫全書, ed. Lu Fusheng 盧輔聖 (Shanghai: Shanghai shuhua chubanshe, 2000), 8:106.

38. Zhang Yanyuan 張彥遠, *Lidai minghua ji* 歷代名畫記 [Records of famous paintings of successive dynasties], *juan* 2, in *Huashi congshu* 畫史叢書, ed. Yu Anlan 于安瀾 (Shanghai: Shanghai renmin meishu chubanshe, 1982), 1:22.

39. Trans. with slight emendation, Susan Bush and Hsio-yen Shih, *Early Chinese Texts on Painting* (Hong Kong: Hong Kong University Press, 2012), 61–62.

40. Shen Kangshen 沈康身, "Jiehua shixue he toushixue" 界畫視學和透視學 [*Jiehua*'s perspective and perspective], in *Kejishi wenji* 科技史文集 (Shanghai: Shanghai kexue jishu chubanshe, 1982), 8:161.

41. Zha Yingguang 查應光, *Jinshi* 靳史 [Jin history], *juan* 21, in *Siku jinhui shu congkan shi bu* 四庫禁燬書叢刊 · 史部 (Beijing: Beijing chubanshe, 1997), 29:451.

42. Anita Chung, *Drawing Boundaries: Architectural Images in Qing China* (Honolulu: University of Hawai'i Press, 2004), 16.

43. Guo Ruoxu 郭若虛, *Tuhua jianwen zhi* 圖畫見聞誌 [Experiences in painting], *juan* 1, in *Huashi congshu* 畫史叢書, ed. Yu Anlan 于安瀾 (Shanghai: Shanghai renmin meishu chubanshe, 1982), 1:6.

44. Tang Hou 湯垕, *Gujin huajian* 古今畫鑒 [Examination of past and present painting], in *Zhongguo shuhua quanshu* 中國書畫全書, ed. Lu Fusheng 盧輔聖 (Shanghai: Shanghai shuhua chubanshe, 2000), 2:903; trans. with slight emendation, Susan Bush and Hsio-yen Shih, *Early Chinese Texts on Painting* (Hong Kong: Hong Kong University Press, 2012), 249.

45. Anita Chung, *Drawing Boundaries: Architectural Images in Qing China* (Honolulu: University of Hawai'i Press, 2004), 16.

46. Marsha Smith Weidner, "Painting and Patronage at the Mongol Court of China, 1260–1368" (PhD diss., University of California, Berkeley, 1982), 234, note 40.

47. Li E 厲鶚, *Nansong yuanhua lu* 南宋院畫錄 [Records on paintings of the Southern Song Academy], *juan* 5, in *Huashi congshu* 畫史叢書, ed. Yu Anlan 于安瀾 (Shanghai: Shanghai renmin meishu chubanshe, 1982), 4:96 and 99.

48. Rao Ziran 饒自然, *Huizong shierji* 繪宗十二忌 [The twelve faults in painting tradition], in *Zhongguo shuhua quanshu* 中國書畫全書, ed. Lu Fusheng 盧輔聖 (Shanghai: Shanghai shuhua chubanshe, 2000), 2:952.

49. Tang Hou 湯垕, *Gujin huajian* 古今畫鑒 [Examination of past and present painting], in *Zhongguo shuhua quanshu* 中國書畫全書, ed. Lu Fusheng 盧輔聖 (Shanghai: Shanghai shuhua chubanshe, 2000), 2:903; trans. slightly modified from Robert J. Maeda, "Chieh-Hua: Ruled-Line Painting in China," *Ars Orientalis* 10 (1975): 141, note 78.

50. *Xuanhe huapu* 宣和畫譜 [The Xuanhe painting catalogue], *juan* 8, in *Huashi congshu* 畫史叢書, ed. Yu Anlan 于安瀾 (Shanghai: Shanghai renmin meishu chubanshe, 1982), 2:81.

51. Trans. with slight emendation, Susan Bush and Hsio-yen Shih, *Early Chinese Texts on Painting* (Hong Kong: Hong Kong University Press, 2012), 112–113.

52. For examples, Anita Chung has already provided a detailed description of principles like "faultless calculation" and "structural clarity." Anita Chung, *Drawing Boundaries: Architectural Images in Qing China* (Honolulu: University of Hawai'i Press, 2004), 17–29.

53. Guo Ruoxu 郭若虛, *Tuhua jianwen zhi* 圖畫見聞誌 [Experiences in painting], *juan* 1, in *Huashi congshu* 畫史叢書, ed. Yu Anlan 于安瀾 (Shanghai: Shanghai renmin meishu chubanshe, 1982), 1:6; trans. by Robert J. Maeda, "Chieh-Hua: Ruled-Line Painting in China," *Ars Orientalis* 10 (1975): 123.

54. Guo Ruoxu 郭若虛, *Tuhua jianwen zhi* 圖畫見聞誌 [Experiences in painting], *juan* 1, in *Huashi congshu* 畫史叢書, ed. Yu Anlan 于安瀾 (Shanghai: Shanghai renmin meishu chubanshe, 1982), 1:6; trans. by Robert J. Maeda, "Chieh-Hua: Ruled-Line Painting in China," *Ars Orientalis* 10 (1975): 123–124.

55. Li Zhi 李廌, *Deyutang huapin* 德隅堂畫品 [Evaluations of painters from the Deyu studio], in *Zhongguo shuhua quanshu* 中國書畫全書, ed. Lu Fusheng 盧輔聖 (Shanghai: Shanghai shuhua chubanshe, 2000), 1:991; trans. modified from Robert J. Maeda, "Chieh-Hua: Ruled-Line Painting in China," *Ars Orientalis* 10 (1975): 126.

56. *Xuanhe huapu* 宣和畫譜 [The Xuanhe painting catalogue], *juan* 8, in *Huashi congshu* 畫史叢書, ed. Yu Anlan 于安瀾 (Shanghai: Shanghai renmin meishu chubanshe, 1982), 2:82; trans. Heping Liu, "Painting and Commerce in Northern Song Dynasty China, 960–1126" (PhD diss., Yale University, 1997), 136.

57. Xu Qin 徐沁, *Ming hua lu* 明畫錄 [Records of Ming painting], *juan* 1, in *Huashi congshu* 畫史叢書, ed. Yu Anlan 于安瀾 (Shanghai: Shanghai renmin meishu chubanshe, 1982), 3:14.

58. Guo Ruoxu 郭若虛, *Tuhua jianwen zhi* 圖畫見聞誌 [Experiences in painting], *juan* 1, in *Huashi congshu* 畫史叢書, ed. Yu Anlan 于安瀾 (Shanghai: Shanghai renmin meishu chubanshe, 1982), 1:6.

59. Trans. with emendation, Alexander C. Soper, *Kuo Jo-Hsü's Experiences in Painting (T'u-hua chien-wen chih): An Eleventh Century History of Chinese Painting Together with the Chinese Text in Facsimile* (Washington: American Council of Learned Societies, 1951), 13.

60. Huang Xiufu 黃休復, *Yizhou minghualu* 益州名畫錄 [Records of famous painters of Yizhou], *juan* Zhong 中, in *Huashi congshu* 畫史叢書, ed. Yu Anlan 于安瀾 (Shanghai: Shanghai renmin meishu chubanshe, 1982), 4:20.

61. Trans. Heping Liu, "Painting and Commerce in Northern Song Dynasty China, 960–1126" (PhD diss., Yale University, 1997), 129.

62. Hu Zhiyu 胡祗遹, *Zishan daquanji* 紫山大全集 [Complete works of Zishan], *juan* 14, in *Wenyuan ge siku quanshu* 文淵閣四庫全書 (Taipei: Taiwan shangwu yinshuguan, 1973), 1196:261.

63. Zhang Yanyuan 張彥遠, *Lidai minghua ji* 歷代名畫記 [Records of famous paintings of successive dynasties], *juan* 5, in *Huashi congshu* 畫史叢書, ed. Yu Anlan 于安瀾 (Shanghai: Shanghai renmin meishu chubanshe, 1982), 1:70; trans. Jerome Silbergeld, "All Receding Together, One Hundred Slanting Lines: Replication, Variation, and Some Fundamental Problems in the Study of Chinese Paintings of Architecture," in *Qiannian danqing: Xidu Zhong Ri cang Zhongguo Tang, Song, Yuan*

huihua zhenpin 千年丹青：細讀中日藏中國唐宋元繪畫珍品, ed. Shanghai Museum (Beijing: Peking University Press, 2010), 16.

64. Zhu Jingxuan 朱景玄, *Taochang minghua lu* 唐朝名畫錄 [Record of famous painters of the Tang dynasty], in *Zhongguo shuhua quanshu* 中國書畫全書, ed. Lu Fusheng 盧輔聖 (Shanghai: Shanghai shuhua chubanshe, 2000), 1:161.

65. Tang Hou 湯垕, *Gujin huajian* 古今畫鑒 [Examination of past and present painting], in *Zhongguo shuhua quanshu* 中國書畫全書, ed. Lu Fusheng 盧輔聖 (Shanghai: Shanghai shuhua chubanshe, 2000), 2:903.

66. Xu Qin 徐沁, *Ming hua lu* 明畫錄 [Records of Ming painting], *juan* 1, in *Huashi congshu* 畫史叢書, ed. Yu Anlan 于安瀾 (Shanghai: Shanghai renmin meishu chubanshe, 1982), 3:14.

67. Trans. Anita Chung, *Drawing Boundaries: Architectural Images in Qing China* (Honolulu: University of Hawai'i Press, 2004), 32.

68. Zheng Ji 鄭績, *Menghuan ju huaxue jianming* 夢幻居畫學簡明 [The essence of the painting technique of the Menghuan studio], *juan* 1, in *Xuxiu siku quanshu* 續修四庫全書 (Shanghai: Shanghai guji chubanshe, 1995), 1086: 191–192.

69. Zhang Yanyuan 張彥遠, *Lidai minghua ji* 歷代名畫記 [Records of famous paintings of successive dynasties], *juan* 2, in *Huashi congshu* 畫史叢書, ed. Yu Anlan 于安瀾 (Shanghai: Shanghai renmin meishu chubanshe, 1982), 1:22; trans. modified from Susan Bush and Hsio-yen Shih, *Early Chinese Texts on Painting* (Hong Kong: Hong Kong University Press, 2012), 61–62.

70. *Xuanhe huapu* 宣和畫譜 [The Xuanhe painting catalogue], *juan* 8, in *Huashi congshu* 畫史叢書, ed. Yu Anlan 于安瀾 (Shanghai: Shanghai renmin meishu chubanshe, 1982), 2:81.

71. William Trousdale, "Architectural Landscapes Attributed to Chao Po-chü," *Ars Orientalis* 4 (1961): 285–313; Robert J. Maeda, "Chieh-hua: Ruled-line Painting in China," *Ars Orientalis* 10 (1975): 123–141.

72. Anita Chung, *Drawing Boundaries: Architectural Images in Qing China* (Honolulu: University of Hawai'i Press, 2004). Some relevant dissertations are as follows: Marsha Smith Weidner, "Painting and Patronage at the Mongol Court of China, 1260–1368" (PhD diss., University of California, Berkeley, 1982); Liu Heping, "Painting and Commerce in Northern Song Dynasty China, 960–1126" (PhD diss., Yale University, 1997); Wang Hui Chuan, "The Use of the Grid System and Diagonal Line in Chinese Architecture Murals: A Study of the 14th Century Yongle Gong Temple with Further Analyses of Two Earlier Examples, Prince Yide's Tomb and Yan Shan Si Temple" (PhD diss., University of Melbourne, 2009). A relevant article is Jerome Silbergeld, "All Receding Together, One Hundred Slanting Lines: Replication, Variation, and Some Fundamental Problems in the Study of Chinese Paintings of Architecture," in *Qiannian danqing: Xidu Zhong Ri cang Zhongguo Tang, Song, Yuan huihua zhenpin* 千年丹青：細讀中日藏中國唐宋元繪畫珍品, ed. Shanghai Museum (Beijing: Peking University Press, 2010), 15–29, 131–150.

73. An example is Fu Xinian 傅熹年, "Wang Ximeng Qianli jiangshan tu zhong de beisong jianzhu" 王希孟《千里江山圖》中的北宋建築 [Northern Song architecture in Wang Ximeng's *One Thousand Li of Rivers and Mountains*], in *Zhongguo shuhua jianding yu yanjiu Fu Xinian juan* 中國書畫鑒定與研究傅熹年卷 (Beijing: Gugong chubanshe, 2014), 84–111.

74. An important study of the Qingming scroll is Roderick Whitfield, "Chang Tse-Tuan's Ch'ing-Ming Shang-Ho t'u" (PhD diss., Princeton University, 1965). More studies of the Qingming scroll have been fully discussed and summarized in Zhou Baozhu 周寶珠, *Qingming shanghe tu yu Qingming shanghe xue* 清明上河圖與清明上河學 [*Qingming shanghe tu* and studies of the Qingming scroll] (Kaifeng: Henan daxue chubanshe, 1997), 178–192; Dai Liqiang 戴立強 ed., *Qingming shanghe tu yanjiu wenxian huibian*《清明上河圖》研究文獻匯編 [Collections of research articles on the *Qingming shanghe tu*] (Shenyang: Wanjuan chuban gongsi, 2007). Other Song *jiehua* also received considerable attention. Some related studies are as follows: Liu Heping, "'The Water Mill' and Northern Song Imperial Patronage of Art, Commerce, and Science," *Art Bulletin* 84, no. 4 (December 2002): 566–595; Cary Y. Liu, "Sung Dynasty Painting of the T'ai-ch'ing-lou Library Hall: From Historical Commemoration to Architectural Renewal," in *Arts of the Sung and Yüan: Ritual, Ethnicity, and Style in Painting*, ed. Cary Y. Liu and Dora C. Y. Ching (Princeton: Princeton University Art Museum, 1999), 94–119.

75. The most recent study of Qing *jiehua* is Anita Chung, *Drawing Boundaries: Architectural Images in Qing China* (Honolulu: University of Hawai'i Press, 2004).

76. The number of extant Yuan *jiehua* follows Yu Hui's count. Yu Hui 余輝, "Renzhi Wang Zhenpeng, Lin Yiqing ji Yuandai gongting jiehua" 認知王振朋、林一清及元代宮廷界畫 [Interpreting Wang Zhenpeng, Lin Yiqing, and the Yuan court *Jiehua*], in *Meishu shi yu guannian shi* 美術史與觀念史, ed. Fan Jingzhong 范景中 and Cao Yiqiang 曹意強 (Nanjing: Nanjing shifan daxue chubanshe, 2003), 82.

77. For example, Marsha Smith Weidner wrote a short subsection on Xia Yong in the chapter on Wang Zhenpeng in her dissertation "Painting and Patronage at the Mongol Court of China, 1260–1368" (PhD diss., University of California, Berkeley, 1982), 177–184. In Anglophone academia, forty years after Weidner, no one has found out much more. Chinese scholars such as Chen Yunru 陳韻如 and Yu Hui 余輝 also have largely limited their research efforts to Wang Zhenpeng. Some examples are: Chen Yunru 陳韻如, "Jiyi de tuxiang: Wang Zhenpeng longzhou tu yanjiu" 記憶的圖像：王振鵬龍舟圖研究 [Images from times past: a study of Wang Zhenpeng's dragon boat paintings], *Gugong xueshu jikan* 故宮學術季刊 20, no. 2 (2002): 129–164; Chen Yunru 陳韻如, "'Jiehua' zai Song Yuan shiqi de zhuanzhe: yi Wang Zhenpeng de jiehua wei li" "界畫"在宋元時期的轉折：以王振鵬的界畫為例 [The change of *jiehua* during the Song-Yuan period: the example of Wang Zhenpeng's *jiehua*], *Meishushi yanjiu jikan* 美術史研究集刊, no. 26 (2009): 135–192; Yu Hui 余輝, "Renzhi Wang Zhenpeng, Lin Yiqing ji Yuandai gongting jiehua" 認知王振朋、林一清及元代宮廷界畫 [Interpreting Wang Zhenpeng, Lin Yiqing, and the Yuan court *Jiehua*], in *Meishu shi yu guannian shi* 美術史與觀念史, ed. Fan Jingzhong 范景中 and Cao Yiqiang 曹意強 (Nanjing: Nanjing shifan daxue chubanshe, 2003), 53–92; Yu Hui 余輝, "Wang Zhenpeng yu Guanghangong tu zhou kao" 王振朋與《廣寒宮圖》軸考 [Wang Zhenpeng and the study of the *Moon Palace* scroll], in *Qiannian yizhen guoji xueshu yantaohui lunwenji* 千年遺珍國際學術研討會論文集, ed. Shanghai Museum (Shanghai: Shanghai shuhua chubanshe, 2006), 620–628.

78. Wei Dong 魏冬, "Xia Yong ji qi jiehua" 夏永及其界畫 [Xia Yong and his *Jiehua*], *Gugong bowuyuan yuankan* 故宮博物院院刊, no. 4 (1984): 68–83; Masaaki Itakura 板

倉聖哲, "Gakazo to shite no kaei、sono seiritsu to tenkai:《take yorozu》o chushin ni" 画家像としての夏永、その成立と展開:《岳陽楼図》を中心に [The formation and development of Xia Yong as a painter: Focusing on the *Yueyang Pavilion* painting], *Bijutsu forum 21* 美術フォーラム21, no. 32 (2015): 103–109; Masaaki Itakura 板倉聖哲, "Kaeihitsu Take yorozu" 夏永筆岳陽楼図 [The *Yueyang Pavilion* painting by Xia Yong], *Kokka* 國華 122, no. 3 (October 2016): 33, 35–39.

79. Note that Xia's signature on the Harvard copy is unclear. Apart from these three artworks, a painting previously in the Jingyuanzhai 景元齋 collection also includes Xia Yong's signature. However, the authenticity of this work is still controversial.

80. Sōami 相阿彌, *Kundaikan sayū chōki* 君台觀左右帳記 [Kundaikan Souchoki] (1511 version), photocopy in Yano Tamaki 矢野環, *Kundaikan sō chōki no sōgō kenkyū* 君台觀左右帳記の総合研究 [A comprehensive study of Kundaikan Souchoki] (Tōkyō: Bensei shuppan, 1999), 51. James Cahill has already realized the record of Xia Yong in *Kundaikan sayū chōki*. See James Cahill, *An Index of Early Chinese Painters and Paintings: T'ang, Sung, and Yüan* (Berkeley: University of California Press, 1980), 277.

81. Shūe Matsushima 松島宗衛, *Kundaikan sō chōki kenkyū* 君台觀左右帳記研究 [A study of Kundaikan Souchoki] (Tōkyō: Chūō Bijutsusha, 1931), 272. Probably due to this period's introduction of Xia's paintings to Japan, today there exist several works attributed to Xia Yong in Japan, but their authenticity is in question.

82. Wei Dong 魏冬, "Xia Yong ji qi jiehua" 夏永及其界畫 [Xia Yong and his *jiehua*], *Gugong bowuyuan yuankan* 故宮博物院院刊, no. 4 (1984): 73.

83. Masaaki Itakura 板倉聖哲, "Kaeihitsu Take yorozu" 夏永筆岳陽楼図 [The *Yueyang Pavilion* painting by Xia Yong], *Kokka* 國華 122, no. 3 (October 2016): 35.

84. This poem is not inscribed on any extant paintings by Xia Yong, but is included in Ling Yunhan 凌雲翰, *Zhexuan ji* 柘軒集 [Zhexuan collection], in *Siku quanshu* 四庫全書 (Shanghai: Shanghai guji chubanshe, 1987), 1227:796. Both Chen Yunru and Itakura discuss this poem in their articles, and I provide a different interpretation in the first chapter of this book. See Chen Yunru 陳韻如, "'Jiehua' zai Song Yuan shiqi de zhuanzhe: yi Wang Zhenpeng de jiehua wei li" "界畫" 在宋元時期的轉折：以王振鵬的界畫為例 [The change of *jiehua* during the Song-Yuan period: The example of Wang Zhenpeng's *jiehua*], *Meishushi yanjiu jikan* 美術史研究集刊, no. 26 (2009): 166; Masaaki Itakura 板倉聖哲, "Kaeihitsu Take yorozu" 夏永筆岳陽楼図 [The *Yueyang Pavilion* painting by Xia Yong], *Kokka* 國華 122, no. 3 (October 2016): 35.

85. Zhan Jingfeng 詹景鳳, *Zhan Dongtu Xuanlan bian* 詹東圖玄覽編 [Zhan Dongtu's notes on masterpieces of art and calligraphy], *juan* 3, in *Zhongguo shuhua quanshu* 中國書畫全書, ed. Lu Fusheng 盧輔聖 (Shanghai: Shanghai shuhua chubanshe, 2000), 4:31.

86. Wei Dong 魏冬, "Xia Yong ji qi jiehua" 夏永及其界畫 [Xia Yong and his *jiehua*], *Gugong bowuyuan yuankan* 故宮博物院院刊, no. 4 (1984): 70; Yu Jianhua 俞劍華, *Zhongguo meishujia renming cidian* 中國美術家人名辭典 [Biographical dictionary of Chinese artists] (Shanghai: Shanghai renmin meishu, 1991), 671.

87. The text from *Huajian xiaoyu* is quoted from Wei Dong 魏冬, "Xia Yong ji qi jiehua" 夏永及其界畫 [Xia Yong and his *jiehua*], *Gugong bowuyuan yuankan* 故宮博物院院刊 no. 4 (1984): 70.

88. Jiang Shaoshu 姜紹書, *Yunshizhai bitan* 韻石齋筆談 [Notes of the Yunshi studio], *juan xia*下, in *Zhibuzuzhai congshu* 知不足齋叢書 (Taipei: Yiwen yinshuguan, 1966), 11.

89. A different interpretation of Jiang's text has been provided by the modern scholar Yuhang Li. Although she realizes the close relationship between the *baimiao* painting style and *faxiu* (hair embroidery), she still treats Xia's works as commercial hair embroidery. Note that she admits it is unclear why there existed such non-Buddhist subjects in hair embroidery as those chosen by Xia. See Yuhang Li, "Embroidering Guanyin: Constructions of the Divine through Hair," *East Asian Science, Technology, and Medicine*, no. 36 (2012): 138, 153. In my opinion, subsequent embroidery craftsmen might use fine embroidery to reproduce Xia Yong's *jiehua*, complicating the relation between Xia's painting and hair embroidery, but meanwhile, I insist that Xia himself was not an embroidery craftsman.

90. Today, there are three extant copies of the *Prince Teng Pavilion*, as well as two copies which have always been regarded as the *Yellow Crane Tower*.

91. I have made a comprehensive investigation of Xia's paintings in the mainland and Taiwan of China, the United States, and Europe—there are at least fourteen works by Xia. I believe that in Japan, there are also some paintings attributable to Xia with varying degrees of plausibility. For example, *Chūgoku kaiga sōgō zuroku* 中國繪畫總合圖錄 (Comprehensive Illustrated Catalog of Chinese Paintings) lists three paintings under Xia Yong's name in Japanese collections, including two in the Nezu Museum and one in the Tokyo National Museum. Unfortunately, I have not had access to these Japanese collections. For Xia's works in Japan, my count mainly depends on Masaaki Itakura's recent studies. In Itakura's opinion, only one piece, among possible works of Xia in Japan, has been judged to be the authentic work of Xia Yong in the reassessment of recent years. See Masaaki Itakura 板倉聖哲, "Gakazo to shite no kaei、sono seiritsu to tenkai:《take yorozu》o chushin ni" 画家像としての夏永、その成立と展開:《岳陽楼図》を中心に [The formation and development of Xia Yong as a painter: focusing on the *Yueyang Pavilion* painting], *Bijutsu forum 21* 美術フォーラム21, no. 32 (2015): 103–109; Masaaki Itakura 板倉聖哲, "Kaeihitsu Take yorozu" 夏永筆岳陽楼図 [The *Yueyang Pavilion* painting by Xia Yong], *Kokka* 國華 122, no. 3 (October 2016): 33, 35–39.

92. Wang Zhenpeng was titled as "Guyun chushi" 孤雲處士 by the Yuan Emperor Renzong. See Wang Deyi 王德毅, Li Rongcun 李榮村, Pan Baicheng 潘柏澄, et al. eds., *Yuanren zhuanji ziliao suoyin* 元人傳記資料索引 [Index to Yuan biographical materials] (Taipei: Xin wenfeng chubanshe, 1979–1982), 192.

93. In academia, the *Boya Plays the Zither* is one of the most widely accepted authentic paintings by Wang Zhenpeng, so there is almost no room for doubt about Wang's seal on it. It follows that the Freer seal, which is so different from the aforementioned seal, must be a counterfeit.

94. Zhao Fumin (the painting's owner)'s 1879 colophon says: "The person who wrote this label ascribed this painting to Wang Guyun." (此幅題籤者識為王孤雲。) Thus, this label was added before Zhao got the painting. Zhao also offers some information about the previous owner: "In the fourth year of the Guangxu reign (1878), I was appointed to work at Pinyang and accidently got this painting. I asked others

and realized that it previously belonged to the family of Zhu Shanhui, a local gentleman living at the beginning of this dynasty. This work should be treasured." (光緒四年攝頻陽，於無意中偶得之，詢知為國初邑紳朱山輝先生家舊物，是可寶已。)

95. These colophons were cut off from the original mounting, disarranged, and then pasted on the reverse of the Boston copy.

96. It must be noted that there was another painting titled Xia Yong's *Yueyang Pavilion* appearing at Sotheby's Hong Kong sale (HK0166) on October 29, 2000. See Sotheby's Hong Kong, Ltd., *Important Classical Chinese Paintings and Calligraphy* (Hong Kong: Sotheby's auction catalogue, 2000), lot 12, page 19. Like Xia's other *Yueyang Pavilion*, this painting also includes Fan Zhongyan's "Yueyang lou ji." However, the artist's seal on this painting reads "Mingyuan" 明遠, which does not appear in any other paintings of Xia Yong; moreover, the painting does not successfully achieve Xia's perfect drawing of lines. Hence, I believe this painting is a fake.

97. The colophon is also recorded in Li Zuoxian 李佐賢, *Shiquan shuwu leigao* 石泉書屋類稿 [Categorized drafts of rock-and-spring studio], *juan* 6 (Shanghai: Shanghai guji chubanshe, 1995), 687.

98. Wang Jie 王杰 et al., eds., *Qinding shiqu baoji xubian* 欽定石渠寶笈續編 [Supplement to the imperially ordered precious bookbox of the Shiqu library) (Haikou: Hainan chubanshe, 2001), 3:267.

99. Ruan Yuan 阮元, *Shiqu suibi* 石渠隨筆 [Shiqu jottings], *juan* 1 (Shanghai: Shanghai guji chubanshe, 1995), 422.

100. The copy includes a label reading "Li Sheng yueyang lou tu" 李昇岳陽樓圖 (Li Sheng's *Yueyang Pavilion*).

101. Wang Jie 王杰 et al., eds., *Qinding shiqu baoji xubian* 欽定石渠寶笈續編 [Supplement to the imperially ordered precious bookbox of the Shiqu library] (Haikou: Hainan chubanshe, 2001), 5:34.

102. Wei Dong 魏冬, "Xia Yong ji qi jiehua" 夏永及其界畫 [Xia Yong and his *Jiehua*], *Gugong bowuyuan yuankan* 故宮博物院院刊, no. 4 (1984): 74–76; Xue Yongnian 薛永年, "Qinggong jiucang chuan Li Sheng yueyanglou tu kaobian" 清宮舊藏傳李昇岳陽樓圖考辨 [A study of the *Yueyang Pavilion* attributed to Li Sheng and previously held by the Qing court), *Shoucang jia* 收藏家, no. 1 (1995): 17.

103. There is another signature by Xia Yong on the Harvard copy, but it is indistinct.

104. Sima Qian 司馬遷, *Shiji* 史記 [Records of the grand historian], *juan* 6 (Beijing: Zhonghua shuju, 2013), 1:328. The Ming local chronicle *Wanli Qiantang Xianzhi* 萬曆錢塘縣志 (Qiantang Chronicle of the Wanli Reign) also records: "The First Emperor of the Qin . . . divided the empire into 36 Commanderies. He named the area of the Wu and Yue as Kuaiji Commandery, which contained 24 Districts. Among these Districts, there were 4 in the Hang area, and Qiantang was one of them. The district name Qiantang first appeared in the Qin." (秦始王……分天下為三十六郡，以吳越地置會稽郡，領縣二十四，在杭者四，錢唐其一也，縣名錢唐自秦昉也。) Nie Xintang 聶心湯, *Wanli Qiantang xianzhi* 萬曆錢塘縣志 [Qiantang chronicle of the Wanli reign] (the 1893 version) (Taipei: Chengwen chubanshe, 1975), 1:40–41.

105. The Song scholar Wang Xiangzhi 王象之 (twelfth century) summarizes: "The place had been written as *Qiantang* 錢唐 from *Hanzhi* to *Suizhi* and began to be

written as *Qiantang* 錢塘 in *Tangshuzhi*" (然自《漢志》至《隋志》并作 "錢唐"。至《唐書志》始作 "錢塘"。) See Wang Xiangzhi 王象之, *Yudi jisheng* 輿地紀勝 [Records of famous places]; *juan* 2 (Chengdu: Sichuan daxue chubanshe, 2005), 1:68. Indeed, Qiantang 錢塘 as a Tang-period district was recorded in *Jiu Tangshu* 舊唐書 [The old Tang history] and *Xin Tangshu* 新唐書 [The new Tang history], and this place name was followed in subsequent official histories such as *Songshi* 宋史 [The Song history], *Yuanshi* 元史 [The Yuan history], and *Mingshi* 明史 [The Ming history]. See Liu Xu 劉昫, *Jiu Tangshu* 舊唐書 [The old Tang history], *juan* 40 (Beijing: Zhonghua shuju, 1975), 5:1588; Ouyang Xiu 歐陽修 and Song Qi 宋祁, *Xin Tangshu* 新唐書 [The new Tang history], *juan* 41 (Beijing: Zhonghua shuju, 1975), 4:1059; Tuotuo 脫脫 et al., *Song shi* 宋史 [The Song history], *juan* 88 (Beijing: Zhonghua shuju, 1977), 7:2174; Song Lian 宋濂 et al., *Yuan shi* 元史 [The Yuan history], *juan* 62 (Beijing: Zhonghua shuju, 1976), 5:1492. Several different explanations for this change of character have been proposed. For example, Liu Daozhen 劉道真, a magistrate of the Qiantang District during the Song period, writes: "The big dam against sea was around one *li* from the east of the district. Hua Xin, a regional official in the Consultation Section, suggested building this dam to prevent sea water from coming into the district. At the beginning, people who could carry a *hu* of earth would be paid a thousand *qian*. In a short time, many people gathered. Before the dam was completed, [the government] no longer asked for more people [to do this]. Thus, those who already carried earth and stones threw these materials there and left. Because of this, the dam was completed, and thus the place name was changed to *Qiantang* 錢塘." (防海大塘在縣東一里許，郡議曹華信家議立此塘以防海水。始開募有能致一斛土者，即與錢一千。旬月之間，來者雲集。塘未成而不復取。于是載土石者皆棄而去。塘以之成，故改名錢塘焉。) See *Qiantang ji* 錢唐記 [Qiantang gazetteer] quoted in Li Daoyuan 酈道元, *Wangshi hejiao shuijing zhu* 王氏合校水經注 [Commentary on the *Waterways Classic*, collated by Wang], collated by Wang Xianqian 王先謙, *juan* 40 (Shanghai: Zhonghua shuju, 1936), 18:6. The most popular explanation in the Ming-Qing period is that changing the character Tang 唐 to Tang 塘 aimed at avoiding the taboo of the dynasty name Tang 唐. For instance, the Ming local chronicle *Wanli Qiantang Xianzhi* 萬曆錢塘縣志 [Qiantang chronicle of the Wanli reign] records: "In the fourth year of the Tang Wude reign (621), its name was changed to Hangzhou again, and Qiantang belonged to Hangzhou. Because of the taboo of the dynasty name, the character Tang was changed to Tang (with the radical Tu), the District name Qiantang began from Tang Wude reign." (唐武德四年復改杭州，錢唐隸杭州，諱國號，易唐為塘，縣名錢塘則自唐武德昉也。) See Nie Xintang 聶心湯, *Wanli Qiantang Xianzhi* 萬曆錢塘縣志 [Qiantang chronicle of the Wanli reign] (the 1893 version) (Taipei: Chengwen chubanshe, 1975), 1:41. The Qing scholar Chen Menglei 陳夢雷 also claims: "During the Tang, [the place name] went against the taboo of the dynasty name, so the character Tang 唐 was changed to Tang 塘, and the place was thus named Qiantang District 錢塘縣." (唐諱國號，易 "唐" 為 "塘"，名錢塘縣。) See Chen Menglei 陳夢雷, *Gujin tushu jicheng fangyu huibian zhifangdian* 古今圖書集成 · 方輿彙編 · 職方典 [Complete collection of illustrations and writings from the earliest to current times, geography, political divisions of China], *juan* 935 (Shanghai: Zhonghua shuju, 1934),

133:55. Gu Zuyu 顧祖禹 also says: "The place name was originally Qiantang 錢唐. The Tang used the character Tang 唐 as the dynasty name, so the radical *tu* 土 was added to the character 唐 in the original place name, and the method was followed in later times." (治本曰錢唐，唐以唐為國號，加土為塘，後因之。) See Gu Zuyu 顧祖禹, *Dushi fangyu jiyao* 讀史方輿紀要 [Essentials of geography for reading history], *juan* 90 (Beijing: Zhonghua shuju, 2005), 4124.

106. This painting was previously collected by the Qing court and was the twelfth leaf in the fourth volume of the *Yanyun jihui* 煙雲集繪 [Collected paintings of smoke and cloud]. See Wang Jie 王杰 et al., eds., *Qinding shiqu baoji xubian* 欽定石渠寶笈續編 [Supplement to the imperially ordered precious bookbox of the Shiqu library] (Haikou: Hainan chubanshe, 2001), 2:50.

107. Yu Ji 虞集 writes in his "Wang Zhizhou muzhiming" 王知州墓志銘 [The Prefect Wang's epitaph]: "[Wang] once created the painting *Daming Palace* and sent it to the court. People praised the work for its ultimate beauty." (嘗為《大明宮圖》以獻，世稱為絕。) See Yu Ji 虞集, *Daoyuan xuegu lu* 道園學古錄 [Daoyuan's record of studying antiquity], *juan* 19 (Taipei: Taiwan zhonghua shuju, 1981), 1.

108. The title label reads "Wang Zhenpeng yingshui loutai" 王振鵬映水樓臺 [Wang Zhenpeng's *Tower Reflected in the Lake*]. Wang Jie 王杰 et al., eds., *Qinding shiqu baoji xubian* 欽定石渠寶笈續編 [Supplement to the imperially ordered precious bookbox of the Shiqu library] (Haikou: Hainan chubanshe, 2001), 2:50.

109. "Object Number 1923.231," the Harvard Art Museums, accessed May 23, 2020, https://www.harvardartmuseums.org/collections/object/210064?q=xia+yong.

110. See Suzuki Kei's note written on October 28, 1975, kept in the archives of the Harvard Museums.

111. Zhejiang daxue zhongguo gudai shuhua yanjiu zhongxin 浙江大學中國古代書畫研究中心, *Yuanhua quanji* 元畫全集 [A complete collection of Yuan painting] (Hangzhou: Zhejiang daxue chubanshe, 2012), no. 4, 1:273; Zhejiang daxue zhongguo gudai shuhua yanjiu zhongxin 浙江大學中國古代書畫研究中心, *Yuanhua quanji* 元畫全集 [A complete collection of Yuan painting] (Hangzhou: Zhejiang daxue chubanshe, 2012), no. 3, 2:292.

112. Qian Shuoyou 潛說友, *Xianchun Lin'an zhi* 咸淳臨安志 [Gazetteer of Lin'an from the Xianchun reign period], *juan* 32, in *Songyuan fangzhi congkan* 宋元方志叢刊 (Beijing: Zhonghua shuju, 1990), 4:3651; Tian Rucheng 田汝成, *Xihu youlan zhi* 西湖遊覽志 [Record on West Lake tour], *juan* 8, in *Siku quanshu* 四庫全書 (Shanghai: Shanghai guji chubanshe, 1987), 585:138.

113. Wei Dong 魏冬, "Xia Yong ji qi jiehua" 夏永及其界畫 [Xia Yong and his *Jiehua*], *Gugong bowuyuan yuankan* 故宮博物院院刊, no. 4 (1984): 78–79.

114. Qian Shuoyou 潛說友, *Xianchun Lin'an zhi* 咸淳臨安志 [Gazetteer of Lin'an from the Xianchun reign period], *juan* 33, in *Songyuan fangzhi congkan* 宋元方志叢刊 (Beijing: Zhonghua shuju, 1990), 4:3665.

115. Wei Dong 魏冬, "Xia Yong ji qi jiehua" 夏永及其界畫 [Xia Yong and his *Jiehua*], *Gugong bowuyuan yuankan* 故宮博物院院刊, no. 4 (1984): 80–81.

Chapter 1

1. Su Zhe 蘇轍, *Su Zhe ji* 蘇轍集 [Collected works of Su Zhe], *juan* 17 (Beijing: Zhonghua shuju, 1999), 1:335.
2. Yan Bojin 閻伯瑾, "Huanghe lou ji" 黃鶴樓記 [Record of the Yellow Crane Tower], in *Quan Tang wen* 全唐文, ed. Dong Gao 董誥 et al., *juan* 440 (Beijing: Zhonghua shuju, 1983), 5:4483.
3. Yue Shi 樂史 ed., *Taiping huanyu ji* 太平寰宇記 [Records of the universal realm in Taiping era], *juan* 112, in *Wenyuan'ge siku quanshu* 文淵閣四庫全書 (Taipei: Taiwan Shangwu yinshuguan, 1983), 470:188; Wang Qi 王圻 and Wang Siyi 王思義, eds., *Sancai tuhui* 三才圖會 [Illustrated compendium of the Three Powers], *juan* 10 (Shanghai: Shanghai guji chubanshe, 1985), 349.
4. For example, *Nanqi zhi* 南齊志 [Southern Qi treatise] writes: "The immortal Wang Zi'an rode a yellow crane and passed this place." (仙人王子安乘黃鶴過此。) See Xue Gang 薛剛 and Wu Tinju 吳廷舉, eds., *Jiajing huguang tujing zhishu* 嘉靖湖廣圖經志書 [Illustrated gazetteer of Huguang province, Jiajing reign], *shang ce* 上冊, *juan* 2 (Beijing: Shumu wenxian chubanshe, 1991), 139.
5. Peng Dingqiu 彭定求 (1645–1719) et al., eds., *Quan Tang shi* 全唐詩 [Complete Tang poems], *juan* 130 (Beijing: Zhonghua shuju, 2012), 4:1329; trans. with small modifications by Stephen Owen, *The Great Age of Chinese Poetry: The High Tang* (New Haven: Yale University Press, 1981), 62. Owen uses another version of this poem which includes the line "昔人已乘白雲去."
6. Li Jifu 李吉甫, *Yuanhe junxian tuzhi* 元和郡縣圖志 [Maps and gazetteer of the commanderies and counties in the Yuanhe period], *juan* 27 (Beijing: Zhonghua shuju, 1983), 644.
7. Lu You 陸遊, "Rushu ji" 入蜀記 [Record of a trip to Shu], *juan* 3, in *Wenyuan'ge siku quanshu* 文淵閣四庫全書 (Taipei: Taiwan Shangwu yinshuguan, 1983), 460:908.
8. Based on several thirteenth-century literati's poems on the Yellow Crane Tower, Wang Zhaopeng 王兆鵬 and Shao Dawei 邵大為 propose that this tower was rebuilt before 1220. See Wang Zhaopeng 王兆鵬 and Shao Dawei 邵大為, "Song qian huanghe lou xingfei kao" 宋前黃鶴樓興廢考 [A study of the rise and fall of the Yellow Crane Tower before the Song], *Jianghan luntan* 江漢論壇, no. 1 (2013): 95–96; Shao Dawei, "Tidai yu buchang: huanghe lou yu sheshan nanlou guanxi kao" 替代與補償：黃鶴樓與蛇山南樓關係考 [Replacement and complement: A study of the relationship between the Yellow Crane Tower and the Southern Pavilion of the Snake Mountain], *Jianghan luntan* 江漢論壇, no. 8 (2020): 94–95. While I agree with their judgement to some extent, I think it is better to be more careful to deal with the relationship between poetic literature and historical facts.
9. Despite the lack of Yuan documents on the Yellow Crane Tower, a few Yuan poets—like those thirteenth-century ones—left us poems on this theme. For example, Chen Fu 陳孚 (1240–1303) wrote the poem "E'zhu wantiao" 鄂渚晚眺 [Overlook in the evening from E'zhu], in *Mingke huanghe lou ji jiaozhu* 明刻黃鶴樓集校注, ed. Sun Chengrong 孫承榮 et al. (Wuhan: Hubei renmin chubanshe, 1992), 109–110. Wang Guangyang 汪廣洋 (d. 1379) wrote the poem "Guimao qiu, dajun wei Wuchang, yu jiyu yideng huanghe lou, bu shuri fuming huan jianye, mosui suohuai, nai fu qiyan

yiji yuxing" 癸卯秋，大軍圍武昌，予極慾一登黃鶴樓，不數日復命還建業，莫遂所懷，乃賦七言以寄予興 (In the autumn of the Guimao year [1363], the army besieged Wuchang. I really hoped to climb the Yellow Crane Tower, but I had to provide an after-action report and thus returned to Jianye, so I did not do what I wanted to do. Hence, I wrote a seven-character verse to express my feelings.), in *Mingke huanghe lou ji jiaozhu* 明刻黃鶴樓集校注, ed. Sun Chengrong 孫承榮 et al. (Wuhan: Hubei renmin chubanshe, 1992), 111–112. Nevertheless, these poems are very expressive. They do not describe the detailed appearance of the Yellow Crane Tower. A reader cannot even decide whether these poets saw the actual building or just imagined the past in its ruins. For instance, the aforementioned poet Wang Guangyang honestly admitted that he did not visit the tower, but still created a poem on it. The earlier Song poet Lu You, whose travel diary confirmed the non-existence of the tower in his time, also composed a poem on this theme. See Lu You 陸遊, "Huanghe lou" 黃鶴樓 [Yellow Crane Tower], in *Mingke huanghe lou ji jiaozhu* 明刻黃鶴樓集校注, ed. Sun Chengrong 孫承榮 et al. (Wuhan: Hubei renmin chubanshe, 1992), 103–104. Therefore, such poetic literature is not so reliable (or decisive) for our investigation.

10. Song Minwang 宋民望, "Chongjian nanlou ji" 重建南樓記 [Record of rebuilding the Southern Pavilion], in *Mingke huanghe lou ji jiaozhu* 明刻黃鶴樓集校注, ed. Sun Chengrong 孫承榮 et al. (Wuhan: Hubei renmin chubanshe, 1992), 480–481.

11. Fang Xiaoru 方孝孺, "Shu huanghe lou juan hou" 書黃鶴樓卷后 [Inscribing at the end of the handscroll painting *Yellow Crane Tower*], in *Mingke huanghe lou ji jiaozhu* 明刻黃鶴樓集校注, ed. Sun Chengrong 孫承榮 et al. (Wuhan: Hubei renmin chubanshe, 1992), 390–392.

12. *Mingshi* 明史 [History of the Ming]: "Zhen, the King Zhao of Chu, was the sixth son of Taizu (the first Ming emperor). When he was born, the news that the Ming army conquered Wuchang was just received. Taizu happily said: 'When he grew up, I would nominate him to the Chu.' In the third year of the Hongwu reign (1370), Zhen was nominated as the Chu king. In the fourteenth year (1381), he arrived at Wuchang." (楚昭王楨，太祖第六子。始生時，平武昌報適至，太祖喜曰："子長，以楚封之。" 洪武三年封楚王。十四年就藩武昌。) See Zhang Tingyu 張廷玉 et al., eds., *Mingshi* 明史 [History of the Ming], *juan* 116 (Beijing: Zhonghua shuju, 1974), 3570. Fang Xiaoru's words suggest that the early Ming Yellow Crane Tower was rebuilt between the nomination of the Chu king and his arrival at Wuchang: namely, between 1370 and 1381.

13. *Daming xuantian shangdi ruiying tulu* 大明玄天上帝瑞應圖錄 [Illustrated record of the auspicious responses by the Supreme Emperor of the Dark Heaven to the great Ming dynasty], in *Zhengtong daozang* 正統道藏, ed. Zhang Yuchu 張宇初 et al. (Taipei: Xinwenfeng, 1985), 32:817.

14. After the reconstruction of the Yellow Crane Tower in the 1370s, the next restoration project of this tower occurred during the Chenghua reign (1465–1487). It is said: "[The Yellow Crane Tower] was damaged because it aged considerably. During the Chenghua reign of this dynasty, Lai Fuxuan from the Chu royal clan donated money and encouraged local people to build [the tower]. Wu Chen, the censor-in-chief, repaired it." (〔黃鶴樓〕年久傾圮，本朝成化間楚府宗室來複軒捐資倡

郡人創建，都御史吳琛脩葺。) See Xue Gang 薛剛 and Wu Tinju 吳廷舉, eds., *Jiajing huguang tujing zhishu* 嘉靖湖廣圖經志書 [Illustrated gazetteer of Huguang province, Jiajing reign], *shang ce* 上冊, *juan* 2 (Beijing: Shumu wenxian chubanshe, 1991), 139. The text corresponding to the aforementioned Yellow Crane Tower illustration indicates that the depicted miracle happened in 1412, and the *Zhengtong daozang* 正統道藏 [Daoist canon of the Zhengtong reign], which preserved the *Daming xuantian shangdi ruiying tulu* 大明玄天上帝瑞應圖錄 [Illustrated record of the auspicious responses by the Supreme Emperor of the Dark Heaven to the great Ming dynasty], was compiled and published in 1445. This means that the second restoration of the Yellow Crane Tower in the Ming period happened after the illustration appeared. Therefore, the depicted tower should be the one built in the 1370s.

15. In this print, the Yellow Crane Tower should be the one in the upper right, instead of the one in the upper left. After all, the right one occupies more space and looks more significant, and there is a pagoda nearby, which should be the Shengxiang baota 勝象寶塔 (Shengxiang Pagoda) standing near the Yellow Crane Tower.

16. The date of the mural series was inscribed by artisans on the south wall in Chunyang Hall. Ka Bo Tsang, "Further Observations on the Yuan Wall Painter Zhu Haogu and the Relationship of the Chunyang Hall Wall Paintings to 'The Maitreya Paradise' at the ROM," *Artibus Asiae* 52, no. 1/2 (1992): 96–97.

17. Miao Shanshi 苗善時 ed., *Chunyang dijun shenhua miaotong ji* 純陽帝君神化妙通紀 [Annals of the wondrous communications and divine transformations of the Sovereign Lord Chunyang], *juan* 5, in *Zhengtong daozang* 正統道藏, ed. Zhang Yuchu 張宇初 et al. (Taipei: Xinwenfeng, 1985), 9:361–362.

18. Some examples are as follows: Li Song 李松, "Yongle gong bihua wuti" 永樂宮壁畫五題 [The five subjects on the murals in the Yongle Monastery], in *Yongle gong bihua* 永樂宮壁畫, ed. Xiao Jun 蕭軍 (Beijing: Wenwu chubanshe, 2008), 21; Xiao Jun 蕭軍, "Yongle gong gaishu" 永樂宮概述 [A profile of the Yongle Monastery], in *Yongle gong bihua* 永樂宮壁畫, ed. Xiao Jun 蕭軍 (Beijing: Wenwu chubanshe, 2008), 43.

19. *Lishi zhenxian tidao tongjian* 歷世真仙體道通鑑 [A comprehensive mirror on successive generations of perfected transcendents who embody the Dao], *juan* 45, in *Zhengtong daozang* 正統道藏, ed. Zhang Yuchu 張宇初 et al. (Taipei: Xinwenfeng, 1985), 8:703.

20. Xiao Jun 蕭軍, "Yongle gong gaishu" 永樂宮概述 [A profile of the Yongle Monastery], in *Yongle gong bihua* 永樂宮壁畫, ed. Xiao Jun 蕭軍 (Beijing: Wenwu chubanshe, 2008), 25.

21. Although this Guangdong painting includes the purported signature of the Northern Song painter Li Gonglin 李公麟 (1049–1106), it has been commonly dated to the Yuan period by modern connoisseurs. See Zhongguo gudai shuhua jianding zu 中國古代書畫鑑定組 ed., *Zhongguo gudai shuhua tumu* 中國古代書畫圖目 [Illustrated catalogue of selected works of ancient Chinese painting and calligraphy] (Beijing: Wenwu chubanshe, 1997), 13:19; Zhejiang daxue zhongguo gudai shuhua yanjiu zhongxin 浙江大學中國古代書畫研究中心 ed., *Yuanhua quanji* 元畫全集 [Complete collection of Yuan painting] (Hangzhou: Zhejiang daxue chubanshe, 2012–), no. 2, 3:321.

22. Ling Yunhan 凌雲翰, *Zhexuan ji* 柘軒集 [Zhexuan collection], in *Siku quanshu* 四庫全書 (Shanghai: Shanghai guji chubanshe, 1987), 1227:796.

23. Peng Dingqiu 彭定求 (1645–1719) et al., eds., *Quan Tang shi* 全唐詩 [Complete Tang poems], *juan* 130 (Beijing: Zhonghua shuju, 2012), 4:1329; translated with small modifications by Stephen Owen, *The Great Age of Chinese Poetry: The High Tang* (New Haven: Yale University Press, 1981), 62.

24. For example, Chen Yunru directly identified the painting Ling saw as a *Yellow Crane Tower*. Chen Yunru 陳韻如, "'Jiehua' zai Song Yuan shiqi de zhuanzhe: yi Wang Zhenpeng de jiehua wei li" "界畫"在宋元時期的轉折：以王振鵬的界畫為例 [The change of *jiehua* during the Song-Yuan period: The example of Wang Zhenpeng's *jiehua*], *Meishushi yanjiu jikan* 美術史研究集刊, no. 26 (2009): 166.

25. Gao Pian 高駢, "Shanting xiari" 山亭夏日 [Summer days in mountain villa], in *Quan Tangshi* 全唐詩, ed. Peng Dingqiu 彭定求 et al., *juan* 598 (Beijing: Zhonghua shuju, 1999), 9:6976.

26. The term *jia he* 駕鶴 is also a euphemism for "die."

27. Sima Guang 司馬光 ed., *Zizhi tongjian* 資治通鑑 [Comprehensive mirror for aid in government], *juan* 254 (Shanghai: Shanghai guji chubanshe, 1987), 782.

28. Sima Guang 司馬光 ed., *Zizhi tongjian* 資治通鑑 [Comprehensive mirror for aid in government], *juan* 254 (Shanghai: Shanghai guji chubanshe, 1987), 782–783.

29. The painter's possible intent will be further discussed in the conclusion of this book.

30. Ledderose has creatively studied the modular production in Chinese art across different media and periods, including Chinese writing scripts, Shang-Zhou ritual bronzes, Qin terracotta army, buildings, woodblock printing, and others. Lothar Ledderose, *Ten Thousand Things: Module and Mass Production in Chinese Art* (Princeton, NJ: Princeton University Press, 2000). Ledderose's module theory has stimulated interest in issues of image transmission and mass production, particularly in the field of Buddhist and Daoist art. Recent studies include Shih-shan Susan Huang, "Media Transfer and Modular Construction: The Printing of Lotus Sutra Frontispieces in Song China," *Ars Orientalis* 41 (2011): 135–163; and Hsueh-man Shen, *Authentic Replicas: Buddhist Art in Medieval China* (Honolulu: University of Hawai'i Press, 2018). As for the field of *jiehua*, Chen Yunru has already depended on the case of Wang Zhenpeng to discuss the modular system in Yuan *jiehua*. Chen Yunru 陳韻如, "Jiyi de tuxiang: Wang Zhenpeng longzhou tu yanjiu" 記憶的圖像：王振鵬龍舟圖研究 [Images from times past: a study of Wang Chen-p'eng's dragon boat paintings], *Gugong xueshu jikan* 故宮學術季刊 20, no. 2 (2002): 129–164; Chen Yunru 陳韻如, "'Jiehua' zai Song Yuan shiqi de zhuanzhe: yi Wang Zhenpeng de jiehua wei li" "界畫"在宋元時期的轉折：以王振鵬的界畫為例 [The change of *Jiehua* during the Song-Yuan period: The example of Wang Zhenpeng's *jiehua*], *Meishushi yanjiu jikan* 美術史研究集刊, no. 26 (2009): 135–192. In this section, I will follow up and concentrate on Xia Yong's art to study the unique modular system in Yuan *jiehua*.

31. Chen Yunru 陳韻如, "'Jiehua' zai Song Yuan shiqi de zhuanzhe: yi Wang Zhenpeng de jiehua wei li" "界畫"在宋元時期的轉折：以王振鵬的界畫為例 [The change of *jiehua* during the Song-Yuan period: The example of Wang Zhenpeng's *jiehua*],

Meishushi yanjiu jikan 美術史研究集刊, no. 26 (2009): 166; Jerome Silbergeld, "All Receding Together, One Hundred Slanting Lines: Replication, Variation, and Some Fundamental Problems in the Study of Chinese Paintings of Architecture," in *Qiannian danqing: Xidu Zhong Ri cang Zhongguo Tang, Song, Yuan huihua zhenpin* 千年丹青：細讀中日藏中國唐宋元繪畫珍品, ed. Shanghai Museum (Beijing: Peking University Press, 2010): 15–29, 131–150.

32. Ledderose made a detailed analysis of the modular system of Chinese architecture (building blocks, brackets, and beams). See Lothar Ledderose, *Ten Thousand Things: Module and Mass Production in Chinese Art* (Princeton, NJ: Princeton University Press, 2000), 103–138.

33. Xia Wenyan 夏文彥, *Tuhui baojian* 圖繪寶鑑 [Precious mirror of painting], *juan* 1, in *Huashi congshu* 畫史叢書, ed. Yu Anlan 于安瀾 (Shanghai: Shanghai renmin meishu chubanshe, 1982), 2:3; trans. with slight modification, Robert Hans Van Gulik, *Chinese Pictorial Art as Viewed by the Connoisseur* (Roma: Istituto Italiano per il Medio ed Estremo Oriente, 1958), 342.

34. Heping Liu, "Painting and Commerce in Northern Song Dynasty China, 960–1126" (PhD diss., Yale University, 1997), 87.

35. Tang Zhiqi 唐志契, *Huishi weiyan* 繪事微言 [Painting matters in subtle words], in *Zhongguo hualun leibian* 中國畫論類編, ed. Yu Jianhua 俞劍華 (Beijing: Renmin meishu chubanshe, 1986), 2:746–747.

36. Trans. with slight modification, Anita Chung, *Drawing Boundaries: Architectural Images in Qing China* (Honolulu: University of Hawai'i Press, 2004), 41.

37. Lothar Ledderose, *Ten Thousand Things: Module and Mass Production in Chinese Art* (Princeton, NJ: Princeton University Press, 2000), 163–186.

38. Tang Zhiqi 唐志契, *Huishi weiyan* 繪事微言 [Painting matters in subtle words], in *Zhongguo hualun leibian* 中國畫論類編, ed. Yu Jianhua 俞劍華 (Beijing: Renmin meishu chubanshe, 1986), 2:747.

39. Trans. with slight modification, Anita Chung, *Drawing Boundaries: Architectural Images in Qing China* (Honolulu: University of Hawai'i Press, 2004), 41.

40. Dai Yiheng 戴以恒, *Zuisu zhai huajue* 醉蘇齋畫訣 [Painting formula of the Zuisu Studio], in *Zhongguo hualun leibian* 中國畫論類編, ed. Yu Jianhua 俞劍華 (Beijing: Renmin meishu chubanshe, 1986), 2:1006.

41. Wang Pu 王溥, *Tang huiyao* 唐會要 [Institutional history of the Tang], *juan* 44 (Beijing: Zhonghua shuju, 1955), 792.

42. See Li Yanshou 李延壽, *Beishi* 北史 [History of Northern dynasties], *juan* 60 (Beijing: Zhonghua shuju, 1974), 2146.

43. More details about the transformation of the roof ridge decorations in the Tang can be found in Qi Yingtao 祁英濤, "Zhongguo gudai jianzhu de jishi" 中國古代建築的脊飾 [Roof ridge ornaments for ancient Chinese architecture], *Wenwu* 文物, no. 3 (1978): 63–64.

44. The use of the term *chiwen* appeared in the Five Dynasties. For example, the Later Jin writer Liu Xu 劉昫 mentions in his *Jiu Tangshu* 舊唐書 [The old Tang history]: "The owl's-mouth-shaped decorations of the Duan Gate all fell off." (端門鴟吻盡落。) See Liu Xu 劉昫, *Jiu Tangshu* 舊唐書 [The old Tang history] (Taipei: Dingwen shuju, 1981), 1357.

45. Shanxi sheng gujianzhu baohu yanjiusuo 山西省古建築保護研究所, Chai Zejun 柴澤俊, and Zhang Chouliang 張丑良, eds., *Fanshi yanshansi* 繁峙岩山寺 [Yanshan Monastery in Fanshi county] (Beijing: Wenwu chubanshe, 1990), 25.

46. Here, I emphasize that representations of architectural components such as *chiwen* could bear a strong resemblance to their contemporary objects. However, it does not mean that all *jiehua* artists' drawing processes completely rely on their observations of nature. Even Wang Kui, mentioned here, depicts two different kinds of *chiwen* on the east and west walls of the south hall, and his depicted fins that jut out from the *chiwen* images look like a feature of Tang-period *chiwen* instead of contemporary objects. Fu Xinian converses more about the different factors that influenced Wang Kui's *chiwen* depictions. See Fu Xinian 傅熹年, "Shanxi sheng Fanshi xian yanshan si nandian jindai bihua zhong suohui jianzhu de chubu fenxi" 山西省繁峙縣岩山寺南殿金代壁畫中所繪建築的初步分析 [A preliminary analysis of architectural images in Jin murals in the South Hall of Yanshan Monastery in Fanshi county, Shanxi province], in *Dangdai zhongguo jianzhu shijia shishu Fu Xinian Zhongguo jianzhu shilun xuanji* 當代中國建築史家十書·傅熹年中國建築史論選集 (Shenyang: Liaoning meishu chubanshe, 2013), 323, 327.

47. An opposing surmise could be that the beast-head-shaped ridge ornaments were widely used on main roof ridges during the Southern Song period and continued their popularity in Xia Yong's period and his region. If so, Xia's portrayals of such *chiwen* could be accurate renderings of real architectural components. However, I do not tend to accept this surmise, since the standardization and mechanization of Xia's roof ridge decoration images are so strong and it is such a strange coincidence that Xia Yong painted all his roof ridge decorations in this way, without exception; meanwhile, there is no piece of a similar object left on main roof ridges of actual Song or Yuan buildings today.

48. Nancy Shatzman Steinhardt, "Bracketing System of the Song Dynasty," in *Chinese Traditional Architecture*, Nancy Shatzman Steinhardt et al. (New York: China Institute in America, China House Gallery, 1984), 122.

49. Nancy Shatzman Steinhardt, "Bracketing System of the Song Dynasty," in *Chinese Traditional Architecture*, Nancy Shatzman Steinhardt et al. (New York: China Institute in America, China House Gallery, 1984), 122.

50. Chen Yunru 陳韻如, "'Jiehua' zai Song Yuan shiqi de zhuanzhe: yi Wang Zhenpeng de jiehua wei li" "界畫"在宋元時期的轉折：以王振鵬的界畫為例 [The change of *jiehua* during the Song-Yuan period: The example of Wang Zhenpeng's *jiehua*], *Meishushi yanjiu jikan* 美術史研究集刊, no. 26 (2009): 149–153; Liu Diyu 劉滌宇, "Zhongguo chuantong wumuhua zhong dougong biaoda fangshi de bianqian" 中國傳統屋木畫中斗拱表達方式的變遷 [The evolution of the bracket set's representation in the architectural painting of traditional China], *Shijie jianzhu* 世界建築, no. 9 (2017): 30–35.

51. All Song editions of *Yingzao fashi*, including the original one published in 1103 and the other two republished in 1145 and during the Shaoding 紹定 period (1228–1233), have been lost today, but there still exist handwritten copies based on the 1145 edition and fragments of the repaired Shaoding edition. In 1925, Tao Xiang 陶湘 (1870–1940) adopted the format of the Song editions and, based on

such handwritten copies as those included in the Qing imperial compilation *Siku quanshu* and other private collections, aimed to reproduce the *Yingzao fashi*. We admit that the *Yingzao fashi* illustrations, particularly those of the color-painting system (*caihuazuo* 彩畫作), might have undergone transformation during their transmissions and thus make the 1925 edition different from the Song ones. But it must be noted that illustrations of the major carpentry system (*damuzuo* 大木作) in the 1925 edition, including the one (fig. 1.20) mentioned in our discussion, could remain in their original form to the largest extent, since they deal with the structural construction rather than painting motifs. More details about the *Yingzao fashi* editions can be found in Jiren Feng, *Chinese Architecture and Metaphor: Song Culture in the Yingzao Fashi Building Manual* (Honolulu: University of Hawaiʻi Press, 2012), 2–4; Liang Sicheng 梁思成, *Yingzao fashi zhushi* 營造法式注釋 [Comments on *Yingzao fashi*] (Beijing: Zhongguo jianzhu gongye chubanshe, 1983), 8, 11.

52. Although our discussion pays more attention to the innovation of Jin and Southern Song painters, we must admit that a few Northern Song *jiehua* painters had already realized the disadvantage of excessive emphasis on clarifying the structure of each bracket set. Liu Diyu discusses the unique example of *Shiyong tu* 十詠圖 ("The Picture of Ten Recitations") held by the Palace Museum in Beijing. In this painting, the Northern Song painter Zhang Xian 張先 adds auxiliary paralleling lines in his representation of bracket sets. See Liu Diyu 劉滌宇, "Zhongguo chuantong wumuhua zhong dougong biaoda fangshi de bianqian" 中國傳統屋木畫中斗拱表達方式的變遷 [The evolution of the bracket set's representation in the architectural painting of traditional China], *Shijie jianzhu* 世界建築, no. 9 (2017): 30–35.

53. This painting, with Li Song's signature, is traditionally attributed to Li. Note that Marsha Smith Weidner bases her reflections on James Cahill's observation—namely, that the painting has vertical cracks, which indicate that it was once a part of a handscroll—to conclude that the signature must be interpolated. See Marsha Smith Weidner, "Painting and Patronage at the Mongol Court of China, 1260–1368" (PhD diss., University of California, Berkeley, 1982), 174, 238, note 81. Here, I follow the traditional attribution and use this painting as an example that reflects the Southern Song manner.

54. Chen Yunru 陳韻如, "'Jiehua' zai Song Yuan shiqi de zhuanzhe: yi Wang Zhenpeng de jiehua wei li" "界畫"在宋元時期的轉折：以王振鵬的界畫為例 [The change of *jiehua* during the Song-Yuan period: The example of Wang Zhenpeng's *jiehua*], *Meishushi yanjiu jikan* 美術史研究集刊, no. 26 (2009): 149–153.

55. Pei Xiu wrote a treatise supplemented with maps, entitled *Yugong diyutu shiba pian* 禹貢地域圖十八篇 [Eighteen regional maps for the Tribute of Yu], and set forth the Six Principles in its preface. See Fang Xuanling 房玄齡 et al., *Jin shu* 晉書 [History of the Jin dynasty], *juan* 35 (Beijing: Zhonghua shuju, 1974), 1039–1040.

56. Pei Xiu writes: "The first is called the graduated divisions, which are used to determine the scale." (一曰分率，所以辨廣輪之度也。) See Fang Xuanling 房玄齡 et al., *Jin shu* 晉書 [History of the Jin dynasty], *juan* 35 (Beijing: Zhonghua shuju, 1974), 1040. Later literati scholars such as the Qing scholar Hu Wei 胡渭 (1633–1714) explain the concept *fenlü* in this way: "The *fenlü* means *ji li hua fang*. Each square means a hundred *li* or/and fifty *li*." (分率者，計里畫方，每方百里五十里之謂也。)

See Hu Wei 胡渭, *Yugong zhuizhi* 禹貢錐指 [A modest approach to the Tributes of Yu] (Shanghai: Shanghai guji chubanshe, 1996), 122; "The *fenlü* means *ji li hua fang.*" (分率者，計里畫方。) See Zhang Tinyu 張廷玉 ed., *Qingchao wenxian tongkao* 清朝文獻通考 [Encyclopedia of the historical records of the Qing dynasty] (Taipei: Taiwan shangwu yinshuguan, 1987), 7265.

57. Chen Zushou 陳組綬 claims in the preface of his treatise *Huangming zhi fang di tu* 皇明職方地圖 [An administrative map of the Ming dynasty]: "The Yuan-period Zhu Siben uses *ji li hua fang.*" (元人朱思本，計里畫方。) See Chen Zushou 陳組綬, *Chen Jiabu wenji* 陳駕部文集 [Chen Jiabu's literary collection], in *Ming jingshi wenbian* 明經世文編, ed. Chen Zilong 陳子龍 et al., *juan* 504 (Beijing: Zhonghua shuju, 1987), 5541.

58. Nancy Shatzman Steinhardt, "Chinese Cartography and Calligraphy," *Oriental Art* 43, no. 1 (1997): 11.

59. Liu Xianting 劉獻廷, *Guangyang zaji* 廣陽雜記 [Miscellaneous records by Guangyang], *juan* 3 (Beijing: Zhonghua shuju, 1985), 158.

60. Li Zhi 李廌, *Deyutang huapin* 德隅堂畫品 [Evaluations of painters from the Deyu Studio], in *Zhongguo shuhua quanshu* 中國書畫全書, ed. Lu Fusheng 盧輔聖 (Shanghai: Shanghai shuhua chubanshe, 2000), 1:991; trans. with slight modification, Robert J. Maeda, "Chieh-Hua: Ruled-Line Painting in China," *Ars Orientalis* 10 (1975): 126.

61. Wang Hui Chuan 王卉娟, *Yuandai Yongle gong Chunyang dian jianzhu bihua xianmiao: Louge jianzhu de huizhi fangfa* 元代永樂宮純陽殿建築壁畫線描：樓閣建築的繪製方法 [Line drawings in architectural murals from the Chunyang Hall of the Yuan Yongle Gong temple: Painting methods of louge architecture] (Beijing: Wenwu chubanshe, 2013), 19–33.

62. Dunhuang wenwu yanjiusuo 敦煌文物研究所 ed., *Zhongguo shiku Dunhuang Mogao ku* 中國石窟・敦煌莫高窟 [Chinese grottos Dunhuang Mogao caves], *juan* 5 (Beijing: Wenwu chubanshe, 1990), 218. See more details about Liang Sicheng's record of Foguang Monastery in Liang Sicheng 梁思成, *Zhongguo jianzhushi* 中國建築史 [A history of Chinese architecture] (Beijing: Sanlian shudian, 2016), 81–82.

63. One related discussion could be found in Kristina Kleutghen, "From Science to Art: The Evolution of Linear Perspective in Eighteenth-Century Chinese Art," in *Qing Encounters: Artistic Exchanges between China and the West*, ed. Petra ten-Doesschate Chu and Ding Ning (Los Angeles: Getty Research Institute, 2015), 173–189.

64. Jerome Silbergeld, *Chinese Painting Style: Media, Methods, and Principles of Form* (Seattle and London: University of Washington Press, 1982), 36.

65. Jerome Silbergeld, *Chinese Painting Style: Media, Methods, and Principles of Form* (Seattle and London: University of Washington Press, 1982), 38.

66. George Rowley, *Principles of Chinese Painting* (Princeton, NJ: Princeton University Press, 1947), 61; Jerome Silbergeld, *Chinese Painting Style: Media, Methods, and Principles of Form* (Seattle and London: University of Washington Press, 1982), 37.

67. More discussions can be found in Benjamin March, *Some Technical Terms of Chinese Painting* (Baltimore: Waverly Press, 1935), 26; Susan Bush and Hsio-yen Shih, *Early Chinese Texts on Painting* (Hong Kong: Hong Kong University Press, 2012), 168–169.

68. Jerome Silbergeld, *Chinese Painting Style: Media, Methods, and Principles of Form* (Seattle and London: University of Washington Press, 1982), 37.

69. This does not mean that Chinese artists after the Yuan period no longer use multiple viewpoints.

Chapter 2

1. *Xuanhe huapu* 宣和畫譜 [The Xuanhe painting catalogue], in *Huashi congshu* 畫史 叢書, ed. Yu Anlan 于安瀾 (Shanghai: Shanghai renmin meishu chubanshe, 1982), 2:29 and 84.

2. These paintings include the Boston and Freer versions of the *Prince Teng Pavilion*, the Beijing fan version of the *Yueyang Pavilion*, the Beijing version of the *Tower Reflected in the Lake*, and the Beijing version of the *Pavilion of Prosperity and Happiness*.

3. Robert J. Maeda, "Chieh-hua: Ruled-line Painting in China," *Ars Orientalis* 10 (1975): 141; Yu Hui 余輝, "Renzhi Wang Zhenpeng, Lin Yiqing ji Yuandai gongting jiehua" 認知王振朋、林一清及元代宮廷界畫 [Interpreting Wang Zhenpeng, Lin Yiqing, and the Yuan court *jiehua*], in *Meishu shi yu guannian shi* 美術史與觀念史, ed. Fan Jingzhong 范景中 and Cao Yiqiang 曹意強 (Nanjing: Nanjing shifan daxue chubanshe, 2003), 59; Yu Hui 余輝, "Yuandai gongting huihua shi ji jiazuo kaobian xuyi" 元代宮廷繪畫史及佳作考辨‧續一 [Yuan court painting history and studies of excellent works, part II], *Gugong bowuyuan yuankan* 故宮博物院院刊 89, no. 3 (2000): 29. Both Maeda and Yu Hui do not document their statements about the relationship between Xia and Wang.

4. Berthold Laufer, *T'ang, Sung and Yüan Paintings Belonging to Various Chinese Collectors* (Paris: Librairie nationale d'art et d'histoire: G. van Oest, 1924), 15–16; James Cahill, *An Index of Early Chinese Painters and Paintings: Tang, Sung, and Yüan* (Berkeley and Los Angeles: University of California Press, 1980), 336. In our correspondence (unpublished), Cary Liu, the curator of Asian art at the Princeton University Art Museum, provides his judgment on the dating. Liu's opinion has been adopted by the Princeton University Art Museum website. Accessed Sep. 7, 2018, https://artmuseum.princeton.edu/collections/objects/58413.

5. See more details about Tang Di's dates and activities in Zhang Yu 張羽, "Fengxun dafu pingjiang lu zhizhou zhishi Zihua Tang jun mujie" 奉訓大夫平江路知州致仕 子華唐君墓碣 [Grave stele epitaph for Mr. Tang Zihua, the retired Grand Master for Admonishment and Pingjiang Route Prefect], in *Wuxing yiwen bu* 吳興藝文補 ed. Dong Sizhang 董斯張, *juan* 30 (Shanghai: Shanghai guji chubanshe, 1995), 97–98; Weng Tongwen 翁同文, "Huaren shengzu nian kao xiapian" 畫人生卒年 攷‧下篇 [A study of painters' birth and death years, part II], *Gugong jikan* 故宮季 刊 4, no. 3 (1970): 65–69; Gao Musen 高木森, "Tang Di qiren qihua" 唐棣其人其畫 [The person Tang Di and his paintings], *Gugong jikan* 故宮季刊 8, no. 2 (Winter 1973): 43–56; She Cheng 佘城, "Yuandai Tang Di zhi yanjiu shang" 元代唐棣之研 究‧上 [A study on the Yuan-period Tang Di, part I], *Gugong jikan* 故宮季刊 16, no. 4 (Summer 1982): 33–54; She Cheng 佘城, "Yuandai Tang Di zhi yanjiu xia" 元代 唐棣之研究‧下 [A study on the Yuan-period Tang Di, part II], *Gugong jikan* 故宮季刊 17, no. 1 (Fall 1982): 1–23; Shih Shou-chien 石守謙, "Youguan Tang Di ji yuandai

Li-Guo fengge fazhan zhi ruogan wenti" 有關唐棣 (1287–1355)及元代李郭風格發展
之若干問題 [A few problems related to Tang Di and the development of the Li-Guo
style during the Yuan dynasty], in *Fengge yu shibian: Zhongguo huihua shilun* 風格與
世變：中國繪畫十論 (Beijing: Beijing daxue chubanshe, 2008), 129–176.

6. Today there are a great number of forgeries attributed to Wang Zhenpeng. Cahill
 records 29 works attributable to Wang with varying degrees of plausibility. See
 James Cahill, *An Index of Early Chinese Painters and Paintings: Tang, Sung, and Yüan*
 (Berkeley and Los Angeles: University of California Press, 1980), 335–337.

7. Xia Wenyan 夏文彥, *Tuhui baojian* 圖繪寶鑑 [Precious mirror of painting], *juan* 5, in
 Huashi congshu 畫史叢書, ed. Yu Anlan 于安瀾 (Shanghai: Shanghai renmin meishu
 chubanshe, 1982), 2:126.

8. Yu Ji 虞集, "Wang Zhizhou muzhiming" 王知州墓志銘 [The Prefect Wang's epitaph],
 in *Daoyuan xuegu lu* 道園學古錄, Yu Ji 虞集, *juan* 19 (Taipei: Taiwan zhonghua shuju,
 1981), 1.

9. Yu Ji 虞集, "Wang Zhizhou muzhiming" 王知州墓志銘 [The Prefect Wang's epitaph],
 in *Daoyuan xuegu lu* 道園學古錄, Yu Ji 虞集, *juan* 19 (Taipei: Taiwan zhonghua shuju,
 1981), 1.

10. Trans. with slight modification, Sherman E. Lee and Wai-Kam Ho, *Chinese Art Under
 the Mongols: The Yüan Dynasty (1279–1368)* (Cleveland: The Cleveland Museum of
 Art, 1968), no. 201.

11. Wang Shidian 王士點 and Shang Qiweng 商企翁 eds., *Mishu jian zhi* 秘書監志
 [Annals of the Imperial Library], *juan* 9 (Hangzhou: Zhejiang guji chubanshe,
 1992), 181.

12. Song Lian 宋濂, *Yuanshi* 元史 [The Yuan history], in *Xin jiaoben yuanshi bing fubian
 er zhong* 新校本元史并附編二種, ed. Yang Jialuo 楊家駱, *zhi* 志 no. 41, *baiguan* 百官 no.
 7 (Taipei: Dingwen shuju, 1981), 4:2315.

13. Based on the same information in Yu Ji's epitaph, Marsha Smith Weidner puts
 Wang Zhenpeng's date of birth sometime between the mid-1270s and mid-1280s.
 See Marsha Smith Weidner, "Painting and Patronage at the Mongol Court of
 China, 1260–1368" (PhD diss., University of California, Berkeley, 1982), 133; Weng
 Tongwen 翁同文 also relies on this epitaph and claims Wang Zhenpeng was born
 around 1280. See Weng Tongwen 翁同文, "Huaren shengzu nian kao xiapian" 畫人
 生卒年攷·下篇 [A study of painters' birth and death years, part II], *Gugong jikan* 故
 宮季刊 4, no. 3 (1970): 60.

14. The occupancy of the throne frequently changed at that time. After Taidingdi's
 death in 1328, his son and successor Tianshundi 天順帝 (Aragibag, ca. 1320–1328;
 r. 1328) only occupied the throne for a short time that year and was defeated by
 Wuzong's 武宗 (Khaishan, 1281–1311; r. 1307–1311) second son Wenzong 文宗
 (Tugh Temür, 1304–1332; r. 1328–1332). Wenzong ascended the throne twice in
 1328 and in 1330, due to his elder brother Mingzong's 明宗 (Khoshila, 1300–1329;
 r. 1329) brief succession and sudden death in 1329. More details about the succes-
 sion struggles of 1328–1329 can be found in Jiang Yihan 姜一涵, *Yuandai kuizhangge
 ji kuizhang renwu* 元代奎章閣及奎章人物 [The Kuizhangge of the Yuan dynasty and
 its luminaries] (Taipei: Lianjing chuban shiye gongsi, 1981), 4–5.

15. Marsha Smith Weidner, "Painting and Patronage at the Mongol Court of China, 1260–1368" (PhD diss., University of California, Berkeley, 1982), 134.

16. Marsha Smith Weidner, "Painting and Patronage at the Mongol Court of China, 1260–1368" (PhD diss., University of California, Berkeley, 1982), 133. Yu Kan 虞堪, "Wei Ji Bingqing ti Wei Mingxuan suo hua zhouqian chujing tu" 為季丙卿題衛明鉉所畫咒錢出井圖 [Inscribed for Ji Bingqing on the picture *Reciting a Spell to Make Money Rise from the Well* painted by Wei Mingxuan]. See Yu Kan 虞堪, *Xidan yuan shiji* 希澹園詩集 [Poetry collection of the Xidan Garden], *juan* 1, in *Wenyuan ge siku quanshu* 文淵閣四庫全書 (Taipei: Taiwan shangwu yinshuguan, 1983), 1233:590.

17. These inscriptions have also been transcribed in detail by the Qing scholar Wang Shizhen 王士禛, who saw this *Vimalakirti and the Doctrine of Nonduality* (now in New York) in Song Lichang's 宋荔裳 collection. See Wang Shizhen 王士禛, "Ji guan Song Lichang hua" 記觀宋荔裳畫 [A record of viewing Song Lichang's painting collection], in *Chibei Outan* 池北偶談, Wang Shizhen 王士禛 (Beijing: Zhonghua shuju, 1997), 359–360.

18. The translation of the second colophon is quoted with slight modification from Alan G. Atkinson, "Beyond the Monastery Walls: Professional Painters and Popular Themes," in *Latter Days of The Law: Images of Chinese Buddhism, 850–1850*, ed., Marsha Smith Weidner (Lawrence: Spencer Museum of Art, the University of Kansas; Honolulu: University of Hawai'i Press, 1994), 349.

19. It should be noted that these two colophons must have been added much later than the painting's execution in 1308, since Wang mentions the emperor's posthumous title (temple name), Renzong, which was only given after the emperor's death in 1320.

20. Both in Cahill's and Fu Shen's 傅申 counts, there are at least seven versions of the similar Dragon Boat Regatta composition. The difference is that Fu saw four in the National Palace Museum at Taipei and none in Beijing, but Cahill listed three versions from the National Palace Museum at Taipei and one in the Palace Museum in Beijing. See James Cahill, *An Index of Early Chinese Painters and Paintings: T'ang, Sung, and Yüan* (Berkeley and Los Angeles: University of California Press, 1980), 335; Fu Shen 傅申, *Yuandai huangshi shuhua shoucang shilue* 元代皇室書畫收藏史略 [History of the Yuan court collecting practices of paintings and calligraphies] (Taipei: National Palace Museum, 1981), 31, note 63.

21. These four versions consist of *Jinming chi duobiao tu* 金明池奪標圖 ("Dragon Boat Regatta on the Jinming Pond") in the Metropolitan Museum of Art in New York, *Longchi jingdu tu* 龍池競渡圖 ("The Boat Race on the Dragon Pond") and *Jinming duojin tu* 金明奪錦圖 ("Winning the Contest on the Jinming Pond"), both in the National Palace Museum in Taipei, and *Jinming chi tu* 金明池圖 ("The Golden Bright Pond") in the collection of Cheng Chi 程琦 in Tokyo. Also, another version, entitled *Longzhou duobiao tu* 龍舟奪標圖 ("The Championship at the Dragon Boat Regatta") and held by the Detroit Institute of Arts, bears an abridged inscription which does not point out Wang's patrons.

22. Trans. with slight modification, Sherman E. Lee and Wai-Kam Ho, *Chinese Art Under the Mongols: The Yüan Dynasty (1279–1368)* (Cleveland: The Cleveland Museum of Art, 1968), no. 201.

23. Yuan Jue 袁桷, "Huanggu Luguo dazhang gongzhu tuhua fengjiao ti·Wang Zhenpeng jinbiao tu" 皇姑魯國大長公主圖畫奉教題·王振鵬錦標圖 [Colophons inscribed under the order of the imperial aunt and grand elder princess of the State of Lu, Wang Zhenpeng's *Championship*] and "Luguo dazhang gongzhu tuhua ji" 魯國大長公主圖畫記 [A record of calligraphy and paintings collected by the grand elder princess of the State of Lu], in *Yuan Jue ji jiao zhu* 袁桷集校注, Yuan Jue 袁桷 (Beijing: Zhonghua shuju, 2012), 5:1979 and 1981–1982.

24. Yuan's and Feng's poems are transcribed in detail in Chen Gaohua 陳高華 ed., *Yuandai huajia shiliao huibian* 元代畫家史料匯編 [Collected historical materials about Yuan painters] (Hangzhou: Hangzhou chubanshe, 2004), 422 and 424–425.

25. Chen Gaohua 陳高華 ed., *Yuandai huajia shiliao huibian* 元代畫家史料匯編 [Collected historical materials about Yuan painters] (Hangzhou: Hangzhou chubanshe, 2004), 420–425.

26. It should be noted that scholars such as Marsha Smith Weidner and Yu Hui have attempted to ascribe the anonymous *jiehua* painting *Guanghan gong tu* 廣寒宮圖 ("The Guanghan Palace") in the Shanghai Museum to Wang Zhenpeng. I agree with their discussions about the painting's style but have decided to reserve my opinion about the painting's attribution until more proof appears. See Marsha Smith Weidner, "Painting and Patronage at the Mongol Court of China, 1260–1368" (PhD diss., University of California, Berkeley, 1982), 162–163; Yu Hui 余輝, "Wang Zhenpeng yu Guanghangong tu zhou kao" 王振朋與《廣寒宮圖》軸考 [Wang Zhenpeng and the study of the *Moon Palace* scroll], in *Qiannian yizhen guoji xueshu yantaohui lunwenji* 千年遺珍國際學術研討會論文集, ed. Shanghai Museum (Shanghai: Shanghai shuhua chubanshe, 2006), 620–628.

27. Similar brief records about these two artists are also included in later painting catalogues, such as the Ming-period Zhu Mouyin 朱謀垔, *Huashi huiyao* 畫史會要 [Essentials in the history of painting], *juan* 3, in *Wenjin ge siku quanshu* 文津閣四庫全書 (Beijing: Shangwu yinshuguan, 2005), 123.

28. Xia Wenyan 夏文彥, *Tuhui baojian* 圖繪寶鑑 [Precious mirror of painting], *juan* 5, in *Huashi congshu* 畫史叢書, ed. Yu Anlan 于安瀾 (Shanghai: Shanghai renmin meishu chubanshe, 1982), 2:134 and 138.

29. One can notice the ambiguities in the sentence 奉中宮教金圖藏經佛像引首以進, which might be garbled and with phrases moved around in transcription. It leads to variants in documents such as *Wuzhong renwu zhi* 吳中人物志 [Biographies of Wuzhong personages] quoted by Wang Shizhen's 王士禎 *Chibei Outan* 池北偶談 (North Pond Casual Talks), *Kunshan renwu zhi* 崑山人物志 [Biographies of Kunshan Personages], and *Suzhou fu zhi* 蘇州府志 (Chronicle of Suzhou fu).

30. This is an excerpt from "Zhu zhengshi muzhiming" 朱徵士墓志銘 [The recluse Zhu's epitaph]. See Yin Kui 殷奎, *Qiangzhai ji* 強齋集 [Qiangzhai collection], *juan* 4, in *Siku quanshu* 四庫全書 (Shanghai: Shanghai guji chubanshe, 1987), 1232:429–430.

31. Xu Youren 許有壬, "Song jiehua Lin Yiqing fu Taizhou bing xu" 送界畫林一清赴台州并序 [Send-off the *jiehua* artist Lin Yiqing to Taizhou and write a preface]. See Xu Youren 許有壬, *Zhizheng ji* 至正集 [Zhizheng collection], *juan* 8, in *Siku quanshu*

zhenben baji 四庫全書珍本八集, ed. Wang Yunwu 王雲五 (Taipei: Taiwan shangwu yinshuguan, 1978), 160:4–5.

32. The translation of the second inscription is quoted from Alan G. Atkinson, "Beyond the Monastery Walls: Professional Painters and Popular Themes," in *Latter Days of The Law: Images of Chinese Buddhism, 850–1850*, ed. Marsha Smith Weidner (Lawrence: Spencer Museum of Art, the University of Kansas; Honolulu: University of Hawai'i Press, 1994), 351.

33. Chen Yunru 陳韻如, "Jiyi de tuxiang: Wang Zhenpeng longzhou tu yanjiu" 記憶的圖像：王振鵬龍舟圖研究 [Images from times past: A study of Wang Chen-p'eng's dragon boat paintings], *Gugong xueshu jikan* 故宮學術季刊 20, no. 2 (2002): 129–164.

34. Xia Wenyan 夏文彥, *Tuhui baojian* 圖繪寶鑑 [Precious mirror of painting], *juan* 1, in *Huashi congshu* 畫史叢書, ed. Yu Anlan 于安瀾 (Shanghai: Shanghai renmin meishu chubanshe, 1982), 2:3.

35. Ruan Yuan 阮元 (1764–1849), one of the painting's previous collectors, leaves a colophon and a seal on this painting, in which he states that the old label said, "The Dragon Boat, painted by Wang Zhenpeng." Sherman E. Lee and Wai-Kam Ho, *Chinese Art Under the Mongols: The Yüan Dynasty (1279–1368)* (Cleveland: The Cleveland Museum of Art, 1968), no. 202.

36. *Wu Qizhen shuhua ji* 吳其貞書畫記 (Wu Qizhen's Record of Calligraphy and Paintings) records: "Li Song's *Palaces and Pavilions* is a silk painting mounted as a square leaf. There is another painting, *Dragon Boat with Palatial Superstructures*, that has a fine-line style and does not use measuring devices but achieves both actual rules and measurements. There is an empty throne placed in the picture and there are only a few eunuchs waiting for the emperor. Both paintings can be categorized in the *neng* class. Both bear the signature 'Li Song.'" (李嵩《宮苑樓閣圖》，絹畫斗方。又《龍舟殿宇圖》，畫法工細，不用界尺，而規矩準繩皆備。圖上空設御座，只內官多人，以俟出朝，意皆能品。每幅識曰"李嵩"。) See Li E 厲鶚, *Nansong yuanhua lu* 南宋院畫錄 [Records on paintings of the Southern Song Academy], *juan* 5, in *Huashi congshu* 畫史叢書, ed. Yu Anlan 于安瀾 (Shanghai: Shanghai renmin meishu chubanshe, 1982), 4:99. Wu Qizhen's description (quoted in Li E's catalogue) matches the appearances of these two Taipei paintings.

37. Cahill's observation is quoted by Marsha Smith Weidner, "Painting and Patronage at the Mongol Court of China, 1260–1368" (PhD diss., University of California, Berkeley, 1982), 174 and 238, note 40. By contrast, it is also worth noting that the scholar Fu Shen 傅申 insists on the attribution of the Taipei album leaf to Li Song. Therefore, due to the remarkable resemblance between the Taipei and the Boston album leaves, Fu believes that the Boston album leaf is a Southern Song painting instead of a Yuan one. See Fu Shen 傅申, *Yuandai huangshi shuhua shoucang shilue* 元代皇室書畫收藏史略 [History of the Yuan court collecting practices of paintings and calligraphies] (Taipei: National Palace Museum, 1981), 54.

38. Although the specific term *baimiao* was more widely used in the Ming and later periods, this traditional "plain-drawing" style had appeared early on in Tang murals' *fenben* (pounce or preparatory sketches) and Song ink paintings (like those by Li Gonglin 李公麟). It was also common for later art connoisseurs and

critics to treat Wang as an exponent of the *baimiao* style, although this style had not been typically named as such during Wang's time. Here, I will follow the convention of using the term *baimiao* in the case of Wang Zhenpeng and other related Yuan *jiehua* masters.

39. After all, there are none of Wang's signatures or inscriptions on the Taipei or Boston leaves. Instead, Li Song's signature appears on the Taipei album leaves.

40. Wang Juhua 王菊華 et al., *Zhongguo gudai zaozhi gongcheng jishu shi* 中國古代造紙工程技術史 [The technical history of ancient China's paper-making industry] (Taiyuan: Shanxi jiaoyu chubanshe, 2006), 224.

41. Yuan Jue 袁桷, "Huanggu Luguo dazhang gongzhu tuhua fengjiao ti·Wang Zhenpeng jinbiao tu" 皇姑魯國大長公主圖畫奉教題·王振鵬錦標圖 [Colophons inscribed under the order of the imperial aunt and grand elder princess of the State of Lu, Wang Zhenpeng's *Championship*], in *Yuan Jue ji jiao zhu* 袁桷集校注, Yuan Jue 袁桷, *juan* 45 (Beijing: Zhonghua shuju, 2012), 5:1979.

42. The artist's signature is written as Zhu Bao 朱珤 on this Taipei work.

43. See "Zhu zhengshi muzhiming" 朱徵士墓志銘 [The recluse Zhu's epitaph], in *Qiangzhai ji* 強齋集, Yin Kui 殷奎, *juan* 4, in *Siku quanshu* 四庫全書 (Shanghai: Shanghai guji chubanshe, 1987), 1232:429–430.

44. Joyce Denney, "Textiles in the Mongol and Yuan Periods," in *The World of Khubilai Khan: Chinese Art in the Yuan Dynasty*, ed. James C. Y. Watt et al. (New Haven and London: Yale University Press, 2010), 247.

45. Robert J. Maeda, "Chieh-Hua: Ruled-Line Painting in China," *Ars Orientalis* 10 (1975): 141.

46. Robert J. Maeda, "Chieh-Hua: Ruled-Line Painting in China," *Ars Orientalis* 10 (1975): 141.

47. Roslyn Lee Hammers, "Khubilai Khan Hunting: Tribute to the Great Khan," *Artibus Asiae* 75, no. 1 (2015): 33.

48. Masaaki Itakura 板倉聖哲, "Kaeihitsu Take yorozu" 夏永筆岳陽楼図 [The *Yueyang Pavilion* painting by Xia Yong], *Kokka* 國華 122, no. 3 (October 2016): 38.

49. Xia Wenyan 夏文彥, *Tuhui baojian* 圖繪寶鑑 [Precious mirror of painting], *juan* 5, in *Huashi congshu* 畫史叢書, ed. Yu Anlan 于安瀾 (Shanghai: Shanghai renmin meishu chubanshe, 1982), 2:133.

50. Trans. Sandra Jean Wetzel, "Sheng Mou: The Coalescence of Professional and Literati Painting in Late Yuan China," *Artibus Asiae* 56, no. 3/4 (1996): 264.

51. Sandra Jean Wetzel, "Sheng Mou: The Coalescence of Professional and Literati Painting in Late Yuan China," *Artibus Asiae* 56, no. 3/4 (1996): 265.

52. Dong Qichang 董其昌, *Rongtai bieji* 容臺別集 [Supplemental literary anthology from the Ministry of Rites], *juan* 4, in *Siku jinhui shu congkan jibu* 四庫禁燬書叢刊·集部 (Beijing: Beijing chubanshe, 2008), 32:514.

53. Sheng Mao's teacher Chen Lin is a pupil of the most influential literati painter of the early Yuan era, Zhao Mengfu. This kind of personal affinity might also contribute to the similarities in taste between Sheng and contemporary scholar-artists.

54. Compared with Sheng Mao, there are fewer or nearly no textual records about Xia Yong's direct connections with contemporary literati painters. Instead, it is

more possible for Xia Yong to have been directly or indirectly influenced by Sheng Mao's landscape style, the one popular in the marketplace.

55. Chen Lin's native place is mentioned as follows: "Chen Jue, a native of Qiantang . . . was a painter-in-waiting of the Baoyou reign . . . Chen Lin, with the courtesy name Zhongmei, was the second son of Jue . . ." (陳珏，錢塘人……寶祐待詔……陳琳，字仲美，珏次子……) See Li E 厲鶚, *Nansong yuanhua lu* 南宋院畫錄 [Records on paintings of the Southern Song Academy], *juan* 8, in *Huashi congshu* 畫史叢書, ed. Yu Anlan 于安瀾 (Shanghai: Shanghai renmin meishu chubanshe, 1982), 4:171–172. Sheng Mao is usually recorded to have come from Weitang, a region of Jiaxing. For example, see Xia Wenyan 夏文彥, *Tuhui baojian* 圖繪寶鑑 [Precious mirror of painting], *juan* 5, in *Huashi congshu* 畫史叢書, ed. Yu Anlan 于安瀾 (Shanghai: Shanghai renmin meishu chubanshe, 1982), 2:133. But scholars like Wang Zhende have also pointed out that Sheng was a native of Lin'an (today's Hangzhou, including the Qiantang region) and moved to Jiaxing later. See Wang Zhende 王振德, *Sheng Mao* 盛懋 (Shanghai: Shanghai renmin meishu chubanshe, 1988), 4 and 7. In this case, Sheng came exactly from Xia Yong's hometown, and they might have had more opportunities to directly communicate with each other.

56. The teacher-student relationship between Zhao Mengfu and Tang Di is mentioned in Tang Di's grave stele epitaph. See Zhang Yu 張羽, "Fengxun dafu pingjiang lu zhizhou zhishi Zihua Tang jun mujie" 奉訓大夫平江路知州致仕子華唐君墓碣 [Grave stele epitaph for Mr. Tang Zihua, the retired Grand Master for Admonishment and Pingjiang Route prefect], in *Wuxing yiwen bu* 吳興藝文補, ed. Dong Sizhang 董斯張, *juan* 30 (Shanghai: Shanghai guji chubanshe, 1995), 97.

57. Feng Zizhen 馮子振, "Zeng Zhu Zemin xu" 贈朱澤民序 [Preface presented for Zhu Zemin], in *Yuandai huajia shiliao* 元代畫家史料, ed. Chen Gaohua 陳高華 (Beijing: Zhongguo shudian, 2015), 1:250–251.

58. Zhou Boqi 周伯琦, "Youyuan ruxue tiju Zhu fujun muzhiming" 有元儒學提舉朱府君墓志銘 [Epitaph for Mr. Zhu, the Yuan supervisor of Confucian Schools], in *Yuandai huajia shiliao* 元代畫家史料, ed. Chen Gaohua 陳高華 (Beijing: Zhongguo shudian, 2015), 1:248–249.

59. Zhang Yu 張羽, "Fengxun dafu pingjiang lu zhizhou zhishi Zihua Tang jun mujie" 奉訓大夫平江路知州致仕子華唐君墓碣 [Grave stele epitaph for Mr. Tang Zihua, the retired Grand Master for Admonishment and Pingjiang Route prefect], in *Wuxing yiwen bu* 吳興藝文補, ed. Dong Sizhang 董斯張, *juan* 30 (Shanghai: Shanghai guji chubanshe, 1995), 97.

60. Gong Shitai 貢師泰, "Zhensu xianshen muzhiming" 貞素先生墓志銘 [Mr. Zhensu's epitaph], in *Yuandai huajia shiliao* 元代畫家史料, ed. Chen Gaohua 陳高華 (Beijing: Zhongguo shudian, 2015), 2:486–487.

Chapter 3

1. The civil service examination system had been discontinued until the Renzong emperor issued a decree in 1313 to restore it. Song Lian 宋濂, *Yuanshi* 元史 [The Yuan history], *benji* 本紀, no. 24 (Taipei: Dingwen shuju, 1981), 558.

2. Xie Fangde 謝枋得, "Song Fang Bozai gui Sanshan xu" 送方伯載歸三山序 [A message of farewell to Fang Bozai returning to Three Mountains (Fuzhou)], in *Xie Dieshan quanji jiaozhu* 謝疊山全集校註, Xie Fangde 謝枋得, *juan* 2 (Shanghai: Huadong shifan daxue chubanshe, 1994), 29–30.

3. Wai-Kam Ho, "Chinese Under the Mongols," in *Chinese Art Under the Mongols: The Yuan Dynasty (1279–1368)*, Sherman E. Lee and Wai-Kam Ho (Cleveland: The Cleveland Museum of Art, 1968), 79.

4. As mentioned earlier, Wang Zhenpeng's date of birth was around 1280, so he was nearly fifty years old when he was promoted to a fifth-grade post in 1327.

5. Yu Hui 余輝, "Renzhi Wang Zhenpeng, Lin Yiqing ji Yuandai gongting jiehua" 認知王振朋、林一清及元代宮廷界畫 [Interpreting Wang Zhenpeng, Lin Yiqing, and the Yuan court *Jiehua*], in *Meishu shi yu guannian shi* 美術史與觀念史, ed. Fan Jingzhong 范景中 and Cao Yiqiang 曹意強 (Nanjing: Nanjing shifan daxue chubanshe, 2003), 83.

6. These two paintings bore the early Ming half-seals and were thus believed to be inherited from the Yuan imperial collection. Related studies can be found in Zhuang Shen 莊申, "Gugong shuhua suojian mingdai banguanyin kao" 故宮書畫所見明代半官印考 [A study on the Ming half-seals on works of calligraphy and paintings in the National Palace Museum), in *Zhongguo huashi yanjiu xuji* 中國畫史研究續集, Zhuang Shen 莊申 (Taipei: Zhengzhong shuju, 1972), 46; Jiang Yihan 姜一涵, "Yuan neifu zhi shuhua shoucang xia" 元內府之書畫收藏 · 下 [The calligraphy and painting collection of the Yuan court, part II], *Gugong jikan* 故宮季刊 14, no. 3 (Spring 1980): 27.

7. "Li Zundao muzhiming" 李遵道墓志銘 [Li Zundao's epitaph], in *Zixi wengao* 滋溪文稿, Su Tianjue 蘇天爵, *juan* 19 (Beijing: Zhonghua shuju, 1997), 313.

8. Xia Wenyan 夏文彥, *Tuhui baojian* 圖繪寶鑒 [Precious mirror of painting], *juan* 5, in *Huashi congshu* 畫史叢書, ed. Yu Anlan 于安瀾 (Shanghai: Shanghai renmin meishu chubanshe, 1982), 2:125.

9. "Li Zundao muzhiming" 李遵道墓志銘 [Li Zundao's epitaph], in *Zixi wengao* 滋溪文稿, Su Tianjue 蘇天爵, *juan* 19 (Beijing: Zhonghua shuju, 1997), 314.

10. Wang's activity can be found in Yu Ji 虞集, "Wang Zhizhou muzhiming" 王知州墓志銘 [The Prefect Wang's epitaph], in *Daoyuan xuegu lu* 道園學古錄, Yu Ji 虞集, *juan* 19 (Taipei: Taiwan zhonghua shuju, 1981), 1.

11. Cheng Jufu 程鉅夫, "Ti He Cheng jiehua sanshou" 題何澄界畫三首 [Three poems inscribed on He Cheng's *jiehua*] and his note, in *Xuelou ji* 雪樓集, Cheng Jufu 程鉅夫 (Shanghai: Shanghai shudian, 1994), 102–103.

12. Cheng Jufu 程鉅夫, "Ti He Cheng jiehua sanshou" 題何澄界畫三首 [Three poems inscribed on He Cheng's *jiehua*] and his note, in *Xuelou ji* 雪樓集, Cheng Jufu 程鉅夫 (Shanghai: Shanghai shudian, 1994), 102–103.

13. Roslyn Lee Hammers, *Pictures of Tilling and Weaving: Art, Labor, and Technology in Song and Yuan China* (Hong Kong: Hong Kong University Press, 2011), 151.

14. Roslyn Lee Hammers, *Pictures of Tilling and Weaving: Art, Labor, and Technology in Song and Yuan China* (Hong Kong: Hong Kong University Press, 2011), 151.

15. Although recent archaeological discoveries have suggested that the E'pang Palace might have never been finished or burned, many historical and literary documents—including Cheng Jufu's poem here—hold such beliefs.

16. Cheng Jufu 程鉅夫, "Ti He Cheng jiehua sanshou" 題何澄界畫三首 [Three poems inscribed on He Cheng's *jiehua*] and his note, in *Xuelou ji* 雪樓集, by Cheng Jufu 程鉅夫 (Shanghai: Shanghai shudian, 1994), 103.

17. Yu Ji 虞集, "Ba Da'an ge tu" 跋大安閣圖 [Colophon on the *Da'an Pavilion* painting], in *Daoyuan xuegu lu* 道園學古錄, Yu Ji 虞集, *juan* 10 (Taipei: Taiwan zhonghua shuju, 1981), 4.

18. Gu Jiegang 顧頡剛 and Liu Qiyu 劉起釪, *Shangshu jiaoshi yilun* 尚書校釋譯論 [Collation, explanation, translation, and discussion of the *Book of Documents*] (Beijing: Zhonghua shuju, 2005), 3:1277.

19. Kong Anguo 孔安國 and Kong Yingda 孔穎達, *Shangshu zhengyi* 尚書正義 [Correct meaning of the *Book of Documents*], *juan* 12 (Shanghai: Shanghai guji chubanshe, 2007), 515; Li Xueqin 李學勤 ed., *Shangshu zhengyi zhoushu* 尚書正義·周書 [Correct meaning of the *Book of Documents*, the *Book of Zhou*], *juan* 13 (Taipei: Taiwan guji, 2002), 414.

20. Su Bai 宿白, "Yuan Dadu 'Shengzhi tejian shijia sheli lingtong zhi ta beiwen' jiaozhu" 元大都《聖旨特建釋迦舍利靈通之塔碑文》校註 [Commentary on the "stele inscription for the Stūpa with Spiritual Influence of the Śakya Relics built especially on imperial command" in Dadu of the Yuan], *Kaogu* 考古, no. 1 (1963): 39.

21. See "Ti Wang Pengmei *jiehua Dadu chiguan tuyang*" 題王朋梅界畫《大都池館圖樣》 [Inscribed on Wang Pengmei's *jiehua* entitled *A Sketch of the Dadu Pond Lodge*], in *Yuandai huajia shiliao huibian* 元代畫家史料匯編, ed. Chen Gaohua 陳高華 (Hangzhou: Hangzhou chubanshe, 2004), 423.

22. Liu Renben 劉仁本, *Yuting ji* 羽庭集 [Yuting's collection], *juan* 6, in *Yuanshi yanjiu ziliao huibian* 元史研究資料彙編, ed. Yang Ne 楊訥 (Beijing: Zhonghua shuju, 2014), 384–385.

23. Cheng Jufu 程鉅夫, "Ti He Cheng jiehua sanshou" 題何澄界畫三首 [Three poems inscribed on He Cheng's *jiehua*] and his note, in *Xuelou ji* 雪樓集, Cheng Jufu 程鉅夫 (Shanghai: Shanghai shudian, 1994), 103.

24. This prohibition was promulgated in the thirtieth year of the Zhiyuan reign (1293). See "Jinyue huadiao longchuan" 禁約撐掉龍船 [Prohibiting paddling dragon boats], in *Yuan Dianzhang* 元典章, *juan* 57, *Xingbu* 刑部 *juan* 19, ed. Chen Gaohua 陳高華 et al. (Tianjin: Zhonghua shuju; Tianjin guji chubanshe, 2012), 1944–1945. Notably, this prohibition was reaffirmed in the fifth year of Chengzong's Dade reign (1301). See Chen Gaohua 陳高華 et al., eds., *Yuan Dianzhang* 元典章, *juan* 57, *Xingbu* 刑部 *juan* 19 (Tianjin: Zhonghua shuju; Tianjin guji chubanshe, 2012), 1945.

25. Chen Gaohua 陳高華 et al. eds., *Yuan Dianzhang* 元典章, *juan* 57, *Xingbu* 刑部 *juan* 19 (Tianjin: Zhonghua shuju; Tianjin guji chubanshe, 2012), 1944.

26. "Jin ti Wang Pengmei *Jinming chi tu*" 謹題王鵬梅《金明池圖》 [Carefully inscribed on Wang Pengmei's *Jinming Pond* picture], in *Yuandai huajia shiliao huibian* 元代畫家史料匯編, ed. Chen Gaohua 陳高華 (Hangzhou: Hangzhou chubanshe, 2004), 424.

27. Trans. Sherman E. Lee and Wai-Kam Ho, *Chinese Art Under the Mongols: The Yüan Dynasty (1279–1368)* (Cleveland: The Cleveland Museum of Art, 1968), no. 201. Here, I take the New York handscroll, a copy of Wang's original painting, as an example.

28. Chen Yunru 陳韻如, "Jiyi de tuxiang: Wang Zhenpeng longzhou tu yanjiu" 記憶的
圖像：王振鵬龍舟圖研究 [Images from times past: A study of Wang Chen-p'eng's
dragon boat paintings], *Gugong xueshu jikan* 故宮學術季刊 20, no. 2 (2002):
129–164.

29. Wu Kuan 吳寬, "Guan wusi jingdu tu" 觀烏絲競渡圖 [Viewing the *Ink-Drawn Regatta*
picture], in *Jiacang ji* 家藏集, Wu Kuan 吳寬, *juan* 25, in *Siku quanshu* 四庫全書
(Shanghai: Shanghai guji chubanshe, 1987), 1255:192.

30. The scene description in Wu Kuan's poem (omitted in my discussion) also matches
that of the Taipei painting. However, the seals with the characters of "Kuizhang"
and "Tianli," mentioned in this poem, do not appear on the Taipei copy.

31. Wu Kuan's sentence quoted here does not mean that the artist Wang Zhenpeng
actually picked up a needle and gathered fine features to make a piece of embroi-
dery (instead of a painting). The term "fine features" is a metaphorical expression
of "fine lines." This sentence also suggests that in pre-modern China, it was more
common for women than men to do embroidery and it was even less possible for
the elite (including the painter Wang Zhenpeng) to do needlework. However, it
is worth noting that there is no problem with being a painter and an embroiderer
as well. For instance, Zhao Furen 趙夫人, a consort of the Wu King Sun Quan 孫權,
was both a painter and an embroiderer, but, obviously, she was female. See Zhang
Yanyuan 張彥遠, *Lidai minghua ji* 歷代名畫記 [Record of famous paintings of succes-
sive dynasties], *juan* 4, in *Huashi congshu* 畫史叢書, ed. Yu Anlan 于安瀾 (Shanghai:
Shanghai renmin meishu chubanshe, 1982), 1:63.

32. Dong You 董逌, *Guangchuan huaba* 廣川畫跋 [Guangchuan's colophons on paint-
ings], *juan* 3, in *Zhongguo shuhua quanshu* 中國書畫全書, ed. Lu Fusheng 盧輔聖
(Shanghai: Shanghai shuhua chubanshe, 1993), 1:829.

33. Roslyn Lee Hammers, *Pictures of Tilling and Weaving: Art, Labor, and Technology in
Song and Yuan China* (Hong Kong: Hong Kong University Press, 2011), 2.

34. Quan Heng 權衡, *Gengshen waishi* 庚申外史 [Unofficial history of the Emperor
Gengshen] (Beijing: Zhonghua shuju, 1985), 23.

35. Quan Heng 權衡, *Gengshen waishi* 庚申外史 [Unofficial history of the Emperor
Gengshen] (Beijing: Zhonghua shuju, 1985), 22.

36. Modern scholars have paid particular attention to Sengge Ragi. Fu Shen 傅申
and Jiang Yihan 姜一涵 were the first ones to comprehensively investigate her art
collection. See Fu Shen 傅申, *Yuandai huangshi shuhua shoucang shilue* 元代皇室書
畫收藏史略 [History of the Yuan court collecting practices of paintings and cal-
ligraphies] (Taipei: National Palace Museum, 1981), 1–34; and Jiang Yihan 姜一
涵, "Yuan neifu zhi shuhua shoucang xia" 元內府之書畫收藏‧下 [The calligraphy
and painting collection of the Yuan court, part II], *Gugong jikan* 故宮季刊 14, no. 3
(Spring 1980): 1–36. There are more recent related studies, such as Chen Yunru
陳韻如, "Mengyuan huangshi de shuhua yishu fengshang yu shoucang" 蒙元皇室
的書畫藝術風尚與收藏 [Art and the Yuan Mongol imperial clan: Collecting of and
trends in painting and calligraphy], in *Dahan de shiji: mengyuan shidai de duoyuan
wenhua yu yishu* 大汗的世紀：蒙元時代的多元文化與藝術, ed. Shih Shou-chien 石守謙
and Ge Wanzhang 葛婉章 (Taipei: National Palace Museum, 2001), 266–285; and
exhibition catalogues such as Chen Yunru 陳韻如 ed., *Gongzhu de yaji: Mengyuan*

huangshi yu shuhua jiancang wenhua tezhan 公主的雅集：蒙元皇室與書畫鑒藏文化特展 [Elegant gathering of the princess: The culture of appreciating and collecting art at the Mongol Yuan court] (Taipei: National Palace Museum, 2016).

37. Sengge Ragi's biographical information is diffuse in the *Yuan shi* 元史 [The Yuan history] and other historical documents. It has been summarized in studies such as Jiang Yihan 姜一涵, *Yuandai kuizhangge ji kuizhang renwu* 元代奎章閣及奎章人物 [The Kuizhangge of the Yuan dynasty and its luminaries] (Taipei: Lianjing chuban shiye gongsi, 1981), 11–15 and 234–235.

38. It must be noted that Fu Shen 傅申 believes that the seal "Huangjie tushu" 皇姐 圖書 (Seal of the Imperial Elder Sister) on the *Boat Race* painting in Taipei was faked. Fu Shen 傅申, *Yuandai huangshi shuhua shoucang shilue* 元代皇室書畫收藏史 略 [History of the Yuan court collecting practices of paintings and calligraphies] (Taipei: National Palace Museum, 1981), 23.

39. This event was recorded in Yuan Jue's 袁桷 "Luguo dazhang gongzhu tuhua ji" 魯 國大長公主圖畫記 [A record of calligraphy and paintings collected by the Grand Elder Princess of the State of Lu], in *Yuan Jue ji jiao zhu* 袁桷集校注, Yuan Jue 袁桷 (Beijing: Zhonghua shuju, 2012), 5:1981–1982.

40. Yuan Jue listed paintings and calligraphy that appeared in this gathering, and this list is included in Fu Shen 傅申, *Yuandai huangshi shuhua shoucang shilue* 元代皇 室書畫收藏史略 [History of the Yuan court collecting practices of paintings and calligraphies] (Taipei: National Palace Museum, 1981), 16–18; and Jiang Yihan 姜 一涵, "Yuan neifu zhi shuhua shoucang xia" 元內府之書畫收藏 · 下 [The calligraphy and painting collection of the Yuan court, part II], *Gugong jikan* 故宮季刊 14, no. 3 (Spring 1980): 1–6.

41. Ankeney Weitz, "Art and Politics at the Mongol Court of China: Tugh Temür's Collection of Chinese Paintings," *Artibus Asiae* 64, no. 2 (2004): 245.

42. Their names and official positions can be found in Fu Shen 傅申, *Yuandai huangshi shuhua shoucang shilue* 元代皇室書畫收藏史略 [History of the Yuan court collecting practices of paintings and calligraphies] (Taipei: National Palace Museum, 1981), 14–15.

43. Shih Shou-chien 石守謙, "Youguan Tang Di ji yuandai Li-Guo fengge fazhan zhi ruogan wenti" 有關唐棣(1287–1355)及元代李郭風格發展之若干問題 [A few questions related to Tang Di and the development of the Li-Guo style during the Yuan dynasty], in *Fengge yu shibian: Zhongguo huihua shilun* 風格與世變：中國繪畫十論, Shih Shou-chien 石守謙 (Beijing: Beijing daxue chubanshe, 2008), 169–170.

44. Shih Shou-chien 石守謙, "Youguan Tang Di ji yuandai Li-Guo fengge fazhan zhi ruogan wenti" 有關唐棣(1287–1355)及元代李郭風格發展之若干問題 [A few questions related to Tang Di and the development of the Li-Guo style during the Yuan dynasty], in *Fengge yu shibian: Zhongguo huihua shilun* 風格與世變：中國繪畫十論, Shih Shou-chien 石守謙 (Beijing: Beijing daxue chubanshe, 2008), 169.

45. Shih Shou-chien 石守謙, "Youguan Tang Di ji yuandai Li-Guo fengge fazhan zhi ruogan wenti" 有關唐棣(1287–1355)及元代李郭風格發展之若干問題 [A few questions related to Tang Di and the development of the Li-Guo style during the Yuan dynasty], in *Fengge yu shibian: Zhongguo huihua shilun* 風格與世變：中國繪畫十論, Shih Shou-chien 石守謙 (Beijing: Beijing daxue chubanshe, 2008), 168–169.

46. Liu Guan 柳貫, "Ba Xianyu Boji yu Qiu Yanzhong xiaotie" 跋鮮于伯幾与仇彥中小帖 [Colopon on calligraphy by Xianyu Boji and Qiu Yanzhong], in *Liu Daizhi wenji* 柳 待制文集, Liu Guan 柳貫, *juan* 18 (Taipei: Taiwan shangwu yinshuguan, 1967), 228.

47. Zhao Mengfu recorded this event both in his colophon on *Sixiang Note* and in his colophon on *Travelling on the River in Clearing Snow*. See Wu Sheng 吳升, *Daguan lu* 大觀錄 [Record of extensive observations], *juan* 1, in *Xuxiu siku quanshu* 續修四庫全 書 (Shanghai: Shanghai guji chubanshe, 1995), 1066:242; and Hu Jing 胡敬, *Xiqing zhaji* 西清劄記 [Notes about works in the imperial collection], *juan* 1, in *Xuxiu siku quanshu* 續修四庫全書 (Shanghai: Shanghai guji chubanshe, 1995), 1082:64.

48. Xiao Qiqing 蕭啟慶, "Yuanchao duozu shiren de yaji" 元朝多族士人的雅集 [Multiethnic literati's "elegant gatherings" of the Yuan dynasty], *Zhongguo wenhua yanjiusuo xuebao* 中國文化研究所學報, no. 6 (1997): 187–188. More details about Gu Ying's elegant gatherings can be found in David Sensabaugh, "Guests at Jade Mountain: Aspects of Patronage in Fourteenth Century K'un-Shan," in *Artists and Patrons: Some Social and Economic Aspects of Chinese Painting*, ed. Li Chu-tsing et al. (Lawrence: University of Kansas, Nelson-Atkins Museum of Art, Kansas City, in association with University of Washington Press, 1989), 93–100; and David A. Sensabaugh, "Life at Jade Mountain: Notes on the Life of the Man of Letters in Fourteenth-Century Wu Society," in *Chūgoku kaigashi ronshū: Suzuki Kei Sensei kanreki kinen* 中国繪畫史論集：鈴木敬先生還曆記念 [Collection of articles on the Chinese painting history: A memorial to Mr. Suzuki Kei] (Tōkyō: Yoshikawa Kōbunkan, 1981), 45–69.

49. The analysis of Gu's guests was quoted from Shih Shou-chien 石守謙, "Youguan Tang Di ji yuandai Li-Guo fengge fazhan zhi ruogan wenti" 有關唐棣 (1287–1355) 及元代李郭風格發展之若干問題 [A few questions related to Tang Di and the development of the Li-Guo style during the Yuan dynasty], in *Fengge yu shibian: Zhongguo huihua shilun* 風格與世變：中國繪畫十論, Shih Shou-chien 石守謙 (Beijing: Beijing daxue chubanshe, 2008), 172–173.

50. David A. Sensabaugh, "Life at Jade Mountain: Notes on the Life of the Man of Letters in Fourteenth-Century Wu Society," in *Chūgoku kaigashi ronshū: Suzuki Kei Sensei kanreki kinen* 中国繪畫史論集：鈴木敬先生還曆記念 [Collection of articles on the Chinese painting history: A memorial to Mr. Suzuki Kei] (Tōkyō: Yoshikawa Kōbunkan, 1981), 55.

Conclusion

1. Tan Qixiang 譚其驤, *Jianming zhongguo lishi ditu ji* 簡明中國歷史地圖集 [Concise historical atlas of China] (Beijing: Zhongguo ditu chubanshe, 1996), 59–60.

2. Zhao Yang 趙陽, "Xia Yong 'Yueyang lou tu' de zhizuo yu gongyong" 夏永《岳陽 樓圖》的製作與功用 [The production process and function of Xia Yong's *Yueyang Pavilion* painting], *Zhonghua wenhua huabao* 中華文化畫報, no. 4 (2018): 33.

3. My comparison between different calligraphic inscriptions on Xia's *Yueyang Pavilion* paintings is based on Zhao Yang's findings, and meanwhile corrects some of his mistakes (for example, Zhao mistakenly reads "gu ren ren" 古仁人 in the Beijing album leaf as "gu ren ren" 古人仁). Information related to the Japan copy,

which is not mentioned by Zhao, is also added. See Zhao Yang 趙陽, "Xia Yong 'Yueyang lou tu' de zhizuo yu gongyong" 夏永《岳陽樓圖》的製作與功用 [The production process and function of Xia Yong's *Yueyang Pavilion* painting], *Zhonghua wenhua huabao* 中華文化畫報, no. 4 (2018): 33. The translation of "Yueyang lou ji" comes from Richard E. Strassberg, *Inscribed Landscapes: Travel Writing from Imperial China* (Berkeley and Los Angeles, CA: University of California Press, 1994), 159.

4. Deng Chun 鄧椿, *Huaji* 畫繼 [A continuation of the history of painting], in *Huashi congshu* 畫史叢書, ed. Yu Anlan 于安瀾 (Shanghai: Shanghai renmin meishu chubanshe, 1982), 1:46 and 57.

5. Lothar Ledderose, *Ten Thousand Things: Module and Mass Production in Chinese Art* (Princeton, NJ: Princeton University Press, 2000), 48.

6. Lothar Ledderose, *Ten Thousand Things: Module and Mass Production in Chinese Art* (Princeton, NJ: Princeton University Press, 2000), 48.

7. Deborah Del Gais Muller, "Hsia Wen-yen and His *T'u-hui pao-chien (Precious Mirror of Painting),*" *Ars Orientalis* 18 (1988): 138–140.

8. Chen Yunru 陳韻如, "Jiyi de tuxiang: Wang Zhenpeng longzhou tu yanjiu" 記憶的圖像：王振鵬龍舟圖研究 [Images from times past: A study of Wang Zhenpeng's dragon boat paintings], *Gugong xueshu jikan* 故宮學術季刊 20, no. 2 (2002): 134.

9. Xu Fei徐菲, "Ling Yunhan shengping xiaokao" 凌雲翰生平小考 [An examination of Ling Yunhan's biography], *Mei yu shidai: xueshu xia* 美與時代：學術 下, no. 11 (2015): 102.

10. Roslyn Lee Hammers, *Pictures of Tilling and Weaving: Art, Labor, and Technology in Song and Yuan China* (Hong Kong: Hong Kong University Press, 2011), 109.

11. Qian Shuoyou 潛說友, *Xianchun Lin'an zhi* 咸淳臨安志 [Gazetteer of Lin'an from the Xianchun reign period (1265–1274)], *juan* 33, in *Songyuan fangzhi congkan* 宋元方志叢刊, ed. Zhonghua shuju bianjibu 中華書局編輯部 (Beijing: Zhonghua shuju, 1990), 4:3665.

12. Fan Zhongyan 范仲淹, *Fan Wenzheng gong wen ji* 范文正公文集 [Fan Zhongyan's collection], *juan* 8 (Beijing: Zhonghua shuju, 1984), 3:80; trans. with slight modification, Richard E. Strassberg, *Inscribed Landscapes: Travel Writing from Imperial China* (Berkeley and Los Angeles, CA: University of California Press, 1994), 159.

13. Su Zhe 蘇轍, *Su Zhe ji* 蘇轍集 [Collected works of Su Zhe], *juan* 17 (Beijing: Zhonghua shuju, 1999), 1:335.

14. Alfreda Murck, *Poetry and Painting in Song China: The Subtle Art of Dissent* (Cambridge, MA: Harvard University Asia Center, 2000).

15. The catastrophic floods occurring in the Yuan period are recorded in Song Lian 宋濂 et al., *Yuan shi* 元史 [The Yuan history], *juan* 51, *zhi* 志 no. 3, *wuxing* 五行 no. 2 (Beijing: Zhonghua shuju, 2000), 743–745.

16. Wen Fong, *Beyond Representation: Chinese Painting, 8th–14th Century* (New York: Metropolitan Museum of Art, 1992): 402.

17. Song Lian 宋濂 et al., *Yuan shi* 元史 [The Yuan history], *juan* 94 (Taipei: Dingwen shuju, 1981), 2402. Although the Maritime Trade Supervisorate in Hangzhou was abolished in 1293, its role in international trade did not change.

Bibliography

Allee, Stephen D. et al. "Song and Yuan Dynasty Painting and Calligraphy: Object Documentation and Images No. 43 and No. 44." Accessed Oct. 27, 2021. https://asia.si.edu/publications/songyuan/documentation/

Allen, Joseph R. "Standing on a Corner in Twelfth Century China: A Semiotic Reading of a Frozen Moment in the 'Qingming shanghe tu.'" *Journal of Song-Yuan Studies*, no. 27 (1997): 109–125.

Allsen, Thomas T. "Guard and Government in the Reign of The Grand Qan Möngke, 1251–59." *Harvard Journal of Asiatic Studies* 46, no. 2 (Dec 1986): 495–521.

Barnhart, Richard. *Along the Border of Heaven: Sung and Yüan Paintings from the C.C. Wang Family Collection*. New York: The Metropolitan Museum of Art, 1983.

Barnhart, Richard, Xin Yang, Chongzheng Nie, James Cahill, Shaojun Lang, and Hung Wu. *Three Thousand Years of Chinese Painting*. New Haven: Yale University Press, 1997.

Bush, Susan. *The Chinese Literati on Painting: Su Shih (1037–1101) to Tung Ch'i-ch'ang (1555–1636)*. Hong Kong: Hong Kong University Press, 2012.

Bush, Susan, and Hsio-yen Shih. *Early Chinese Texts on Painting*. Hong Kong: Hong Kong University Press, 2012.

Cahill, James. *Chinese Album Leaves in the Freer Gallery of Art*. Washington, D.C.: Smithsonian Institution, 1961.

Cahill, James. "Early Chinese Paintings in Japan: An Outsider's View." Accessed Jan. 15, 2018. http://jamescahill.info/the-writings-of-james-cahill/cahill-lectures-and-papers/323–early-chinese-paintings-in-japan-an-outsiders-

Cahill, James. *Hills Beyond a River: Chinese Painting of the Yüan Dynasty, 1279–1368*. New York: Weatherhill, 1976.

Cahill, James. *An Index of Early Chinese Painters and Paintings: Tang, Sung, and Yüan*. Berkeley and Los Angeles: University of California Press, 1980.

Cahill, James. *The Painter's Practice: How Artists Lived and Worked in Traditional China*. New York: Columbia University Press, 1994.

Chai Zejun 柴澤俊. *Shuozhou Chongfu si* 朔州崇福寺 [Chongfu Monastery in Shuozhou]. Beijing: Wenwu chubanshe, 1996.

Chen Gaohua 陳高華. *Yuandai huajia shiliao huibian* 元代畫家史料匯編 [Collected historical materials about Yuan painters]. Hangzhou: Hangzhou chubanshe, 2004.

Chen Gaohua 陳高華, Zhang Fan 張帆, and Liu Xiao 劉曉. *Yuandai wenhua shi* 元代文化史 [The cultural history of the Yuan dynasty]. Guangzhou: Guangdong jiaoyu chubanshe, 2009.

Chen Gaohua 陳高華, Zhang Fan 張帆, Liu Xiao 劉曉, and Dang Baohai 黨寶海, eds. *Yuan Dianzhang* 元典章 [Statues and precedents of the Yuan dynasty]. Tianjin: Zhonghua shuju; Tianjin guji chubanshe, 2012.

Chen Jiru 陳繼儒. *Nigu lu* 妮古錄 [Record of fondness for antiquity]. Taipei: Yiwen yin-shuguan, 1965.

Chen Lei 陳磊. "Wumu shanshui—zhongguo gudai jianzhu yu shanshui huihua yanjiu" 屋木山水—中國古代建築與山水繪畫研究 [Wooden construction and landscape painting—a study of ancient Chinese architecture and landscape paintings]. PhD diss., China Academy of Art, 2011.

Chen Menglei 陳夢雷. *Gujin tushu jicheng* 古今圖書集成 [Complete collection of illustrations and writings from the earliest to current times]. Shanghai: Zhonghua shuju, 1934.

Chen Yan 陳衍, ed. *Yuanshi jishi* 元詩紀事 [Commentaries on Yuan poetry]. Shanghai: Shanghai guji chubanshe, 1987.

Chen Yunru 陳韻如, ed. *Gongzhu de yaji: Mengyuan huangshi yu shuhua jiancang wenhua tezhan* 公主的雅集：蒙元皇室與書畫鑒藏文化特展 [Elegant gathering of the princess: The culture of appreciating and collecting art at the Mongol Yuan court]. Taipei: National Palace Museum, 2016.

Chen Yunru 陳韻如. "'Jiehua' zai Song Yuan shiqi de zhuanzhe: yi Wang Zhenpeng de jiehua wei li" "界畫" 在宋元時期的轉折：以王振鵬的界畫為例 [The change of *jiehua* during the Song-Yuan period: The example of Wang Zhenpeng's *jiehua*]. *Meishushi yanjiu jikan* 美術史研究集刊, no. 26 (2009): 135–192.

Chen Yunru 陳韻如. "Jiyi de tuxiang: Wang Zhenpeng longzhou tu yanjiu" 記憶的圖像：王振鵬龍舟圖研究 [Images from times past: A study of Wang Chen-p'eng's dragon boat paintings]. *Gugong xueshu jikan* 故宮學術季刊 20, no. 2 (2002): 129–164.

Chen Zilong 陳子龍 et al., eds. *Ming jingshi wenbian* 明經世文編 [Compendium of state-craft documents of the Ming]. Beijing: Zhonghua shuju, 1987.

Cheng Jufu 程鉅夫. *Xuelou ji* 雪樓集 [Xuelou's collection]. Shanghai: Shanghai shudian, 1994.

Chou, Diana Yeongchau. *A Study and Translation from the Chinese of Tang Hou's Huajian (Examination of Painting): Cultivating Taste in Yuan China, 1279–1368.* Lewiston, NY: Edwin Mellen Press, 2005.

Chung, Anita. *Drawing Boundaries: Architectural Images in Qing China.* Honolulu: University of Hawai'i Press, 2004.

Cleaves, Francis Woodman. "A Chancellery Practice of The Mongols in The Thirteenth and Fourteenth Centuries." *Harvard Journal of Asiatic Studies* 14, no. ¾ (December 1951): 493–526.

Dai Liqiang 戴立強, ed. *Qingming shanghe tu yanjiu wenxian huibian* 《清明上河圖》研究文獻匯編 [Collections of research articles on the *Qingming shanghe tu*]. Shenyang: Wanjuan chuban gongsi, 2007.

Dai Yiheng 戴以恒. *Zuisu zhai huajue* 醉蘇齋畫訣 [Painting formula of the Zuisu Studio]. In *Zhongguo hualun leibian* 中國畫論類編, edited by Yu Jianhua 俞劍華, *bian* 6. Beijing: Renmin meishu chubanshe, 1986.

Dardess, John W. *Conquerors and Confucians: Aspects of Political Change in Late Yüan China.* New York: Columbia University Press, 1973.

Deng Chun 鄧椿. *Huaji* 畫繼 [A continuation of the history of painting]. Vol. 1 of *Huashi congshu* 畫史叢書, edited by Yu Anlan 于安瀾. Shanghai: Shanghai renmin meishu chubanshe, 1982.

Dong Gao 董誥 et al., eds. *Quan Tang wen* 全唐文 [Complete Tang prose]. Beijing: Zhonghua shuju, 1983.

Dong Qichang 董其昌. *Huachanshi suibi* 畫禪室隨筆 [Notes from the Painting-Meditation Studio]. Vol. 867 of *Siku quanshu* 四庫全書. Shanghai: Shanghai guji chubanshe, 1987.

Dong Qichang 董其昌. *Rongtai bieji* 容臺別集 [Supplemental literary anthology from the Ministry of Rites]. In *Siku jinhui shu congkan* 四庫禁燬書叢刊. Beijing: Beijing chubanshe, 2008.

Duan Yucai 段玉裁. *Shuowen jiezi zhu* 說文解字注 [Commentary on explaining graphs and analyzing characters]. Taipei: Yiwen yinshuguan, 1974.

Fan Zhongyan 范仲淹. *Fan Wenzheng gong wenji* 范文正公文集 [Collected works of Mr. Fan Wenzheng]. Beijing: Zhonghua shuju, 1985.

Fang Xuanling 房玄齡 et al. *Jin shu* 晉書 [History of the Jin dynasty]. Beijing: Zhonghua shuju, 1974.

Feng Jiren. *Chinese Architecture and Metaphor: Song Culture in the Yingzao fashi Building Manual.* Honolulu: University of Hawai‘i Press, 2012.

Feng Tianyu 馮天瑜, ed. *Huanghe lou zhi* 黃鶴樓志 [The chronicle of the Yellow Crane Tower]. Wuhan: Wuhan daxue chubanshe, 1999.

Fong, Wen. *Beyond Representation: Chinese Painting and Calligraphy, 8th–14th Century.* New York: Metropolitan Museum of Art, 1992.

Fong, Wen. "The Problem of Forgeries in Chinese Painting. Part One." *Artibus Asiae* 25, no. 2/3 (1962): 95–119, 121–140.

Fong, Wen. "Toward a Structural Analysis of Chinese Landscape Painting." *Art Journal* 28, no. 4 (Summer 1969): 388–397.

Franke, Herbert. "Consecration of the 'White Stūpa' in 1279." *Asia Major* 7, no. 1 (1994): 155–184.

Fu Boxing 傅伯星. *Songhua zhong de Nansong jianzhu* 宋畫中的南宋建築 [Southern Song architecture in Song paintings]. Hangzhou: Xiling yinshe, 2011.

Fu Shen 傅申. "Princess Sengge Ragi: Collector of Painting and Calligraphy." In *Flowering in the Shadows: Women in the History of Chinese and Japanese Painting*, edited by Marsha Smith Weidner, 55–80. Honolulu: University of Hawai‘i Press, 1990.

Fu Shen 傅申. *Yuandai huangshi shuhua shoucang shilue* 元代皇室書畫收藏史略 [History of the Yuan court collecting practices of paintings and calligraphies]. Taipei: National Palace Museum, 1981.

Fu Xinian 傅熹年. *Fu Xinian shuhua jianding ji* 傅熹年書畫鑒定集 [Fu Xinian's collection of essays on the connoisseurship of painting and calligraphy]. Zhengzhou: Henan meishu chubanshe, 1998.

Fu Xinian 傅熹年. "Lun jifu chuanwei Li Sixun huapai jinbi shanshui de huizhi shidai" 論幾幅傳為李思訓畫派金碧山水的繪製時代 [A discussion about the creation periods of a few blue-green-gold-style landscapes attributed to the Li Sixun painting school]. *Wenwu* 文物, no. 11 (1983): 76–86.

Fu Xinian 傅熹年. "Shanxi sheng Fanshi xian yanshan si nandian jindai bihua zhong suohui jianzhu de chubu fenxi" 山西省繁峙縣岩山寺南殿金代壁畫中所繪建築的初步分析 [A preliminary analysis of architectural images in Jin murals in the South Hall of Yanshan Monastery in Fanshi county, Shanxi province]. In *Dangdai zhongguo jianzhu shijia shishu Fu Xinian Zhongguo jianzhu shilun xuanji* 當代中國建築史家十書 · 傅熹年中國建築史論選集, 297–331. Shenyang: Liaoning meishu chubanshe, 2013.

Fu Xinian 傅熹年. "Wang Ximeng Qianli jiangshan tu zhong de beisong jianzhu" 王希孟《千里江山圖》中的北宋建築 [Northern Song architecture in Wang Ximeng's *One Thousand Li of Rivers and Mountains*]. In *Zhongguo shuhua jianding yu yanjiu Fu Xinian juan* 中國書畫鑒定與研究傅熹年卷, 84–111. Beijing: Gugong chubanshe, 2014.

Fu Xinian 傅熹年. "Zhongguo gudai de jianzhuhua" 中國古代的建築畫 [On architectural painting of ancient China]. *Wenwu* 文物, no. 3 (1998): 75–94.

Gao Musen 高木森. "Tang Di qiren qihua" 唐棣其人其畫 [The person Tang Di and his paintings]. *Gugong jikan* 故宮季刊 8, no. 2 (Winter 1973): 43–56.

Giles, Herbert A. *An Introduction to the History of Chinese Pictorial Art*. Shanghai: Messrs. Kelly & Walsh, Ld., 1918.

Greene, David B. "Handscroll Landscape Paintings of the Song Period and Their Tightening Perspective." *Oriental Art* 39, no. 3 (1993): 20–27.

Gu Jiegang 顧頡剛 and Liu Qiyu 劉起釪. *Shangshu jiaoshi yilun* 尚書校釋譯論 [Collation, explanation, translation, and discussion of the *Book of Documents*]. 4 vols. Beijing: Zhonghua shuju, 2005.

Gu Zuyu 顧祖禹. *Dushi fangyu jiyao* 讀史方輿紀要 [Essentials of geography for reading history]. Beijing: Zhonghua shuju, 2005.

Gulik, Robert Hans Van. *Chinese Pictorial Art as Viewed by the Connoisseur: Notes on the Means and Methods of Traditional Chinese Connoisseurship of Pictorial Art, Based upon a Study of the Art of Mounting Scrolls in China and Japan*. Roma: Istituto Italiano per il Medio ed Estremo Oriente, 1958.

Guo Daiheng 郭黛姮, ed. *Zhongguo gudai jianzhushi Song Liao Jin Xixia jianzhu* 中國古代建築史：宋、遼、金、西夏建築 [History of premodern Chinese architecture: Song, Liao, Jin, and Xixia architecture]. Beijing: Zhongguo jianzhu gongye chubanshe, 2016.

Guo Qinghua. *Chinese Architecture and Planning: Ideas, Methods, Techniques*. Stuttgart; London: Edition Axel Menges, 2005.

Guo Qinghua. *Visual Dictionary of Chinese Architecture*. Australia: Images Publishing, 2002.

Guo Ruoxu 郭若虛. *Tuhua jianwen zhi* 圖畫見聞誌 [Experiences in painting]. Vol. 1 of *Huashi congshu* 畫史叢書, edited by Yu Anlan 于安瀾. Shanghai: Shanghai renmin meishu chubanshe, 1982.

Hammers, Roslyn Lee. "'Khubilai Khan Hunting': Tribute to the Great Khan." *Artibus Asiae* 75, no. 1 (2015): 5–44.

Hammers, Roslyn Lee. *Pictures of Tilling and Weaving: Art, Labor, and Technology in Song and Yuan China*. Hong Kong: Hong Kong University Press, 2011.

Hansen, Valerie. "The Mystery of the Qingming Scroll and Its Subject: The Case against Kaifeng." *Journal of Song-Yuan Studies*, no. 26 (1996): 183–200.

Hay, Jonathan. "He Ch'eng, Liu Kuan-tao, and North-Chinese Wall-painting Traditions at the Yüan Court." *Gugong xueshu jikan* 故宮學術季刊 20, no. 1 (Fall 2002): 49–92.

Hay, Jonathan. "The Reproductive Hand." In *Between East and West: Reproductions in Art (Proceedings of the CIHA Colloquium in Naruto, Japan, 15th–18th January 2013)*, edited by Shigetoshi Osano, 319–333. Cracow: IRSA, 2014.

He Fuxin 何傳馨, ed. *Wenyi shaoxing: Nansong yishu yu wenhua shuhua juan* 文藝紹興：南宋藝術與文化・書畫卷 [Dynastic renaissance: Art and culture of the Southern Song, painting and calligraphy]. Taipei: National Palace Museum, 2010.

He Yanzhe 何延哲. "Yuandai shanshui de Li-Guo chuanpai" 元代山水的李郭傳派 [The Li-Guo traditions in Yuan landscape paintings]. *Meishu yanjiu* 美術研究, no. 4 (1986): 56–64.

Hearn, Maxwell K. "Shifting Paradigms in Yuan Literati Art: The Case of the Li-Guo Tradition." *Ars Orientalis* 37 (2009): 78–106.

Hu Jing 胡敬. *Xiqing Zhaji* 西清箚記 [Notes about works in the imperial collection]. Vol. 1082 of *Xuxiu siku quanshu* 續修四庫全書. Shanghai: Shanghai guji chubanshe, 1995.

Hu Wei 胡渭. *Yugong zhuizhi* 禹貢錐指 [A modest approach to the Tributes of Yu]. Shanghai: Shanghai guji chubanshe, 1996.

Hu Zhiyu 胡祗遹. *Zishan daquanji* 紫山大全集 [Complete works of Zishan]. In *Wenyuan ge siku quanshu version* 文淵閣四庫全書本. Taipei: Taiwan shangwu yinshuguan, 1973.

Huang, Shih-shan Susan. "Media Transfer and Modular Construction: The Printing of Lotus Sutra Frontispieces in Song China." *Ars Orientalis* 41 (2011): 135–163.

Huang Xiufu 黃休復. *Yizhou minghualu* 益州名畫錄 [Records of famous painters of Yizhou]. Vol. 4 of *Huashi congshu* 畫史叢書, edited by Yu Anlan 于安瀾. Shanghai: Shanghai renmin meishu chubanshe, 1982.

Itakura, Masaaki 板倉聖哲. "Gakazo to shite no kaei、 sono seiritsu to tenkai: 《take yorozu》 o chushin ni" 画家像としての夏永、その成立と展開：《岳陽楼図》を中心に [The formation and development of Xia Yong as a painter: Focusing on the *Yueyang Pavilion* painting]. *Bijutsu forum 21* 美術フォーラム21, no. 32 (2015): 103–109.

Itakura, Masaaki. "Kaeihitsu Take yorozu" 夏永筆岳陽楼図 [The *Yueyang Pavilion* painting by Xia Yong]. *Kokka* 國華 122, no. 3 (October 2016): 33, 35–39.

Jang, Ju-Yu Scarlett. "Issues of Public Service in the Themes of Chinese Court Painting." PhD diss., University of California at Berkeley, 1989.

Jiang Renjie 蔣人傑, ed. *Shuowen jiezi jizhu* 說文解字集注 [Collected commentaries on explaining graphs and analyzing characters]. Shanghai: Shanghai guji chubanshe, 1996.

Jiang Shaoshu 姜紹書. *Yunshizhai bitan* 韻石齋筆談 [Miscellaneous notes from the Yunshi Studio]. In *Zhibuzuzhai congshu* 知不足齋叢書. Taipei: Yiwen yinshuguan, 1966.

Jiang Yihan 姜一涵. *Yuandai kuizhangge ji kuizhang renwu* 元代奎章閣及奎章人物 [The Kuizhangge of the Yuan dynasty and its luminaries]. Taipei: Lianjing chuban shiye gongsi, 1981.

Jiang Yihan 姜一涵. "Yuan neifu zhi shuhua shoucang shang" 元內府之書畫收藏・上 [The calligraphy and painting collection of the Yuan court, part I]. *Gugong jikan* 故宮季刊 14, no. 2 (Winter 1979): 25–54.

Jiang Yihan 姜一涵. "Yuan neifu zhi shuhua shoucang xia" 元內府之書畫收藏・下 [The calligraphy and painting collection of the Yuan court, part II]. *Gugong jikan* 故宮季刊 14, no. 3 (Spring 1980): 1–36.

Jing, Anning. "Yongle Palace: The Transformation of the Daoist Pantheon during the Yuan Dynasty (1260–1368)." PhD diss., Princeton University, 1994.

Johnson, Linda Cooke. "The Place of 'Qingming shanghe tu' in the Historical Geography of Song Dynasty Dongjing." *Journal of Song-Yuan Studies*, no. 26 (1996): 145–182.

Ju Qingyuan 鞠清遠. "Yuandai xiguan jianghu yanjiu" 元代係官匠戶研究 [A study of Yuan artisan households]. *Shihuo banyuekan* 食貨半月刊 1, no. 9 (1935): 11–45.

Kong Anguo 孔安國 and Kong Yingda 孔穎達. *Shangshu zhengyi* 尚書正義 [Correct meaning of the *Book of Documents*]. Shanghai: Shanghai guji chubanshe, 2007.

Kwok, Zoe Song-Yi. "An Intimate View of the Inner Quarters: A Study of Court Women and Architecture in *Palace Banquet*." PhD diss., Princeton University, 2013.

Laing, Ellen Johnston. "Li Sung and Some Aspects of Southern Sung Figure Painting." *Artibus Asiae* 37, no. 1/2 (1975): 5–38.

Laing, Ellen Johnston. "'Suzhou Pian' and Other Dubious Paintings in the Received 'Oeuvre' of Qiu Ying." *Artibus Asiae* 59, no. 3/4 (2000): 265–295.

Langlois, John D. "Yü Chi and His Mongol Sovereign: The Scholar as Apologist." *The Journal of Asian Studies* 38, no. 1 (November 1978): 99–116.

Laufer, Berthold. *T'ang, Sung and Yüan Paintings Belonging to Various Chinese Collectors*. Paris: Librairie nationale d'art et d'histoire: G. van Oest, 1924.

Ledderose, Lothar. "Subject Matter in Early Chinese Painting Criticism." *Oriental Art* 19, no. 1 (1973): 69–83.

Ledderose, Lothar. *Ten Thousand Things: Module and Mass Production in Chinese Art*. Princeton, NJ: Princeton University Press, 2000.

Lee, Sherman E., and Wai-Kam Ho. *Chinese Art Under the Mongols: The Yüan Dynasty (1279–1368)*. Cleveland: The Cleveland Museum of Art, 1968.

Li Chu-tsing, James Cahill, Wai-kam Ho, and Claudia Brown, eds. *Artists and Patrons: Some Social and Economic Aspects of Chinese Painting*. Lawrence: University of Kansas, Nelson-Atkins Museum of Art, Kansas City, in association with University of Washington Press, 1989.

Li Chu-tsing. "Recent Studies in Yüan Painting." *Gugong xueshu jikan* 故宮學術季刊 4, no. 2 (Winter 1986): 37–44.

Li Chu-tsing, and C. T. L. "The Autumn Colors on the Ch'iao and Hua Mountains: A Landscape by Chao Meng-Fu." *Artibus Asiae, Supplementum* 21 (1965): 4–7, 9–85, 87, 89–109.

Li Daoyuan 酈道元. *Wangshi hejiao shuijing zhu* 王氏合校水經注 [Commentary on the *Waterways Classic*, collated by Wang]. Collated by Wang Xianqian 王先謙. Shanghai: Zhonghua shuju, 1936.

Li E 厲鶚. *Nansong yuanhua lu* 南宋院畫錄 [Records on paintings of the Southern Song Academy]. Vol. 4 of *Huashi congshu* 畫史叢書, edited by Yu Anlan 于安瀾. Shanghai: Shanghai renmin meishu chubanshe, 1982.

Li Jie 李誡. *Yingzao fashi* 營造法式 [State building standards]. Shanghai: Shanghai guji chubanshe, 1987.

Li Jifu 李吉甫. *Yuanhe junxian tuzhi* 元和郡縣圖志 [Maps and gazetteer of the command-eries and counties in the Yuanhe period]. Beijing: Zhonghua shuju, 1983.

Li Yanshou 李延壽. *Beishi* 北史 [History of Northern dynasties]. Beijing: Zhonghua shuju, 1974.

Li Yuhang. "Embroidering Guanyin: Constructions of the Divine through Hair." *East Asian Science, Technology, and Medicine*, no. 36 (2012): 131–166.

Li Zhi 李廌. *Deyutang huapin* 德隅堂畫品 [Evaluations of painters from the Deyu Studio]. Vol. 1 of *Zhongguo shuhua quanshu* 中國書畫全書, edited by Lu Fusheng 盧輔聖. Shanghai: Shanghai shuhua chubanshe, 2000.

Li Zuoxian 李佐賢. *Shiquan shuwu leigao* 石泉書屋類稿 [Categorized drafts of Rock-and-Spring Studio]. In *Xuxiu siku quanshu* 續修四庫全書. Shanghai: Shanghai guji chu-banshe, 1995.

Liang Sicheng 梁思成. *Yingzao fashi zhushi* 營造法式注釋 [Comments on *Yingzao fashi*]. Beijing: Zhongguo jianzhu gongye chubanshe, 1983.

Liang Sicheng 梁思成. *Zhongguo jianzhushi* 中國建築史 [A history of Chinese architec-ture]. Beijing: Sanlian shudian, 2016.

Liaoning Provincial Museum, ed. *"Qingming shanghe tu" yanjiu wenxian huibian* 《清明上河圖》研究文獻匯編 [A compilation of research papers on the *Qingming shanghe tu*]. Shenyang: Wanjuan chuban gongsi, 2007.

Lin Lina 林莉娜. *Gongshi louge zhi mei: jiehua tezhan* 宮室樓閣之美‧界畫特展 [The elegance and elements of Chinese architecture: Catalogue to the special exhibition "the beauty of traditional Chinese architecture in painting"]. Taipei: National Palace Museum, 2000.

Ling Yunhan 凌雲翰. *Zhexuan ji* 柘軒集 [Zhexuan collection]. Vol. 1227 of *Siku quanshu* 四庫全書. Shanghai: Shanghai guji chubanshe, 1987.

Lippit, Yukio. "Ningbo Buddhist Painting: A Reassessment." *Orientations* 40, no. 5 (2009): 54–62.

Liscomb, Kathlyn Maurean. "Social Status and Art Collecting: The Collections of Shen Zhou and Wang Zhen." *The Art Bulletin* 78, no. 1 (March 1996): 111–136.

Liu Daochun 劉道醇. *Shengchao minghua ping* 聖朝名畫評 [Evaluations of Song dynasty painters of renown]. Vol. 1 of *Zhongguo shuhua quanshu* 中國書畫全書, edited by Lu Fusheng 盧輔聖. Shanghai: Shanghai shuhua chubanshe, 2000.

Liu Daochun 劉道醇. *Wudai minghua buyi* 五代名畫補遺 [A supplement on the famous painters of the Five Dynasties]. Vol. 1 of *Zhongguo shuhua quanshu* 中國書畫全書, edited by Lu Fusheng 盧輔聖. Shanghai: Shanghai shuhua chubanshe, 2000.

Liu Diyu 劉滌宇. "Zhongguo chuantong wumuhua zhong dougong biaoda fangshi de bianqian" 中國傳統屋木畫中斗拱表達方式的變遷 [The evolution of the bracket set's representation in the architectural painting of traditional China]. *Shijie jianzhu* 世界建築, no. 9 (2017): 30–35.

Liu Dunzhen 劉敦楨, ed. *Zhongguo gudai jianzhushi* 中國古代建築史 [History of premod-ern Chinese architecture]. Beijing: Zhongguo jianzhu gongye chubanshe, 2016.

Liu Fangru 劉芳如. "Wei Jiuding yu Luoshen tu—jiantan Yuandai de baimiao renwu yu hezuo hua" 衛九鼎與洛神圖——兼談元代的白描人物與合作畫 [Wei Jiuding and the *Goddess of the Luo River*—also discuss the Yuan *baimiao*-style figure paintings and

co-operated paintings]. *Gugong wenwu yuekan* 故宮文物月刊 20, no. 1 (April 2002): 20–43.

Liu Guan 柳貫. *Liu Daizhi wenji* 柳待制文集 [Liu Daizhi's literay collection]. Taipei: Taiwan shangwu yinshuguan, 1967.

Liu Heping. "Painting and Commerce in Northern Song Dynasty China, 960–1126." PhD diss., Yale University, 1997.

Liu Heping. "The Water Mill and Northern Song Imperial Patronage of Art, Commerce, and Science." *The Art Bulletin* 84, no. 4 (2002): 566–595.

Liu Xiang 劉向. *Shuoyuan* 說苑 [Garden of persuasions]. In *Taiping guangji* 太平廣記, edited by Li Fang 李昉. Beijing: Zhonghua shuju, 1961.

Liu Xianting 劉獻廷. *Guangyang zaji* 廣陽雜記 [Miscellaneous records by Guangyang]. Beijing: Zhonghua shuju, 1985.

Liu Xu 劉昫. *Jiu Tangshu* 舊唐書 [The old Tang history]. Beijing: Zhonghua shuju, 1975.

Loehr, Max. *Chinese Painting After Sung*. New Haven: Yale University Art Gallery, 1968.

Lu You 陸遊. "Rushu ji" 入蜀記 [Record of a trip to Shu]. Vol. 460 of *Wenyuan'ge siku quanshu* 文淵閣四庫全書. Taipei: Taiwan Shangwu yinshuguan, 1983.

Maeda, Robert J. "Chieh-hua: Ruled-line Painting in China." *Ars Orientalis* 10 (1975): 123–141.

Mair, Victor H., Ch'eng Mei, and Po Wang. *Mei Cherng's "Seven Stimuli" and Wang Bor's "Pavilion of King Terng": Chinese Poems for Princes*. Lewiston, NY: The Edwin Mellen Press, 1988.

March, Benjamin. *Some Technical Terms of Chinese Painting*. Baltimore: Waverly Press, 1935.

Matsushima, Shūe 松島宗衛. *Kundaikan sō chōki kenkyū* 君台觀左右帳記研究 [A study of Kundaikan Souchoki]. Tōkyō: Chūō Bijutsusha, 1931.

McCausland, Shane. *The Mongol Century: Visual Cultures of Yuan China, 1271–1368*. Honolulu: University of Hawai'i Press, 2015.

McCausland, Shane. "Zhao Mengfu (1254–1322) and the Revolution of Elite Culture in Mongol China." PhD diss., Princeton University, 2000.

McCausland, Shane. *Zhao Mengfu: Calligraphy and Painting for Khubilai's China*. Hong Kong: Hong Kong University Press, 2011.

McNair, Amy. *Xuanhe Catalogue of Paintings: An Annotated Translation with Introduction*. Ithaca, New York: East Asia Program, Cornell University, 2019.

Muller, Deborah Del Gais. "Hsia Wen-yen and His 'T'u-hui pao-chien (Precious Mirror of Painting).'" *Ars Orientalis* 18 (1988): 131–148.

Murck, Alfreda. *Poetry and Painting in Song China: The Subtle Art of Dissent*. Cambridge, MA: Harvard University Asia Center, 2000.

Murray, Julia K. "Water Under a Bridge: Further Thoughts on the 'Qingming' Scroll." *Journal of Song-Yuan Studies*, no. 27 (1997): 99–107.

National Palace Museum. *Gugong shuhua lu* 故宮書畫錄 [Catalogue of paintings and calligraphy in the National Palace Museum]. 4 vols. Taipei: National Palace Museum, 1965.

National Palace Museum. *Gugong shuhua tulu* 故宮書畫圖錄 [Illustrated catalogue of paintings and calligraphy in the National Palace Museum]. 20+ vols. Taipei: National Palace Museum, 1989–.

National Palace Museum. *Jiehua tezhan tulu* 界畫特展圖錄 [Illustrated catalogue of the special exhibition of ruled-line paintings]. Taipei: National Palace Museum, 1986.

National Palace Museum. *Miaofa lianhua jing tulu* 妙法蓮華經圖錄 [A special exhibition of illustrations of the *Lotus Sutra*]. Taipei: National Palace Museum, 1995.

National Palace Museum. *Midian zhulin shiqu baoji* 秘殿珠林石渠寶笈 [Beaded grove of the Secret Hall and precious bookbox of the Shiqu Library]. Taipei: National Palace Museum, 1971.

National Palace Museum. *Midian zhulin shiqu baoji sanbian* 秘殿珠林石渠寶笈三編 [Beaded grove of the Secret Hall and precious bookbox of the Shiqu Library, third series]. Taipei: National Palace Museum, 1969.

National Palace Museum. *Midian zhulin shiqu baoji xubian* 秘殿珠林石渠寶笈續編 [Beaded grove of the Secret Hall and precious bookbox of the Shiqu Library, supplement]. Taipei: National Palace Museum, 1971.

National Palace Museum. *Proceedings of the International Symposium on Chinese Painting, June 18–24, 1970*. Taipei: National Palace Museum, 1970.

National Palace Museum. *Songdai shuhua ceye mingpin tezhan* 宋代書畫冊頁名品特展 [Famous album leaves of the Song dynasty]. Taipei: National Palace Museum, 1995.

National Palace Museum. *Wenxue mingzhu yu meishu tezhan* 文學名著與美術特展 [Representations of the literary mind: The theme of poetry and literature in Chinese art; catalogue to a special exhibition of works from the collection of the National Palace Museum]. Taipei: National Palace Museum, 2001.

Nie Xintang 聶心湯. *Wanli Qiantang xianzhi* 萬歷錢塘縣志 [Qiantang chronicle of the Wanli reign] (the 1893 version). Taipei: Chengwen chubanshe, 1975.

Ogawa, Hiromitsu 小川裕充 and Masaaki Itakura 板倉聖哲, comp. *Chūgoku kaiga sōgō zuroku Sanpen* 中國繪畫總合圖錄三編 [Comprehensive illustrated catalog of Chinese paintings third series]. Tōkyō: Tōkyō Daigaku Shuppankai, 2013–.

Ouyang Xiu 歐陽修 and Song Qi 宋祁. *Xin Tangshu* 新唐書 [The new Tang history]. Beijing: Zhonghua shuju, 1975.

Owen, Stephen. *The Great Age of Chinese Poetry: The High Tang*. New Haven: Yale University Press, 1981.

Pan Guxi 潘谷西, ed. *Zhongguo gudai jianzhushi Yuan Ming jianzhu* 中國古代建築史：元、明建築 [History of premodern Chinese architecture: Yuan and Ming architecture]. Beijing: Zhongguo jianzhu gongye chubanshe, 2016.

Peng Dingqiu 彭定求 et al., eds. *Quan Tangshi* 全唐詩 [Complete Tang poems]. 25 vols. Beijing: Zhonghua shuju, 2012.

Ping, Foong. *The Efficacious Landscape: On the Authorities of Painting at the Northern Song Court*. Cambridge and London: Harvard University Press, 2015.

Powers, Martin J. "Garden Rocks, Fractals, and Freedom: Tao Yuanming Comes Home." *Oriental Art* 44, no. 1 (1998): 28–38.

Qi Ping 齊平, Chai Zejun 柴澤俊, Zhang Wu'an 張武安, and Ren Yimin 任毅敏, eds. *Datong huayansi* 大同華嚴寺 [Huayan Monastery in Datong]. Beijing: Wenwu chubanshe, 2008.

Qi Yingtao 祁英濤. "Zhongguo gudai jianzhu de jishi" 中國古代建築的脊飾 [Roof ridge ornaments for ancient Chinese architecture]. *Wenwu* 文物, no. 3 (1978): 62–70.

Qian Shuoyou 潛說友. *Xianchun Lin'an zhi* 咸淳臨安志 [Gazetteer of Lin'an from the Xianchun reign period (1265–1274)]. Vol. 4 of *Songyuan fangzhi congkan* 宋元方志叢刊, edited by Zhonghua shuju bianjibu 中華書局編輯部. Beijing: Zhonghua shuju, 1990.

Quan Heng 權衡, ed. *Gengshen waishi* 庚申外史 [Unofficial history of the Emperor Gengshen]. Beijing: Zhonghua shuju, 1985.

Rao Ziran 饒自然. *Huizong shierji* 繪宗十二忌 [The twelve faults in painting tradition]. Vol. 2 of *Zhongguo shuhua quanshu* 中國書畫全書, edited by Lu Fusheng 盧輔聖. Shanghai: Shanghai shuhua chubanshe, 2000.

Rossabi, Morris. *Khubilai Khan: His Life and Times.* Berkeley and Los Angeles: University of California Press, 2009.

Rowley, George. *Principles of Chinese Painting.* Princeton, NJ: Princeton University Press, 1947.

Ruan Yuan 阮元. *Shiqu suibi* 石渠隨筆 [Shiqu jottings]. In *Xuxiu siku quanshu* 續修四庫全書. Shanghai: Shanghai guji chubanshe, 1995.

Saunders, John Joseph. *The History of the Mongol Conquests.* Philadelphia: University of Pennsylvania Press, 2001.

Sensabaugh, David A. "Life at Jade Mountain: Notes on the Life of the Man of Letters in Fourteenth-Century Wu Society." In *Chūgoku kaigashi ronshū: Suzuki Kei Sensei kanreki kinen* 中国繪畫史論集：鈴木敬先生還曆記念 [Collection of articles on the Chinese painting history: A memorial to Mr. Suzuki Kei], 45–69. Tokyo: Yoshikawa Kōbunkan, 1981.

Shanxi sheng gujianzhu baohu yanjiusuo 山西省古建築保護研究所, ed. *Yanshan si jindai bihua* 岩山寺金代壁畫 [Jin murals from the Yanshan Temple]. Beijing: Wenwu chubanshe, 1983.

Shanxi sheng gujianzhu baohu yanjiusuo 山西省古建築保護研究所, Chai Zejun 柴澤俊, and Zhang Chouliang 張丑良, eds. *Fanshi yanshansi* 繁峙岩山寺 [Yanshan Monastery in Fanshi county]. Beijing: Wenwu chubanshe, 1990.

Shao Dawei 邵大為. "Tidai yu buchang: huanghe lou yu sheshan nanlou guanxi kao" 替代與補償：黃鶴樓與蛇山南樓關係考 [Replacement and complement: A study of the relationship between the Yellow Crane Tower and the Southern Pavilion of the Snake Mountain]. *Jianghan luntan* 江漢論壇, no. 8 (2020): 92–96.

Shao Dawei 邵大為 and Wang Zhaopeng 王兆鵬. "Song qian huanghe lou xingfei kao" 宋前黃鶴樓興廢考 [A study of the rise and fall of the Yellow Crane Tower before the Song]. *Jianghan luntan* 江漢論壇, no. 1 (2013): 91–96.

Shao Yuanping 邵遠平. *Xu hongjian lu yuanshi leibian* 續弘簡錄元史類編 [Classified writings on the history of the Yuan dynasty, a continuation of the Hongjian records]. 42 vols. Vol. 313 of *Xuxiu siku quanshu* 續修四庫全書. Shanghai: Shanghai guji chubanshe, 1995.

She Cheng 佘城. "Yuandai Tang Di zhi yanjiu shang" 元代唐棣之研究·上 [A study on the Yuan-period Tang Di, part I]. *Gugong jikan* 故宮季刊 16, no. 4 (Summer 1982): 33–54.

She Cheng 佘城. "Yuandai Tang Di zhi yanjiu xia" 元代唐棣之研究·下 [A study on the Yuan-period Tang Di, part II]. *Gugong jikan* 故宮季刊 17, no. 1 (Fall 1982): 1–23.

Shea, Eiren L. *Mongol Court Dress, Identity Formation, and Global Exchange*. New York: Routledge, 2020.

Shen, Hsueh-man. *Authentic Replicas: Buddhist Art in Medieval China*. Honolulu: University of Hawai'i Press, 2018.

Shen Kangshen 沈康身. "Jiehua shixue he toushixue" 界畫視學和透視學 [*Jiehua* perspective and perspective]. Vol. 8 of *Kejishi wenji* 科技史文集, 159–176. Shanghai: Shanghai kexue jishu chubanshe, 1982.

Shih Shou-chien 石守謙. "Cong Xia Wenyan dao xuezhou—lun 'tuhui baojian' dui shisi shiwu shiji dongya diqu de shanshui huashi lijie zhi xingsu" 從夏文彥到雪舟——論《圖繪寶鑑》對十四、十五世紀東亞地區的山水畫史理解之形塑 [From Xia Wenyan to Sesshu: The *Precious Mirror of Painting* and the shaping of historical knowledge of landscape painting in East Asia in the fourteenth and fifteenth centuries]. *Zhongyang yanjiuyuan lishi yuyan yanjiusuo jikan* 中央研究院歷史語言研究所集刊 81, no. 2 (2010): 229–287.

Shih Shou-chien 石守謙. "Youguan Tang Di ji yuandai Li-Guo fengge fazhan zhi ruogan wenti" 有關唐棣(1287–1355)及元代李郭風格發展之若干問題 [A few problems related to Tang Di and the development of the Li-Guo style during the Yuan dynasty]. In *Fengge yu shibian: Zhongguo huihua shilun* 風格與世變：中國繪畫十論, 129–176. Beijing: Beijing daxue chubanshe, 2008.

Shih Shou-chien 石守謙. "Yuan wenzong de gongtin yishu yu Beisong dianfan de zaisheng" 元文宗的宮廷藝術與北宋典範的再生 [The court art of the Yuan emperor Wenzong and the regeneration of Northern Song paradigms]. *Zhongguo wenhua yanjiusuo xuebao* 中國文化研究所學報, no. 65 (July 2017): 97–138.

Shih Shou-chien 石守謙, and Ge Wanzhang 葛婉章, eds. *Dahan de shiji: mengyuan shidai de duoyuan wenhua yu yishu* 大汗的世紀：蒙元時代的多元文化與藝術 [Age of the Great Khan: Pluralism in Chinese art and culture under the Mongols]. Taipei: National Palace Museum, 2001.

Silbergeld, Jerome. "All Receding Together, One Hundred Slanting Lines: Replication, Variation, and Some Fundamental Problems in the Study of Chinese Paintings of Architecture." 一去百斜：複製，變化及中國界畫研究中的若干基本問題. In *Qiannian danqing: Xidu Zhong Ri cang Zhongguo Tang, Song, Yuan huihua zhenpin* 千年丹青：細讀中日藏中國唐宋元繪畫珍品, edited by Shanghai Museum, 15–29, 131–150. Beijing: Peking University Press, 2010.

Silbergeld, Jerome. *Chinese Painting Style: Media, Methods, and Principles of Form*. Seattle and London: University of Washington Press, 1982.

Sima Guang 司馬光. *Zizhi tongjian* 資治通鑑 [Comprehensive mirror for aid in government]. Shanghai: Shanghai guji chubanshe, 1987.

Sima Qian 司馬遷. *Shiji* 史記 [Records of the grand historian]. Beijing: Zhonghua shuju, 2013.

Sōami 相阿彌. *Kundaikan sayū chōki* 君台觀左右帳記 [Kundaikan Souchoki]. Tōkyō: Koten Hozonkai, 1933.

Song Lian 宋濂 et al. *Yuan shi* 元史 [The Yuan history]. Beijing: Zhonghua shuju, 1976.

Soper, Alexander C. *Kuo Jo-Hsü's Experiences in Painting (T'u-hua chien-wen chih): An Eleventh Century History of Chinese Painting, Together with the Chinese Text in Facsimile*. Washington: American Council of Learned Societies, 1951.

Sotheby's Hong Kong, Ltd. *Important Classical Chinese Paintings and Calligraphy*. Hong Kong: Sotheby's auction catalogue, 2000.

Stanley-Baker, Joan. "The Development of Brush-Modes in Sung and Yuan." *Artibus Asiae* 39, no. 1 (1977): 13–59.

Steinhardt, Nancy Shatzman. *Chinese Architecture*. New Haven: Yale University Press, 2002.

Steinhardt, Nancy Shatzman. "Chinese Cartography and Calligraphy." *Oriental Art* 43, no. 1 (1997): 10–20.

Steinhardt, Nancy Shatzman. *Chinese Imperial City Planning*. Honolulu: University of Hawaiʻi, 1990.

Steinhardt, Nancy Shatzman. *Chinese Traditional Architecture*. New York: China Institute in America, China House Gallery, 1984.

Steinhardt, Nancy Shatzman. "Zhu Haogu Reconsidered: A New Date for the ROM Painting and the Southern Shanxi Buddhist-Daoist Style." *Artibus Asiae* 48, no. 1/2 (1987): 5–38.

Strassberg, Richard E. *Inscribed Landscapes: Travel Writing from Imperial China*. Berkeley and Los Angeles, CA: University of California Press, 1994.

Su Bai 宿白. *Baisha Song mu* 白沙宋墓 [The Song tomb in Baisha]. Beijing: Wenwu chubanshe, 2002.

Su Bai 宿白. "Yongle gong diaocha riji—fu Yongle gong dashi nianbiao" 永樂宮調查日記——附永樂宮大事年表 [Research diaries of the Yongle Monastery—with an event chronological table]. *Wenwu* 文物, no. 8 (1963): 53–78.

Su Bai 宿白. "Yuan Dadu 'Shengzhi tejian shijia sheli lingtong zhi ta beiwen' jiaozhu" 元大都《聖旨特建釋迦舍利靈通之塔碑文》校註 [Commentary on the "Stele inscription for the Stūpa with Spiritual Influence of the Śakya Relics built especially on imperial command" in Dadu of the Yuan]. *Kaogu* 考古, no. 1 (1963): 37–47, 50.

Su Tianjue 蘇天爵. *Zixi wengao* 滋溪文稿 [Zixi's literary manuscripts]. Beijing: Zhonghua shuju, 1997.

Su Zhe 蘇轍. *Su Zhe ji* 蘇轍集 [Collected works of Su Zhe]. Beijing: Zhonghua shuju, 1999.

Sun Chengrong 孫承榮 et al., eds. *Mingke huanghe lou ji jiao zhu* 明刻黃鶴樓集校注 [Annotation of the Ming block-printed edition of the *Yellow Crane Tower collection*]. Wuhan: Hubei renmin chubanshe, 1992.

Sun Chengze 孫承澤. *Gengzi xiaoxia lu* 庚子銷夏錄 [Notes written to idle away the summer of 1660]. Vol. 7 of *Zhongguo shuhua quanshu* 中國書畫全書, edited by Lu Fusheng 盧輔聖. Shanghai: Shanghai shuhua chubanshe, 2000.

Sun Kekuan 孫克寬. *Yuandai hanwenhua zhi huodong* 元代漢文化之活動 [Han cultural activities in the Yuan dynasty]. Taipei: Taiwan zhonghua shuju, 2015.

Suzuki, Kei 鈴木敬 comp. *Chūgoku kaiga sōgō zuroku* 中國繪畫總合圖錄 [Comprehensive illustrated catalog of Chinese paintings]. 5 vols. Tokyo: University of Tokyo Press, 1982–1983.

Sze, Mai-mai. *The Tao of Painting: A Study of the Ritual Disposition of Chinese Painting. With a Translation of the Chieh-tzŭ-yüan hua-chuan or Mustard Seed Garden Manual of Painting 1679–1701*. Princeton, NJ: Princeton University Press, 1963.

Tang Hou 湯垕. *Gujin huajian* 古今畫鑒 [Examination of past and present painting]. Vol. 2 of *Zhongguo shuhua quanshu* 中國書畫全書, edited by Lu Fusheng 盧輔聖. Shanghai: Shanghai shuhua chubanshe, 2000.

Tang Zhiqi 唐志契. *Huishi weiyan* 繪事微言 [Painting matters in subtle words]. In *Zhongguo hualun leibian* 中國畫論類編, edited by Yu Jianhua 俞劍華, *bian* 6. Beijing: Renmin meishu chubanshe, 1986.

Tao Zongyi 陶宗儀. *Nancun chuogeng lu* 南村輟耕錄 [Respite from plowing in the Southern Village]. Beijing: Zhonghua shuju, 1959.

Tian Rucheng 田汝成. *Xihu youlan zhi* 西湖遊覽志 [Record on West Lake tour]. Vol. 585 of *Siku quanshu* 四庫全書. Shanghai: Shanghai guji chubanshe, 1987.

Toda Teisuke 戶田禎佑 and Ogawa Hiromitsu 小川裕充 comp. *Chūgoku kaiga sōgō zuroku Zokuhen* 中國繪畫總合圖錄續編 [Comprehensive illustrated catalog of Chinese paintings second series]. 5 vols. Tokyo: Tōkyō Daigaku Shuppankai, 1998.

Trousdale, William. "Architectural Landscapes Attributed to Chao Po-chü." *Ars Orientalis* 4 (1961): 285–313.

Tsang, Ka Bo. "Further Observations on the Yuan Wall Painter Zhu Haogu and the Relationship of the Chunyang Hall Wall Paintings to 'The Maitreya Paradise' at the ROM." *Artibus Asiae* 52, no. 1/2 (1992): 94–118.

Tsang, Ka Bo. "Yongle gong Chunyang dian bihua tiji shiyi—jianji Zhu Haogu ziliao de buchong" 永樂宮純陽殿壁畫題記釋義——兼及朱好古資料的補充 [Explanation of inscriptions on the Chunyang Hall wall paintings from the Yongle Monastery—also including supplement to Zhu Haogu's materials]. *Meishu yanjiu* 美術研究 55, no. 3 (1989): 44–48.

Tsao, Hsingyuan. "Unraveling the Mystery of the Handscroll 'Qingming shanghe tu.'" *Journal of Song-Yuan Studies*, no. 33 (2003): 155–179.

Tuotuo 脫脫 et al. *Song shi* 宋史 [The Song history]. Beijing: Zhonghua shuju, 1977.

Vinograd, Richard. "De-centering Yuan Painting." *Ars Orientalis* 37 (2009): 195–212.

Waley, Arthur D. "A Chinese Picture." *The Burlington Magazine for Connoisseurs* 30, no. 166 (January 1917): 3–4, 6–7, 9–10.

Wang Bo 王勃. *Wang Zian jizhu* 王子安集註 [Collected annotations of Wang Zian]. Shanghai: Shanghai guji chubanshe, 1995.

Wang Deyi 王德毅, Li Rongcun 李榮村, and Pan Baicheng 潘柏澄, eds. *Yuanren zhuanji ziliao suoyin* 元人傳記資料索引 [Index to Yuan biographical materials]. Taipei: Xin wenfeng chubanshe, 1979–1982.

Wang Juhua 王菊華 et al. *Zhongguo gudai zaozhi gongcheng jishu shi* 中國古代造紙工程技術史 [The technical history of ancient China's paper-making industry]. Taiyuan: Shanxi jiaoyu chubanshe, 2006.

Wang, Hui Chuan 王卉娟. "Huage yu xiexian zai Jin Yuan shiqi lou jianzhu bihua zhong de shiyong fangfa" 畫格與斜線在金元時期樓建築壁畫中的使用方法 [The use of the grid system and diagonal in Jin-Yuan murals of *lou* architecture]. Vol. 8 of *Zhongguo jianzhu shilun huikan* 中國建築史論匯刊, edited by Wang Guixiang 王貴祥, 214–254. Beijing: Zhongguo gongye chubanshe, 2013.

Wang, Hui Chuan 王卉娟. "Tangdai Yide taizi mu 'quelou tu'—huage yu xiexian zai zhongguo gudai jianzhu bihua zhong de shiyong" 唐代懿德太子墓《闕樓圖》——畫格與斜線在中國古代建築壁畫中的使用 [The *Que Gate Towers* from Tang Prince

Yide's tomb: The use of the grid system and diagonal line in Chinese architecture murals]. Vol. 13 of *Zhongguo jianzhu shilun huikan* 中國建築史論匯刊, edited by Wang Guixiang 王貴祥, 244–270. Beijing: Zhongguo gongye chubanshe, 2016.

Wang, Hui Chuan 王卉娟. "The Use of the Grid System and Diagonal Line in Chinese Architecture Murals: A Study of the 14th Century Yongle Gong Temple with Further Analyses of Two Earlier Examples, Prince Yide's Tomb and Yan Shan Si Temple." PhD diss., University of Melbourne, 2009.

Wang, Hui Chuan 王卉娟. *Yuandai Yongle gong Chunyang dian jianzhu bihua xianmiao: Louge Jianzhu de huizhi fangfa* 元代永樂宮純陽殿建築壁畫線描：樓閣建築的繪製方法 [Line drawings in architectural murals from the Chunyang Hall of the Yuan Yonglegong temple: Painting methods of *louge* architecture]. Beijing: Wenwu chubanshe, 2013.

Wang Jie 王杰 et al., eds. *Qinding shiqu baoji xubian* 欽定石渠寶笈續編 [Supplement to the imperially ordered precious bookbox of the Shiqu Library]. Haikou: Hainan chubanshe, 2001.

Wang Pu 王溥. *Tang huiyao* 唐會要 [Institutional history of the Tang]. Beijing: Zhonghua shuju, 1955.

Wang Qi 王圻, and Wang Siyi 王思義, eds. *Sancai tuhui* 三才圖會 [Illustrated compendium of the Three Powers] (Ming Wanli version). Shanghai: Shanghai guji chubanshe, 1985.

Wang, Sara. "Consistencies and Contradictions: From the Gate to the River Bend in the 'Qingming shanghe tu.'" *Journal of Song-Yuan Studies*, no. 27 (1997): 127–136.

Wang Shidian 王士點, and Shang Qiweng 商企翁, eds. *Mishu jian zhi* 秘書監志 [Annals of the Imperial Library]. Hangzhou: Zhejiang guji chubanshe, 1992.

Wang Shizhen 王士禛. *Chibei outan* 池北偶談 [North Pond casual talks]. Beijing: Zhonghua shuju, 1997.

Wang Xiangzhi 王象之. *Yudi jisheng* 輿地紀勝 [Records of famous places]. Chengdu: Sichuan daxue chubanshe, 2005.

Wang Zhende 王振德. *Sheng Mao* 盛懋. Shanghai: Shanghai renmin meishu chubanshe, 1988.

Watt, James C. Y., Maxwell K. Hearn, Denise Patry Leidy, Zhixin Jason Sun, John Guy, Joyce Denney, Birgitta Augustin, and Nancy S. Steinhardt. *The World of Khubilai Khan: Chinese Art in the Yuan Dynasty*. New York: Metropolitan Museum of Art; New Haven and London: Yale University Press, 2010.

Watt, James C. Y., and Anne E. Wardwell. *When Silk Was Gold: Central Asian and Chinese Textiles*. New York: The Metropolitan Museum of Art, 1997.

Wei Dong 魏冬. "Xia Yong ji qi jiehua" 夏永及其界畫 [Xia Yong and his *jiehua*]. *Gugong bowuyuan yuankan* 故宮博物院院刊, no. 4 (1984): 68–83.

Wei Dong 畏冬. "Xia Yong he ta de jiehua" 夏永和他的界畫 [Xia Yong and his *jiehua*]. *Zijincheng* 紫禁城, no. S1 (2005): 124.

Weidner, Marsha Smith. "Aspects of Painting and Patronage at the Mongol Court, 1260–1368." In *Artists and Patrons: Some Social and Economic Aspects of Chinese Painting*, edited by Chu-tsing Li, 37–59. Lawrence: University of Kansas, Nelson-Atkins Museum of Art, Kansas City, in association with University of Washington Press, 1989.

Weidner, Marsha Smith. "Ho Ch'eng and Early Yüan Dynasty Painting in Northern China." *Archives of Asian Art* 39 (1986): 6–22.

Weidner, Marsha Smith, ed. *Latter Days of The Law: Images of Chinese Buddhism, 850–1850.* Lawrence: Spencer Museum of Art, the University of Kansas; Honolulu: University of Hawai'i Press, 1994.

Weidner, Marsha Smith. "Painting and Patronage at the Mongol Court of China, 1260–1368." PhD diss., University of California, Berkeley, 1982.

Weitz, Ankeney. "Art and Politics at the Mongol Court of China: Tugh Temür's Collection of Chinese Paintings." *Artibus Asiae* 64, no. 2 (2004): 243–280.

Weitz, Ankeney. "Notes on the Early Yuan Antique Art Market in Hangzhou." *Ars Orientalis* 27 (1997): 27–38.

Wen Fong. *Beyond Representation: Chinese Painting, 8th–14th Century.* New York: Metropolitan Museum of Art, 1992.

Weng Tongwen 翁同文. "Huaren shengzu nian kao xiapian" 畫人生卒年攷・下篇 [A study of painters' birth and death years, part II]. *Gugong jikan* 故宮季刊 4, no. 3 (1970): 45–72.

Wenying 文瑩. *Yuhu qinghua* 玉壺清話 [Stories excerpted from corpora at Yuhu]. Beijing: Zhonghua shuju, 1997.

Wetzel, Sandra Jean. "Sheng Mou: The Coalescence of Professional and Literati Painting in Late Yuan China." *Artibus Asiae* 56, no. 3/4 (1996): 263–289.

Wetzel, Sandra Jean. "Sheng Mou: The Relationship between Professional and Literati Painters in Yuan-dynasty China." PhD diss., University of Kansas, 1991.

Whitfield, Roderick. "Aspects of Time and Place in Zhang Zeduan's *Qingming shanghe tu.*" In *Toyo bijutsu ni okeru Fuzoku hyogen* [The representation of genre in East Asian art], 40–46. Toyonaka-shi: Kokusai koryu bijutsushi kenkyukai, 1986.

Whitfield, Roderick. "Chang Tse-Tuan's Ch'ing-Ming Shang-Ho t'u." PhD diss., Princeton University, 1965; authorized xerographic copy, Ann Arbor, Michigan: University Microfilms, Inc., 1973.

Wu Chongxi 吳重熹, ed. *Shilian'an huike jiu jinren ji* 石蓮盦彙刻九金人集 [Collection of nine Jin scholars complied by Shilian'an]. Taipei: Chengwen chubanshe, 1967.

Wu Cong 吳蔥. *Zai touying zhi wai: wenhua shiye xia de jianzhu tuxue yanjiu* 在投影之外：文化視野下的建築圖學研究 [Beyond projection: Studies of architectural drawing from a cultural perspective]. Tianjin: Tianjin daxue chubanshe, 2004.

Wu Kuan 吳寬. *Jiacang ji* 家藏集 [Collection from the family storehouse]. Vol. 1255 of *Siku quanshu* 四庫全書. Shanghai: Shanghai guji chubanshe, 1987.

Wu Qizhen 吳其貞. *Shuhua ji* 書畫記 [A record of paintings and calligraphies]. Vol. 8 of *Zhongguo shuhua quanshu* 中國書畫全書, edited by Lu Fusheng 盧輔聖. Shanghai: Shanghai shuhua chubanshe, 2000.

Wu Sheng 吳升. *Daguan lu* 大觀錄 [Record of extensive observations]. Vol. 1066 of *Xuxiu siku quanshu* 續修四庫全書. Shanghai: Shanghai guji chubanshe, 1995.

Xiao Jun 蕭軍, ed. *Yongle gong bihua* 永樂宮壁畫 [The murals of the Yongle Monastery]. Beijing: Wenwu chubanshe, 2008.

Xiao Qiqing 蕭啟慶. *Jiuzhou sihai fengya tong: Yuandai duozu shirenquan de xingcheng yu fazhan* 九州四海風雅同：元代多族士人圈的形成與發展 [The nine provinces and the four seas share the elegance: the formation and development of a multiethnic literati circle during the Yuan dynasty]. Taipei: Lianjing chuban gongsi, 2012.

Xiao Qiqing 蕭啟慶. "Yuanchao duozu shiren de yaji" 元朝多族士人的雅集 [Multiethnic literati's "elegant gatherings" of the Yuan dynasty]. *Zhongguo wenhua yanjiusuo xuebao* 中國文化研究所學報, no. 6 (1997): 179–203.

Xiao Qiqing 蕭啟慶. *Yuandai de zuqun wenhua yu keju* 元代的族群文化與科舉 [The ethnic cultures and civil service examinations during the Yuan dynasty]. Taipei: Lianjing chuban gongsi, 2008.

Xiao Qiqing 蕭啟慶. "Yuandai duozu shiren de shuhua tiba" 元代多族士人的書畫題跋 [Yuan multiethnic literati's inscriptions on calligraphy and paintings]. *Wenshi* 文史 95, no. 2 (2011): 209–247.

Xiao Xun 蕭洵. *Gugong yilu* 故宮遺錄 [Record of the remains of the old palace]. Beijing: Beijing guji chubanshe, 1983.

Xie Chenglin 謝成林. "Yuandai gongtin de huihua huodong jilu" 元代宮廷的繪畫活動輯錄 [Collected painting activities at the Yuan court]. *Meishu yanjiu* 美術研究 57, no. 1 (1990): 54–57.

Xie Fangde 謝枋得. *Xie Dieshan quanji jiaozhu* 謝疊山全集校註 [Annotation of Xie Dieshan's complete collection]. Shanghai: Huadong shifan daxue chubanshe, 1994.

Xie Zhiliu 謝稚柳. *Tang Wudai Song Yuan mingji* 唐五代宋元名跡 [Masterpieces of the Tang, Five Dynasties, Song, and Yuan]. Shanghai: Gudian wenxue chubanshe, 1957.

Xuanhe huapu 宣和畫譜 [Xuanhe catalogue of paintings]. Vol. 2 of *Huashi congshu* 畫史叢書, edited by Yu Anlan 于安瀾. Shanghai: Shanghai renmin meishu chubanshe, 1982.

Xu Fei 徐菲. "Ling Yunhan shengping xiaokao" 凌雲翰生平小考 [An examination of Ling Yunhan's biography]. *Mei yu shidai: xueshu xia* 美與時代：學術・下, no. 11 (2015): 100–102.

Xu Guohuang 許郭璜. *Li-Guo shanshui huaxi tezhan* 李郭山水畫系特展 [The landscape painting tradition of Li Cheng and Guo Xi: Catalogue to the special exhibition of paintings in the Li-Guo style]. Taipei: National Palace Museum, 1999.

Xu Jianrong 徐建融. *Yuandai shuhua zaojian yu yishu shichang* 元代書畫藻鑒與藝術市場 [Yuan calligraphy and painting connoisseurship and the art market]. Shanghai: Shanghai shudian chubanshe, 1999.

Xu Qin 徐沁. *Ming hua lu* 明畫錄 [Records of Ming painting]. Vol. 3 of *Huashi congshu* 畫史叢書, edited by Yu Anlan 于安瀾. Shanghai: Shanghai renmin meishu chubanshe, 1982.

Xu Youren 許有壬. *Zhizheng ji* 至正集 [The collection of Zhizheng]. Vol. 1211 of *Siku quanshu* 四庫全書. Shanghai: Shanghai guji chubanshe, 1987.

Xu Zhongling 許忠陵. "*Weimo yanjiao tu* ji qi xiangguan wenti taolun" 《維摩演教圖》及其相關問題討論 [A discussion of illustrations of *Vimalakirti Teaching* and related questions]. *Gugong bowuyuan yuankan* 故宮博物院院刊 114, no. 4 (2004): 120–129.

Xu Zhongshu 徐中舒, ed. *Hanyu da zidian* 漢語大字典 [The grand dictionary of Chinese characters]. Wuhan: Hubei cishu chubanshe, 2006.

Xue Gang 薛剛, and Wu Tinju 吳廷舉, eds. *Jiajing huguang tujing zhishu* 嘉靖湖廣圖經志書 [Illustrated gazetteer of Huguang province, Jiajing reign]. 2 vols. Beijing: Shumu wenxian chubanshe, 1991.

Xue Yongnian 薛永年. "Qinggong jiucang chuan Li Sheng yueyanglou tu kaobian" 清宮舊藏傳李昇岳陽樓圖考辨 [A study of the *Yueyang Pavilion* attributed to Li Sheng and previously held by the Qing court]. *Shoucang jia* 收藏家, no. 1 (1995): 17.

Yamato Bunkakan 大和文華館, ed. *Gen jidai no kaiga: Mongoru sekai teikoku no isseiki* 元時代の絵画：モンゴル世界帝国の一世紀 [Paintings of the Yuan dynasty: One century of the Mongol empire]. Nara: Yamato Bunkakan, 1998.

Yang Ne 楊訥. *Yuanshi yanjiu ziliao huibian* 元史研究資料彙編 [Collected materials of Yuan history studies]. Beijing: Zhonghua shuju, 2014.

Yang Renkai 楊仁愷. "1950 nian dongbei bowuguan guicang Puyi shuhua jianding baogaoshu" 1950年東北博物館庋藏溥儀書畫鑒定報告書 [Connoisseurship report on Puyi's collection of paintings and calligraphies held by the Dongbei Museum, written in 1950]. *Liaoningsheng bowuguan guankan* 遼寧省博物館館刊, no. 00 (2006): 1–13, 535.

Yang Xin 楊新. *Jixian Dule si* 薊縣獨樂寺 [Dule Temple in Ji county]. Beijing: Wenwu chubanshe, 2007.

Yanai, Wataru 箭内亘. *Mōkoshi kenkyū* 蒙古史研究 [Studies in Mongol history]. Tōkyō: Tōkō Shoin, 1930.

Yano, Tamaki 矢野環. *Kundaikan sō chōki no sōgō kenkyū* 君台観左右帳記の総合研究 [A comprehensive study of Kundaikan Souchoki]. Tōkyō: Bensei shuppan, 1999.

Yin Kui 殷奎. *Qiangzhai ji* 強齋集 [Qiangzhai collection]. Vol. 1232 of *Siku quanshu* 四庫全書. Shanghai: Shanghai guji chubanshe, 1987.

You Xinmin 遊新民. *Jiehua jiqiao* 界畫技巧 [Ruled-line painting techniques]. Beijing: Renmin meishu chubanshe, 1989.

Yu Anlan 于安瀾, ed. *Huashi congshu* 畫史叢書 [Collections of the painting history]. 5 vols. Shanghai: Shanghai renmin meishu chubanshe, 1963.

Yu Hui 余輝. "Renzhi Wang Zhenpeng, Lin Yiqing ji Yuandai gongting jiehua" 認知王振朋、林一清及元代宮廷界畫 [Interpreting Wang Zhenpeng, Lin Yiqing, and the Yuan court *jiehua*]. In *Meishu shi yu guannian shi* 美術史與觀念史, edited by Fan Jingzhong 范景中 and Cao Yiqiang 曹意強, 53–92. Nanjing: Nanjing shifan daxue chubanshe, 2003.

Yu Hui 余輝. "Song yuan longzhou ticai huihua yanjiu—xunzhao Zhang Zeduan 'Xihu zhengbiao tu' juan" 宋元龍舟題材繪畫研究——尋找張擇端《西湖爭標圖》卷 [On the Song-Yuan dragon-boat race paintings—tracing the handscroll of the *Dragon-Boat Race in the West Lake* attributed to Zhang Zeduan]. *Gugong bowuyuan yuankan* 故宮博物院院刊 190, no. 2 (2017): 6–36.

Yu Hui 余輝. "Wang Zhenpeng yu Guanghangong tu zhou kao" 王振朋與《廣寒宮圖》軸考 [Wang Zhenpeng and the study of the *Moon Palace* scroll]. In *Qiannian yizhen guoji xueshu yantaohui lunwenji* 千年遺珍國際學術研討會論文集, edited by Shanghai Museum, 620–628. Shanghai: Shanghai shuhua chubanshe, 2006.

Yu Hui 余輝. "Yuandai gongting huihua jigou chutan" 元代宮廷繪畫機構初探 [A preliminary exploration of the Yuan court painting institutes]. *Gugong bowuyuan yuankan* 故宮博物院院刊 79, no. 1 (1998): 29–33.

Yu Hui 余輝. "Yuandai gongting huihua shi ji jiazuo kaobian" 元代宮廷繪畫史及佳作考辨 [Yuan court painting history and studies of excellent works]. *Gugong bowuyuan yuankan* 故宮博物院院刊 81, no. 3 (1998): 61–78.

Yu Hui 余輝. "Yuandai gongting huihua shi ji jiazuo kaobian xu'er" 元代宮廷繪畫史及佳作考辨・續二 [Yuan court painting history and studies of excellent works, part III]. *Gugong bowuyuan yuankan* 故宮博物院院刊 90, no. 4 (2000): 49–59.

Yu Hui 余輝. "Yuandai gongting huihua shi ji jiazuo kaobian xuyi" 元代宮廷繪畫史及佳作考辨・續一 [Yuan court painting history and studies of excellent works, part II]. *Gugong bowuyuan yuankan* 故宮博物院院刊 89, no. 3 (2000): 25–35.

Yu Hui 余輝. "Yuandai gongting huihua yanjiu—jian kao Yuanting yiming jiazuo" 元代宮廷繪畫研究——兼考元廷佚名佳作 [A study of Yuan court paintings and an examination of Yuan court anonymous masterpieces]. In *Huashi jieyi* 畫史解疑, edited by Yu Hui 余輝, 269–335. Taipei: Dongda tushu gufen youxian gongsi, 2000.

Yu Ji 虞集. *Daoyuan xuegu lu* 道園學古錄 [Daoyuan's record of studying antiquity]. In *Sibu beiyao jibu* 四部備要・集部. Taipei: Taiwan zhonghua shuju, 1981.

Yu Jianhua 俞劍華. *Zhongguo meishujia renming cidian* 中國美術家人名辭典 [Biographical dictionary of Chinese artists]. Shanghai: Shanghai renming meishu, 1991.

Yuan Jue 袁桷. *Yuan Jue ji jiao zhu* 袁桷集校注 [An annotated collection of Yuan Jue]. Beijing: Zhonghua shuju, 2012.

Yu Kan 虞堪. *Xidan yuan shiji* 希澹園詩集 [Poetry collection of the Xidan Garden]. Vol. 1233 of *Wenyuan ge siku quanshu* 文淵閣四庫全書. Taipei: Taiwan shangwu yinshuguan, 1983.

Yue Shi 樂史, ed. *Taiping huanyu ji* 太平寰宇記 [Records of the universal realm in Taiping era]. Vol. 470 of *Wenyuan'ge siku quanshu* 文淵閣四庫全書. Taipci: Taiwan Shangwu yinshuguan, 1983.

Zha Yingguang 查應光. *Jinshi* 靳史 [Jin history]. Vol. 29 of *Siku jinhui shu congkan shi bu* 四庫禁燬書叢刊・史部. Beijing: Beijing chubanshe, 1997.

Zhan Jingfeng 詹景鳳. *Zhan Dongtu Xuanlan bian* 詹東圖玄覽編 [Zhan Dongtu's notes on masterpieces of art and calligraphy]. Vol. 4 of *Zhongguo shuhua quanshu* 中國書畫全書, edited by Lu Fusheng 盧輔聖. Shanghai: Shanghai shuhua chubanshe, 2000.

Zhang Tingyu 張廷玉 et al., eds. *Mingshi* 明史 [History of the Ming]. Beijing: Zhonghua shuju, 1974.

Zhang Tingyu 張廷玉. *Qingchao wenxian tongkao* 清朝文獻通考 [Encyclopedia of the historical records of the Qing dynasty]. Taipei: Taiwan shangwu yinshuguan, 1987.

Zhang Yanyuan 張彥遠. *Lidai minghua ji* 歷代名畫記 [Records of famous paintings of successive dynasties]. Vol. 1 of *Huashi congshu* 畫史叢書, edited by Yu Anlan 于安瀾. Shanghai: Shanghai renmin meishu chubanshe, 1982.

Zhang Yu 張羽. "Fengxun dafu pingjiang lu zhizhou zhishi Zihua Tang jun mujie" 奉訓大夫平江路知州致仕子華唐君墓碣 [Grave stele epitaph for Mr. Tang Zihua, the retired Grand Master for Admonishment and Pingjiang Route prefect). In *Wuxing yiwen bu* 吳興藝文補, edited by Dong Sizhang 董斯張, *juan* 30, 97–98. Shanghai: Shanghai guji chubanshe, 1995.

Zhang Yuchu 張宇初 et al., eds. *Zhengtong daozang* 正統道藏 [Daoist canon of the Zhengtong reign] (photocopy of Shanghai Hanfenlou version). Taipei: Xinwenfeng, 1985.

Zhao Yang 趙陽. "Xia Yong 'Yueyang lou tu' de zhizuo yu gongyong" 夏永《岳陽樓圖》的製作與功用 [The production process and function of Xia Yong's *Yueyang Pavilion* painting]. *Zhonghua wenhua huabao* 中華文化畫報, no. 4 (2018): 32–37.

Zhao Yanwei 趙彥衛. *Yunlu manchao* 雲麓漫鈔 [Casual notes from the Cloudy Foothill]. Beijing: Zhonghua shuju, 1998.

Zhejiang daxue zhongguo gudai shuhua yanjiu zhongxin 浙江大學中國古代書畫研究中心. *Songhua quanji* 宋畫全集 [Complete collection of Song painting]. Hangzhou: Zhejiang daxue chubanshe, 2009–.

Zhejiang daxue zhongguo gudai shuhua yanjiu zhongxin 浙江大學中國古代書畫研究中心. *Yuanhua quanji* 元畫全集 [Complete collection of Yuan painting]. Hangzhou: Zhejiang daxue chubanshe, 2012–.

Zheng Ji 鄭績. *Menghuan ju huaxue jianming* 夢幻居畫學簡明 [The essence of the painting technique of the Menghuan Studio]. In *Xuxiu siku quanshu* 續修四庫全書. Shanghai: Shanghai guji chubanshe, 1995.

Zhongguo meishu quanji bianji weiyuanhui 中國美術全集編輯委員會. *Zhongguo meishu quanji* 中國美術全集 [The complete works of Chinese fine arts]. 60 vols. Beijing and Shanghai: Wenwu chubanshe, 1984–1989.

Zhongguo gudai shuhua jiandingzu 中國古代書畫鑒定組. *Zhongguo gudai shuhua tumu* 中國古代書畫圖目 [Illustrated catalogue of selected works of ancient Chinese painting and calligraphy]. 24 vols. Beijing: Remin meishu chubanshe, 1978–2001.

Zhongguo gudai shuhua jiandingzu 中國古代書畫鑒定組. *Zhongguo huihua quanji* 中國繪畫全集 [The complete works of Chinese paintings]. 30 vols. Beijing: Wenwu chubanshe, 1997–2001.

Zhou Baozhu 周寶珠. *Qingming shanghe tu yu Qingming shanghe xue* 《清明上河圖》與清明上河學 [*Qingming shanghe tu* and studies of the Qingming scroll]. Kaifeng: Henan daxue chubanshe, 1997.

Zhu Jingxuan 朱景玄. *Tangchao minghua lu* 唐朝名畫錄 [Record of famous painters of the Tang dynasty]. Vol. 1 of *Zhongguo shuhua quanshu* 中國書畫全書, edited by Lu Fusheng 盧輔聖. Shanghai: Shanghai shuhua chubanshe, 2000.

Zhu Mouyin 朱謀堊. *Huashi huiyao* 畫史會要 [Essentials in the history of painting]. In *Wenjin ge siku quanshu* 文津閣四庫全書. Beijing: Shangwu yinshuguan, 2005.

Zhuang Shen 莊申. "Gugong shuhua suojian mingdai banguanyin kao" 故宮書畫所見明代半官印考 [A study on the Ming half-seals on works of calligraphy and paintings in the National Palace Museum]. In *Zhongguo huashi yanjiu xuji* 中國畫史研究續集, 1–46. Taipei: Zhengzhong shuju, 1972.

Zuo, Lala. *Diversity in the Great Unity: Regional Yuan Architecture*. Honolulu: University of Hawai'i Press, 2019.

Index

Note: Page numbers in *italics* refer to figures.